ODYSSEUS' ITHACA
The Riddle Solved

To E on the 7th August
a gift from Keffalonia. (Greece)
with loads of love.
Kiv + Mam.

Approved by the Hellenic Ministry of Education,
General Education Directorate.

Greek Edition 1998
Cephallenia: The Revelation of Homeric Ithaca

© Copyright Nicolas G. Livadas
Athens 2000
http://www.forthnet.gr/Homer-Ithaki
www.herasamos.co.uk
E-mail: Livadas@x-treme.gr
Hellas, Athens Tel – Fax: +301 9656529
Mobile: +30944 855330 Cephallonia +30671 85296
ISBN: 960-90803-1-6

NICOLAS G. LIVADAS

ODYSSEUS' ITHACA
The Riddle Solved

TRANSLATED AND EDITED
BY
CONSTANTINE BISTICAS

PUBLICATIONS: NICOLAS G. LIVADAS

ATHENS 2000

Thank you very much for sending me your very interesting study regardingh Homeric Ithaca.

Constantine Stephanopoulos
President of the Republic

Your arguments as well as the material you presented are noteworthy.

Professor E. Mikrogiannakis
Athens University

Warm congratulations. Not only you have minutely analysed the pertinent verses from *The Odyssey*, but you have collected Strabo's frequently enlightening comments, which no scholiast of Homer has done with such thoroughness. Your work as a whole, is an important contribution to the understanding of Homer, and will have a place in contemporary research. I would recommend this study to all readers of Homer.

Professor Tilman Krischer
Berlin University

You have accomplished your task with labour and zeal your conclusion being very clear. You deserve congratulations from all men of letters.

Pan. Georgountzos, President
Hellenic Philological Society

Your book is most interesting. Literally provocative. Congratulations … You write methodically, with care and characteristic Cephallenian wit. You are very convincing and I hope you will be justified in the end.

Father George D. Metallinos
Athens University

What I can say with certainty is that Nicolas Livadas is a direct descendant of Odysseus. For more than twenty years he literally 'consumed' Cephallenia, *The Odyssey* and all pertinent books about Odysseus with his eyes, in the effort to prove that the cove of Atheras is the place where the Phaeacians deposited Odysseus, and that his palace lies in Pallis. The research regarding the land and the available sources is exhaustive.

Sarantos Kargakos
Philologist - Historian

*This book is dedicated to all those who,
throughout the world, carry the torch of
the immortal Greek spirit*

TABLE OF CONTENTS

PREFACE TO THE ENGLISH EDITION13

TRANSLATOR'S NOTE ..15

INTRODUCTION ..17

I. THE KINGDOM OF ODYSSEUS21

 1. Taphian Ithacus, Founder of Ithaca.....................22
 2. Cephallenia, Homer's Ithaca23
 3. Magnificent Mt. Neriton32
 4. Low-Lying Ithaca Under Mt. Neion34
 5. Ithaca's Curving Beach39
 6. Cyllenian Hermes and Crikellos40
 7. The Hermes Hill above the City of Ithaca43
 8. The Boundary of Odysseus' Kingdom..................44
 9. Herds and Livestock in Homeric Ithaca...............47
 10. Agriculture in Homeric Ithaca52

II. THE HARBOURS OF HOMERIC ITHACA....................55

 1. The Harbour of the City of Ithaca at Livadi56
 2. The Phorcys Harbour at Atheras60
 3. Phorcys: An Ancient God Awaits62
 4. The Reithron Harbour at Samoli71

III. TELEMACHUS' VOYAGE TO PYLOS77

 1. The Temple at Kioni.......................................77
 2. Telemachus' Departure for Pylos80
 3. The Suitors' Ambush at Asteris86
 4. Alalcomenae and the Vardiani Reef96
 5. Asteris and 'Deskálio' or 'Daskalió'103

IV. ODYSSEUS' ARRIVAL AT LONGED-FOR ITHACA109

 1. Corcyra, the Enchanted Island of the Phaeacians109
 2. The Orbit of Venus, A Compass to Homeric Ithaca115
 3. Odysseus' Arrival at the Phorcys Harbour.......................119
 4. The Sacred Olive Tree and the Road to the Grotto121
 5. The Grotto of the Nymphs125
 6. The Phaeacian Ship Turned to Stone130
 7. The First Approach to the Gates of the Immortals132

V. FROM THE HARBOUR OF PHORCYS
 TO EUMAEUS' SWINESTY ...133

VI. FROM EUMAEUS' SWINESTY TO THE PALACE137

 1. Katagous and the Treacherous Road...................................138
 2. Fair-Flowing Fountain (Καλλίροος Κρήνη).......................139

VII. THE PALACE ON THE HILL ...143

 1. The Great Wall, the Eastern Gate and the Propylaea.........144
 2. The Palace Building and the Handmills...........................151
 3. The Royal Estate and the Court's Northern Gate154
 4. The Great Altar of Zeus159
 5. The Well-built Tower of Telemachus................................161
 6. The West Side Wall and Other Ruins on Crikellos Hill165
 7. Swiftly they Came Down to the Sea166
 8. Radiocarbon Dating of Plaster Sample166

VIII. THE ESTATE OF LAERTES AT PLATIES STRATES...........169

IX. ITHACA, CITY OF DREAMS..173

 1. The Landscape of Homeric Ithaca173
 2. Ocean Currents (Ὠκεανοῦ Ῥοαί).....................................176
 3. The Rock Leucas (Λευκάδα πέτρη)...................................176

4. Agonas - Pylaros: The Gates of the Sun (Ἡλίοιο πύλαι)176
5. The Land of Dreams (Δῆμος Ὀνείρων)178
6. The Meadow of Asphodel (Ἀσφοδελός Λειμῶν)178
7. The Dank Ways (Εὐρώεντα Κέλευθα)179
8. The Ghosts Followed Gibbering (ταί δέ τρίζουσαι ἕποντο).........180

X THE ROCK LEUCAS AND THE ALTAR OF APOLLO183

1. Cephalus, the Patriarch of the Cephallenians...................183
2. Sappho, the Tenth Muse..188
3. Lesbos – Cephallenia ...193
4. Apollo, Ithaca's Patron God..194
 I. Apollo the Purifier ..194
 II. Apollo Clytotoxus...196
5. The Sacred Hecatomb ...198
6. The Shady Grove of Apollo ...199
7. The Sacred Altar of Apollo..201
8. The Leap..202

XI. DULICHIUM ...204

1. The Lost Homeric Island...204
2. Dulichium Facing Ithaca ...212
3. The Island of Dulichium ..217
4. Dulichium and the Dolichus Race218
5. Dulichium and the Epeians ...219
6. Invocatory Inscription at Demeter's Temple.....................224

XII. THE LEGENDARY CITY OF NERICUS259

XIII. AEGILIPS AND CROCYLEIA...275

XIV. LIXOURI AND THE PLANCTAE ROCKS279

XV. CHARYBDIS AT ARGOSTOLI...285

XVI. TEIRESIAS' RIDDLE AND THE TOMB OF ODYSSEUS295

XVII. CEPHALLENIA'S TOPONYMS303

 1. Petanoi ...303
 2. Kakoïlion ...303
 3. Assos – Pedaus ..303
 4. Kouttavos or Cottabus308
 5. The Bay of Myrtos, 'Myrton and Eretmon'309

XVIII. CEPHALLENIA, HOMER'S ENCHANTED ITHACA313

 1. Beautiful Rocky Ithaca313
 2. The Climate of Cephallenia317
 3. Thiaco, the Wine of Ithaca319
 4. The Name Ithaca All Over Cephallenia320

XIX. THE ORIGIN OF HOMER323

 1. The Argonautic Expedition323
 2. The Delphic Oracle324
 3. Cephallenia, Melite (Malta) of the New Testament327
 4. Milesigenes Homer329

EPILOGUE ..333

APPENDICES ..335

GLOSSARY ..347

BIBLIOGRAPHY ...357

INDEX OF HOMERIC ITHACA'S SITES
AND TEXT REFERENCES ...363

MAP OF HOMERIC ITHACA'S SITES

PREFACE TO THE ENGLISH EDITION

THE JOURNEY in search for Odysseus' Ithaca started over twenty years ago. It was a long and fascinating voyage, wandering in Homeric descriptions and around the shores, the hills and precipices of the enchanting island of Cephallenia. Old tales and stories told by the simple folk on the island kindled my imagination and strengthened my conviction that I was indeed treading the soil on which Odysseus lived out his final passion. Little by little, site by site, Homer's descriptions came to life in the living landscape of Cephallenia's Pallis peninsula. I set out and followed Odysseus' route from the island of the Phaeacians (Corcyra) to the leeward harbour of Phorcys (Atheras), experiencing the rough seas and the calmness of the beaching at Atheras. I climbed the hills from Atheras to Fakimia where Eumaeus' swinesty should have been. I followed Odysseus' footsteps to the palace on Hermes hill (Crikellos). I treaded the narrow paths over the precipices to the white rock, a pilgrim to the Altar of Apollo. This book is the result of endless re-reading of Homer's exquisite descriptions, numberless trips and walks in the wilderness of Cephallenia's hills and coves, and of hopes and dreams, in the conviction that this was indeed Odysseus' land. The original finds and conclusions, on which this book is based, were presented in a study entitled «Return to Homeric Ithaca» which was put together and distributed to friends, acquaintances, government officials and others, in 1992. The encouraging reception of this original study led to the Greek edition in 1998, containing additional material and information. The present English edition is based on the Greek text, rearranged for increased clarity.

My first debt is to my parents who instilled in me boundless love for my native island. The support of my family, who stood by me throughout this adventure, was invaluable, particularly that of my son Gerassimos who accompanied me in my wanderings all these long years.

Personal acknowledgements must begin with an expression of gratitude to my compatriot and friend Leonidas Katsaïtis, living now in the U.S.A., who read and studied the original Greek edition, visited all

sites described and urged me to publish the book in English so as to reach a wider public. To father George D. Metallinos, of the University of Athens, who supported and encouraged this effort since its inception and strengthened my faith in the endeavour to uncover long lost Odysseus' Ithaca through the verses of the divine bard.

N.G.L.

TRANSLATOR'S NOTE

THE ORIGINAL publication in Greek entitled 'Cephallenia', the Revelation of Homeric Ithaca' appeared in 1998. The book published in haste at that time, had certain inadequacies, which were rectified during the course of the present translation. No new material was added, while not a verse, sentence or meaning intended by the author was removed or altered. The material, however, was restructured and put in a more logical sequence. It was thus possible to delete obvious repetitions.

Certain other measures were also taken with the author's permission, which, we believe, made the text easier to follow. Most of the detailed word and term analyses were removed from the main body of the work and were listed alphabetically in a glossary included in the end of the book. The corresponding words in the text have been printed in bold type so that the reader may, if he wishes, refer to them. Certain parts were included in appendices, while comments and complementary information were annotated.

In rendering the original Homeric verses into English the A. T. Murray translations of *The Odyssey* and *The Iliad* were used (Loeb, 1998 and 1999). Given that excerpts of the original Greek verses are extensively quoted, an effort was made to render Murray's translation in verse as well, so that each line in English should correspond exactly to the Greek original. Because of the excellence and exactness of Murray's work, it was possible to do this without altering or injuring the English rendition, even though in a few instances it was found necessary to transpose certain words or sequence of words. Thus the reader who is familiar with Homeric Greek can follow the translation and compare it to the original, verse for verse. Both Greek and English verse reference numbers are given, while all words written in Greek are also rendered phonetically in English.

The Loeb editions of Strabo (H. L. Jones), Apollodorus (J. G. Frazer), Apollonius Rhodius (R. C. Seaton, M. A.), and Hesiod (H. G. Evelyn-White), were used as needed and, of course, the Liddell and Scott Greek – English Lexikon (9th Ed., 1992 Impr.)

Many thanks are extended to Thalia Bisticas, of the British Council, who read and critically examined the final text and to Maria Nanouri whose untiring typing efforts made the timely completion of the work possible.

Chalandri 2000
C.B.

INTRODUCTION

THE MAIN theme of the Homeric epic poem, *The Odyssey*, is the return of the hero Odysseus to his beloved native land Ithaca, to the sacred soil of his ancestors where his family lived: his wife Penelope, his son Telemachus and his father Laertes. The poem consists of 24 rhapsodies and 12,110 verses, a large part of which recounts the adventures of the sorely tried Odysseus during his ten years of wandering following his departure from Troy. Extensive mention is also made of the reminiscences of King Nestor of Pylos and King Menelaus of Sparta regarding the fate of the Achean heroes who fought at Troy. Odysseus' voyage from the island of Ogygia to Ithaca following Zeus' decision is then described and finally the events following Odysseus' homecoming. The specific time period from the point of Zeus' decision to Odysseus' actual arrival in Ithaca is only forty-two days, during which the main theme of *The Odyssey* unfolds. The present study is founded mainly, but not solely, on these events, containing, as it were, the salient descriptions and information sought. In brief, Odysseus' itinerary is as follows:

The first day a confrontation takes place on Mt. Olympus, the abode of the gods, between Zeus, the father of the gods, and his daughter Athena, goddess of wisdom. The latter asks her father to permit Odysseus to leave the island of Ogygia, where he has been held captive by the nymph Calypso, so that he can return to his much-longed for island of Ithaca. Zeus assents to his daughter's request. Eight days go by during which certain decisions are made regarding Odysseus' return and on the eighth day, Hermes, the messenger of the gods, brings a message to Calypso bidding her to release Odysseus (Od. 5.212). At the same time Athena, on her father's bidding, departs to come to the assistance of Telemachus, son of Odysseus, who was on his way to visit King Nestor of Pylos and King Menelaus of Sparta seeking tidings of his father.

The following day Odysseus, having been informed by Calypso of the message Hermes brought regarding his release and of his freedom to leave the island of Ogygia (Od. 5.160), begins constructing the raft

that will carry him over the sea. This takes four days, from day nine to day twelve inclusive (Od. 5.262).

The thirteenth day, Odysseus sets sail (Od. 5.263), heading East, keeping the Bear star on his left (Od. 5.276-7). He sails for seventeen days and on the eighteenth day, that is the thirtieth day since the beginning of the events described, appear the «shadowy mountains of the land of the Phaeacians» (Od. 5.278-80 & 7.267-9). At this point, a fierce sea storm erupts, Odysseus' raft is demolished by the waves and he, clinging to a wooden plank (Od. 5.370-1), remains in the water for two days and two nights (Od. 5.388-9).

The third day, or the twentieth day since he set sail, and the thirty-second day of *The Odyssey* «the wind ceased and there was a windless calm» and he «caught sight of the shore close at hand» (Od. 5.390-2). Thus the unfortunate king of Ithaca lands on the island of the Phaeacians (Od. 5.353-4 & 6.170).

The thirty-third day, as dawn breaks, Nausicaa, daughter of Alcinous, King of the Phaeacians, finds Odysseus (Od. 6.141) naked in the bushes by the river and directs him to her father's palace (Od. 6.255-6).

He stays there two days (Od. 8.35 & 64-5) and on the thirty-fifth day sails again at dusk and finally, during the early hours of the dawn, arrives at the harbour of Phorcys, the old man of the sea, that is the windless harbour of Ithaca (Od. 8.93-5). He thus completes his voyage in thirty-six days since the day he set sail from Calypso's island.

In general, the events described in *The Iliad* and *The Odyssey* took place during or immediately following the sack of Troy (ca.1150 BC). The four centuries intervening between this date and ca. 750 BC are known as the Dark Ages. At that point, Greek civilisation had begun to flourish again and the Homeric saga was recorded (some say composed). In the meantime, all historical memory was erased and the sequence of historical events was lost to us. Nearly thirty-two centuries have elapsed since then. In spite of the fact that many cities and sites described by Homer have been located and identified and also in spite of ceaseless efforts since classical antiquity to this day, the location of Odysseus' longed-for land has not been found. Strabo (64-63 BC to ca. 25 AD) in his *Geography* reports:

ἐν τε τῇ Ἰθάκῃ οὐδέν ἐστιν ἄντρον τοιοῦτον, οὐδὲ Νυμφαῖον, οἷόν
φησιν Ὅμηρος· βέλτιον δὲ αἰτιᾶσθαι μεταβολὴν ἢ ἄγνοιαν ἢ
κατάψευσιν τῶν τόπων κατὰ τό μυθῶδες. τοῦτο μὲν δὴ ἀσαφὲς
ὃν ἐῶ ἐν κοινῷ σκοπεῖν.

<div align="right">Στράβων, Α.Γ-18</div>

*Further, in Ithaca there is no cave, neither grotto of the
Nymphs, such as Homer describes; but it is better to ascribe
the cause to physical change rather than to Homer's igno-
rance or to a false account of the places to suit the fabu-
lous element of his poetry. Since this matter, however, is
uncertain, I leave it to the public to investigate.*

<div align="right">Str. 1.3.18</div>

Contemporary archaeological research and excavations on the island
known today as Ithaca and elsewhere have revealed nothing of impor-
tance, at least nothing comparable to the finds of Troy, Mycenae or
Pylos. At the same time, Strabo's testimony lends credence to the sus-
picion that the approach adopted by ancient philosophers, geographers
and travellers regarding the identification of pre-historic Ithaca's loca-
tion was identical to that of contemporary researchers. They have all
searched and are still searching, it is believed, in the wrong places.
Homer's detailed geographical and topographical descriptions and di-
rections have not been given the meticulous attention required.

What follows is not a philological analysis, but rather a quest for the
discovery of Homeric Ithaca based on Homer's precise descriptions
and terminology. The method employed consists of using Homer him-
self as a guiding light, which should lead to Odysseus' Ithaca, on the
basis of the geographical and topographical information with which he
abundantly supplies the reader. Specifically, the intention here is to
correlate Homer's descriptions with known places and locations in the
Ionian Islands, by means of an analysis of the precise meanings of the
terms used. It is proposed that Homeric Ithaca is none other than the
island of Cephallenia, given that Homer's descriptions fit the geogra-
phy of this land. The reader will, it is hoped, be able to form his own
opinion on how successfully this task has been accomplished.

CANDID GUIDE TO IONIAN

FISCARDON

ASTERIS

ASSOS

MIRTOS BAY

HOMERIC
SAME

ATHERAS

AGKONAS

AGIA EVFIMIA

SAMI

FARSA

LIXOURION

ARGOSTOLI

PORO

ISLAND OF
VARDHIANI

1628 m.
Mt. ENOS

ISLAND OF CEPHALONIA
HOMERIC ITHACA

N

CEPHALLONIA ISLAND MAP

CHAPTER ONE

THE KINGDOM OF ODYSSEUS

ITHACA was not, as Homer testifies, the only part of Odysseus' realm, as it is generally assumed. In *The Iliad*, the poet gives a comprehensive catalogue of the islands and the regions which, «lying close by one another» (Od. 9.25), constitute the hero's kingdom. These were Ithaca, Neritum, Crocyleia and the rugged Aegilips, Zacynthus, Same and the shores opposite Same. In his own words he states:

Αὐτὰρ Ὀδυσσεὺς ἦγε Κεφαλλῆνας μεγαθύμους,
οἵ ῥ' Ἰθάκην εἶχον καὶ Νήριτον εἰνοσίφυλλον,
καὶ Κροκύλει' ἐνέμοντο καὶ Αἰγίλιπα τρηχεῖαν,
οἵ τε Ζάκυνθον ἔχον ἠδ' οἳ Σάμον ἀμφενέμοντο,
οἵ τ' ἤπειρον ἔχον ἠδ' ἀντιπέραι' ἐνέμοντο·
τῶν μὲν Ὀδυσσεὺς ἦρχε Διὶ μῆτιν ἀτάλαντος.

B 631-6

And Odysseus led the great-hearted Cephallenians
who held Ithaca and Neritum with waving forests,
and who dwelt in Crocyleia and rugged Aegilips;
and those who held Zacynthus, and who dwelt about Samos,
and held the mainland and dwelt on the shores opposite
the isles. These Odysseus led, the peer of Zeus in counsel.

Il. 2.631-6

In this island cluster Dulichium (Od. 9.24) should be counted even though the ships that sailed for Troy from this city were led by Meges[1].

1 Meges, who led the Epeians of Dulichium (inhabitants of the Echinae islands, Kophiniotis Homeric Lexicon) was not the King of Dulichium. He was the son of Phyleus, ruler of the Eleian country, who quarrelled with his father and went to live in the rich in wheat and grass Dulichium. This was the land of King Aretias, whose son was Nisus and grandson Amphinomus, the one who led Penelope's suitors (Od. 16.394-7). It appears that Odysseus held Aretias' family in great esteem and this is apparent in his conversations with Amphinomus.

The fact that the Dulichian ships did not follow Odysseus' naval convoy should not be misconstrued as not being under his command. Odysseus sailed for Troy along with Agamemnon and Menelaus leading only twelve ships (Il. 2.637), their crews coming from all other parts of the kingdom except Dulichium. This was a purely strategic choice which allowed Odysseus freedom to move and manoeuvre, given that his role was clearly that of a high-level staff officer, as is known from the descriptions of *The Iliad* and *The Odyssey*. Tactical reasons then obliged Odysseus to sail independently with his flag ship and support vessels. Dulichium, therefore, was part of Odysseus' realm and this is made abundantly clear from the fact that half of Penelope's suitors, fifty-two in number, came from that city. If they were not subject to the kingdom of Ithaca, they would not be legally able to take part in the people's assemblies and, what is more, to vie for the position of the new archon as a result of Penelope's choice of a new husband. But these points will be examined in more detail when the still unknown geographical location of Dulichium is discussed.

1. Taphian Ithacus, the Founder of Ithaca

[...] καὶ ἐπὶ κρήνην ἀφίκοντο
τυκτὴν καλλίροον, ὅθεν ὑδρεύοντο πολῖται,
τὴν ποίησ᾽ Ἴθακος καὶ Νήριτος ἠδὲ Πολύκτωρ· [...]
ρ 205-7

[...] and had come to the fountain,
well-wrought and fair-flowing, from which the townsfolk drew water –
this Ithacus had made, and Neritus and Polyctor, [...]
Od. 17.205-7

According to the information supplied by the above verse (Od. 17.207), Ithacus along with his brothers built the «well-rought and fair-flowing fountain». This confirms the view that he built his own palace in the area, and the city which he named Ithaca. Obviously, following the establishment of the city of Ithaca, the general area of the

Pallis peninsula was named *démos* of Ithaca. Ithacus, Neritus and Polyctor were sons of Pterelaus, King of the Taphians. The fact that the Callirous fountain is located in the general area of Halkes, and that the Taphioi site is found in southwest Pallis, confirm the proposition that the Taphians were settled in the area before Amphitryon's expedition[2]. Cephalus' son, Pales, settled there but was later deposed by Cephalus' first born Arceisius, Laertes' father and Odysseus' grandfather. Thus the kingdom of Ithaca was inherited by Odysseus, the glorious king, who made it known forever to the whole world.

2. Cephallenia, Homer's Ithaca

Many claims have been made in the past regarding present day Ithaca, the island of Leucas, the island of Poros and other localities proposed as being Homeric Ithaca. These, however, bear no relation to Homer's specifications. The geographical facts, the formation of the land and the orientation of Homeric descriptions, leave little room for doubt as to the correctness of the propositions presented above. For example, there is no indication in *The Odyssey* supporting the identification of the island of Leucas with Homer's Ithaca. Strabo (Str. 1.3.18) on the other hand, informs us that «Leucas, since the Corinthians cut a canal through the isthmus [connecting it to the mainland] has become an island». Before that, it was a headland of Acarnania, which is located on the mainland across from Same. In fact, certain theories have in the past been put forth to the effect that Ithaca was not an island. Homer, however, informs us quite clearly that the Phaeacians brought Odysseus home, «to the island», thus putting to rest all such claims.

[...] τῆμος δὴ νήσῳ προσεπίλνατο ποντοπόρος νηῦς.

ν 95

2 Amphitryon, in early times, made an expedition against Cephallenia along with Cephalus, seized the island and turned it over to Cephalus; it was thus named Cephallenia. (Strabo, 10.2.14 and 10.2.20) Trans. note.

[…] then it was that the seafaring ship drew near to the island.
Od., 13.95

And again,

[…] μῆλα γὰρ ἐξ' Ἰϑάκης Μεσσήνιοι ἄνδρες ἄειραν
νηυσὶ πολυκλήϊσι τριηκόσι ἠδὲ νομῆας.

φ 18-9

[…] for the men of Messene had lifted from Ithaca
in the benched ships three hundred sheep and their
shepherds with them.

Od. 21.18-9

As far as the island which bears the name of Ithaca in contemporary times is concerned, the most plausible explanation is that the island in Homer's time was known as Same, and bears the name of Ithaca today due to erroneous tradition. The inhabitants of prehistoric Same, most likely abandoned it due to the devastation brought about by war or other calamities. They migrated across the narrow seaway to the coast of Cephallenia and settled in the general area of the modern city of Same, bestowing upon the place the name of their homeland. This is a practice handed down through the ages to this day, many cities on all four continents and Greece itself having names originating in older locations. Furthermore, one should consider that the inhabitants of the island of Cephallenia are in contemporary times called Cephallenians, the same name that the poet uses to describe the inhabitants of Homeric Ithaca. Thus, it is an easily drawn conclusion that the island of Cephallenia is Homeric Ithaca, and consequently, Homeric Same lies across from it, being separated by a narrow seaway, the islet of Asteris is lying in the straits. Same, on the other hand, lies east of Ithaca, and across from Same lies Acarnania's coast, that is modern-day Leucas, etc.

[…] οἵ τε Ζάκυνϑον ἔχον ἠδ' οἳ Σάμον ἀμφενέμοντο,
οἵ τ' ἤπειρον ἔχον ἠδ' ἀντιπέραι' ἐνέμοντο· […]

B 634-5

[...] and those who held Zacynthus, and who dwelt about Same,
and held the mainland and dwelt on the shores opposite the isles.
Il., 2.634-5

As noted, the islands mentioned by Homer (Od. 9.21-4) are Dulichium, Same, Zacynthus and Ithaca. Of these, Zacynthus alone has preserved its name, while Dulichium is totally lost and Same along with Ithaca lost their true archaic identity. Leucas has been variably used as an alternate site for prehistoric Ithaca by various researchers, but it has been mostly excluded as part of the Homeric islands. On the basis of the above and on the evidence to be presented in the following chapters, an initial map is created, placing each island in the proper position in relation to each other, in conformity with Homeric descriptions. Lost Dulichium is not considered at this point. It will be treated separately in a subsequent chapter.

Following Odysseus' encounter with Nausicaa, he was directed to the palace of her father King Alcinous. There he was given succour and the following day he revealed his identity and that of his homeland, giving details of its location and the features of the landscape.

ναιετάω δ' Ἰθάκην εὐδείελον· ἐν δ' ὄρος αὐτῇ
Νήριτον εἰνοσίφυλλον, ἀριπρεπές· ἀμφὶ δὲ νῆσοι
πολλαὶ ναιετάουσι μάλα σχεδὸν ἀλλήλῃσι,
Δουλίχιόν τε Σάμη τε καὶ ὑλήεσσα Ζάκυνθος.
αὐτὴ δὲ χθαμαλὴ πανυπερτάτη εἰν ἁλὶ κεῖται
πρὸς ζόφον, αἱ δέ τ' ἄνευθε πρὸς ἠῶ τ' ἠέλιόν τε,
τρηχεῖ, ἀλλ' ἀγαθὴ κουροτρόφος· οὔ τοι ἐγώ γε
ἧς γαίης δύναμαι γλυκερώτερον ἄλλο ἰδέσθαι.
ι 21-8

I dwell in clear seen Ithaca; on it is a mountain,
Neriton, covered with waving forests, conspicuous from afar;
and around it
lie many islands close by one another,
Dulichium, and Same and wooded Zacynthus.

Ithaca itself lies low in the sea, farthest of all
toward the dark[ness], but the others lie apart towards the dawn
and the sun –
a rugged island, but a good nurse of young men; and for myself
no other thing can I see sweeter than one's own land.

Od. 9.21-8

This brief, yet very precise, description gives indeed the possibility of definitely pinpointing Ithaca's geographical location, creating, as it were, a topographical chart of the region where it lay. The significance of the characteristic terms that clarify Homer's description are underlined (see glossary).

The word εὐδείελον 'eudeíelon', in Homeric Greek, means clearly seen from afar, distinct. It is a compound word consisting of εὖ 'eu' an adverb meaning well, correct, appropriate, its opposite being κακῶς 'kakós', meaning bad, evil (See lemma in Liddell & Scott Lex.) and δείελος 'deíelos' meaning evening, late afternoon, dusk. The derivative adjectival form δειελινός 'deielinós' means, of, or belonging to, evening (see approp. lemmata in Lid. & Scott Lex.). Ithaca, then, is connected to dusk, the latter part of the day, and is set by Homer in the late afternoon landscape. It appears to constitute the central point of a picture whose background is the horizon and the setting sun. The term πανυ-περτάτη 'panhypertáte' is also a compound word consisting of πᾶν 'pan', an adverb meaning 'all' and ὑπερτάτη 'hypertáti', the feminine adjectival form of the superlative 'hypértatos' which is usually applied to places, P. 13.8.73. The exact significance in this case is that Ithaca, the island, lies at the extremity of the region, in the farthest place. As far as the noun ζόφος 'zóphos' is concerned, many theories have been expounded from time to time, namely that 'zóphos' is the North and not the West[3]. It has even been suggested that Homer was ignorant of

3. North is in front, East to the right and West to the left. Ζόφος zóphos is also briefly mentioned in Od. 11,57,155. In the Kaktos edition Od. Rhapsody 3, the scholiast notes that «Homer places the setting of the sun in the ocean and from the ocean the rising of the sun.»

the four points of the compass, and of geography, thus giving erroneous geographical information. It is true that remarks of this sort are not new, but were made even in antiquity (Str. 10.2.12), probably in an effort to justify the inability of the commentators to locate Ithaca. This crucial question is answered by Homer himself, who, regarding the North, West and East, states quite clearly:

> [...] εἴτ' ἐπὶ δεξί' ἴωσι πρὸς ἠῶ τ' ἠέλιόν τε,
> εἴτ' ἐπ' ἀριστερά τοί γε ποτὶ ζόφον ἠερόεντα.
>
> N 239-40

> [...] whether they go to the right toward dawn and the sun,
> or to the left toward the murky darkness.
>
> Il. 12.239-40

Again, describing the grotto of the Nymphs, he states:

> [...] δύω δέ τέ οἱ θύραι εἰσίν,
> αἱ μὲν πρὸς Βορέαο καταιβαταὶ ἀνθρώποισιν,
> αἱ δ' αὖ πρὸς Νότου εἰσὶ θεώτεραι· [...]
>
> ν 109-12

> [...] two doors there are [to the cave]
> one toward the North Wind, by which men go down,
> but that toward the South Wind is sacred, [...]
>
> Od. 13.109-12

There is no doubt, therefore, as to where Ithaca is located by the poet in relation to the other islands of the cluster. «Ithaca itself lies low in the sea, farthest of all toward the dark(ness) (Od. 9.25-6), but the others lie apart towards the dawn and the sun...» (Od. 9.26). Thus, Ithaca lies to the extreme West of the island cluster described while the rest lie to the East. As he states in another description:

[...] μετόπισθε⁴ ποτὶ ζόφον ἠερόεντα.

ν 241

[...] behind toward the murky darkness.

Od., 13.241

The key element in the effort to locate Odysseus' islands and pre-
pare a map of them and one that provides the solution to the Homeric
issue, putting an end to the endless disputes between scholars of
Homer, is the differentiation made regarding the name of Ithaca. The
poet alternatively uses the name Ithaca[5]:

I. when he refers to the island itself on which the magnificent Mt.
 Neriton rises up and which due to its height and massive size, con-
 stitutes a primary element in the morphology of ancient Ithaca;

II. when he mentions the city, where the activities of the citizens take
 place, constituting as such, the administrative centre of Odysseus'
 kingdom. It has a very large harbour and the king's palace is built
 there;

III. when he makes reference to the peninsula of Pallis (the *démos*),
 which in fact offers the possibility of a natural extension of the
 city's activities. The morphology of the land permits this, because
 of the great length of the harbour, extending for 17 km. The penin-
 sula, including the Vardiani island, from the northernmost point of
 Atheras to the southernmost point at Xi is over 21 km long.

The verb ναιετάω 'naeetáo', means dwell in, inhabit when referring to
persons, and to be situated, lie when referring to places. It also means
to be inhabited as is revealed by the following verses:

4. Μετόπισθε (metópisthe), adv. Of place: behind, in the rear.
5. Appendix I presents analytically these differentiations, listing the verses where
 the proper noun 'Ithaca' appears in reference to the island, the city and the
 municipality (*démos*).

[…] κτήματ' ἀπορραίσει, Ἰθάκης ἔτι ναιεταώσης.
α 404

[…] shall wrest your possessions from you, while men yet live in Ithaca.

Od. 1.404

And again,

[…] ἀμφὶ δὲ νῆσοι
πολλαὶ ναιετάουσι μάλα σχεδὸν ἀλλήλῃσι, […]
ι 22-3

[…] and round it lie
many islands close by one another, […]

Od. 9.22-3

The use, therefore, of the verb ναιετάω 'naeetáo', «I dwell in clear-seen Ithaca» (Od. 9.21) indicates that the poet intends to underline a specific inhabited place, the city where Odysseus dwells and not his place of origin in general: the island of Ithaca. Thus, one can safely conclude that there was an island of Ithaca as well as a city of Ithaca, just like many islands in contemporary Greece carry the same name as their capital cities. For example, the capital of the island of Zacynthus is Zacynthus and that of the island of Corcyra (Corfu) is Corcyra. The word εὐδείελος 'eudeíelos', refers not only to Ithaca the city, but to the larger area around it as well, which could be described as the *démos* or municipality of Ithaca. This is confirmed by the verses quoted below describing the interpretation given by the old hero Halithersis, son of Mastor, at the assembly of the Ithacians, regarding the appearance of two eagles as constituting a bad omen for the fate of Penelope's suitors.

[…] πολέσιν δὲ καὶ ἄλλοισιν κακὸν ἔσται,
οἳ νεμόμεσθ' Ἰθάκην εὐδείελον.
β 166-7

[...] and to many others of us also will be an evil,
who dwell in clear-seen Ithaca.

Od. 2.166-7

After the brief discussions that followed, the assembly broke up and,

οἱ μὲν ἄρ' ἐσκίδναντο ἑὰ πρὸς δώμαθ' ἕκαστος,
μνηστῆρες δ' ἐς δώματ' ἴσαν θείου Ὀδυσῆος.

ϐ 258-9

Then they scattered, each one to his own house,
and the suitors went to the house of divine Odysseus.

Od. 2.258-9

The assembly was composed of the inhabitants of the city of Ithaca whom Halithersis chastised because they did not restrain the suitors. During the course of the same assembly, Mentor expresses his indignation at the Ithacians.

νῦν δ' ἄλλῳ δήμῳ νεμεσίζομαι, οἷον ἅπαντες
ἦσθ' ἄνεω, ἀτὰρ οὔ τι καθαπτόμενοι ἐπέεσσι
παύρους μνηστῆρας καταπαύετε πολλοὶ ἐόντες.

ϐ 239

Rather, it is with the rest of the people that I am indignant,
that you all sit thus in silence, and utter no word of rebuke
to make the suitors cease, though you are many and they but few.

Od. 2.239

When Odysseus awoke he found himself on the beach and wondered where he was. He then saw Athena in the form of a young shepherd and asked her to tell him where he was. She showed him the signs and convinced him that he was in his beloved country.

[...] τίς γῆ, τίς δῆμος, τίνες ἀνέρες ἐγγεγάασιν;
ἦ πού τις νήσων εὐδείελος, ἦέ τις ἀκτὴ
κεῖθ' ἁλὶ κεκλιμένη ἐριβώλακος ἠπείροιο;

ν 233-5

What land, what people is this? What men dwell here?
Is it some clear-seen island, or a shore
of the deep-soiled mainland that lies sloping down to the sea?
 Od. 13.233-5

The poet's intention to convey the meaning of a strip of land protruding into the sea is quite evident. It could not, in fact, have been anything else. This description fits exactly the Pallis peninsula's features which, surrounded as it is by water, resembles an island without being one.

The harbour of the city of Ithaca was not Phorcys, which was situated at the northern end of the Pallis peninsula and which is known today as the port of Atheras. This port is quite a distance away from Homeric Ithaca, which of course was itself a port. It is, nevertheless, situated in Ithaca, that is, in the *démos* (municipality) of Ithaca. The tiny leeward port of Phorcys is the one reached by Odysseus after leaving the land of the Phaeacians. Homer states:

Φόρκυνος δέ τίς ἐστι λιμήν, ἁλίοιο γέροντος,
ἐν δήμῳ Ἰθάκης· [...]

 ν 96-7

A certain harbour of Phorcys, the old man of the sea,
there is in the land [démos] of Ithaca; [...]
 Od. 13.96-7

This indicates that the meaning of the term *démos* includes the broader area of the peninsula where the city of Ithaca was situated. In similar fashion today, visitors to the island of Cephallenia, upon asking where the villages of Kounopetra, Kipouria or Petanoi are to be found, they are told «at Lixouri», even though all these places are in fact fairly far, outside the city of Lixouri. In summary, by the name Ithaca, home of Odysseus, Homer refers at times to the city, at other times to the municipality or *démos* and still at others to the island. Odysseus dwells in «clear-seen Ithaca», which lies in the West, towards the setting sun and around it are many islands close to each

other. The term εὐδείελος 'eudeíelos' clear-seen is applied, therefore, to the city, the municipality and the island.

3. Magnificent Mount Neriton: the "Ep-Aenos" of Homer

The magnificent presence of Cephallenia's big mountain has often been related in the past by Homeric students to Mt. Neriton, to which the poet refers as the main characteristic of Ithaca, Odysseus' home-land (Od. 9.21-2, 13.351, 17.207). At the same time, those questioning this view wonder how it would be possible for such a large and renown mountain not to have retained its original name and change from Mt. Neriton to Mt. Aenos. The obvious answer is that the name changed just as Ithaca's name changed. The word αἶνος 'aénos', however, means word, tale, story, fable, saying, praise and fits precisely and logically Homer's description of this mountain[6] and of the glorious city of Ner-icus (Od. 24.377), on account of the conquest of which Laertes became King of the Cephallenians. Aenos, then, is a story praising Neritus (Od. 17.207) founder of the city, who along with Ithacus and Polyctor also built the «fair flowing fountain». Thus it is the poet's 'aénos', praise for the name 'Neritus', and thus Aénos, (praise), remained in the con-science of the people through tradition and epic poetry (Illus. 1).

Ἀριπρεπές 'ariprepés' Mt. Neriton, meaning, majestic, conspicuous from afar, shares the same properties and qualities as the word 'aénos', also meaning dreaded, horrible, terrible, exceeding, used particularly of Zeus (αἰνότατε Κρονίδη) whom everyone fears, or of goddess Athena (αἰνοτάτη Ἀθηνᾶ). It is conceivable that the mountain was named after the Thracian city of Aenos, since the leader of the Thracians, Peiros, hailed from there (Il. 4.519-20). He was Odysseus' comrade at arms, and due to the bravery shown by him and Aias during a certain battle (Il. 4.473-594) he caused the wrath of Apollo (Il. 4.507). Odysseus lost his noble and faithful comrade Leucus during that battle. The loss

6. Lidell & Scott lex. Αἶνος (Aénos) Αἰνός; also see ἔπαινος, praise.

angered him against the Trojans, and in revenge he killed King Priam's son Democoon (Il. 4.499). It is possible that in memory of this battle, Mt. Neriton was named Aenos after the Thracian city. On Mt. Neriton, due to its height, the wind makes the tree foliage quiver εἰνοσίφυλλον 'einosíphyllon'. Due to its pre-eminence, it is clearly seen, εὐδείελον 'eudeíelon', from afar. According then to Homer's description, Mt. Neriton is the main feature of the physiognomy of Ithaca's landscape. This feature closely resembles that of 'Megalo Vouno', the 'Big Mountain', as Cephallenia's beautiful Mt. Aenos is known to its inhabitants. Thus, an Ithaca dominated by a Mt. Neriton comes into view, with the islands Dulichium, Same, and Zacynthus around it 'amphí' and very 'mála' close 'schedón' to each other ἀλλήλων 'allílon'. «Ithaca itself lies low in the sea, farthest of all toward the dark(ness), but the others lie apart toward the dawn and the sun.» The intent of the poet to define the geographical relation of the islands to each other is apparent. Another characteristic of Homer's Ithaca is that it is, as he describes it, χθαμαλή 'chthamalé'.

> αὐτ' δὲ χθαμαλὴ πανυπερτάτη εἰν' ἁλὶ κεῖται
> πρὸς ζόφον, αἱ δέ τ' ἄνευθε πρὸς ἠῶ τ' ἠέλιόν τε, [...]
> ι 25-6

> *Ithaca itself lies low in the sea, farthest of all*
> *toward the dark[ness], but the others lie apart toward the dawn*
> *and the sun.*
> Od. 9.25-6

In other words, lying on low ground, not connected to the tall and conspicuous Mt. Neriton. This apparent contradiction has kept humanity from locating Homeric Ithaca for more than three thousand years now. Homer, however, states quite clearly (Od. 9.25-6 above), «Ithaca itself lies low in the sea, farthest of all towards the dark[ness]». Nowhere does Homer say that the city of Ithaca is located on Mt. Neriton, but rather that Mt. Neriton is in Ithaca, that is, the island. (Str. Geo. 10.2.11). The most likely place for the city of Ithaca then is none other than the peninsula of Pallis, which, due to its geographical posi-

tion and morphology was justly described by Homer as χθαμαλή Ἰθάκη 'chthamalé Itháke', i.e., low-lying Ithaca. The city of Ithaca then, the capital of the island, the centre of Odysseus' kingdom, is to be found on this peninsula, fitting exactly Homer's description. Thus, prehistoric Ithaca finally emerges and is «clear-seen». Its geographical location and the morphology of its land mass is clearly discerned. A majestic mountain, conspicuous from afar, is located there. The terms 'eudeíelos' and 'zóphos' (toward the darkness, the West), lead us to the westernmost edge of the Ionian Islands. From the description of the proceedings and the 'minutes', so to speak, of the assembly of the citizens, it is clear that Homer's Ithaca is in fact the Pallis peninsula, where both the city and the *démos* are located and around it, and close to it, lie the islands of Dulichium, Same and Zacynthus. A drive starting from the village of Fiskardo at the northernmost tip of Cephallenia, southwards towards Myrtos – Agonas – Thinea – Pharsa – Argostoli – Lasse - Leivatho, to the coast of Abythos, would prove the point. On the left side of the 70 km run, as one travels south, the magical spectre of dusk engulfs the horizon. Εὐδείελος 'Eudeíelos' Ithaca is «clearly» seen, floating in the vast sea, sinking along with it into the deepening darkness.

4. Low Lying Ithaca, under Mount Neion

The elevation of the Pallis peninsula with its low Mt. Mílo and its rolling hills near the village of Kaminaráta does not exceed 451 meters. It is a narrow land strip which viewed from across, low as it is, gives the feeling that it travels quietly in the calm, shallow waters of the bay of Livadi, leaving behind it the horizon open to the play of the setting sun's flickering rays. It is the only mountain that sits apart, not being connected with the Aenos ridge, which lies across the bay covering with its massive bulkiness, the entire island of Cephallenia.

The Aenos massive starts at the southeastern end of Cephallenia, continues in a northwestern direction, crossing the narrow isthmus and reaches the northern part of the Pallis peninsula, ending at the Lithari promontory, or Katergaki, or Kakata. There, in the open sea, between Lithari and the Atheras promontory which lies next to it, a delightful

small port is formed, the Atheras port, with a beautiful sand beach and clear blue waters. A small leeward harbour, lying at the extreme end of Greece, in the middle of the wild sea, about which the most glorious story of all time was written, one that held humanity speechless for three thousand five hundred years now, keeping alight the hope for the return to Ithaca. Soon, Greek seafaring men will build two huge lighthouses on the tip of these promontories. One will symbolize the inextinguishable flame of Greek spirit and the other the flame of Greek civilization that influenced humanity since the beginning of time.

The Phaeacian ship sailed between these two headlands and brought Odysseus home to Ithaca. Telemachus' ship followed the same route on his way back from Pylos, where he travelled seeking tidings of his father. Odysseus' return home was the will of the gods of Olympus:

[...] αὐτὰρ ἐγὼν Ἰθάκηνδ᾽ ἐσελεύσομαι, ὄφρα οἱ υἱὸν
μᾶλλον ἐποτρύνω καί οἱ μένος ἐν φρεσὶ θείω,
εἰς ἀγορὴν κελέσαντα κάρη κομόωντας Ἀχαιοὺς
πᾶσι μνηστήρεσσιν ἀπειπέμεν, οἵ τέ οἱ αἰεὶ
μῆλ᾽ ἁδινὰ σφάζουσι καὶ εἰλίποδας ἕλικας βοῦς.
πέμψω δ᾽ ἐς Σπάρτην τε καὶ ἐς Πύλον ἠμαθόεντα
νόστον πευσόμενον πατρὸς φίλου, ἤ που ἀκούσῃ,
ἠδ᾽ ἵνα μιν κλέος ἐσθλὸν ἐν ἀνθρώποισιν ἔχῃσιν.»
<div align="right">Od. 1.88-95</div>

[...] I will go to Ithaca, that I may the more arouse his son,
and set courage in his heart
to call an assembly of long haired Achaeans,
and speak his word to all the suitors, who continue
to slay his thronging sheep and his spiral horned shambling cattle.
And I will guide him to Sparta and sandy Pylos,
to seek tidings of the return of his staunch father, if per chance
he may hear of it,
that good report among men may be his.»
<div align="right">Od. 1.88-95</div>

The gods of Olympus wish Odysseus and Telemachus to be immortal:

[...] ἠδ' ἵνα μιν κλέος ἐσθλὸν ἐν ἀνθρώποισιν ἔχῃσιν.
α 95

[...] that good report among men may be his.
Od. 1.95

This then, the northwestern edge is in fact the main mountainous section of the Pallis peninsula which, as already stated, is the tail end of the Neriton mountain (Aenos). Atheras summit is 517 meters high and is the tallest point of the entire peninsula. Near this summit, where eagles nest, in a southern direction, lies the Homeric place Korako-petra.

As stated, the Pallis peninsula is joined to the main body of the island of Cephallenia by an isthmus, the northern end of the bay of Livadi being one side of it. From this point southward the peninsula is reduced in height and sets apart from the Aenos ridge, which continues northwest towards Atheras. The southern part of the peninsula consists mostly of rolling hills, and low Mt. Milo. This name brings up the question if perchance the word 'milo' derives from 'chtha-malo' meaning low lying. It is not far fetched. The low mountain, in time, may have become 'malo', or 'milo'. It has, nevertheless, the same characteristics as Mt. Neion.

Following ἀριπρεπές 'ariprepés', preeminent Mt. Neriton, the second mountain mentioned by Homer is Neion. Below it lay the spacious city of Ithaca (Od. 24.468), the proud home of Odysseus. It was situated on the low lying coast, on the shallow shore of the deep πολυβενθής 'poly-benthís'[7] bay (Od. 16.352), and on the «curving beach» (keílos aegialós, Od. 22.385). It is mentioned quite separately from Mt. Neri-

7. Πολυβενθής (polybenthés) meaning deep, refers to its great length and rather narrow breadth. Trans. note.

ton and exactly where it is most appropriate to describe it. The city of Lixouri is built on the coast of the deep bay and the villages are scattered on the sides of the low mountain. Ithaca was built under the mountain as the poet states:

ὑμεῖς ἐξ Ἰθάκης ὑπονηίου ἐιλήλουθμεν [...]
γ 81

We have come from Ithaca that is below Neion; [...]
Od. 3.81

And further,

[...] ἐν λιμένι Ρείθρῳ ὑπὸ **Νηίῳ** ὑλήεντι.
α 186

[...] in the harbour of Rheithron, under woody Neion.
Od. 1.186

Ithaca, low lying in the west, toward the open sea. Even the magnificent Mt. Neriton is incapable of casting its shadow over the beautifully orgiastic landscape. Ithaca below Neion ὑπονηίου, 'hyponeios' (Od. 3.81) was built on the slope of the Hermes hill, today's Crikellos hill, near the village of Livadi, in the Livadi bay! A fertile land, an incomparable landscape sloping toward the water, ideally suited to build the spacious εὐρυχόριο, 'euryhório' (Od. 24.468), city of Ithaca.

...] ἀθρόοι ἠγερέθοντο πρὸ ἄστεος εὐρυχόριο.
ω 468

[...] they gathered together in front of the spacious city.
Od. 3.81

The houses reached all the way up, to Odysseus' palace, and the inhabitants used the road that passes by it.

[...] ἤ ἀν' ὁδὸν στείχων, ἤ οἵ περιναιετάουσι· [...]

ψ 136

[...] whether a passerby or one of those who dwell around, [...]

Od. 23.136

Eumaeus, the swineherd, testifies as to the location of the palace, when upon his return to his hut (at Atheras) told Telemachus what he saw at the palace.

ἄλλο δέ τοι τό γε οἶδα· τὸ γὰρ ἴδον ὀφθαλμοῖσιν.
ἤδη ὑπὲρ πόλιος, ὅθι θ' Ἕρμαιος λόφος ἐστίν,
ἦα κιών, ὅτε νῆα θοὴν ἰδόμην κατιοῦσαν
ἐς λιμέν' ἡμέτερον· [...]

π 470-3

And this further thing I know, for I saw it with my own eyes.
I was now above the city, where the hill of Hermes is,
as I went on my way, when I saw a swift ship putting
in to our harbour, [...]

Od. 16.470-3

From these verses it is obvious that the city lay under the Hermes hill and that the palace was situated on the top of it. Eumaeus, it is reminded, went there bringing Telemachus' message to Penelope upon the latter's return from Pylos. The palace commanded a view over the whole area and from it one could see the entire city and the harbour traffic. This Homeric description relates directly to the landscape of the village of Livadi, and the Crikellos hill, which is none other than the Hermes hill. Ithaca's picture becomes, in fact, more distinct when completed by the identification and description of its three harbours, presented in detail by the poet.

5. Ithaca's Curving Beach

Each village and city along the coast of the Livadi bay has its own sandy beach with its own peculiar characteristics. The Argostoli side has Makry Yalo and Platy Yalo, the southern side of the Pallis peninsula has Xi, a coast that does indeed have the shape of a lower case Greek ξ, starting from the Agios Georgios promontory to the Akrotiri headland, Kalamia and so on. The beautiful Agonas beach, the Platia Ammos, is indeed long and wide. The harbour of the village of Livadi (Homeric Ithaca) has the shape of a near perfect semi-circle. The curving beach starts at the point where the Louros creek (Reithron) coming from Kleisoura empties into the sea near the old windmill, and reaches the inner point of the Livadi bay at the Skavdolitis precipice. The shape of Ithaca's coast (Livadi village coast) inspired the poet to state that Odysseus:

τοὺς δὲ ἴδεν μάλα πάντας ἐν αἵματι καὶ κονίῃσι
πεπτεῶτας πολλούς, ὥστ' ἰχθύας, οὕς θ' ἁλιῆες
κοῖλον ἐς αἰγιαλὸν πολιῆς[8] ἔκτοσθε θαλάσσης
δικτύῳ ἐξέρυσαν πολυωπῷ· οἱ δέ τε πάντες
κύμαθ' ἁλὸς ποθέοντες ἐπὶ ψαμάθοισι κέχυνται·
τῶν μέν τ' Ἠέλιος φαέθων ἐξείλετο θυμόν·
ὣς τότ' ἄρα μνηστῆρες ἐπ' ἀλλήλοισι κέχυντο.

χ 383-9

But he found them one and all in the blood and dust –
fallen – all the host of them, like fishes that fishermen
upon the curving beach from the gray sea
have drawn forth in the meshes of their net; and they all
lie heaped upon the sand, longing for the waves of the sea;
and the bright sun takes away their life;
even so now the suitors lay heaped upon each other.

22.383-9

The poet, in the above verses, says that Odysseus saw many of the suitors lying on the «curving beach» like fish that fishermen have

drawn forth from the grey sea. These fishes «lie heaped upon the sand, the bright sun having taken their life». This is a description of the daily activity of the fishermen on the beach of the city of Homeric Ithaca; Homer, through Odysseus, expressing what he saw on the beach by a metaphor, indicating that he was familiar with this daily event. The «curving beach» is none other than the extensive sandy beach formed on the inner end of the Livadi bay and constituted Homeric Ithaca's harbour. The waters of the bay of Livadi do not exceed 5 to 6 meters in depth. Thus they do not reflect the deep blue of the sky but have the colour of the waters of a river. The white sea is a familiar epithet from verse Od. 2.260-1. In that instance, Telemachus descended to the shallow sea to wash his hands in the waters that appear to be white[8]. The poet calls the sea white when it is completely calm (Od. 10.94) which is exactly what happens in the calm harbour of the Livadi village.

This then is the «κοῖλος αἰγιαλός», the curved beach, and the hill above it and the surrounding area is still called Κρίκελλος (Crikellos or Krikellos). The main characteristic of the above area, the round shape of the coast resembling a ring, a chain link, an armlet, remained unchanged for three and one half thousand years. The perseverance of this land's history is indeed remarkable. While even rocks cannot withstand the force of the elements and change shape and location, this coast, through tradition and the god given power to the Greek language, has preserved both its name and the name's meaning which refers to its morphology.

6. Cyllenian Hermes and Crikellos

ἤδη ὑπὲρ πόλιος, ὅθι θ' Ἑρμαιος λόφος ἐστίν [...]

π 471

8. The Murray translation renders this word as grey. The Homeric text states πολιῆς indicating the very light (almost white) colour of the waters of a river. It could, therefore, be translated as «white». See also Od. 10.94. Trans. note.

*I was now above the city, as I went on my way, where the hill of
Hermes is, [...]*
Od. 16.471

[...] κοῖλον ἐς αἰγιαλὸν πολιῆς ἔκτοσθε θαλάσσης [...]
χ 385

[...] have drawn forth from the gray sea upon the curving beach [...]
Od. 22.385

Ἑρμῆς δὲ ψυχὰς Κυλλήνιος ἐξεκαλεῖτο [...]
ω 1

But Cyllenian Hermes was calling forth the ghosts [...]
Od. 24.1

[...] Ἑρμείας ἀκάκητα κατ᾽ εὐρώεντα κέλευθα.
ω 10

[...] Hermes, the Helper, led them down the dank ways.
Od. 24.10

Homer attaches a number of epithets to Hermes, denoting the vari-
ous attributes of the god, such as Ἀργεϊφόντης 'Argeïphóntes'[9], Ἐριούνης
'Eriúnius'[10], Κυλλήνιος 'Cyllénius'[11], Ἄναξ 'Ánax'[12], Διάκτωρ 'Diáktor'[13],
Ἀκάκητας 'Akáketas'[14], Ἄγγελος 'Ángelos'[15], Φίλος 'Phílos'[16], and others.
An analysis of the terms 'Cyllénius' and 'Akáketas' shall be undertaken
because they relate to the area under discussion and coincide topo-
graphically and in terms of toponyms with 'Crikellos' and 'Scavdolites'.

9. Argeïphóntes: Uncertain meaning. The poet probably interpreted it as slayer of
 Argus (Ios watchdog). See Od. 1.38, 84, Il. 2.103, 16.181, 21.497. Trans. note.
10. Eriúnius: Helper, see Il. 20.34-5, 72, 24.360, 440, 457, 679. Trans. note.
11. Cyllénius: Not translated in Loeb. See Od. 24.1. Trans. note.
12. Ánax: Lord, Il. 2.104. Trans. note.
13. Diáktor: Guide, Od. 1.84, 8.335, 12.390, 15.319. Trans. note.
14. Akáketas: Helper, Od. 24.10, Il. 16.185. Trans. note.
15. Ángelos: Messenger, Od. 5.29. Trans. note.
16. Phílos: Friend, beloved, faithful, Od. 5.28, Il. 24.333. Trans. note.

Cyllenian Hermes, starting from Odysseus' palace on the hill of Hermes (Crikellos) and following the 'cylle', curved coast of Livadi, led the ghosts of the dead suitors «...down the dank ways, past the streams of Oceanus, past the rock Leucas, past the gates of the sun and the land of dreams, and quickly came to the meadow of asphodel...».(Od. 24.10-3) (Valtos of Livadi). These descriptions correspond to the actual physical environment of the inner end of the bay of Livadi (Od. 22.385), its name Κρίκελλος 'Críkellos' standing for circular, curving, round.

κυλλόω (kyllóo): To crook, flex. ἀγκυλόω (angylóo): crook, bend the hand as in throwing to cottabus.
κυλλός (kyllós): Deformed, contracted. Of things, ἀγκυλωτός (angylotós), or javelin furnished with a thong.

In calling Hermes 'Cyllenian' in *The Odyssey* (24.1-14), the poet, obviously, intended to place emphasis on this particular characteristic of the curving beach of the harbour. The appellation in question is found only once in Homer[17], and that, in connection to this specific procession of the dead souls. Therefore, the origin of the epithet derives from this particular act of the god and is related exclusively to Homeric Ithaca. Subsequently, Cyllenius Hermes was connected to Peloponnesian Cyllene. The epithet fits the morphology of the coast of Cyllene, situated to the east of the Helomata promontory (Glarentza) on the northwestern coast of the Peloponnese, which is also κυλλή 'cyllé', whence the name. But this is another subject unrelated to Cyllenius Hermes of Ithaca.

Another epithet characteristic of Hermes is the term ἀκάκητα 'akáketa' or guileless, gracious (Od. 24.10). The poet's intention is quite obvious in using guileless Hermes to conduct the souls of the dead suitors to a place of purification near the 'rock of Leucas' on which the altar of enduring Apollo was located. Under the altar, at the

17. The epithet is not found applied to Hermes in the Iliad.

base of the rock, the sacred grove of Apollo was situated near which the 'meadow of asphodel' is found even today. The ghosts of the dead were led there by Apollo in order to enter Hades, the underworld. This is an occult site, where the souls, the ghosts of the dead dwell, and about which many beliefs circulate among the local population.

7. The Hermes Hill above the City of Ithaca

Crikellos hill (Hermes hill) is a long and narrow rise about two and one half kilometres in length. (Illus. 2) The elevation on the southern end of the hill is about 150 meters, while the north-northwestern end of it reaches 176 meters in height. The top is level and of trapezoid shape. The great palace court, the royal estate, and the great wall were located there. The ruins of the tower of Telemachus are found on the north-northwestern elevation of the hill. The western hillside is smoothly inclined, ending in a small channel or through whose waters drain into Reithron (Kleisoura) inlet. The eastern end of the hill has a smooth amphitheatrical inclination from the top to the sea. The hillside is covered with vineyards, the ground supported by well built long retaining walls. The spacious city of Ithaca was built on this large expanse. One can still discern traces of buildings of great antiquity on the hill, in spite of catastrophic earthquakes that occurred repeatedly through the ages. On the public road, 200 meters north of the village of Livadi, remnants of the classical period were located; these having been reported to the competent archaeological authorities. Across from the hill, at a distance of approximately 1500 meters, to the west, one can see the Mycenaean tombs excavated by the renown archaeologist S. Maritatos who hailed from this area.

The long and flat surface of the hilltop is due to the natural morphology of the ground, human intervention being restricted to the building of drywalls and the levelling of the ground in the area where games took place (ἐν τυκτῷ δαπέδῳ, Od. 4.627). It is quite easy to run along the whole length of the hill because of the level ground, and this fact supports the proposition that the hill was thus named after Hermes the wing-footed god. As long as the true location of Ithaca remains

unknown, and as long as the hill in question remains unfamiliar, the origin of its name will remain unknown. If, however, one walks the narrow and long hilltop, one will undoubtedly realize why it was named after Hermes. Hermes was mainly the messenger of Zeus but of the other gods as well, and would execute his missions swiftly. He wore golden winged sandals, and could go anywhere over the land and the seas. He was one of the most popular of the twelve gods and his activities and jurisdictions varied. He was the protector of commerce, of wisdom, messenger of the gods, conductor of souls to the under-world, companion of wayfarers and helper of the peasants. He appears as a helper of men in their difficulties always in a benign way. It is noted that Odysseus possesses all these characteristics and virtues and that the temperament of the inhabitants of Ithaca, but of Cephallenians in general, are quite similar to those of Hermes, who was the god pro-tector of Odysseus' kingdom.

8. The Boundary of Odysseus' Kingdom

[...] οὔτ' ἠπείροιο μελαίνης [...]

ξ 97

[...] on the dark mainland [...]

Od. 14.97

δώδεκ' ἐν ἠπείρῳ ἀγέλαι· [...]

ξ 100

[...] twelve herds of cattle has he on the mainland; [...]
Od. 14.100

Eumaeus told Odysseus of the number of herds found on the border of Ithaca, ἐσχατιη 'eschatié' (Od. 14.104), that is where the Atheras vil-lage is located. He also enumerated the herds that grazed on the dark mainland side of the island, which lay across from the Pallis peninsu-la. The main body of the island of Cephallenia is called 'mainland'

ἤπειρος (épeiros) by the poet, on account of its massive size, but also because of the tall mountain ridge on it, Mt. Aenos (Homeric Mt. Neriton) rising to a height of 1000 - 1650 meters above sea level. In contrast to the low-lying Pallis peninsula, it is the 'mainland' (épeirus). Should the reader venture a walk starting from the Atheras village toward the Lithari promontory, reaching the top at Polemi, and looking eastward to the Agonas mountains from Pylaros to Thinea, he will understand the writer's insistence, but the poet's as well, in calling the imposing view confronting him as 'mainland' or epirotic. On the northern coasts of the Agonas village area, between the Aspros Yalos precipice and the Armacas promontory, above the Pezoulia and Limpes locations, there is a place called Peiraeas. A brief analysis of the word 'peiraeas', coupled with the morphology of the site thus named and the meaning itself of the word, confirms the Homeric verse since the word 'peiraeus' is related to the word 'épeirus' or 'épirus', meaning mainland.

πειραϊκός (peiraikós): over the border, border country, Th., 2.23 «παριόντες δὲ Ὠρωπόν, τὴν γῆν τὴν πειραϊκὴν[18] καλουμένην [...] ἐδῄωσαν.»

It concerns, indeed, the border line of the *démos* of Ithaca, particularly in geographical terms, because the precipitous mountain sides (sheer rocks 250 meters in height), as well as the extension of the Pallis peninsula to Avlaki of Heimoniko and to Mardari can be considered as the physical boundary of the peninsula. Even today the boundary of the Pallis prefecture (Homeric *démos* of Ithaca), as shown on the maps of the General Army Service (G.A.S.), extends beyond the peninsula. They start at Agia Sotira, continue on to Avlaki of Pontikos, Koutoupa, Daphni, Paloukoto, Gerani, Agioi Theodoroi and end at Avlaki of Heimoniko, close to the Peiraeus site. The same boundary (Pallis - Atheras - Thinea) is noted on the map of the administrative divisions of Cephallenia, prepared by J. Partsch, 1890[19]. The map divides Cephal-

18. The Loeb edition of Thucydides uses the word γραϊκήν (graikén). The L&S Lexikon, however, refers to Th., 2.23 as using the word πειραϊκήν (peiraikén). Trans. note.
19. See E. Kosmetatos, Report on the Roads of Cephallenia, 1991.

lenia into sixteen districts, Thinea constituting an extension of the Pallis peninsula and a common district with Atheras. The extensive perimeter of the Thinea district, extending from the border with Pylaros to the vicinity of Farsa village, covers a distance of approximately fifteen kilometres and is part of a mountain region reaching a height of 1000 meters above sea level. These details are provided so that the reader may become acquainted with the land and appreciate the fact that this region is sufficiently large to permit the grazing of twelve herds of cattle, twelve flocks of sheep, as many herds of goats and twelve droves of swine (Od. 14.100-4).

Odysseus' herds, even though he was king over all of Ithaca and the other islands, were not uncontrolled and dispersed all over his kingdom. The animals were located in a specific area as testified by the herdsman Philoetius' annoyance at their increased numbers (Od. 20.218-25). They were, therefore, too many for the specific land available. If they were dispersed all over the island there would have been no problem of available pasturing land, the island being able to sustain thousands of grazing animals. Philoetius, exasperated by the behaviour of the suitors, thought of departing along with his cattle and going to another people's *démos* (Od. 20.219-23). It is obvious from Philoetius' statements that he grazed his flocks on the *démos* of the Cephallenians, which lies on the opposite side of the Pallis peninsula across the bay.

Homer states that on the island of Ithaca there were two municipalities (*démoe*). The *démos* of Ithaca and that of the Cephallenians. Considering that in Scheria, land of the Phaeacians, there were twelve *démoe* and twelve kings, Alcinous being the thirteenth (Od. 8.390-1), one can safely conclude that in Ithaca also there were more than two *démoe* or municipalities. Theoclymenus' statement to Telemachus that «No other descent than yours in Ithaca is more kingly;» (Od. 15.533-4) confirms the fact that there were other powerful families on the island. Eumaeus' statement that Odysseus was wealthier than twenty men (kings) together (Od. 14.98-9) confirms that there were that many wealthy archons on the island, particularly since it is the largest of all the rest. It is noted that Eumaeus referred to the island of Ithaca and not to other faraway places. Verses Od. 1.394-8 are quite revealing in that they state that in «seagirt Ithaca» ἀμφιάλῳ Ἰθάκῃ, the *démos* of

Ithaca that is, there are other Achaean kings in plenty, Odysseus being the greatest. Dulichium is also mentioned, stating that when Odysseus returned to Ithaca, there were two kings, one being Acastus (Od. 14.336) and the other Nisos (Od. 16.394-5), father of Amphinomus.

It is clear that other wealthy archons were present on the island and consequently, there were many other herds. Each of them was carrying on his activities within the boundaries of his own *démos* where he lived, thus avoiding disorder which would cause the mingling of herds, resulting in thievery and, of course, trouble. Since it was natural that each big cattleman should operate within his own territory, as is the case this day, then it stands to reason that Odysseus' land was the Pallis peninsula and Thinea, from the boundary of Pylaros to Farsa, at the most. Thus, the Peiraeus site constitutes the boundary of Odysseus' realm. A more in-depth analysis of the word 'Peiraeus' may reveal, perhaps, some synonymic relation of the word to ἠπείρειο 'e-peíroeo', which defines more precisely the region to which the poet refers.

9. Herds and Livestock in Homeric Ithaca

In a conversation taking place at Odysseus' palace, Noemon, Telemachus' friend, inquired of Antinous if he knew when Telemachus and the ship he lent him will return from Pylos. This is how Homer described the inquiry, conveying in verse a reality of 3,500 years ago which was still alive just a few years back.

«'Αντίνο', ἦ ῥά τι ἴδμεν ἐνὶ φρεσίν, ἦε καὶ οὐκί,
ὁππότε Τηλέμαχος νεῖτ' ἐκ Πύλου ἠμαθέοντος;
νῆά μοι οἴχετ' ἄγων· ἐμὲ δὲ χρεὼ γίγνεται αὐτῆς
Ἤλιδ' ἐς εὐρύχορον διαβήμεναι, ἔνθα μοι ἵπποι
δώδεκα θήλειαι, ὑπὸ δ' ἡμίονοι ταλαεργοὶ
ἀδμῆτες· τῶν κέν τιν' ἐλασσάμενος δαμασαίμην.»
 δ 632-7

«Antinous, know we at all in our hearts, or do we not,
when Tlemachus will return from sadny Pylos?

He is gone, taking a ship of mine, and I have need of her
To cross over to spacious Elis, where I have a brood of
twelve mares, and the teat sturdy mules
as yet unbroken. Of these I mean to drive one off and break him in.»

Od. 4.632-7

The mules in Homeric Ithaca (Pallis) were numerous. It is noted that when Odysseus along with Eumaeus on their way to the palace, arrived at the court entrance by the northern side of the Royal Estate, they found the dog Argus lying on a pile of mule and cattle dung. It was plentiful and was used by Odysseus' slaves to manure the Royal Estate.

[...] ἐν πολλῇ κόπρῳ, ἥ οἱ προπάροιθε θυράων
ἡμιόνων τε βοῶν τε ἅλις κέχυτ', ὄφρ' ἂν ἄγοιεν
δμῶες Ὀδυσσῆος τέμενος μέγα κοπτήσοντες· [...]

ρ 297-9

[...] in the deep dung, before the doors,
of mules and cattle, which lay in heaps, till it should be taken
away
by the slaves of Odysseus to manure his wide lands.

Od. 17.297-9

The existence of cattle on the island of Ithaca is mentioned by the following personages: Eumaeus, Philoetius and goddess Athena. Eumaeus, describing Odysseus' herds, states:

ἐνθάδε δ' αἰπόλια πλατέ αἰγῶν ἕνδεκα πάντα
ἐσχατιῇ βόσκοντ, ἐπὶ δ' ἀνέρες ἐσθλοὶ ὄρονται.

ξ 103-4

And here too wide-ranging herds of goats, eleven in all,
graze on the borders of the island, and ever them trusty men keep
watch.

Od. 14.103-4

It was, thus, in Ithaca, on the borders of the island, ἐσχατιῇ 'eschatié' (Od. 14.104), where ἐνθάδε 'entháde' (Od. 14.103), eleven herds of goats and twelve droves of swine were to be found. The remaining herds were pasturing across the bay, on the main body of the island, since the available land was much more extensive there than on the Pallis peninsula. Much has been said regarding the herds of cattle grazing on the mainland, ἐν ἠπείρῳ. Some are of the opinion that ἐν ἠπείρῳ 'én epeíro' concerns mainland Greece, across from the islands. The following verses describing the approach of the Phaeacian ship to the island of Ithaca, relate directly to the subject and answer the question.

[...] τῆμος δὴ νήσῳ προσεπίλνατο ποντοπόρος νηῦς.

ν 95

[...] then it was that the seafaring ship drew near to the island.
Od. 13.95

On the island, he found goddess Athena, who showed him the signs that convinced him that he had reached his homeland. She told him that on this land, among other things, herds of cattle were found.

[...] αἰγίβοτος δ' ἀγαθὴ καὶ βούβοτος· ἔστι μὲν ὕλη [...]

ν 246

It is a good land for pasturing goats and cattle; there are trees [...]
Od. 13.246

Besides Athena, Eumaeus, the swineherder, told Odysseus about his possessions, which included twelve herds of cattle, to be found on the mainland, ἐν ἠπείρῳ 'én ereíro'.

δώδεκ' ἐν ἠπείρῳ ἀγέλαι· τόσα πώεα οἰῶν,
τόσσα συῶν συβόσια, τόσ' αἰπόλια πλατέ' αἰγῶν
βόσκουσι ξεῖνοί τε καὶ αὐτοῦ βώτορες ἄνδρες.

ξ 100-2

[...] twelve herds of cattle has he on the mainland; as many
flocks of sheep;
as many droves of swine; as many wide-ranging herds of goats
do herdsmen, both foreigners and his own people, pasture.

Od. 14.100-2

The poet states that a third herdsman was driving «a barren heifer and
fat she-goats» (Od. 20.186), while the same man specified that he pas-
tured them at the municipality (démos) of the Cephallenians. This was
Philoetius, who came from the municipality (*démos*) of the Cephal-
lenians having been brought over by ferrymen, that is by boatsmen
(Od. 20.187).

τοῖσι δ' ἐπὶ τρίτος ἦλθε Φιλοίτιος, ὄρχαμος ἀνδρῶν,
βοῦν στεῖραν μνηστῆρσιν ἄγων καὶ πίονας αἶγας.
πορθμῆες δ' ἄρα τούς γε διήγαγον, οἵ τε καὶ ἄλλους
ἀνθρώπους πέμπουσιν, ὅτις σφέας εἰσαφίκηται.

υ 185-8

Besides these a third man came, Philoetius, leader of men,
driving for the suitors a barren heifer and fat she-goats.
These had been brought over from the mainland by ferrymen,
who other
men they convey, too, on their way, whoever comes to them.

Od. 20.185-8

[...] ὤ μοι ἔπειτ' Ὀδυσῆος ἀμύμονος, ὅς μ' ἐπὶ βουσὶν
εἷσ' ἔτι τυτθὸν ἐόντα Κεφαλλήνων ἐνὶ δήμῳ.

υ 209-10

[...] then woe is me for flawless Odysseus, who set me over his
cattle,
when I was yet a boy, in the land of the Cephallenians.

Od. 20.209-10

This itinerary can only be carried out within the bay of Livadi, since it is impossible to do this, on a daily basis, from one island to another having to ply the open sea. The meaning of the word 'ferrymen' πορθμῆες 'porthmées' should be given careful consideration, since it has been misinterpreted repeatedly in the past causing interminable discussions regarding a non-existent strait or canal. The poet refers clearly to those who perform the job of 'ferrymen', the boatsmen, that is, who move «inside the deep harbour» (liménos polybenthéos entós, Od. 16.352). It should be remembered that the Livadi bay is very extended[20], its total length being about 17 kilometres, thus the ferrymen transported men and goods within the bay. The transport took place between the two opposing coasts of the long bay, that is, between the *démos* of the Cephallenians, which was on the side of contemporary Argostoli and Agios Sotiras, and that of Ithaca, which was the contemporary Pallis peninsula. In conclusion, the herds grazed on the Pallis peninsula, as well as on the mainland of Cephallenia. To this day, throughout this northernmost part of the peninsula, hundreds of goats are found grazing. Many of these are wild (Od. 17.295) living on precipitous ground. Their meat is very tasty. In addition, Atheras until recently was the only place in Cephallenia where pork was produced. This, however, has been discontinued in recent times.

While on the subject of Homeric Ithaca's livestock, it would be well to mention the farm animals used in Cephallenia, a generation or two ago. Mules, horses, mares and humble donkeys were the animals used to till the land, sow, thresh, and for the transportation in carts of wheat, hay, animal feed, produce, fruit, potatoes, olives to the oil mills and the like. Particularly in the Pallis peninsula, the animals had to be strong and sturdy. As told by old-timers of the area, the animals were tried for their strength and endurance by making them pull the loaded carts on the uphill road to Skavdolitis. From there they would carry and sell their produce to Thinea and Pylaros and reach as far as Eryssos and Fiscardo. This tradition was kept until some years ago, when all this was replaced by machines of all sorts.

20. The bay is rather shallow, the depth of the water not exceeding five or six meters

This reference to the farm animals may not be of great interest to the general reader. It strikes a cord, however, in the hearts of those Cephallenians who have lived this type of life and know the hardships they have endured and the livelihood they obtained through these animals, before they were replaced by automobiles and farm machinery.

10. Agriculture in Homeric Ithaca

From the questions Odysseus asked regarding the place in which he found himself, but also from the replies given to him by Athena, we perceive a new aspect regarding the morphology and the wealth of the land in which the King of Ithaca had arrived.

> *[...] τίς γῆ, τίς δῆμος, τίνες ἀνέρες ἐγγεγάασιν;*
> *ἦ πού τις νήσων εὐδείελος, ἦέ τις ἀκτὴ*
> *κεῖθ' ἁλὶ κεκλιμένη ἐριβώλακος ἠπείροιο;»*
>
> ν 233-5

> *What land, what people is this? What men dwell here?*
> *Is it some clear-seen island, or a shore*
> *of the deep-soiled mainland that lies sloping down to the sea?»*
> Od. 13.233-5

Athena's answer to this question is crucial, since it is the first time the poet makes a statement regarding the agricultural conditions prevailing in Homeric Ithaca and the island's wealth, the fertile soil, the grain produced, the livestock to be found there. If one compares these resources to those available in today's Ithaca one can easily conclude that there is no connection whatsoever. On the other hand, the ample land available in Cephallenia conforms to this description.

> *ἦ τοι μὲν τρηχεῖα καὶ οὐχ ἱππήλατός ἐστιν,*
> *οὐδὲ λίην λυπρή, ἀτὰρ οὐδ' εὐρεῖα τέτυκται.*
> *ἐν μὲν γάρ οἱ σῖτος ἀθέσφατος, ἐν δέ τε οἶνος*
> *γίγνεται· αἰεὶ δ' ὄμβρος ἔχει τεθαλυῖά τ' ἐέρση·*

αἰγίβοτος δ' ἀγαθὴ καὶ βούβοτος· ἔστι μὲν ὕλη
παντοίη, ἐν δ' ἀρδμοὶ ἐπηετανοὶ πάρεασι.

<div align="right">ν 242-7</div>

It is a rugged island, not fit for driving horses,
yet it is not utterly poor, narrow though it is.
In it grain beyond measure, and the wine grape as well
grow; and the rain never fails it, nor the rich dew.
It is good land for pasturing goats and cattle; there are trees
of every sort, and in it are watering places that never fail.

<div align="right">Od. 13.242-7</div>

The Ithaca Odysseus reached produced ἀθέσφατος 'athésphatos', abundant wheat and wine, this being an important bit of information, regarding the agricultural production of the island and the livestock to be found there. This statement refers to Dulichium as well as mentioned in verses Od. 14.335, 16.396. Therefore, both Dulichium and the place where Odysseus arrived produced abundant wheat, and were suited for the raising of cattle. It should be remembered that the herdsman Philoetius (Od. 20.209) raised many cattle and he grazed them in the *démos* of the Cephallenians, but they got to be too many for him to handle.

[...] ἐπεὶ οὐκετ' ἀνεκτὰ πέλονται· [...]

<div align="right">υ 223</div>

[...] for things are no longer to be borne, [...]

<div align="right">Od. 20.223</div>

This subject, however, shall be analysed in more detail when the location of lost Dulichium is examined.

CORCYRA
ISLAND
Island of the
Phaeolcians

IONIO PELAGOS

THESPROTIA
(Od. 19.287)

39°

OPPOSITE
← MAINLAND

ASTERIS

AEGILIPS SAMOS

ITHACA CITY
LAND OF ITHACA

NEION Mt. E
DULICHIUM CROCYLEIA

NERITON Mt.

LAND OF CEPHALLENIANS

38°

ELIS

ZACYNTHUS

20° 21°

HOMERIC TOPONYMS AND ISLANDS

CHAPTER TWO

THE HARBOURS OF HOMERIC ITHACA

T HE ANALYSIS presented so far concerned the elements contained in Odysseus' account of his wanderings at the palace of Alcinous, King of the Phaeacians. As stated above, a full description of Ithaca's landscape is given there, answering all possible questions and clearing all doubts. The confusion that was hitherto characteristic of archaeological inquiry is cleared up and the unveiling of the mystery of lost Ithaca is complete. It was possible, thus, to place Ithaca in its geographical position, to the west of all other islands, coinciding with the Pallis peninsula of Cephallenia. What remains is to correlate all other Homeric descriptions to this new fact and to reverse the corresponding arbitrary positions on the subject, which as time advanced, resulted in restricting objective research to the detriment of historical truth. An important element in this effort is the leeward port of Phorcys, that is the small port of Atheras lying at the northernmost tip of the Pallis peninsula, where both Odysseus and his son Telemachus landed.

Odysseus reached the port of Phorcys (Od. 13.100-1, 13.418-23, 14.1-15) sailing from the island of the Phaeacians. Telemachus reached the same port returning to Ithaca from Pylos (Od. 15.36-8, 15.555). This port is situated near Eumaeus' farmstead, where the swine were kept and this is where they both went upon landing and met for the first time since the time Odysseus left for Troy when Telemachus was still an infant. As will be seen in what follows, a large part of the events described by Homer take place on Ithaca's soil and specifically in the area between the port of Phorcys and the city of Ithaca. That is between modern-day Atheras and the village of Livadi on the Pallis peninsula. The morphology of the land here, which remained unknown to humanity for thousands of years, should therefore, be examined before the return trip and the course followed both by Odysseus and Telemachus are analysed.

Many theories have been advanced in the past regarding Ithaca's harbours, but rather than clarifying the issue, they added confusion to

it. Some maintained that the port of Reithron is Ithaca's harbour and others that the port of Phorcys is the one. According to Homer's descriptions, however, there are three distinct harbours. The main one is Ithaca's harbour, a second which one could describe as auxiliary, is situated a short distance from the city, that is the port of Reithron. Finally the windless harbour of Phorcys, lying on the main coast of the island, quite a distance from the city. The poet's verses will be quoted in what follows, to allow the reader to form his own opinion regarding the events that took place in each of them, so that their true location can be determined.

1. The Harbour of the City of Ithaca at Livadi

The Ithacians apparently had a seafaring tradition and their fleet was made up of black warships[1], and ships whose sides were painted red[2]. In the harbour were also moored many merchantmen and fishing vessels (Illus. 3).

εἰσὶ δὲ νῆες
πολλαὶ ἐν ἀμφιάλῳ Ἰθάκῃ, νέαι ἠδὲ παλαιαί· [...]
β 292-3

And ships there were
in abundance in sea-girt Ithaca, both new and old; [...]
Od. 2.292-3

The above verses clearly indicate that the ships found in the harbour were many, some new and some old. It is also known that the ship in which Telemachus sailed to Pylos was black[3], while those that followed Odysseus to Troy had their sides painted red[4]. Judging from the

1. Odyssey, 15.503, «Do you now row the black ship to the city.»
2. Iliad, 2,637, «And with him there followed twelve ships with vermilion prows.»
3. See note 1.
4. See note 2.

large number of ships found in Ithaca's harbour, one can safely surmise that there was a well developed shipbuilding activity on the island. It is reasonable to assume, therefore, that the main harbour was able to support both the day-to-day needs of the inhabitants as well as the military needs of the kingdom being as it were the center of Ithaca since Laertes' time. This, coupled with the fact that the city itself as well as the royal palace were located there, made it imperative that it be well protected from possible enemy raids. The harbour of today's Livadi village was selected, because of its ideal location in Pallis, which, due to the morphology of the land and its precipitous coast, constitutes a natural impregnable fortress. Furthermore, the city and port located at the crossroads of the Mediterranean shipping lanes, connecting the then Hellenic world with East and West, served the needs of the ships plying these routes (Illus. 4).

It is obvious that no possibility of enemy invasion of the state of Ithaca from the northeastern and western sides of the peninsula existed. Such action could only be attempted from the southern side, and particularly from the Xi promontory the Mégas Lákos, where the entire coast is covered by the well-known red sand beach, which today is a favorite tourist resort where thousands of visitors gather during the summer months. To reach, however, this location by ship takes such a long time, that any activity there would be noticed and the attempt would be thwarted in time. The only possibility of entry is through the Livadi bay where the invading enemy, to reach the city of Ithaca, would have to cover a distance of eighteen kilometres, sailing within a long and narrow stretch of water which has the shape of a strait without exit. The deep Livadi bay constitutes, thus, a death trap for any enemy attempting to enter it. Those who tried to identify Ithaca with some other location, defied not only the deeper meaning of the Homeric text, but underestimated Odysseus' wisdom and that of his ancestors. The Pallis peninsula is a natural fortress, an impregnable castle of great strategic importance.

The famous harbour of Ithaca was visited about that time by the leaders of the Trojan expedition, King Menelaus of Sparta and the Mycenean King Agamemnon (Od. 24.115-8). The chiefs of the strongest powers of the then known world sailed to Ithaca to persuade

Odysseus to join them in the expedition. This fact is mentioned by Homer in terms of an account given by Agamemnon to Amphimedon, one of Penelope's suitors, while in Hades (the underworld).

ἔγνω δὲ ψυχὴ Ἀγαμέμνονος Ἀτρεΐδαο
παῖδα φίλον Μελανῆος, ἀγακλυτὸν Ἀμφιμέδοντα·
ξεῖνος γάρ οἱ ἔην Ἰθάκῃ ἔνι οἰκία ναίων.

ω 102-4

And the ghost of Agamemnon, son of Atreus,
recognized the staunch son of Menelaus, glorious Amphidemon,
who had been his host, dwelling in Ithaca.

Od. 24.102-4

And again,

ἦ οὐ μέμνῃ ὅτε κεῖσαι κατήλυθον ὑμέτερον δῶ,
ὀτρυνέων Ὀδυσσῆα σὺν ἀντιθέῳ Μενελάῳ
Ἴλιον εἰς ἅμ᾽ ἔπεσθαι ἐϋσσέλμων ἐπὶ νηῶν;

ω 115-7

Do you not remember when I came there to your house
with godlike Menelaus to urge Odysseus
to go with us to Ilium on the benched ships?

Od. 24.115-7

This is an important piece of information having historical value. The participation of Odysseus in the expedition was so important that two great kings, the most important of the time, came to Ithaca in order to convince crafty Odysseus, the king, to join them. They convinced him with much difficulty.

μηνὶ δ᾽ ἄρ᾽ οὔλῳ πάντα περήσαμεν εὐρέα πόντον,
σπουδῇ παρπεπιθόντες Ὀδυσσῆα πτολίπορθον.

ω 118-9

A full month it took us to cross all the wide sea,
for hardly could we win to our will Odysseus the sacker of cities.

Od. 24.118-9

And again, Penelope, Odysseus' wife, addressing her son Telemachus, states:

[...] ἐξ οὗ Ὀδυσσεὺς
ᾤχεϑ' ἅμ' Ἀτρεΐδῃσιν ἐς Ἴλιον· [...]

ρ 103-4

[...] since the day Odysseus
set forth with the sons of Atreus for Ilium.[...]

Od. 17.103-4

This testimony from Penelope, confirms Agamemnon's statement that Odysseus sailed for Troy along with him and his brother Menelaus, the sons of Atreus, and that they visited Ithaca in order to take Odysseus with them, at the time of their expedition to Troy. The most historic naval convoy ever gathered, entered what is today known as the deep bay of Livadi and anchored at the point where the Livadi village is situated today. At the head of the convoy were two great kings, Agamemnon and Menelaus, setting off from there, along with Odysseus, on the most glorious expedition of all time. This fact remained hidden for aeons, even though it confers the greatest of honours to Ithaca, Odysseus and the race of Cephallenians.

Considering the pride with which Agamemnon showed off to his soldiers, decked out in his shining armour, it is safe to assume that on his visit to Ithaca he was accompanied by an armada of ships, to prove to Odysseus that he was determined to sail for Troy and thus convince him to go along. The ship convoy sailing out from Ithaca must have been impressive consisting, as it were, of the ships of Menelaus, Agamemnon, Odysseus and those from Dulichium. King Menelaus, Homer informs us, was commanding one hundred ships, and his followers were the most by far of all other commanders (Il. 2.575-80). This, in the final analysis, is the harbour of Ithaca. Large, windless,

invisible to the outside world, unassailable, self sufficient, able to communicate with the rest of the island of Cephallenia, possessing routes of escape from the port of Phorcys (Atheras) in case of need.

2. The Phorcys Harbour at Atheras

The entire northern, northeastern and western sides of the coast of Cephallenia is rocky and precipitous, exposed to the deep open sea, and battered by frequent storms. The mere thought of landing there is inconceivable. The small Atheras harbour (not so small for the needs of the era) is the only point of landing for a ship sailing in these waters, because of its sandy beach. (Illus. 5) The two headlands acting as breakwaters, protect the harbour from the stormy sea (Od. 13.97-9). The westward one is the Atheras promontory, or Koukoula, and the other is the physical continuation of the Aenos ridge and is called Kakata or Katergaki. At the point where the latter ends, in the sea, the rock named Lithári is found. This entire side, from the Atheras port to Lithari, is referred to today as Kakoplagiá (Bad Slope), exactly because it slopes down on the side towards the harbour (ποτιπεπτηυῖαι, Od. 13.98), but are sheer to seaward, ἀπορρῶγες 'aporróges' (Od. 13.98), as the poet states. Precisely the same situation prevails on the opposite side, at Athéras or Koukoúla. Here again the coast is sheer to the sea, the waters being very deep reaching 80 to 100 meters in depth. The sides rise almost vertically. The PLOEGOS publication of the Hellenic Navy's Hydrographical Service refers to them as Kremastá Nerá, or Hanging Waters. The poet informs us quite clearly of the morphology of the coast in the verses that follow, which describe the Phorcys harbour:

Φόρκυνος δέ τίς ἔστι λιμήν, ἁλίοιο γέροντος,
ἐν δήμῳ Ἰθάκης· δύο δὲ προβλῆτες ἐν αὐτῷ
ἀκταὶ ἀπορρῶγες, λιμένος ποτιπεπτηυῖαι,
αἵ τ' ἀνέμων σκεπόωσι δυσαήων μέγα κῦμα
ἔκτοθεν· ἔντοσθεν δέ τ' ἄνευ δεσμοῖο μένουσι
νῆες ἐυσελμοι, ὅτ' ἂν ὅρμου μέτρον ἵκωνται.

ν 96-101

There is in the land of Ithaca a certain harbour of Phorcys, the
old man of the sea,
and at its mouth two projecting headlands,
sheer to seaward, but sloping down on the side toward the harbour.
These keep back the great waves raised by heavy winds
outside; but inside lie unmoored,
the benched ships, when they have reached to point of anchorage.

<div align="right">Od. 13.96-101</div>

The Phorcys harbour is described by Homer as being surrounded by rocky and sheer cliffs, the back of the bay, the innermost part of it, forming a beautiful sandy beach. In fact the sand on the Atheras beach extends until the sea bottom can be seen no more, the inclination of the sea floor being no more than 3-5°.

ἔνϑ' οἵ γ' εἰσέλασαν, πρὶν εἰδότες· ἡ μὲν ἔπειτα
ἠπείρῳ ἐπέχελσεν, ὅσον τ' ἐπὶ ἥμισυ πάσης,
σπερχομένῃ· τοῖον γὰρ ἐπείγετο χέρσ' ἐρετάων [...]

<div align="right">ν 113-5</div>

Here they rowed in, knowing the place of old; and the ship
run full half her length on the shore
in her swift course, at such speed was she driven by the arms of
the rowers.

<div align="right">Od. 13.113-5</div>

The sailors who brought Odysseus to Ithaca from the land of the Phaeacians carried him, while sleeping, out of their ship and deposited him on the sandy beach, ἐπὶ ψαμάϑῳ 'epí psamátho' as Homer states (Od. 13.119). Such a beach consisting of fine sand, on which a ship can be beached by the mere strength of the oarsmen, cannot be found anywhere in modern day Ithaca. This statement could not have been made, then, if the landing spot was rocky or sheer. The reason, therefore, that half the length of the ship was beached was that the bottom of the shallows was very smooth.

The above verses, which describe how the Phaeacian ship run half her length on the sandy shore[5], have created a problem for Ithaca's searchers, which they were never able to solve, since the harbour of Phorcys had to be sandy. The characteristics of the harbours proposed so far as being Phorcys did not comply with Homer's descriptions. What's more, there was no sand to be found, and this incited strong disagreements among students of Homer. And with reason. The existence of sand was a prerequisite since no ship can run half her length on a shore covered with pebbles by the mere strength of her rowing crew. No place indicated as being the port of Phorcys came close to the true location, since it was selected strictly on the basis of the proposed location of Ithaca. In contrast, all other coastal locations put forth as being Homeric Phorcys by older but also by more recent researchers, do not possess all the features of the Phorcys harbour as the poet sets them forth, while the morphology of the proposed sites is quite different. They usually consist of pebbles of various sizes while the shallows are full of rocks. The characteristics of the Homeric harbour of Phorcys, the windless harbour of Ithaca, the object of nostalgia for many generations of men, coincide exactly with those of Atheras. Everything that Homer describes is found there.

3. Phorcys: An Ancient God Lies in Wait

When time was ripe, all the gods took pity on Odysseus, except Poseidon, the god of the sea and earthquakes. Athena, on Mt. Olympus, asked her father Zeus, to set him free from the island of Ogygia where he was held captive by the nymph Calypso. Athena addressed her father in bitter words, telling him that he was cruel and his heart could not be moved.

5. Though the poet does not specify 'sandy' in this particular verse, this is understood by the context. Trans. note.

I. KEFALLONIA

(1) CRANE
1, 17, 18, 28, 78, 86, 88

(2) ERYSSOS
2, 11, 83, 84, 103

(3) ASTERIS
12, 144

(4) ELEIOS
31

(5) DULICHIUM
29, 30

(6) SCAVDOLITIS
5, 6, 7, 20, 39, 43, 45,
48, 74, 75, 76, 125

(7) HALKES
13, 14, 15, 129, 143

(8) THINEA
16, 62, 79

(9) AENOS
81, 87, 90

(10) CROCYLEIA
24

ATHERAS

4, 8, 21, 22, 32, 33, 34, 35, 36, 38, 41, 63, 92, 102, 105, 106, 107, 108, 109, 110, 112, 113, 114, 116, 120, 124, 143, 147

⑫
LIVADI

9, 10, 26, 27, 37, 40, 46, 54, 55, 58, 59, 64, 69, 70, 71, 72, 73, 77, 91, 117, 118, 127, 132, 137, 139

⑬
CRIKELLOS HILL - PALACE

23, 42, 44, 47, 66, 68, 93, 94, 95, 96, 97, 98, 99, 100, 101, 119, 121, 133, 135, 138, 142, 148, 153

⑭
PALLIS

3, 25, 49, 50, 51, 52, 53, 56, 57, 61, 67, 82, 85, 89

INDEX OF HOMERIC ITHACA' SITES

With Reference to the Homeric Text

and Present Day Toponyms

οὐδέ νυ σοί περ
ἐντρέπεται φίλον ἦτορ, Ὀλύμπιε. οὔ νύ τ' Ὀδυσσεύς
Ἀργείων παρὰ νηυσὶ χαρίζετο ἱερὰ ῥέζων
Τροίη ἐν εὐρείη; τί νύ οἱ τόσον ὠδύσαο, Ζεῦ;»
 α 59-62

Yet does not
your heart regard it, Olympian. Did not Odysseus
beside the ships of the Argives win your favour by his sacrifices
in the broad land of Troy? Why then did you will him such pain,
O Zeus?»
 Od. 1.59-62

Zeus, surprised at his daughter's audacity, answered her thus:

«τέκνον ἐμόν, ποῖόν σε ἔπος φύγεν ἕρκος ὀδόντων.
πῶς ἂν ἔπειτ' Ὀδυσῆος ἐγὼ θείοιο λαθοίμιν,
ὃς περὶ μὲν νόον ἐστὶ βροτῶν, περὶ δ' ἱρὰ θεοῖσιν
ἀθανάτοισιν ἔδωκε, τοὶ οὐρανὸν εὐρὺν ἔχουσιν;
ἀλλὰ Ποσειδάων γαιήοχος ἀσκελὲς αἰεὶ
Κύκλωπος κεχόλωται, ὃν ὀφθαλμοῦ ἀλάωσεν,
ἀντίθεον Πολύφημον, ὅου κράτος ἐστὶ μέγιστον
πᾶσιν Κυκλώπεσσι· Θόωσα δέ μιν τέκε νύμφη,
Φόρκυνος θυγάτηρ ἁλὸς ἀτρυγέτοιο μέδοντος,
ἐν σπέσσι γλαφυροῖσι Ποσειδάωνι μιγεῖσα.
ἐκ τοῦ δὴ Ὀδυσῆα Ποσειδάων ἐνοσίχθων
οὔ τι κατακτείνει, πλάζει δ' ἀπὸ πατρίδος αἴης.
 α 68-75

«My child, what a word has escaped the barrier of your teeth?
How should I, then, forget godlike Odysseus,
who is beyond all mortals in wisdom, and beyond all sacrifice to
the gods
the immortal has paid, who hold broad heaven?
No, it is Poseidon, the earth-bearer, who is constantly filled with
stubborn
wrath because of the Cyclops, whose eye Odysseus blinded –
namely the godlike Polyphemus, whose strength is greatest

among all the Cyclopes; and the nymph Thoösa bore him,
daughter of Phorcys who rules over the barren sea;
for in the hollow caves she lay with Poseidon.
From that time forth Poseidon, the earth-shaker, Odysseus
does not indeed slay, but beats him off from his native land.

Od. 1.64-75

Whoever studies Homer in depth, without prejudice, and is able to penetrate into the Homeric spirit, will be amazed at the revelations inherent in the Homeric verses. It is worth the effort to try and share Homer's genius and examine the characteristics of this unknown old man of the sea who rules over the barren expanses.

Phorcys is mentioned three times in *The Odyssey*, the poet using his name whenever he mentions the harbour Odysseus reached upon his return to Ithaca. One would think that the name of the old man of the sea was known to everyone. This fearful god, indirectly responsible for Odysseus' wanderings for ten extra years away from his beloved land, had countless descendents. He mated with Ceto and produced, among others, the Gorgons, the Hesperides, the Graiae, Stheno, Euryale, Medusa, Echidna, Crysaor and Pegasus. Homer also counts the Nymph Thoösa among his daughters. She was the mother of Cyclops, having conceived him after laying with Poseidon (Od. 1.72-3). Phorcys, born from the union of Gaea (Earth) and Pontus (Sea) was a very ancient god, being among the first great powers after the creation of Earth (Gaea). He was an old man, as old as his mother Earth, and a sea god, being the son of Pontus (Sea). According to Hesiodic Theogony, the lineage of the original gods was as follows[6]:

6. The diagram is part of the Hesiodic Theogony chart prepared by Evanggelos Roussos, specialist on the 'History of the Hellenic Nation', Ekdotiki Athinon, vol. 2, p. 176-7, and is based on a critical publication of the text prepared by professor Solmsen, Oxford 1970.

```
                  ┌─────────────────┬──────────────────┐
        CHAOS  -  GAEA            EROS
                  (Earth)         (Love or Attraction)
                     │
           ┌─────────┴─────────┐
URANUS - GAEA            GAEA - PONTUS
(Heaven)  (Earth)        (Earth)   (Sea)
           │                  │
        CRONOS            PHORCYS
```

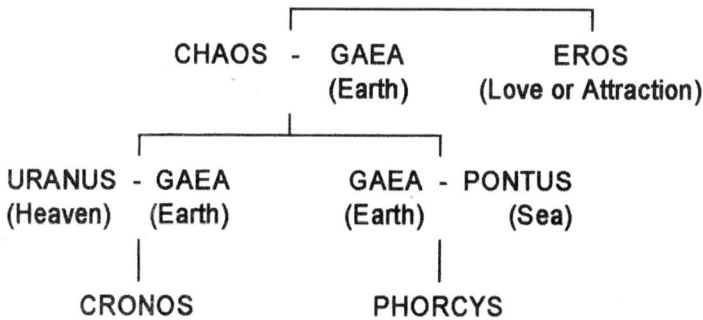

Thus, CHAOS and EARTH begot the SEA and EARTH and the SEA begot PHORCYS.

The annotations on the above Theogony Chart include the following remarks in reference to the chronological progression of genesis.

According to Hesiod's Theogony regarding the creation of the World, first Chaos was created, then Earth and then Eros. Chaos is the void, Earth the mother of gods and men, and Eros is attraction.

These were the original three deities, they were not born of each other. They were self-existent. The order in which they appear underlines only the chronological process of creation. Everything else goes back to these three deities, the three elements of creation.

There is no reference in Hesiod to one beginning, nor is the Earth a creation of the gods, but rather the gods are a creation of the earth.

Among the three original deities, Eros is barren. His mission is to bring about the union of others and lead them to creation.

Certain indications of Hesiod's conception regarding the origin, the essence and the character of the various forces and phenomena should be underlined at this point.

Chaos begot Erebus (Darkness) and Nyx (Night). Nyx begot Ether (Air) and Hemera (Day).

Gaea (Earth) begot Uranus (Heaven), Pontus (Sea) and the Mountains.

Hypnos (Sleep) and Thanatos (Death) are brothers, sons of Nyx (Night).
The creation of the Universe was the result of the union of Chaos and Earth who, assisted by Eros (Attraction), begot Uranus (Heaven) and Pontus (Sea).
Heaven (Uranus) and Earth (Gaea) begot Cronos and the other deities. Earth (Gaea) and the Sea (Pontus) begot Phorcys.

On the basis of the above, one could visualize the character and power inherent in and personified by the name Phorcys. He is the off-spring of the Earth and the Sea and was born secretly in a cavern. He ruled over the barren sea (Od. 1.72). In order to approach this marine demon and appreciate his character and his power, one needs to pene-trate the boundaries of his domain.

[...] Φόρκυνος θυγάτηρ ἁλὸς ἀτρυγέτοιο μέδοντος, [...]
α 72

[...] daughter of Phorcys who rules over the barren sea; [...]
Od. 1.72

Phorcys (Φόρκυς), therefore, is the ruler, the sovereign, the one who governs, the master of the tumultus, tempestuous but also barren, fath-omless sea, the sea that has no harvest to offer. Earth and Sea begot Phorcys, who was born in secret in, one could safely say, a deep, dark and inaccessible cavern. Gaea and Pontus begot earthquakes which are born in the dark and inaccessible depths of the sea and the earth. The presence of the terrible Titan, Phorcys, is unmistakable. His past per-formance should, therefore, be briefly investigated to ascertain if, in fact, he tyrannized the area in question in Homeric times as he has since then.

The rectangular outlined by the coordinates longitude 20,2° and 20,5°, and latitude 38,1° and 38,4°, encloses a region within which lies only the Pallis peninsula. A great number of earthquakes ranging from 5,0 to 7,6 points on the Richter scale have been officially recorded in this region. Appendix IV presents an analytical listing of seismic activ-

ity experienced since A.D. 1469, as recorded by observatories in adjacent regions. This fact is corroborated by scientists the world over, who monitor and record the frequency and intensity of seismic activity in the region, placing it on top of the list of seismic areas in Europe (See Appendix II).

This frightening aspect of the marine demon, the old man who ruled over the region and beautiful Ithaca since before Homer's time to this day, was known to the people of the era. They had located the center and the epicentre of this realm in the small picturesque harbour of Phorcys (Atheras). Thus, by decoding the name of Phorcys, later replaced by Enceladus, one realizes that the earthquake phenomenon was painfully present in Homeric times. Earthquakes, being a distinct characteristic of the region, could not be overlooked by Homer. This reference to Phorcys was the means by which he accomplished this task, indicating thus that in Homeric times and in previous times lost to the memory of men, earthquakes in their destructive power shook the entire Ionian Sea. It is well to transcribe at this point an annotation from the 'Kaktos' edition of *The Odyssey* [7].

> *«9. verse 96, Harbour of Phorcys: It has not been established where the harbour of Phorcys lay. It was built, at some point, by a certain god named Phorcys, and was named after him.»*
>
> *«Phorcys: Phorcys, the old man of the sea, was father of Thoösa, mother of Cyclops. Verse Od. 1.70-1 states: 'godlike Polyphemus ... the nymph Thoösa bore him, daughter of Phorcys...'.»*
>
> *«Phorcys, being a marine deity, belongs to the same category of gods as Proteus, Nereus, etc.»*
>
> *«Phorcys, marine god. Initially he lived in Arymnion, a mountain in Achaea, dwelling in a valley called Phorcys valley after him. He then moved on to Cephallenia, and settled there after selecting an appropriate site. This place is called Ammos ("Αμ-μος). Reaching finally Ithaca, he was honoured by having his name bestowed on the harbour of Phorcys.»*

7. *The Odyssey*, 'Kaktos', vol. 84, p. 178, verse 13.96, note 9.

References: (1) *Herodorus, The History of Phorcys V.*
(2) *Of Phorcys as a mythological personality - see (1).*
(3) *Hesiod, Theogony, 270.33.*
(4) *Apollodorus, The Library, I.26.*
(5) *Virgil, Aeneid, v 824, x 388.*
(6) *Apollonius Rhodius, Argonautica, IV 828.*

Kaktos scholiast's summary of ancient sources regarding Phorcys is quite revealing. Obviously, the chthonian origin of seismic phenomena was known to humanity since its inception. In the case of Phorcys, however, a shifting of the activity from Achaea to Elis, then to Cephallenia and finally to Ithaca is noted, indicating that the isostatic balance of the geological mass in the area in question, is changing. There is a steady movement of earthquake epicentres from east to west.

Of particular interest is the remark that when Phorcys reached Cephallenia he settled in a place called Ammos, Ἄμμος. The origin of this bit of information is not known but, nevertheless, the area resembles the valley of Hypapandi, Ὑπαπαντή, (see analysis on Dulichium, the cultivated fields of Ithaca, next to the sea, chapter XI-2). Another site carrying a relative name is Ammoudares lying above Skavdoliti, also a seismic epicentre. Herodotus notes that he visited a place in Cephallenia called Ammos (hence, Skavdoliti's Ammoudares) and settled at the harbour of Phorcys. He, in fact, mentions the impressive vaulted cavern. It appears that the ancient inhabitants of Greece not only observed the phenomenon, but evaluated as well its intensity and in particular noticed its gradual shifting from Achaea to Cephallenia.

The morphology of the Pallis peninsula's land mass, in general, indicates that the area has been subject to great geological transformations. The land on the western side of the Livadi bay, all along the Pallis peninsula, rises to a height of 451 m., to the top of Mt. Milo (Mt. Neriton). At that point the mountain is sheer to the sea forming a continuous precipice from Acrotiri and the lighthouse of Gerogombou to the northern tip of the Atheras promontory. It continues on to the Daphnoudi headland of Eryssos. A great underwater precipice, that approaches a depth of 650 meters, starts very close to the western coast of the Pallis peninsula. It continues northward and reaches a depth of

2,000 to 3,500 meters at a point approximately 4 nautical miles west of the Atheras promontory. These are great depths that make a barren desert out of the wide sea, as the poet very aptly characterises it. Fishing in such waters is impossible and for this reason they are out-of-bounds to fishermen laying, as such, within the boundaries of Abyss. It is quite possible, therefore, that the westward movement of the epicentre of earthquakes resulted from continuous geological upheavals, which created the deep (3,000 to 5,000 m.) chasm in the southwestern Ionian Sea, a short distance from the island of Cephallenia, which extends all the way to southern Peloponnese.

Pallis, this beautiful extremity of Greece, the enchanting home of much-enduring Odysseus, son of Laertes, presents a marvellous landscape marked by the signs of this geological upheaval wrought by the wrath of the endless sea's archon. The great precipitation of the western coasts of Cephallenia and Zacyntus is one of the great works of Phorcys who settled for the past several thousands of years in today's Atheras. Scientific research, based on the information provided by Homer and other writers of antiquity, could possibly produce important data regarding the development and progression of geological phenomena in the region. Since this land is the most earthquake prone area on the European continent, it seems that such an effort would be worthwhile.

From Achaea Phrocys moved to Elis, then to Cephallenia and finally he settled in Ithaca's windless harbour. His activities, however, continued in conjunction with other major forces: the Cyclops Polyphemus, son of Thoösa and Poseidon, and the other Cyclopes in Sicily, across the western coast of the Ionian Sea. It would be interesting to attempt a correlation of Phorcys' seismic activity in the bay of Patras in Achaea, Elis, Cephallenia and the Pallis peninsula, with that of Sicily. At this point, however, it will suffice to note only a few pertinent facts about Aetna. Aetna or Etna is a volcano, 10,700 ft. high, on the east coast of Sicily. It is the highest active volcano in Europe. The shape and height of its central cone have often been changed by eruptions. There are more than 260 lesser craters on the slopes, formed by lateral eruptions. The southeastern slope is cut by a deep, precipitous cleft, the 'Valle del Bove'. The first known eruption occurred in 475 B.C.

and was described by Pindar and Aeschylus; the most recent occurred in 1961. Smoke is often seen rising from the central cone. There are many similarities between Homeric descriptions of the land of the Cyclopes and the above.

Κυκλώπων δ' ἐς γαῖαν ἐλεύσσομεν ἐγγὺς ἐόντων,
καπνόν τ' αὐτῶν τε φθογγὴν ὀίων τε καὶ αἰγῶν.
ι 166-7

And we looked across to the land of the Cyclopes, who dwelt close at hand,
and noticed smoke, and the voices of the Cyclopes, and of their sheep and goats.

Od. 9.166-7

And further on,

ἔνθα δ' ἀνὴρ ἐνίαυε πελώριος, ὅς ῥα τὰ μῆλα
οἶος ποιμαίνεσκεν ἀπόπροθεν· οὐδὲ μετ' ἄλλους
πωλεῖτ', ἀλλ' ἀπάνευθεν ἐὼν ἀθεμίστια ᾔδη.
καὶ γὰρ θαῦμ' ἐτέτυκτο πελώριον, οὐδὲ ἐῴκει
ἀνδρί γε σιτοφάγῳ, ἀλλὰ ῥίῳ ὑλήεντι
ὑψηλῶν ὀρέων, ὅ τε φαίνεται οἶον ἐπ' ἄλλων.
ι 187-92

There a monstrous man spent his nights, who his flocks
herded alone and afar, and did not with others
mingle, but lived apart, obedient to no law.
For he was created a monstrous marvel, and was not like
a man that lives by bread, but like a wooded peak
of lofty mountains, which stand out to view alone, apart from the rest.

Od. 9.187-92

Phorcys, an offspring of the Earth, born of earthquakes, an invincible element of nature, remains there at the leeward harbour of Phorcys since the beginning of time, to the time of Homer, and to this day.

4. The Reithron Harbour at Samoli

The second harbour mentioned in *The Odyssey*, is that of Phorcys. It lies at the northernmost coast of the Pallis peninsula, at a distance of about nine kilometres from the Homeric city of Ithaca (today's port of Livadi). This has been already covered, but a detailed analysis will be presented when the homeward voyage of Odysseus is described (Illus. 6).

The existence of a third harbour is mentioned in *The Odyssey*, that of Reithron. To identify its location, one needs to set it apart from the other two harbours mentioned. The Reithron harbour is situated side by side with that of the Homeric city of Ithaca, on the western coast of the Livadi bay, under Mt. Neion. The Samoli village is next to the Livadi village and the Kleisoura channel is found under the low mountain of the Pallis peninsula. The coast of the Livadi village describes an arc in a northeastern direction, while the coast at Samoli describes an opposite arc in a southeastern direction, the two arcs converging at the point where the Reithron stream flows into the sea. Great controversy, disagreements and misinterpretations among researchers are associated with the location of this harbour as well, due to the fact that since it lies under the Neion mountain, it was claimed that it should also be the main harbour of Homeric Ithaca. Those who held this opinion were, however, in the wrong since they did not take into account all the facts at their disposal.

Athena, Homer states, patroness goddess of Odysseus but of Telemachus, his son, as well, requested and urged Zeus to send Hermes, the messenger of the gods, to bid the fair-tressed Calypso to free Odysseus. After obtaining his ascent, she departed immediately from Mt. Olympus for Ithaca in order to offer succour to Telemachus. She sent him off to seek tidings of his father so ...

[...] νόστον πευσόμενον πατρὸς φίλου, ἤν που ἀκούσῃ,
ἠδ' ἵνα μιν κλέος ἐσθλόν ἐν ἀνθρώποισιν ἔχῃσιν.

α 94-5

*[...] to seek tidings of the return of his staunch father, if per-
chance he may hear it,
that good report among men may be his.*

<div style="text-align: right;">Od. 1.94-5</div>

The true location of the port of Reithron is divulged in the verses
that follow:

βῆ δὲ κατ' Οὐλύμποιο καρήνων ἀΐξασα,
στῆ δ' Ἰθάκης ἐνὶ δήμῳ ἐπὶ προθύροις Ὀδυσσῆος,
οὐδοῦ ἐπ' αὐλείου· παλάμῃ δ' ἔχε χάλκεον ἔγχος,
εἰδομένη ξείνῳ, Ταφίων ἡγήτορι Μέντῃ.

<div style="text-align: right;">α 102-5</div>

*Then she went darting down from the heights of Olympus,
and took her stand in the land of Ithaca at the outer gate of
Odysseus,
on the threshold of the court. In her hand she held the spear of
bronze,
and she was in the likeness of a stranger, Mentes, the leader of
the Taphians.*

<div style="text-align: right;">Od. 1.102-5</div>

Telemachus saw the foreign visitor, approached him, they entered
the palace and he asked him who he was and where he came from.
Goddess Athena, in the guise of Mentes, replied as follows:

τὸν δ' αὖτε προσέειπε θεά, γλαυκῶπις Ἀθήνη·
ἦτοιγὰρ ἐγώ τοι ταῦτα μάλ' ἀτρεκέως ἀγορεύσω.
Μέντης Ἀγχιάλοιο δαΐφρονος εὔχομαι εἶναι
υἱός, ἀτὰρ Ταφίοισι φιληρέτμοισιν ἀνάσσω.
νῦν δ' ὧδε ξὺν νηὶ κατήλυθον ἠδ' ἑτάροισιν
πλέων ἐπὶ οἴνοπα πόντον ἐπ' ἀλλοθρόους ἀνθρώπους,
ἐς Τεμέσην μετὰ χαλκόν, ἄγω δ' αἴθωνα σίδηρον.
νηῦς δέ μοι ἥδ' ἔστηκεν ἐπ' **ἀγροῦ νόσφι** πόληος,
ἐν λιμένι **Ῥείθρῳ** ὑπὸ Νηΐῳ ὑλήεντι.

ξεῖνοι δ᾽ ἀλλήλων πατρώιοι εὐχόμεθ᾽ εἶναι
ἐξ᾽ ἀρχῆς, εἴ πέρ τε γέροντ᾽ εἴρηαι ἐπελθὼν
Λαέρτην ἥρωα, τὸν οὐκέτι φασὶ πόλινδε
ἔρχεσθ᾽, ἀλλ᾽ ἀπάνευθεν ἐπ᾽ ἀγροῦ πήματα πάσχειν [...]

α 178-91

Then the goddess, flashing-eyed Athene, answered him:
«Therefore I will frankly tell you all.
I declare that I am Mentes, the son of Anchialus,
and I am lord over the oar-loving Taphians.
And now I have put in here as you see, with ship and crew,
while sailing over the wine-dark sea to men of strange speech,
on my way to Temese for copper; and I bear with me shining iron.
My ship lies yonder beside the fields away from the city,
in the harbour of Reithron, under woody Neion.
Friends of one another do we declare oursleves to be, just as our
fathers were,
friends from old. You may, if you will, go and ask the old
hero Laertes, who, they say, no longer to the city
comes, but afar in the fields suffers woes [...]

Od. 1.178-91

Probing carefully the spirit of the poet's verses and considering the words Mentes used in describing his relation to Odysseus and the location of Reithron, one could draw certain important conclusions.

At the far end of the bay the marshes, draining into the sea, form a small brook. In an initial study, the writer had proposed that the Reithron port was located there. New evidence, however, as well as computations on the spot, along with a more thorough interpretation of the opening verses of rhapsody 24 (ω), which describes the train of souls descending into Hades, revealed the true location of the Reithron harbour, and provided additional facts concerning the area. The Reithron port where Mentes beached his ship lies under wooded Mt. Neion. This last fact is key to the identification of Reithron's location. The analysis of the words used by Mentes above, make it clear that his ship ἔστη-κεν 'hésteken', completed his voyage and moored at the port of Reithron

which is to be found in a rural area beside a cultivated field, ἀγρός 'agrós', which lies away, behind, νόσφι 'nósphi' the city and cannot be seen from it.

[...] ἐν λιμένι Ῥείθρῳ ὑπὸ Νηίῳ ὑλήεντι.

α 186

[...] in the harbour of Reithron, under woody Neion.
Od. 1.186

Of course the harbour of Ithaca, which is also the city of Ithaca, lies under the same Neion mountain.

ἡμεῖς ἐξ' Ἰθάκης ὑπονηίου εἰλήλουθμεν· [...]

γ 81

We have come from Ithaca that is below Neion; [...]
Od. 3.81

One wonders whether the poet speaks of one and the same harbour, given that both are mentioned as lying under Mt. Neion. The answer is a categorical no. The harbour is to be found νόσφι 'nósphi', away from, set apart, from the city of Ithaca. The ship is stationary, she is moored there, in a rural area besides a cultivated field, outside the city, in the country. It is the harbour with the ρείθρον 'reíthron', the brook. It is certain, therefore, that the poet speaks of another harbour, situated near the fields, in the country, away and behind the city, invisible from it and under the same mountain Neion. This is what Mentes reported when he was already at the palace over the city, the «spacious city» as the poet describes it.

The term νόσφι 'nósphi', away from, far from, is, of course, relative. Mentes beached or anchored his ship there and walked to his friend's Odysseus' house. The distance travelled could not be very great, since he was not tired by the time he reached his destination. Furthermore, Mentes' precaution not to appear in his ship in the harbour of Ithaca is justified, due to the presence of Penelope's suitors. He travelled to Ithaca only in order to meet and talk to Telemachus and left without being noticed by them. This, moreover, was his purpose. In Homer's

descriptions of Ithaca, however no mention of ρείθρον 'reíthron' (brook) is made.

On the way to the city of Lixouri, 500 meters to the south of the Livadi village, a small settlement is found, the village of Samoli. Between Livadi and Samoli the road bends slightly around a small foot hill, which blocks the view of Livadi placing it, as it were, 'nósphi', behind it. Reithron is located there, at the channel of Kleisoura which receives the waters coming from the villages of Schinia and Agia Thekla and those of Rema (stream) coming from behind Crikellos hill, starting from around the area of Platies Strates. The channel of Kleisoura collects more water than any other place on the Pallis peninsula. All these waters go through Samoli and flow into the sea near by, and reach the edge of the harbour of Livadi (the harbour of Ithaca). The Reithron harbour is situated side by side with that of the Homeric city of Ithtaca. Near this point, Telemachus' ship set sail, as will be seen in the pages that follow. Many cultivated fields and orchards are found there which have a long history, as testified by the well known Ralatos estate, whose ruined installations, centuries old trees and abundant running waters, bear witness to the interest of the inhabitants in this fertile land, since Homer's time. On the coast of the Samoli settlement stands also the mansion of the Foresti family. The stately house has been standing there for over 300 years preserving the grandeur and glory that it has known in the past, in spite of repeated catastrophic earthquakes. It withstood even the 1953 quake which literally demolished the island. The love and care of the Foresti family has turned the 125 acre estate into something of a museum, where daily life and traditional agricultural activities are preserved. The main house is built on the water edge and sits on an immense foundation consisting of cyclopean blocks of stone, dating from Mycenean times. There is every indication that this was the pier of the Reithron harbour, just as the poet's verses describe it.

νηῦς δέ μοι ἥδ ἕστηκεν ἐπ' ἀγροῦ νόσφι πόληος, [...]
α 185

My ship lies yonder beside the fields away from the city, [...]
Od. 1.185

40°

CORFU
Phaeacian
island

(return course
of Odysseus)

IONIO
PELAGOS

ACARNANIA

HOMERIC GREEK

CEPHALLENIA
HOMERIC ITHACA

38°

ZACYNTHUS

PELOPONNESOS

return course
of Telemachus

SPARTA

PYLOS

36°

20°

22°

**DIAGRAM SHOWING RETURN COURSE OF ODYSSEUS
AND TELEMACHUS' SHIPS TO ITHACA**

CHAPTER THREE

TELEMACHUS' VOYAGE TO PYLOS

1. The temple at Kioni

Following the departure of Mentes, king of the Taphians, Telemachus decided to travel to Pylos, to seek tidings of his father, following which he called for an assembly of the Ithacians to announce his decision. After the assembly dissolved, Telemachus walked to the coast (Od. 2.261) and washed his hands in the clear, **white water**[1] **of the** shallow calm **sea** (πολιῆς ἁλός, Od. 2.261, 22.85). The whiteness of the calm sea in the deeply outstretched bay of Livadi, near the Homeric city of Ithaca, is a characteristic and permanent phenomenon. The poet, therefore, evoking the calmness of the setting, is aware of the conditions prevailing. This fact strengthens the theory that his place of origin was Ithaca. This, however, shall be discussed in the appropriate chapter.

Obviously the people's assembly took place at a site not far from the sea, the most likely place being the center of the modern village of Livadi. It was in this exact location that the author discovered sections and capitals of columns belonging to an ancient Doric temple (Illus. 7). These finds were reported in writing to the archaeological Authorities at Patras, on January 1, 1993 (Ref. No. 315), as well as to the Ministry of Culture (See Appendix III). The finds were inspected by the archaeologist Mr. And. Sotiriou and, immediately following him, on March 21, 1993, by the Director of the Archaeological Directorate of Patras, Mr. Laz. Kolonas. On April 23, 1993, and following instructions given by Mr. Kolonas, all pieces of column sections and capitals were collected by Mr. Ant. Sotiriou and are now kept in safety by the Livadi community. In addition, the community financed an unsuccessful attempt to locate the foundations of the structure by digging a small test trench.

1. See note 8, Chapter One.

According to competent archaeologists, the finds in question date to about B.C. 600-700, the temple being of Doric style. This, however, does not refute the fact that if a temple or sanctuary was built on that location, this certainly means that the site was a cult center. It is known, moreover, that the cult of Apollo was practised in Ithaca. This is verified by Homer's verses that follow:

κήρυκες δ' ἀνὰ ἄστυ θεῶν ἱερ ν ἑκατόμβην
ἦγον· τοὶ δ' ἀγέροντο κάρη κομόωντες Ἀχαιοὶ
ἄλσος ὕπο σκιερὸν ἑκατηβόλου Ἀπόλλωνος.

<div align="right">υ 276-8</div>

Meanwhile the heralds through the city the holy hecatomb of the gods
they were leading, and the long haired Achaeans gathered together
beneath the shady grove of Apollo, the archer god.

<div align="right">Od. 20.276-8</div>

An annotation in the Kaktos Edition of *The Odyssey* (verse 20.276, Ann. 8), regarding the meaning of the word κήρυκες 'kérykes' or heralds, suggests that the heralds in question leading 100 oxen to be sacrificed, represented the people of Ithaca and not the suitors. This indicates that the festival was a public one and as such it was dedicated to Apollo. This revealing interpretation confirms the existence of a temple of the god in Ithaca and supports the identification of the ruins at Livadi with Apollo's sanctuary. It is noteworthy that the field where the relics were found, near the central square of the village, is known as Kióni.

αὐτοὶ δ' εἰς ἀγορὴν κίον ἀθρόοι, οὐδέ τιν' ἄλλον
εἴων οὔτε νέων μεταΐζειν οὔτε γερόντων.

<div align="right">π 361-2</div>

They themselves meanwhile went all together to the place of assembly, and no one else
would they allow to sit with them, either the young men or the old.

<div align="right">Od. 16.361-2</div>

Again,

> [...] πολλὰ δέ μοι καρδίη πόρφυρε κίοντι.
>
> δ 427

[...] and many things did my heart darkly ponder as I went.
Od. 4.427

And again,

> τῶν μὲν πεντήκοντα νέες κίον, [...]
>
> B 509

Of these there came fifty ships, [...]
Il. 2.509

So, there they went, κίον, 'kíon' all together, and from κίον 'kíon' came the toponym Κιόνι or Kióni. This is the site to which they went, at the center of the village, a few meters away from the church, at the field where the remnants of the sanctuary were found. Under this site, extending all the way to the sea, a large flat area planted with vineyards is to be seen. It is known as Vassilokipi or Vassilochorapha, which means King's gardens or King's fields. It is now realised that these were the lands of Laertes, Odysseus and Telemachus, Kings of Ithaca. Thus, Kioni and Vassilokipi are near the center of the village, next to the harbour, the harbour of Odysseus' Ithaca. The conclusions to be drawn from the above are self evident. No more need to be said to convince the reader. As far as the dating of the sanctuary is concerned, one cannot contradict the competent archaeologists, since the structure is of the Doric style and, therefore, dates to approximately B.C. 650. It is believed, however, that the subject should be studied further, and for the following reasons: The palaces of the era were luxurious establishments, as testified by Homer in his description of the palace of king Alcinous of the Phaeacians, that of Menelaus of Sparta and that of Priam of Troy. They were richly decorated with bronze and gold, with golden implements and statues. One, therefore, can surmise that tem-

ples dedicated to gods were also built on majestic lines and were equally richly decorated. This is confirmed by the statement of Eurylochus, Odysseus' comrade, made at the time when he and the rest of the men, found themselves stranded on the island of the Hyperion Helios:

εἰ δέ κεν εἰς Ἰθάκην ἀφικοίμεθα, πατρῖδα γαῖαν,
αἶψά κεν Ἡελίῳ Ὑπερίονι πίονα νηὸν
τεύξομεν, ἐν δέ κε θεῖμεν ἀγάλματα πολλὰ καὶ ἐσθλά.

μ 345-7

And if we ever reach Ithaca, our nativland,
we will at once to Helios Hyperion a rich temple
build, and put in it many choise offerings.

Od. 12.345-7

Odysseus' companion, by referring to such a rich temple, must have been aware of the existence of luxurious sanctuaries. Also, Nausithous, king Alcinous' father, had built walls and temples to the gods in Scheria, the land of the Phaeacians. In conclusion, the temple in Homeric Ithaca, whose remains were found in the center of the Livadi village, must have been an imposing structure, justifying its existence in a city where both nobles and citizens respected the gods.

2. Telemachus' Departure for Pylos

As has already been mentioned, new and old ships were moored in the harbour of Ithaca.

εἰσὶ δὲ νῆες
πολλαὶ ἐν ἀμφιάλῳ Ἰθάκῃ, νέαι ἠδὲ παλαιαί· [...]

β 292-3

And ships there were
in abundance in sea-girt Ithaca, both new and old; [...]

Od. 2.292-3

One of these ships, painted black, was picked by Telemachus to carry him on his voyage. The crew was selected, the ship's gear was prepared, and it was moored at the mouth of the harbour.

στῆσε δ' ἐπ' ἐσχατιῇ λιμένος, περὶ δ' ἐσθλοὶ ἑταῖροι
ἀθρόοι ἠγερέθοντο· θεὰ δ' ὤτρυνεν ἕκαστον
ϛ 391-2

And she moored it at the mouth of the harbour, and the noble company
was gathered together, and the goddess heartened each man.
Od. 2.391-2

The above is a detailed and very precise description of the events as they transpired, at the exact point where they took place. The rendering is extraordinary, bringing into life both action and landscape. The port of Livadi (Homeric Ithaca's harbour) has a circular shape. It surprises the visitor to find that where the arc ends, that is right at the farthest point, a land strip is formed in the shallow waters. At the rear of this point, the Vassilokipi (the King's gardens) are located. Further back and higher, lies the Kioni site, and still further up the Crikellos hill. Precisely on the edge of the harbour, outside the head of the little cape, the waters of the Kleisoura channel, the Reithron as was identified, are discharged into the sea. Close by, an old pier is found covered by the sea, along with many stones. A remnant, like a huge finger print, which time did not erase. A little to the north, at a distance of some two hundred meters from the first one, another pier is found. Also near the first pier, on the edge of the harbour, an old ruined windmill still stands over the gentle waves. The pier on the edge of the harbour, brings to life Telemachus' noble companions gathered around their ship, waiting for the time of departure (Od. 2.391).

After Telemachus prepared the food and supplies for the trip (Od. 2.337-58), Athena, still in the guise of Mentes, «calling him forth before the stately hall» at the top of the hill, told him that the ship was ready to sail and the crew was already sitting at the oars (Od. 2.399-404). By then the sun had set (Od. 2.388) and Telemachus along with

Athena quickly came down to the ship (Od. 2.405-6). It should be noted that from the palace one can easily view the harbour. The distance between them is such that it allows easy travelling back and forth. This movement of people between the palace and the harbour will be noted again in the course of this study. Odysseus' palace was built on the top of the Hermes hill, on what is today known as the Crikellos hill, raising gently over the Livadi village. Those lucky enough to climb this hill will be overtaken by the most pleasant feelings, realizing that they are stepping on the sacred ground where the house of a most ancient hero once was, but also because this is a splendidly unrivalled, regal landscape. A spot selected with wisdom and unequalled taste. The harmony of physical beauty finds its fulfilment in this place.

When Telemachus and Athena reached the harbour they climbed on board the ship.

[...] τοὶ δὲ πρυμνῆσι ἔλυσαν,
ἂν δὲ καὶ αὐτοὶ βάντες ἐπὶ κληῖσι καθῖζον.
τοῖσιν δ' ἴκμενον οὖρον ἵει γλαυκῶπις Ἀθήνη,
ἀκραῆ Ζέφυρον, κελάδοντ' ἐπὶ οἴνοπα πόντον.
Τηλέμαχος δ' ἑτάροισιν ἐποτρύνας ἐκέλευσεν
ὅπλων ἅπτεσθαι· τοὶ δ' ὀτρύνοντος ἄκουσαν.
ἱστὸν δ' εἰλάτινον κοίλης ἔντοσθεν μεσόδμης
στῆσαν ἀείραντες, κατὰ δὲ προτόνοισιν ἔδησαν,
ἕλκον δ' ἱστία λευκὰ ἐϋστρέπτοισι βοεῦσιν.
ἔπρησεν δ' ἄνεμος μέσον ἱστίον, ἀμφὶ δὲ κῦμα
στείρῃ πορφύρεον μεγάλ' ἴαχε νηὸς ἰούσης·
ἡ δ' ἔθεεν κατὰ κῦμα διαπρήσσουσα κέλευθον.
δησάμενοι δ' ἄρα ὅπλα θοὴν ἀνὰ νῆα μέλαιναν
στήσαντο κρητῆρας ἐπιστεφέας οἴνοιο,
λεῖβον δ' ἀθανάτοισι θεοῖς αἰειγενέτῃσιν,
ἐκ πάντων δὲ μάλιστα Διὸς γλαυκώπιδι κούρῃ.
παννυχίη μέν ῥ' ἥ γε καὶ ἠῶ πεῖρε κέλευθον.

<div align="right">β 418-34</div>

[...] while the men loosed the stern cables

and themselves stepped on board, and sat down up the benches.
And flashing-eyed Athene sent them a favorable wind,
a strong-blowing West Wind that sang over the wine-dark sea.
And Telemachus called to his men, and told them
to lay hold of the tackling, and they hearkened to his call.
The mast of fir they in the hollow socket
they set and raised, and made it fast with forestays,
and hauled up the white sail with twisted thongs of oxhide.
So the wind filled the belly of the sail and the dark wave
sang loudly about the stem of the ship as she went,
and she sped over the wave accomplishing her way.
Then, when they had made the tackling fast in the swift black ship
they set forth bowls brimful of wine,
and poured libations to the immortal gods that are forever,
and chiefest of all to the flashing-eyed daughter of Zeus.
So all night long and through the dawn the ship cleft her way.

<div align="center">Od. 2.418-34</div>

The ship set off after the sunset, in the dark and from the point near the edge or mouth of the harbour, from the pier, that is, near where the old ruined windmill stands now. Here again, the interpretation of certain words clarifies the departure of the ship and the direction toward which she sailed.

The Livadi bay is protected on the western side by the low mountains of the Pallis peninsula (Neion). The wind, nevertheless, enters the deep bay from the low-lying meadow area, so that it is literally windswept in a north to south direction. To understand the phenomenon, one should take into account the geographical position of Cephallenia lying, as it does, in the open Ionian Sea at the mouth of the Adriatic. When the strong westerly wind is strengthened by northern currents, it takes a north-northeastern direction and sweeps the bay coming through the low lying meadow region. This is an almost daily occurrence, taking place usually in the afternoon hours. It is not unusual, in fact, to see at times the sea overflow the Argostoli bridge. Following the setting of the sun, dusk set in and the light diminished «all the ways grew dark;» (Od. 2.288). The accuracy of the poet's description is

noteworthy. He states that as soon as they released the stern cables, the wind filled the belly of the sail and the dark wave sang loudly about the stern. This is exactly what happens to this day. The old ruined windmill is indisputable evidence that Telemachus's ship sailed from this point, since it is not common to find a windmill built on the deep end of a gulf, low, next to the water. Windmills are normally built on high, open ground. Thus, the ship, having a favourable wind, released its stern cables, sailed directly for the mouth of the bay and from there to the open sea towards Pylos. The sun had set by then, and the low mountain of the Pallis peninsula allowed the crimson and violet light illuminating the moist air to penetrate into the gulf and reflect on the bay's waters. The unequalled in beauty play of the diminishing light, fell on Telemachus' prow, painting the sea the colour of Ithaca's sweet wine. Some may think that this description is exaggerated. However, if one should sail over the beautiful waters of the Livadi bay, some late afternoon, one would admit that a similar unequalled spectacle is not to be experienced on the eastern side of Cephallenia, in Leucas or in today's Ithaca.

The way to approach Homeric Ithaca, is to try and penetrate the poet's logic and spirit. Then the path should be clear. The palace was situated above, over the harbour. From there one could observe every movement of the people below in the spacious city, the comings and goings of the ships over the entire breath of the deep bay, the flight of eagles over the Neriton mountain across the bay. The ship, with her mast of fir from Mt. Neriton of the quivering foliage, sailed past the coast where today lie the cities of Lixouri and Argostoli. A strait, where the sea is frequently tumultuous, as the contemporary folk songs has it:

> *My pretty little Argostoli,*
> *Renown Lixouri through the world,*
> *Now you're lost in the waves,*
> *Now you surface through the foam.*

A thousand songs have been sung about the rare beauty of the land-scape by the divine songsters of Homeric Ithaca and by the contemporary sweet-voiced Cephallenians.

During Telemachus' stay at Sparta and Pylos, Ithaca's landscape is described again, and certain points of this description provide very useful information, confirming what has so far been said regarding Ithaca. Telemachus addressing King Nestor of Pylos states:

ἡμεῖς ἐξ' Ἰθάκης ὑπονηίου εἰλήλουθμεν· [...]

γ 81

We have come from Ithaca that is below Neion; [...]

Od. 3.81

Telemachus refused to accept King Menelaus's gift of horses because,

[...] ἵππους δ' εἰς Ἰθάκην οὐκ ἄξομαι, [...]

δ 601

[...] but horses I will not take to Ithaca [...]

Od. 4.601

And further down,

ἐν δ' Ἰθάκῃ οὔτ' ἄρ δρόμοι εὐρέες οὔτε τι λειμών· [...]

δ 605

But in Ithaca there are no broad courses nor meadow land at all [...]

Od. 4.605

These characteristics of Mt. Neion and rocky Ithaca have already been described and correspond to the land morphology of Cephallenia's Pallis peninsula.

3. The Suitors' Ambush at Asteris

Back in Ithaca, Penelope's suitors had by now been informed of
Telemachus' departure and following Antinous' proposition decided to
ambush him, during his return trip, and kill him.

> *[...] ἀλλ' ἄγε μοι δότε νῆα θοὴν καὶ εἴκοσ' ἑταίρους,
> ὄφρα μιν αὐτὸν ἰόντα λοχήσομαι ἠδὲ φυλάξω
> ἐν πορθμῷ Ἰθάκης τε Σάμοιό τε παιπαλοέσσης, [...]*
>
> δ 669-71

*[...] But come, give me a swift ship and twenty men,
as he makes his lonely passage, that I may watch in ambush for
him,
in the strait between Ithaca and rugged Samos [...]*

Od. 4.669-71

There was agreement with this proposition, following which they
departed in order to put their plan into action and wait by the sea for
Telemachus' return.

> *μνηστῆρες δ' ἀναβάντες ἐπέπλεον ὑγρὰ κέλευθα
> Τηλεμάχῳ φόνον αἰπὺν ἐνὶ φρεσὶν ὁρμαίνοντες.
> ἔστι δέ τις νῆσος μέσσῃ ἁλὶ πετρήεσσα,
> μεσσηγὺς Ἰθάκης τε Σάμοιό τε παιπαλοέσσης,
> Ἀστερίς, οὐ μεγάλη· λιμένες δ' ἔνι ναύλοχοι αὐτῇ
> ἀμφίδυμοι· τῇ τόν γε μένον λοχόωντες Ἀχαιοί.*
>
> δ 842-7

*But the suitors embarked, and sailed over the watery ways,
pondering in their hearts utter murder for Telemachus.
There is a rocky isle in the mist of the sea,
midway between Ithaca and rugged Samos,
Asteris, of no great size, but in it is a harbour where ships may lie,
with an entrance on either side; there, in ambush, the Achaeans
waited for him.*

Od. 4.842-7

Athena Pallas[2] found Telemachus awake at Menelaus' house, and convinced him to depart for Ithaca in order to defend his home. She gave him at the same time advice to beware of the ambush laid for him by the suitors during his return trip and upon his arrival at Ithaca.

ἄλλο δέ τοί τι ἔπος ἐρέω, σὺ δὲ σύνθεο θυμῷ.
μνηστήρων σ' ἐπιτηδὲς ἀριστῆες λοχόωσιν
ἐν πορθμῷ Ἰθάκης τε Σάμοιό τε παιπαλοέσσης,
ἱέμενοι κτεῖναι, πρὶν πατρίδα γαῖαν ἱκέσθαι.
ἀλλὰ τά γ' οὐκ ὀίω· πρὶν καί τινα γαῖα καθέξει
ἀνδρῶν μνηστήρων, οἵ τοι βίοτον κατέδουσιν.
ἀλλὰ ἑκὰς νήσων ἀπέχειν εὐεργέα νῆα,
νυκτὶ δ' ὁμῶς πλείειν· πέμψει δέ τοι οὖρον ὄπισθεν
ἀθανάτων ὅς τίς σε φυλάσσει τε ῥύεταί τε.
αὐτὰρ ἐπὴν πρώτην ἀκτὴν Ἰθάκης ἀφίκηαι,
νῆα μὲν ἐς πόλιν ὀτρῦναι καὶ πάντας ἑταίρους,
αὐτὸς δὲ πρώτιστα συβώτην εἰσαφικέσθαι,
ὅς τοι ὑῶν ἐπίκουρος, ὁμῶς δέ τοι ἤπια οἶδεν.
ἔνθα δὲ νύκτ' ἀέσαι· τὸν δ' ὀτρῦναι πόλιν εἴσω
ἀγγελίην ἐρέοντα περίφρονι Πηνελοπείῃ,
οὕνεκά οἱ σῶς ἐσσὶ καὶ ἐκ Πύλου εἰλήλουθας.

o 27-42

And another thing will I tell you, and you must lay it to heart.
The best men of the suitors lie in wait for you of set purpose
in the strait between Ithaca and rugged Samos,
eager to slay you before you come to your native land.
But I do not think this shall be; before that shall the earth cover
many a one of the suitors that devour your property.
But keep your well-built ship far from the islands,
and sail by night as well as by day, and fair wind will send in your wake
that one of the immortals who keeps and guards you.

2. Epithet attached to goddess Athena. Trans. note.

But when you have reached the nearest shore of Ithaca,
send your ship and all your comrades on to the city,
but yourself go first of all to the swineherd
who keeps your swine, and has a kindly heart toward you as
well.
There spend the night; and tell him to go to the city
to bear word to wise Penelope
that she has you safe and that you have come back from Pylos.

<div align="right">Od. 15.27-42</div>

A careful analysis of the meaning of the above verses, describing the relative position of the islands mentioned, can contribute important and useful information and allow certain conclusions which should assist in solving the central problem, namely the identification of Homeric Ithaca.

As stated, the suitors' intention was to set an ambush, to attack unexpectedly Telemachus' ship and slay him. Their ship had twenty rowers (Od. 4.669), which was the standard crew for ships plying the open sea. Telemachus' ship was similarly manned. A ship, however, intending to attack another cannot wait idle hiding behind an island's headland and start moving only when the one to be attacked passes by. In such a case, she would have to set sail and overtake its opponent covering a considerable distance, given that a sailing ship does not travel very close to the shore. The suitors, therefore, as the poet quite rightly states, were under sail while they were anxiously pondering, ὁρμαίνοντες 'hormaénontes', the best way to attack suddenly and unexpectedly, so that they may succeed in their undertaking. Their intention, quite clearly, was to move swiftly, rush the ship while in motion and attack Telemachus and his companions. Swiftly rushing an opponent can have the expected results when he is lying idle, is unaware, and not on guard. Otherwise, he will naturally take flight and avoid the onslaught.

The selection of the rocky islet, Asteris, was most appropriate and essential, as far as the suitors were concerned, so that they could remain there in hiding and mount their attack at the moment Telemachus' ship would sail by. The Asteris islet does not lie in the middle of the strait between Cephallenia and Ithaca (i.e., Homeric Ithaca and Samos) but

much closer to Cephallenia (i.e., Homeric Ithaca). A ship's navigation course, as is the practice to this day, is not set in the middle of the strait, but rather between Cephallenia and Asteris, a much narrower passage and, in fact, almost touching Asteris. Special attention should be paid to Homer's verses defining the position of the islet. He states:

> [...] ἐν πορθμῷ Ἰθάκης τε Σάμοιό τε παιπαλοέσσης, [...]
> δ 671

> [...] in the strait between Ithaca and rugged Samos [...]
> Od. 4.671

And further:

> ἔστι δέ νῆσος μέσση ἁλὶ πετρήεσσα,
> μεσσηγύς Ἰθάκης τε Σάμοιό τε παιπαλοέσσης, [...]
> δ 844-5

> There is a rocky isle in the mist of the sea,
> midway between Ithaca and rugged Samos, [...]
> Od. 4.844-5

All translators of these verses and Homer's interpreters concur that the words μέσση 'mésse' in the midst, in the middle, and μεσσηγύς 'messegýs', midway, have the same meaning, that is, the isle Asteris lies between the two islands in the middle of the sea. Since, however, the poet had already defined the position of the islet with the words strait, πορθμῷ, and middle, 'mésse', he had no reason to mention the word 'messegýs', unless he used it to clearly indicate that he meant the middle navigation course of the ship. In other words, the islet was located in the middle of the ship's navigation course, just as it is today. Since Telemachus' vessel would, by necessity, pass very close to Asteris, at a breath's distance so to speak, it would have been very easy for the suitors to rush the ship and board her. The two harbours mentioned as located on Asteris (see Od. 4.845-46) would serve to temporarily moor and conceal their ship.

The rocky isle Asteris, today's Daskalió, across from the Doulicha bay of Eryssos, is a low islet not more than three to four meters above sea level. Today, no double, ἀμφίδυμοι 'amphídyme', entry harbour may be found. This is logical considering that the sea level has risen by two or three meters since Homer's time, but still it is not a matter of great concern since a harbour in a rocky islet is rather meaningless. The isle, considering its height and the fact that the sea level, as noted, was a few meters lower, offered perfect cover from detection to the suitors' ship, particularly if they removed the mast.

[...] μηδέ τι μεσσηγύς γε κακὸν καὶ πῆμα πάθῃσι, [...]
η 195

Nor shall he meanwhile suffer any evil or harm, [...]
Od. 7.195

Also,

[...] ἔχει δ' ἄξων ἀτάλαντον ἀπάντη μεσσηγύς γαῖαν.
Ἄρατος Ἐπικ. 22

[...] it has a stable axis[3] in its entire length that passes through the center of the earth.
Arat. Epic., 22

The word μεσσηγύς 'messegýs', of space means in the middle, between; of time, meanwhile, in mid-voyage. The true meaning of the word refers, therefore, to the axis of the ship's navigation route, and is intended to inform Telemachus, that when he entered the strait and sailed northward, he should navigate on the left hand side of the strait, on the side of Ithaca (Cephallenia today), otherwise he would run into the Asteris islet, that is into the suitors' ambush. One should remember that the ship was navigating at night and was forced to hug the

3. Axis of the celestial sphere. Trans. note

TELEMACHUS' VOYAGE TO PYLOS

coast. However, even if one sailed in daytime, one should take his bearing on Fiscardo to have a point of reference. In this case, also, the navigation route of the ship would pass over the islet[4]. After rounding Fiscardo the ship would sail in a westward direction toward the Atheras promontory. Athena, therefore, forewarned Telemachus of the danger to run into the Asteris islet, and to be careful because it was to be used by the suitors as the point at which the ambush was to be set. More than three thousand years later, the same forewarning is noted in the 'Navigational Directives' contained in PLOEGOS Vol. A, 3rd Edition 1971, on page 126, a publication of the 'Hydrographical Service of the Naval Headquarters of Greece'. The directive reads as follows:

The rocky islet Dascalió or Asteris, constitutes the sole danger when navigating the strait of Ithaca. It is situated two (2) miles southeast of the Fiscardo light house and four tenths (4/10) of a mile from the city of Ithaca, lying across the small harbour on the coast of Cephallenia. It is of a reddish hue, three (3) meters above sea level, on it the ruins of an old tower are found. Water depths of less than 10 meters extend on both sides of its perimeter toward the southeast and the north-northwest. Discernible during the day, constitutes a danger during the night. Vessels navigating in its proximity should not take their bearings on the light house situated on the edge of Fiscardo, at an arc greater than 327o until they have safely by-passed it.

It is noted, with some satisfaction, that the modern directives to navigators are the same as those of Homer, who was not only an epic poet but a seaman capable of giving safe navigation directions.

What Telemachus was concerned about was, of course, the danger coming from the suitors and not Asteris itself. At any rate, when one's life and that of his companions is in danger, one tries to avoid being

4. This is exactly what happened to S.S. TASSOS in 1920. Taking her bearing on the edge of Fiscardo, in order to exit the strait, she run aground on the islet. In fact, she climbed on it.

trapped in a narrow strait. One changes his route and lets his foes await in vain. The divine inspiration that saved Telemachus and his friends, was to change direction, avoid the strait and keep at a distance from the isle. Athena, the goddess of wisdom, personifying Telemachus' wisdom, gave the correct and lifesaving advice:

ἀλλὰ ἑκὰς νήσων ἀπέχειν εὐεργέα νῆα,
νυκτὶ δ' ὁμῶς πλείειν·

o 33-4

But keep your well-built ship far from the islands,
and sail by night as well as by day; [...]

Od. 15.33-4

And again,

αὐτὰρ ἐπὴν πρώτην ἀκτὴν Ἰθάκης ἀφίκηαι,
νῆα μὲν ἐς πόλιν ὀτρύναι καὶ πάντας ἑταίρους,
αὐτὸς δὲ πρώτιστα συβώτην εἰσαφικέσθαι, [...]

o 36-8

But when you have reached the nearest shore of Ithaca,
send your ship and all your comrades to the city,
but yourself go first of all to the swineherd [...]

Od. 15.36-8

Telemachus' decision was to change route and, sailing away from the islands, set a course along the coast of Ithaca that would take him near Eumaeus' swinesty. He reached Cyllene (in Elis) and set his course away from the islands Athena mentioned, that is Ithaca, Samos and Asteris. He had to reach his destination without being seen by the suitors who were looking out for him all along the coast. He should, therefore, have avoided sailing between Cephallenia (Homeric Ithaca) and Zachynthus and enter directly the Livadi bay. Alcinous, in fact admitted as much, later on, hearing that Telemachus had returned to Ithaca.

«ὦ πόποι, ὡς τόνδ᾽ ἄνδρα θεοὶ κακότητος ἔλυσαν.
ἤματα μὲν σκοποὶ ἷζον ἐπ᾽ ἄκρας ἠνεμονέσσας
αἰὲν ἐπασσύτεροι· ἅμα δ᾽ ἠέλιῳ καταδύντι
οὔ ποτ᾽ ἐπ᾽ ἠπείρου νύκτ᾽ ἄσαμεν, ἀλλ᾽ ἐνὶ πόντῳ
νηὶ θοῇ πλείοντες ἐμίμνομεν Ἠῶ δῖαν,
Τηλέμαχον λοχόωντες, ἵνα φθίσωμεν ἑλόντες
αὐτόν· [...]

<div align="right">π 364-70</div>

«Now look! Just see how the gods have delivered this man from
destruction.
Day by day watchmen set upon the windy heights,
watch constantly following watch, and at set of sun
we never spent a night upon the shore, but sailing out at sea
in our swift ships we waited for the bright Dawn,
lying in wait for Telemachus, that we might take him and slay
the man himself;[...]

<div align="right">Od. 16.364-70</div>

Since the suitors had set their minds on Telemachus, it was logical
to post lookouts to spot the direction from which he would sail into
Ithaca, so that they could apprehend him and kill him. They were
patrolling the sea between Ithaca's harbour and Asteris with one ship
only (Od. 16.368), setting off each day, after sun set, from Ithaca and
returning from Asteris at dawn. Telemachus' return to Ithaca through
the gulf of Livadi was, thus, impossible. He would have been detected
whether day or night. He was forced, then, to go first to Eumaeus'
swinesty and, in fact, arrive there at night. On the other hand, it was
impossible to sail south of Cephallenia without being detected, not to
mention the fact that in such a case he would have had to travel along
the entire length of the western coast of the island to reach the port of
Phorcys (Atheras). This would have meant travelling in the open sea,
with all the dangers inherent thereof, not counting the danger of attack.
Telemachus had only one option left open to him. He had to sail from
Elis north toward the Echinae islands and follow a course east of Itha-
ca and Samos (now Cephallenia and Ithaca respectively).

[...] ἠδὲ παρ' Ἤλιδα δῖαν, ὅθι κρατέουσιν Ἐπειοί.
ἔνθεν δ' αὖ νήσοισιν ἐπιπροέηκε θοῇσιν,
ὁρμαίνων ἤ κεν θάνατον φύγοι ἤ κεν ἁλώῃ.

o 298-300

[...] and on past splendid Elis, where the Epeians hold sway.
From there again he steered for the swift islands,
pondering whether he should escape death or be taken.

Od. 15.298-300

The sun had set as he reached Elis (Od. 15.296), and at that point he sailed north, avoiding the narrow strait, where Asteris lay, while keeping Ithaca and Same (Cephallenia and Ithaca today) to his left and at a distance from his ship. The sun having set, he was travelling now by night. When his ship reached the northernmost edge of today's Ithaca, at the Mélissa promontory, he set his course west, sailed past the Aphales bay, and reaching the Daphnoúdi headland near Fiscárdo, took his bearing on the Atheras promontory (southwest), and reached the windless harbour of Ithaca at dawn (Od. 15.495), «the first coast»[5], as the poet calls it. Eumaeus' swinesty was to be found there (Od. 15.38). It was, in fact, the first coast reached past the point where the suitors lay in ambush. The sailors disembarked, rested for a while, lunched and drunk wine (Od. 15.500), following which Telemachus bid them take the ship to Ithaca's harbour (Od. 15.503), while he set off on foot to come to the swineherd's sty. At the same time, at dawn, the suitors that kept guard at Asteris, seeing that Telemachus' ship was not coming through the bay, set off to return to Ithaca as well.

5. Nearest coast that offered safe landing. Trans. note.

**DIAGRAM SHOWING RETURN COURSE OF TELEMACHUS'
SHIP TO THE HARBOUR OF ITHACA**

4. Alalcomenae and the Vardiani Reef

Special attention should be given to the Asteris islet, so that certain questions raised in the past but which persist to this day, may be answered. By these questions and arguments it is attempted to interpret Homer in such a way as to give credence to certain views, which do not concur with Homeric descriptions. Strabo in his geography states:

> [...] and Asteria has been changed, which the poet calls Asteris: «Now there is a rocky isle in the mid-sea Asteris, a little isle; and there is a harbour therein with a double entrance, where ships may lie at anchor.» But at the present time it has not even a good anchorage.

<div align="right">Str. 1.3.18</div>

Further, in regards to Cephallenia and Asteris he states the following:

> Cephallenia lies opposite Acarnania, at a distance of about fifty stadia[6] from Leucates (some say forty), and about one hundred and eighty[7] from Chelonatas. It has a perimeter of about three hundred[8] stadia[9], is long, extending towards Eurus[10] and is mountainous. The largest mountain upon it is Aenus, whereon is the temple of Zeus Aenesius; and where the island is narrowest, it forms an isthmus so low-lying that it is often submerged from sea to sea. Both Paleis and Cranii are on the gulf near the narrows.

<div align="right">Str. 10.2.15</div>

6. About 9 kilometres. Trans. note.
7. About 32.5 kilometres. Trans. note.
8. About 54 kilometres. Trans. note.
9. Instead of τριακοσίων (τ' = 300), Strabo probably wrote ἑπτακοσίων (ψ' = 700), which, not counting the sinusities of the gulfs, is about correct. Pliny (4.19) says 93 miles (744 stadia). Loeb ed. note.
10. i.e. towards the direction of winter sunrise (rather south-east) as explained by Poseidonius. Trans. note.

And further on,

> *Between Ithaca and Cephallenia is the small island Asteria (the poet calls it Asteris), which the Sceptian[11] says no longer remains such as the poet describes it, «but in it are harbours safe for anchorage with entrances on either side»; Apollodorus[12], however, says that it still remains so to this day, and mentions a town Alalcomenae upon it, situated on the isthmus itself.*
>
> Str. 10.2.16

One should consider carefully Strabo's descriptions who maintains that Asteris was small, did not possess the characteristics attributed to it by Homer and had no harbours. In spite of the misinterpretations that the above quotations have caused, in fact, they provide answers to many questions that have repeatedly arisen. Strabo records his own testimony regarding the location of Asteris and its condition in his time. He agrees with Scepsis that the islet's configuration had changed since Homer's time. One should also take into account that the islet is not but a reddish elongated rock, two hundred and ten meters long, three meters above sea level. Shallows of less than ten meters are extended on both extremities, while the strait between it and Cephallenia reaches a depth of sixty five meters. At a short distance from it, the waters are 100-180 meters deep. Apollodorus' quotation in Strabos' text, however, (Str. 10.2.16), suggests that the islet «remains so to this day». This has been erroneously connected to the islet in question. In the above paragraph (C.457), Strabo states:

> ὁ δὲ Ἀπολλόδωρος μένειν καὶ νῦν, καὶ πολίχνιον λέγει ἐν αὐτῇ Ἀλαλκομενάς, τὸ ἐπ' αὐτῷ τῷ ἰσθμῷ κείμενον.
>
> Στράβων 10.2.16

> *Apollodorus, however, says that it still remains so to this day, and mentions a town Alalcomenae upon it, situated on the isthmus itself.*
>
> Str. 10.2.16

11. Demetrius of Scepsis.
12. Apollodorus B.C. 180-109.

One, therefore, is justified in wondering to what isthmus Apollodorus is referring, since there is no isthmus on the rocky islet Asteris (modern Dascaleió), situated between Cephallenia and Ithaca. The depth of the water in the above strait, as stated, reaches sixty-five meters, and it would have been impossible for an isthmus, connecting it to the shore across, to have been there. It is also improbable for a small settlement to have been built on a rocky islet devoid of water and direct communication with the main island. From the above it is obvious that Apollodorus refers to some other isthmus, on which Alalcomenae was built and not to Asteris. This isthmus must be the one Strabo mentions in his geography (10.2.15) saying «it forms an isthmus so low lying that it is often submerged from sea to sea. Both Paleis and Crannii are on the gulf near the narrows».

The gulf mentioned, then, can be identified with today's deep gulf of Livadi in Cephallenia where the cities of Lixouri and Argostoli are found[13]. At the entrance of this gulf, on the western side and to the south of the Pallis peninsula, at a distance of 2.5 kilometres from the Megas Lakos coast, lies a small island by the name Vardiani. It is about 1,500 meters long and its maximum width is about 500 meters. Vardiani, at one time, was connected to the coast of Megas Lakos by means of a narrow strip of land, which today is submerged and is found in the form of a reef at a depth of about five meters. The isthmus, therefore, mentioned by Strabo and the one by Apollodorus are one and the same, and it connected the Pallis peninsula with the Vardiani isle. It has disappeared by now since the sea level has risen by at least three meters, not to mention that according to Strabo, it was so low that it was often submerged from sea to sea. This area, lying in the open sea, is subject to strong winds both from the south and the north, resulting in huge waves, which in fact destroyed the isthmus. The naval maps published by the Hydrographic Service of the Headquarters of the Greek Navy and the British Admiralty indicate the existence of the reef

13. This is exactly where the ancient geographer locates the two cities Crannii and Paleis, the former toward todays Koutavos (Cranaea district), the district of the city of Argostoli, and the latter on the Pallis peninsula, the Lixouri district.

from Vardiani Island to the neighbouring coast. The navigation directives published in PLOEGOS, 1971, page 136, 'Regarding the extremity of Agios Georgios, Cephallenia', reads as follows:

> *A little further towards the open sea, at a distance of one mile, north of the Vardiani lighthouse, extends the Vardiani reef, at a minimum depth of 5 meters to the north of it and 9 to 13 meters on either side of it.*

The identification of the isthmus between the main island and Vardiani has important archaeological and historical significance, since Odysseus, the future King of Ithaca was raised there[14]. Homer states that Odysseus was reared in the Ithaca *démos* (Il. 3.201), the Pallis peninsula, that is, which is related to the *démos*, and Alalcomenae, which correspond to the Vardiani islet, confirm the propositions presented so far. Certain historians, students of the Odyssey, identify Asteris with the Vardiani island, arguing that it lies between Ithaca and Samos, meaning that one side of the bay is Ithaca and the other Samos. The other argument advanced is that a port with two entries is found there. The pros and cons of these arguments will not be discussed at this point, with the exception of one item, which, it is felt, refutes the above thesis. Assuming that Vardiani is in fact Asteris one should consider the following:

I. Telemachus had decided not to sail past Asteris under any circumstances. Therefore, during the voyage, Telemachus and his comrades avoided the trap set at Asteris and landed on the **nearest** Ithacian coast.

14. In 1983 in the area of the Vardiani reef, four ancient statues were retrieved from the sea and were delivered to Ministry of Culture for cleaning, maintenance and study. They have not, as yet, been returned to Cephallenias museum. Nothing more is known about them. It would be an important element contributing to the ancient history of the area, if the period to which they belong was officially announced, and if further search was undertaken in the shallows of Vardiani islet, since much could come to light.

αὐτὰρ ἐπὴν πρώτην¹⁵ ἀκτὴν Ἰθάκης ἀφίκηαι,
νῆα μὲν ἐς πόλιν ὀτρῦναι καὶ πάντας ἑταίρους [...]
o 36-7

But when you have reached the nearest shore of Ithaca,
send your ship and all your comrades on to the city, [...]
Od. 15.36-7

II. From Elis, the ship took a course toward the Echinades isles,
 she, therefore, sailed north of Cephallenia toward Athera and not
 toward Vardiani; since there was great danger of being detected.
 Where then is the nearest place where Telemachus put in, since
 Asteris is supposed to be lying at the entrance of the bay in
 which Ithaca was situated?

III. If Vardiani was the ambush point, then Telemachus' ship would
 have been apprehended by the suitors. Seeing that the man they
 sought was not on board, they would have immediately fore-
 warned their friends that he had landed somewhere else.

Instead of this happening, Telemachus' ship arrived at Ithaca's har-
bour first, a sailor disembarked and went to Penelope to bring tidings
of her son (Od. 16.328-9). It was then that the suitors learned of Tele-
machus' arrival. So, they left Odysseus' palace led by Amphinomus,
and sometime later they saw their own ship entering the harbour (Od.
16.351-3). Telemachus' ship had obviously entered the harbour ahead
of the suitors' ship, passing by Vardiani, undetected by them. Since,
therefore, the two ships did not meet, it is quite plain that Telemachus'
ship did not sail past the point of ambush.

ἤ τίς σφιν τόδ᾽ ἔειπε θεῶν, ἢ εἴσιδον αὐτοὶ
νῆα παρερχομένην, τὴν δ᾽ οὐκ ἐδύναντο κιχῆναι.»
π 356-7

15. The Homeric text states πρώτην, first, while the Murray translation renders it as
 nearest. In fact, by first or nearest, that coast is meant that offered safe landing
 after bypassing the danger point where the suitors lay in wait. Trans. ίote.

*Either some god told them of this, or they themselves caught
sight of Telemachus'
ship as she sailed by, but could not catch her.»*
 Od. 16.356-7

As noted above, when Telemachus and his comrades reached the
Atheras port in early dawn, they sat and lunched for a short while, then,
at his bidding, set off to take the ship to Ithaca's harbour, taking a
southwesternly direction, moving along the Pallis peninsula. At about
the same time, at dawn, the suitors, as they did every day, set off from
Asteris where they lay in ambush (today's island of Dascalio, between
Cephallenia and Ithaca) and sailed towards today's Daphnoudi, promon-
tory of Eryssos. When, therefore, the suitors were sailing around Daph-
noudi, Telemachus' ship was coming around the Atheras promontory,
the destination of both ships being the port of Ithaca. Ôhe two ships
reached the harbour within one to two hours of each other. As the poet
puts it, «Either some god told them of this, or they themselves caught
sight of Telemachus' ship as she sailed by, but could not catch her.»

One of the key elements in solving the problem of locating Home-
ric Ithaca is the identification and location of the Asteris islet. The
analysis presented above gives an adequate answer to the above criti-
cal question, covering the geographical descriptions of Homer, the
events that took place, the interactions of the characters and the move-
ments of the ships involved. The identification of Asteris with other
islets, as for example, Arkoudi, Oxia or the island of Ithaca itself, pro-
posed by various students of Homer, was, most likely, attempted in
order to satisfy certain theories which, however, do not concur with
Homer. Both ships, nevertheless, reached the harbour of Ithaca, that of
Telemachus arriving first.

ὣς οἱ μὲν τοιαῦτα πρὸς ἀλλήλους ἀγόρευον,
ἡ δ' ἄρ' ἔπειτ' Ἰθάκηνδε κατήγετο νηῦς ἐυεργής,
ἡ φέρε Τηλέμαχον Πυλόθεν καὶ πάντας ἑταίρους.
οἱ δ' ὅτε δὴ λιμένος πολυβενθέος ἐντὸς ἵκοντο,
νῆα μὲν οἵ γε μέλαιναν ἐπ' ἠπείροιο ἔρυσσαν, [...]
 π 321-5

Thus they spoke to one another,
but meanwhile the well-built ship that to Ithaca
brought Telemachus and all his companions from Pylos;
and they, when they had come into the deep harbour,
drew the black ship up on the shore, [...]

Od. 16.321-5

Following their disembarkment, they immediately sent word to
Penelope by messenger, that Telemachus was back, while Eumaeus,
the swineherd, was already there to bring the good tidings to his mis-
tress. The suitors in Odysseus' palace, dismayed by the news of Tele-
machus' return, exited the hall, walked past the great wall of the court,
while considering whether to send another ship to bid their compan-
ions to return, as Eurymachus was advising them, when Amphinomus
saw her arriving (Od. 16.351-57).

οὔ πω πᾶν εἴρηϑ', ὅτ' ἄρ' Ἀμφίνομος ἴδε νῆα,
στρεφϑεὶς ἐκ χώρης, λιμένος πολυβενϑέος ἐντός,
ἱστία τε στέλλοντας ἐρετμά τε χερσὶν ἔχοντας.
ἡδὺ δ' ἄρ ἐκγελάσας μετεφώνεεν οἷς ἑτάροισι·
«μή τιν' ἔτ' ἀγγελίην ὀτρύνομεν· οἵδε γὰρ ἔνδον.
ἤ τίς σφιν τόδ' ἔειπε ϑεῶν, ἤ εἴσιδον αὐτοὶ
νῆα παρερχομένην, τὴν δ' οὐκ ἐδύναντο κιχῆναι.»

π 351-7

Not yet was the word fully uttered when Amphinomus saw a ship,
turning in his place, in the deep harbour,
and men furling the sail, and with oars in their hands.
Then breaking into a merry laugh, he spoke among his comrades:
«Let us not be sending a message anymore, for here they are at
home.
Either some god told them of this, or they themselves caught sight
of the ship of Telemachus as she sailed by, but could not catch
her.»

Od. 16.351-7

Greece

0523

EDITERRANEAN RAPHICS

The reference regarding the arrival of the ships was made so as to give the reader the opportunity to visualise the course they took and the events that took place, as the poet intended them. It should be remembered that the suitors had lookouts posted at the entrance of the Livadi gulf, where the port of Ithaca is situated, at the mouth of which the Vardiani island and the isthmus are located. This is the reason why Telemachus was forced to land at the Phorcys harbour, go to Eumaeus' swinesty and send his ship to Ithaca without being on board himself.

ἤματα μὲν σκοποὶ ἷζον ἐπ' ἄκριας ἠνεμοέσσας
αἰὲν ἐπασσύτεροι· ἅμα δ' ἠελίῳ καταδύντι
οὔ ποτ' ἐπ' ἠπείρου νύκτ' ἄσαμεν, ἀλλ' ἐνὶ πόντῳ
νηὶ θοῇ πλείοντες ἐμίμνομεν Ἠῶ δῖαν,
Τηλέμαχον λοχόωντες, ἵνα φθίσωμεν ἑλόντες
αὐτόν· [...]

 π 365-70

Day by day watchmen sat upon the windy heights,
watch constantly following watch, and at set of sun
we never spent a night upon the shore, but sailing out at sea
in our swift ship we waited for the bright Dawn,
lying in wait for Telemachus, that we might take him and slay
the man himself;[...]

 Od. 16.364-70

5. Asteris and Descálio or Dascalió

The Asteris question has been a bone of contention between scholars in the past, as it still is today. No convincing answer has been given so far, nor has it been possible to define its true location. The result of this controversy is that, its location being uncertain, the route which Telemachus followed during his return trip from Pylos is also uncertain. The strait where Asteris ostensibly lay, keeps changing position, depending on the different needs of each researcher. This continuous 'shuffling' of the Homeric facts, contributed also to the current confu-

sion concerning the names of Ithaca and Samos, thus, making the problem even more difficult to solve. The lack of a two entry port on the Asteris (or Daskalio today) islet, as the poet specifies, has been the main reason why it is not accepted as being the one mentioned by Homer. It is apparent that the corresponding Homeric verse was not studied and interpreted with sufficient care, and this particular detail has caused the entire structure of the Odyssey to be disputed.

ἔστι δέ τις νῆσος μέσση ἁλὶ πετρίεσσα,
μεσσηγὺς Ἰθάκης τε Σάμοιό τε παιπαλοέσσης,
Ἀστερίς, οὐ μεγάλη· λιμένες[16] δ' ἔνι[17] ναύλοχοι αὐτῇ
ἀμφίδυμοι· τῇ τόν γε μένον λοχόωντες Ἀχαιοί.

δ 844-7

There is a rocky isle in the mist of the sea,
midway between Ithaca and rugged Samos,
Asteris, of no great size, but in it is a harbour where ships may lie,
with an entrance on either side; There, in ambush, the Achaeans
waited for him.

Od. 4.844-7

Today's Asteris or Dascalio is a narrow rocky islet some 200 meters long, possessing no two entry harbours. The poet's description nevertheless proves, once again, to be accurate. This becomes clear upon close examination of the verse in question and an analysis of the terms used. The term λιμένες 'liménes' (harbours) combined with ἔνι 'éni' (among them), and ἀμφίδυμοι 'amphídymoe' (double), denotes the existence of two harbours related to the rocky islet Asteris, not necessarily located on it but rather that the isle is 'among them', or present

16. Contrary to the Murray translation which renders the word as harbour (in the singular), the Homeric text indicates the plural. Thus the text refers to two harbours, and this is confirmed by the use of the epithet amphidymoe, also in the plural. Trans.note.

17. ἔνι: See glossary for definition.

among them. In this case, therefore, the isle lies between the harbours, facing them. This interpretation resolves a controversy that sustained continued 'Homeric battles' for centuries. The term, taken in the sense intended, places the 'amphídymoe' (double) harbours affording safe anchorage, not in the rocky islet itself but across it in the Cephallenian coast. Two safe anchorage harbours are indeed located there, the Paliokaravo cove on the north side, and the Douliha or Kamini cove on the south side of the rocky islet. The poet, therefore, did not mean that these harbours were part of the topographical morphology of the islet itself but rather that the harbours had openings or entrances on either side of it. The Asteris islet was, then, used by the poet to define the location, the co-ordinates, so to speak, of the two harbours offering safe anchorage, inside which the suitors were lying in wait in order to apprehend and kill Telemachus. «There in ambush the Achaeans waited for him» (Od. 4.847).

On the northeastern coast of Cephallenia, the side that is lying inside the strait of Ithaca, from Fiscardo to the southernmost edge of it, at the Agriosyko promontory near the Agia Eufimia bay, many inlets are found. Immediately to the south of Asteris the Kokogylos or Sikidi inlet is found, followed by the inlets Xylokaravo, Agios Gerassimos, Kalo Limani, Platy Limani, Agios Panteleimon, Sarakiniko and finally the Yiagana inlet, near the Agriosyko promontory. If to these nine inlets, those lying near Asteris, that is Douliha and Paliokaravo are added, and also Foki and Fiscardo lying to the north of Asteris, one ends up with thirteen coves, out of which the suitors could organise their operation of exterminating Telemachus as he sailed by in his ship. These coves have been charted by the 'Hydrographic Service of the Hellenic Navy' and are mentioned in the Service's publication PLOEGOS Vol. A', page 127. Their actual number is over 15 if those not recorded are added.

The enumeration and description of all the coves and inlets along the entire length of the bay serves an obvious purpose. One should understand that Homer deemed it necessary to mention rocky Asteris, in order to define the exact position of the two harbours, lying opposite and on either side of it. At the same time, the strategic position of the isle located on the navigation route of any ship on its way to the

Fiscardo promontory is apparent. Telemachus' ship, had he taken this course, sailing between rocky Asteris and the coast of Cephallenia (Homeric Ithaca), was certain to pass by the double harbours, inside which the suitors lay at bay. Thus, the passage constituted a trap from which it would have been difficult to escape. For the reasons enumerated above, goddess Athena forewarned Telemachus of the ambush, advising him not to sail the strait (Od. 15.27-30). He finally set his course «far from the islands» (Od. 15.33) far that is from Homeric Samos (today's Ithaca). He reached the northern mouth of the bay while still night and advanced toward the nearest coast of Ithaca (Od. 15.36), the Phorcys harbour, where the swinesty of Eumaeus was located. Odysseus was already there, and they met for the first time.

The above analysis and the new conclusions are founded upon the astonishing discovery of the meaning of the word 'éni' (Od. 4.846) or 'to be among', which differentiates the double harbours from the islet Asteris. All Homeric text theoreticians have failed, thus far, to consider this point, placing the harbours on the islet Asteris.

As mentioned before, several islands lying in the general vicinity of the Ionian Sea have been proposed by various Homeric scholars as being Homeric Asteris. Some maintain that today's Daskalio is the one, while others advance the candidacy of various smaller or larger islands on the evidence that twin harbours are to be found there. These claims, however, are not based on convincing arguments. The evidence presented above is confirmed by the double name it carries today. These two names are, in fact, noted on maps published during the last two centuries. The official naval map of the British Admiralty indicates the name as being **Deskálio**. Another map drawn by Professor J. Partsch, British historian, in his work «Cephallenia and Ithaca, Geographical Monograph», records the name of the islet as **Daskálio** or Asterís[18]. The accent, in the English rendition of the name, is placed on the antepenult (third syllable from the end), giving the correct pronunciation of the word. Both renditions of the name Deskálio are similar,

18. See also «Report on the roads of Cephallenia», by E. Kosmetatos, 1991

with the exception that the first uses 'e' in the first component of the word, while the second uses 'a'. The word, in fact, is a compound, consisting of the Greek 'Di' or 'De' and the latin 'skálio', thus Di-skálio or De-skálio. The word was obviously latinised and was later repatriated in a corrupt form as Daskalió or, as some would have it, Daskaleió. The latter being an erroneous correction from 'e' to 'ei', which changes its meaning[19]. It is fortunate that the original spelling was preserved in its Latin rendition and thus the correct meaning was also preserved.

The composite name Da-skálio or De-skálio and in official (catharévousa) Greek Diskálion is analysed as follows: The first component 'Di' stands for 'Dis' (Δίς) an adverb meaning doubly, twice, with nouns. In compound words it is found as 'Di-' (Δί-), and forms nouns such as δίθυρος 'díthyros' - with double doors, δισύλλαβος 'disýllabos' or disyllabic, having two syllables, δίσκαλμος 'dískalmos', of having two toggles, or belaying pins, or oar-locks. The second compound, as can be clearly discerned from its spelling, is derived from 'skálion' meaning scale, stair, ladder. The Latin word 'scala', medieval and demotic, means ladder, particularly that of a ship (gangway, gangplank). In Greek use it also means port, coastal landing-stage, a stretch of the coast suitable for landing, i.e., Peiraeus, the port of Athens, also the ports of call between the port of departure and that of arrival.

It is obvious, that Daskalió, the name by which the Diskálion islet is known today, means that it has two 'scales'. The two-scale island or the double harbour island, providing secure anchorage. Corruption has changed the name to Daskalió. Thus, the double harbours (amphídyma) of Asteris became, with time, two scaled harbours or Diskálion or Daskalió. Two names, as seen, are associated with this small islet, while it is connected to two harbours, both in Homeric times and in the present. That it is so should not appear surprising. People, throughout the ages, could only thus describe the harbours that lie across from the

19. Daskaleió in demotic Greek means teaching institution or school. Trans. note

islet. A case in point is the northwestern promontory of Atheras. The name of the promontory is Lithari or Kakata, a name deriving from a comparatively small rock 'lithári', that lies right in front of it. A not very large rock, lying in the sea, is the characteristic that determines the name of an extensive in length promontory. The double harbours lent their descriptive adjective to tiny, rocky Asteris. Perhaps, the living language retains this name so that by its musical harmony, the agonies and memories of Homeric Asteris are preserved in the conscience of inhabitants and travellers, now and in the future. Asteris will be standing where it lies, as a memorial to the beauty of the Homeric verse, and to the love of goddess Athena for young Telemachus who, with his sharp Cephallenian mind proves, as the popular proverb has it, that «the brave young man knows of alternative paths».

CHAPTER FOUR

ODYSSEUS REACHES LONGED-FOR ITHACA

O DYSSEUS, the man of many devices, arrived at the island of the Phaeacians on the thirty second day of *The Odyssey*. It took twenty days for him to reach the land of the Phaeacians since the day of his departure from the island of Calypso, having fought during this time the elements and having visited Hades, the underworld.

1. Corcyra, the Enchanting Scheria of the Phaeacians

No answer has been given or at least no conclusive evidence has been provided to this day regarding the identification of the island of the Phaeacians. This analysis is undertaken in order to give a definite answer and prove positively that Corcyra and Scheria are one and the same.

> οἰκέομεν δ' ἀπάνευθε πολυκλύστῳ ἐνὶ πόντῳ,
> ἔσχατοι, οὐδέ τις ἄμμι βροτῶν ἐπιμίγεται ἄλλος.
>
> ζ 204-5

Far off we dwell in the surging sea,
the farthermost of men, and no other mortals have dealings with us.
Od. 6.204-5

We inhabit (we live) away, apart from other people, in the sea with many waves that surround us, ἐνὶ 'éni', farthermost (the last from the other islands), that do not communicate and deal with us, ἄμμι 'ámmi', the local inhabitants, βροτοί 'vrotoí'. Many mortals, βροτοί or θνητοί 'vrotoí' or 'thnetoí' who bear no evil intentions arrive, ἵκεται 'íketai', in the land of the Phaeacians. As Nausicaa states «There is no man so slippery, nor will there be one, as to come to the land of the Phaeacians bringing hostility, for we are very dear to the immortals» (Od. 6.200-

3). The view, maintained by some at one time or another, that the poet does not specify whether Scheria, the land of the Phaeacians, is an island surrounded by the sea or a continental land, is refuted by the above verses (Od. 6.204-5). The term ἐνί πόντῳ 'éni pónto', in the sea, confirms that Corcyra is, in fact, the fair island of the Phaeacians. Furthermore, the characterisation ἔσχατοι 'éschatoi', or farthermost of men (Od. 6.205), suggests that the island of the Phaeacians is the last one among other islands, lying far off, ἀπάνευθε 'apáneuthe', and in, ἐνί 'éni', the surging, πολυκλύστῳ 'polyclýsto', sea (Od. 6.204). The surging sea is also referred to as barren, ἀτρυγέτοιο 'atrygétoio', meaning that one cannot fish in it due to its great depth. The word is found in the description of the coast near the palace of King Alcinous «ἐπί θῖν' ἀλλός ἀτρυγέτοιο», to the shore of the barren sea (Od. 8.49). The poet uses the same term when he speaks of the sea at Phorcys, the one who rules over the barren sea (Od. 1.72), meaning the sea in Homeric Ithaca's vicinity.

As mentioned previously, the Phaeacian ship that conveyed Odysseus to the windless harbour of Phorcys (Atheras), followed a steady course in the direction of the rising Venus (southeast of Corfu). This fact, in conjunction with the appearance of the morning star (Venus) at the time of the ship's arrival and the duration of the voyage, indicates clearly a coincidence of the relative positions of Scheria and Homeric Ithaca with that of today's Corcyra (Corfu) and the north-western side of Cephallenia. The Homeric descriptions of the land of King Alcinous, son of Nausithous and Arete of the Phaeacians are exquisite. «For as the Phaeacian men above all others are skilled in speeding a swift ship upon the sea, so are the women cunning workers at the loom; for Athene has given to them above all others knowledge of beautiful handiwork, and excellent character» (Od. 7.108-11). And the poet continues his praise of the land of the Phaeacians, land of Corcyrians, thus:

«In it grow trees tall and luxuriant, pears and pomegranates and apple trees with their bright fruit, and sweet figs, and luxuriant olives. The fruit of these neither perishes nor fails in winter or summer, but lasts throughout the year; and continually the West Wind, as it blows, quickens to life some fruits, and ripens others; pear upon pear waxes

ripe, apple upon apple, grape bunch upon grape bunch, and fig upon fig. There, too, is his fruitful vineyard planted, one part of which, a warm spot on level ground, is for drying in the sun, while the other grapes men are gathering, and others, too, they are treading; but in front are unripe grapes that are shedding the blossom, and others that are turning purple. There again, by the last row of the vines, grow trim garden beds of every sort, blooming the year through, and in the orchard are two springs, one of which sends its water throughout all the garden, while the other, opposite to it, flows beneath the threshold of the court toward the high house; from this the townsfolk draw their water. Such were the glorious gifts of the gods at the dwelling of Alcinous» (Od. 7.114-32).

Innumerable slender daffodils, daisies, camomiles, freshly sprung grass, like sunfired brush strokes, scented the air of Corcyra, where the Phaeacians lived, the singers, the minstrels, who knew well the art of the sea, as Homer tells it, but of music as well. Such splendid gifts did the gods give to the house of Alcinous. Noble, much-enduring Odysseus, was standing there beholding all this. Sacred voices engulfed the seashores and the moonlit night's sweet air. Tender longings were kindled in the heart of the beholder of the divine landscape, urging him to stay there forever. Unending longings in innumerable green pastures, in meadows full of blooming anemones and violets, scented the spring dew, welcoming and honouring the hero returned, the wandering king of neighbouring Ithaca, who was first hosted by the Phaeacians, the nearest relatives of the gods. May the gods of the Phaeacians grant us the happiness of straddling, some day, the gates of the sacred palace, when its location is discovered. This will not be long in coming. The Ionian Islands continue, since ancient times to this day, to excel among Greeks in music and song. Corcyra, the nymph of the Ionian Sea, about which many songs have been sung, the land of Nausithous, of Alcinous and white-armed Queen Arete, of Nausicaa and the «divine minstrel, Demodorus; for him above all others has the god granted skill in song, to give delight» (Od. 9.43-5). Ithaca with her own minstrel Phemius (Od. 22.330-1); contemporary Zachynthus with her sweet-voiced inhabitants.

Odysseus stayed with the Phaeacians four days, at the end of which, after a sumptuous dinner, they bade him farewell. They honoured him highly, offered him many gifts and rigged a ship with fifty two oarsmen (Od. 8.34-7) sailing for the first time to take him home.

ἀλλ᾽ ἄγε νῆα μέλαιναν ἐρύσσομεν εἰς ἅλα δῖαν
πρωτόπλοον, κούρω δὲ δύω καὶ πεντήκοντα
κρινάσθων κατὰ δῆμον, ὅσοι πάρος εἰσὶν ἄριστοι.
ϑ 34-6

No, come, let us draw a black ship down to the bright sea
for her first voyage, and two and fifty youths
let men choose from the people, all who before were the best.
Od. 8.34-6

They then brought the ship down to the sea, they raised the mast and sail.

αὐτὰρ ἐπεί ῥ᾽ ἐπὶ νῆα κατήλυθον ἠδὲ θάλασσαν,
νῆα μὲν οἵ γε μέλαιναν ἁλὸς βένθοσδε ἔρυσσαν,
ἐν δ᾽ ἱστόν τ᾽ ἐτίθεντο καὶ ἱστία νηὶ μελαίνῃ,
ἠρτύναντο δ᾽ ἐρετμὰ τροποῖς ἐν δερματίνοισι, [...]
ϑ 50-3

And when they had come down to the ship and the sea,
they drew the black ship down to the deep water,
and placed the mast and sail in the black ship,
and fitted the oars in the leather thole straps, [...]
Od. 8.50-3

On the thirty-fifth day, in late afternoon, at sun set, the Phaeacian ship set off and sailed swiftly over the sea «bearing a man wise as the gods are wise» (Od. 13.81-9):

ἡ δ᾽ ὥς τ᾽ ἐν πεδίῳ τετράοροι ἄρσενες ἵπποι,
πάντες ἅμ᾽ ὁρμηθέντες ὑπὸ πληγῆσιν ἱμάσθλης,

ὑψόσ' ἀειρόμενοι ῥίμφα πρήσσουσι κέλευθον,
ὣς ἄρα τῆς πρύμνη μὲν ἀείρετο, κῦμα δ' ὄπισθε
πορφύρεον μέγα θῦε πολυφλοίσβοιο θαλάσσης.
ἡ δὲ μάλ' ἀσφαλέως θέεν ἔμπεδον· οὐδέ κεν ἴρηξ
κίρκος ἁμαρτήσειεν, ἐλαφρότατος πετεηνῶν.
ὣς ἡ ῥίμφα θέουσα θαλάσσης κύματ' ἔταμνεν,
ἄνδρα φέρουσα θεοῖς ἐναλίγκια μήδ' ἔχοντα· [...]

ν 81-9

And as on a plain four yoked stallions spring forward
all together beneath the strokes of the lash,
and leaping high swiftly accomplish their way,
even so the stern of that ship leapt high, and in her wake
the gleaming wave of the loud-sounding sea foamed mightily,
and she sped safely and surely on her way; not even the hawk
circling, the swiftest of winged things, could keep pace with her.
Thus she sped on swiftly and cut through the waves of the sea,
bearing a man wise as the gods are wise, [...]

Od. 13.81-9

The above verses give a full picture of the voyage. Fifty-two of the best Phaeacian oarsmen were pulling hard at the oars. The ship was travelling fast, and according to the above description, one could say that she was travelling with a speed comparable to that of modern fast sailboats.

On a spring day around April or May, Persephone, Demeter's daughter, rose once again from Hades to prepare nature to receive the immortal hero, the castle conqueror, the equal to Zeus in wisdom, long suffering Odysseus, King of Ithaca. Peace reigned in the fair harbour; everything was blooming, nature in her Sunday best, the birds filling the air with their sweet warble, to welcome the greatest man of all time, there on the edge of the land of the Cephallenians, at the port of the old man of the sea. In the spring, in these parts, the sun rises sending his golden rays through the blue sky to the earth, at about 5:30 a.m. and sets at about 7:30 p.m. The night lasts approximately ten hours, while the distance travelled by a sailboat moving at an average speed

of ten knots, is about 100 nautical miles, which is the distance between
the island of Corcyra and Atheras. This simple calculation, being the
usual way of measuring distances in such cases, confirms that the ship
that carried Odysseus, travelling through the night, started from Corcyra,
the island of the Phaeacians, that is from Homeric Scheria. The ship
sailed through the night, and reached its destination toward dawn:

εὖτ' ἀστὴρ ὑπερέσχε φαάντατος, ὅς τε μάλιστα
ἔρχεται ἀγγέλων φάος Ἠοῦς ἠριγενείης,
τῆμος δὴ νήσῳ προσεπίλνατο ποντοπόρος νηῦς.
Φόρκυνος δέ τίς ἔστι λιμήν, ἁλίοιο γέροντος,
ἐν δήμῳ Ἰθάκης· δύο δὲ προβλῆτες ἐν αὐτῷ
ἀκταὶ ἀπορρῶγες, λιμένος ποτιπεπτηυῖαι,
αἵ τ' ἀνέμων σκεπόωσι δυσαήων μέγα κῦμα
ἔκτοθεν· ἔντοσθεν δέ τ' ἄνευ δεσμοῖο μένουσι
νῆες ἐυσσελμοι, ὅτ' ἂν ὅρμου μέτρον ἵκωνται.

 ν 93-101

Now when that brightest of stars rose which beyond others
comes to herald the light of early Dawn,
then it was that the seafaring ship drew near to the island.
There is a certain harbour of Phorcys, the old man of the sea,
in the land[1] of Ithaca; and two projecting headlands are at its
mouth,
sheer to seaward, but sloping down on the side towards the har-
bour.
These keep back the great waves raised by heavy winds
outside; but inside lie unmoored
the benched ships when they have reached the point of anchorage.

 Od. 13.93-101

1. The verse states ἐν δήμῳ Ἰθάκης or in the Ithaca démos, or municipality. The
 Murray translation renders it as land of Ithaca. Trans. note.

At any rate, what is certain from the above, concerning the departure and arrival of the ship from the Phaeacian island to Ithaca, is that the voyage, from sun-set to dawn, was of a duration of about ten to twelve hours. One night's sailing was enough to reach their destination.

[...] ἀτραπιτοί τε διηνεκέες λιμένες τε πάνορμοι
πέτραι τ' ἠλίβατοι καὶ δένδρεα τηλεθόωντα.
 ν 195-6

[...] the long paths, the bays offering safe anchorage
the sheer cliffs, and the luxuriant trees.
 Od. 13.195-6

2. The Orbit of Venus, a Compass to Homeric Ithaca

In the first 100 verses of the 13th (ν) rhapsody of *The Odyssey*, Homer describes the preparations for Odysseus' departure from the island of Scheria, his farewell to King Alcinous and Queen Arete, his boarding the ship that was to convey him on his trip, the nocturnal voyage and his arrival at his longed-for Ithaca. The verses describing the departure of the Phaeacian ship from the island of Scheria were examined closely, in an effort to determine the direction in which she sailed, whether according to the stars or the wind. No concrete fact is given, however, that would assist in determining the geographical co-ordinates and the direction taken by the departing ship. The poet, nevertheless, provides two references as to the ship's route as she set-off from the island of the Phaeacians. First, the ship's destination, being the harbour of Phorcys and, second, the exact time of the ship's arrival at Phorcys, coinciding with the coming of dawn and the rising of Venus, the morning star.

εὖτ' ἀστὴρ ὑπερέσχε φαάντατος, ὅς τε μάλιστα
ἔρχεται ἀγγέλλων φάος Ἠοῦς ἠριγενείης,
τῆμος δὴ νήσῳ προσεπίλνατο ποντοπόρος νηῦς.
 ν 93-5

Now when the brightest of stars rose which beyond others
comes to herald the light of early Dawn,
then it was that the seafaring ship drew near to the island.
<div align="center">Od. 13.93-5</div>

Homer, in the above three verses, gives the exact position of the ship in relation to the harbour of Phorcys, by stating that the morning star rose over, *ὑπερέσχε*, the prow of the ship. This is, in reality, the only bit of information given, other than that the ship was plowing the purple, *πορφύρεα* 'porphýrea' waves, which indicates that the light of the setting sun reflecting from the violet-coloured sky onto the sea surface gave it a purple colouring. The ship's course was, therefore, westward. Since, however, the point of the ship's departure is unknown, one should attempt to locate, at least, the point of arrival. Assuming that this point was in fact the harbour of Atheras, lying between the Atheras and Lithari promontories, one should try to locate the exact point where Venus appears over the horizon when viewed from the Atheras promontory. In this case, Venus rises over the top of the mountain on the slopes of which the village of Agonas is built, in a south-south-western direction. A line drawn from the point of the rising star through Atheras and extended in a north-northwestern direction will reach the western side of Corcyra (Corfu). Accepting then the proposition that the ship carrying Odysseus was already near the Atheras promontory and was about to enter the Phorcys harbour, one would find that the morning star was straight over its course. Therefore, the ship reached the Atheras promontory having set a direct course from her point of departure. This is confirmed by the following verse:

<div align="center">*[...] ἡ δὲ μάλ' ἀσφαλέως θέεν ἔμπεδον· [...]*
ν 86</div>

<div align="center">*[...] and she sped safely and surely on her way; [...]*
Od. 13.86</div>

A ship's captain sets his route, making all necessary adjustments, then instructs his helmsman on the course to be followed. The latter,

unless otherwise instructed, keeps that course steadily to the end of the voyage. This is what Homer expresses by ϑέεν ἔμπεδον or «speed on her way steadily.» The ship sailed as soon as they loosened the ropes and swiftly, cutting through the waves, set her course toward Ithaca, keeping a steady run, unchanging, continuous and without interruptions. A run through the night, speedy and steady that led her at dawn to the Atheras headland at the time Venus, the morning star, was rising. The notional line running from the ship approaching the Atheras harbour to the rising Venus, also establishes the position of the harbour and, by extending it, the point whence the ship set off. Phorcys, the old man of the sea, is the key provided by *The Odyssey* with which to unlock the unknown, to this day, location of Ithaca. Examining the position of the ship when sailing from Ithaca to Scheria on her way home, it is noted that, according to the poet, she was sailing up the misty sea.

[...] ἐκ πομπῆς ἀνιοῦσαν², ἐν ἠεροειδέι πόντῳ [...]
ν 150

[...] as she comes back2 from her convoy on the misty deep, [...]
Od. 13.150

The word ἀνιοῦσαν 'anioúsan' is the feminine participle of ἀνιών, 'anión', deriving from the verb ἄνειμι, 'áneimi', meaning moving in an upward direction. In today's vernacular one would say that «the ship sailed up to Corfu», that is from Cephallenia northward to Corcyra. She came, therefore, "down" from the upper part of the Ionian Sea and sailed "up" the sea on her return trip. In other words from today's Cephallenia, where she was, she sailed up towards Corcyra (Corfu), which is the only island in the northern Ionian sea. In fact, if one considers the orientation of the Atheras harbour, one will note that the mouth of the bay points directly to Corcyra on a straight line. The Phorcys harbour was well known to shipmasters of the day, not only because it lay on a frequented ship route but also because of its seismic nature.

2. The text specifies ἀνιοῦσαν, sailing up. The Murray translation renders the term as comes back. Trans. note.

ἔνϑ' οἵ εἰσέλασαν, πρὶν εἰδότες· [...]

ν 112

Here they rowed in, knowing the place of old; [...]

Od. 13.112

The above underline Phorcys' importance both as a natural phe-
nomenon observed and evaluated since before Homer's time but also
because it establishes the coordinates Morning Star – Phorcys – Phaea-
cian Ship – Scheria. The official chart of the irregular appearances of
Venus on the horizon prepared by the Athens observatory is presented
below, from which one may note the exact time of appearance of the
bright star that announces the coming of dawn. The critical time of
interest concerning the return of Odysseus to Ithaca, is the second fort-
night of April when the oak (holm oak) is in bloom as the poet states.
A computer programme is under way, designed to establish the exact
time of Venus' appearances following the Trojan events, so that in con-
junction with other measurements, sufficient data may be gathered
which will make possible the determination of the exact year of
Odysseus' return to Ithaca. The plan is ambitious, the hopes are great.
The table is shown below.

TABLE OF PERIODIC APPEARANCES OF THE PLANET 'VENUS'

YEAR A.D.	RISE				SET			
	APRIL 14		MAY 14		APRIL 14		MAY 14	
	VENUS	SUN	VENUS	SUN	VENUS	SUN	VENUS	SUN
1985	4:39		3:25		17:32		16:00	
1986	6:49		6:53		20:47		21:47	
1987	4:34		4:09		16:13		17:09	
1988	7:52	5:49	7:15	5:16	22:58	19:00	22:33	19:27
1989	6:02		5:51		19:14		20:18	
1990	3:58		3:31		15:15		15:55	
1991	7:37		7:52		22:15		22:58	
1992	5:18		4:57		17:40		18:41	
1993	4:33	5:49	3:24	5:16	17:17	19:02	15:55	19:27
1994	6:51	5:52	6:56	5:16	20:50	19:00	21:50	19:27
1995	4:35		4:10		16:16		17:12	
1996	7:50		7:09		22:57		22:26	

3. Odysseus' Arrival at the Phorcys Harbour

Odysseus, then, arrived at the Phorcys harbour, the port of the old man of the sea, the only windless (Od. 13.99) fair harbour of Ithaca offering safe anchorage (Od. 13.195). Telemachus, Odysseus' son, arrived at the same port returning from Pylos. Goddess Athena had directed him to land on the nearest (first) coast of Ithaca (Od. 15.36) and go directly to the hut of the faithful swineherd Eumaeus. Father and son met there for the first time in twenty years. This, then, is the ἐσχατιῇ 'eschatié', (Od. 14.104), the farthest lying point of Ithaca, where Odysseus found himself, following his twenty years of wandering around the world. The port of Atheras, the last promontory of the land of the Hellenes, the land of the Cephallenians (Il. 2.631) where Odysseus reigned who in wisdom was equal to Zeus (Il. 2.636).

The Phaeacian ship, travelling through the night, reached the Atheras promontory in northwestern Cephallenia, and at this point, sailing in the dark sea, straight ahead of the prow, the first star, the morning star (Venus), the star that announces Dawn, appeared over the mountain rising above the Agona village. The two headlands, the Atheras or Exo Koukouli promontory and the Kakata or Katergaki or Lithari promontory, are to be found there. The two headlands do indeed slope down on the side, ποτιπεπτηυῖαι 'potipepteyíae', toward the harbour (Od. 13.98) offering thus complete protection from the tempestuous sea. The Phaeacian ship sailed between the two headlands and toward the beautiful sandy beach boarded by clear blue waters. And the oarsmen pulling hard on their oars beached the ship on the fine sand, then lifted Odysseus, as he was sleeping on the ship's prow, with his mattress and fine sheet and laid him on the sand. They then picked the gifts and deposited them under an olive tree near by, so that he could find them when he would awake and not lose them to some passing thief (Illus. 8,9).

αὐτὰρ ἐπὶ κρατὸς λιμένος τανύφυλλος ἐλαίη,
ἀγχόθι δ' αὐτῆς ἄντρον ἐπήρατον ἠεροειδές,
ἱρὸν νυμφάων αἳ νηιάδες καλέονται.
ἐν δὲ κρητῆρές τε καὶ ἀμφιφορῆες ἔασιν

λάινοι· ἔνθα δ' ἔπειτα τιθαιβώσσουσι μέλισσαι.
ἐν δ' ἱστοὶ λίθεοι περιμήκεες, ἔνθα τε νύμφαι
φάρε' ὑφαίνουσιν ἁλιπόρφυρα, θαῦμα ἰδέσθαι·
ἐν δ' ὕδατ' ἀενάοντα. δύω δέ τέ οἱ θύραι εἰσίν,
αἱ μὲν πρὸς Βορέαο καταβαταὶ ἀνθρώποισιν,
αἱ δ' αὖ πρὸς Νότου εἰσὶ θεώτεραι· οὐδέ τι κείνῃ
ἄνδρες ἐσέρχονται, ἀλλ' ἀθανάτων ὁδός ἐστιν.
 ν 102-12

καὶ τὰ μὲν οὖν παρὰ πυθμέν' ἐλαίης ἀθρόα θῆκαν
ἐκτὸς ὁδοῦ, μή πώς τις ὁδιτάων ἀνθρώπων,
πρίν γ' Ὀδυσῆ ἔγρεσθαι, ἐπελθὼν δηλήσαιτο· [...]
 ν 122-4

At the head of the harbour is a long-leafed olive tree,
and near it is a pleasant, shadowy cave
sacred to the nymphs that are called Naiads.
In it are mixing bowls and jars
of stone, and there too the bees store honey.
And in the cave are long looms of stone, at which the nymphs
weave purple webs, a wonder to behold;
and in it are also ever-flowing springs. Two doors there are to
the cave,
one toward the North Wind, by which men go down,
but that toward the South Wind is sacred, and men do not
enter by it; it is the way of the immortals.
 Od. 13.102-12

These they set all together by the trunk of the olive tree,
out of the path, for fear perchance some wayfarer,
before Odysseus awoke, might come upon them and make spoil
of them;[...]
 Od. 13.122-4

A glance at the map of Cephallenia is sufficient to convince one that
the only other harbour in Cephallenia, excepting the deep bay of Liva-

di, is that of Atheras. A ship finding herself in a severe storm, in the open sea across from Cephallenia, should hasten to take shelter at the Atheras port, Atheras being the only haven available from the Eryssos headland all the way to Gero Gombo, which is from the northwest to the southeast end of the island. At the little chapel of Agios Spyridon and in a monk's cell near by, the fishermen of old, having escaped the storm, would light a fire using old nets and broken up planks that the sea cast ashore, to dry their wet cloths. Many have escaped with their lives at this refuge, without knowing that at that exact spot, on the edge of the beach, the hero Odysseus had once landed.

4. The Sacred Olive Tree and the Road to the Grotto

αὐτὰρ ἐπὶ κρατὸς λιμένος τανύφυλλος ἐλαίη,
ἀγχόθι δ' αὐτῆς ἄντρον ἐπήρατον ἠεροειδές, [...]
ν 102-3

At the head of the harbour is a long-leafed olive tree,
and near it is a pleasant, shadowy cave [...]
Od. 13.102-3

The ship was lying on the beach. Ten meters away there was an olive tree. Some fifty meters from the beach, toward Agios Spyridon, the cave is found, the famous Grotto of the Nymphs of Ithaca. A short wall starts from the grotto, follows the beach, just over the pebbles, passes by the olive tree, and continues in a southerly direction toward the point where it starts climbing toward the short hills on the way to the Atheras village. Impressions that time left intact, lead us toward a truth that some thought and others believed that it was all a myth. The olive tree! It is unbelievable, but it still stands there to this day[3]. (Illus. 10) Is it possible that, after so many aeons, an olive tree may constitute

3. An olive tree of great age in fact, perhaps centuries old. Trans. note.

proof regarding such an earth-shaking discovery? Yes, indeed. An olive tree, by itself, the only one along the entire length of the coast, besides the road (Od. 13.123) and «long-leafed» (Od. 13.102).

The word κρατός 'kratós', deriving from κράς 'kras', according to the Lidell and Scott Lexicon means, in the case of harbours, the head or the far end of the bay. (See also Od. 9.140). This is exactly the point! The olive tree in the harbour of Atheras is found on the edge of the beach that is the innermost part, the back of the bay. The olive tree that we find today in the harbour, as we motor down to the sand beach, is growing on the inner part of the road and, as stated above, it stands alone on the edge of the harbour. The stones, that support the road that passes by the foot of the olive tree, and continues toward the edge of the beach, is nothing but a breakwater over the sea that has been standing there for thousands of years (Illus. 10). Archaeologists who have examined this retaining wall have expressed the opinion that it was built according to the well-known Mycenaean manner and is of proto-Helladic character. There is no other structure such as this wall in the vicinity of this beach, along the entire length of the Atheras harbour. We would venture to say that this section of the wall, passing in front of the olive tree and leading to the entrance of the grotto leads, on the other end, uphill toward Eumaeus' cabin.

The grotto, the poet states, was sacred to the Nymphs.

> *[...] ἀγχόϑι δ' αὐτῆς ἄντρον ἐπήρατον ἠεροειδές,*
> *ἱρὸν νυμφάων αἵ νηιάδες καλέονται.*
>
> v 103-4 & v 347-8

> *[...] and near it is a pleasant, shadowy cave*
> *sacred to the nymphs that are called Naiads.*
>
> Od. 13.103-4 & 13.347-8

It has, quite rightly, been stated that there is no antecedent of a god or a goddess serving a mortal, as Athena does with Odysseus, when the two of them carry his gifts to hide them in the cave.

ἀλλὰ χρήματα μὲν μυχῷ ἄντρου θεσπεσίοιο
θείμεν αὐτίκα νῦν, ἵνα περ τάδε τοι σόα μίμνῃ· [...]
ν 363-4

But let us your goods, in the innermost recess of the sacred cave,
set them at once now, where they may remain for you in safety,
[...]
Od. 13.363-4

ὣς εἰποῦσα θεὰ δῦναι σπέος ἠεροειδές,
μαιομένη κευθμῶνας ἀνὰ σπέος· αὐτὰρ Ὀδυσσεὺς
ἆσσον πάντ᾽ ἐφόρει, χρυσὸν καὶ ἀτειρέα χαλκὸν
εἵματά τ᾽ εὐποίητα, τά οἱ Φαίηκες ἔδωκαν.
καὶ τὰ μὲν εὖ κατέθηκε, λίθον δ᾽ ἐπέθηκε θύρῃσι
Παλλὰς Ἀθηναίη, κούρη Διὸς αἰγιόχοιο.
ν 366-71

So saying, the goddess entered the shadowy cave
and searched out its hiding places. And Odysseus
brought all the treasure inside, the gold and tough bronze
and the finely wrought clothing, which the Phaeacians had given
him.
These things he carefully laid away, and a stone was set at the
door,
by Pallas Athena, daughter of Zeus, who bears the aegis.
Od. 13.366-71

Again,

τὼ δὲ καθεζομένω ἱερῆς παρὰ πυθμέν᾽ ἐλαίης
φραζέσθην μνηστῆρσιν ὑπερφιάλοισιν ὄλεθρον.
ν 372-3

Then the two sat them down by the trunk of the sacred olive tree,
and devised death for the insolent suitors.
Od. 13.372-3

And again,

> [...] τοῦτο δέ τοι σπέος ἐστί⁴ κατηρεφές, ἔνθα σὺ πολλὰς
> ἔρδεσκες νύμφῃσι τεληέσσας ἑκατόμβας· [...]
>
> ν 349-50

> [...] This, you may be sure, is the vaulted cave in which, you many
> perfect hecatombs, used to offer to the Nymphs; [...]
>
> Od. 13.349-50

The above excerpts of *The Odyssey*, related to the visits and cere-
monies performed by Odysseus in the sacred Nymphaeum of Ithaca
are presented here, so that the reader may become familiar with the
place, the reverence in which the King of Ithaca held the gods and his
attention to ceremonies and religious rites. Odysseus' devotion to the
gods is well attested by Homer when he has Zeus address Athena in
these words:

> [...] «τέκνον ἐμόν, ποῖόν σε ἔπος φύγεν ἔρκος ὀδόντων.
> πῶς ἂν ἔπειτ᾽ Ὀδυσῆος ἐγὼ θείοιο λαθοίμην,
> ὃς περὶ μὲν νόον ἐστὶ βροτῶν, περὶ δ᾽ ἱρὰ θεοῖσιν
> ἀθανάτοισιν ἔδωκε, τοὶ οὐρανὸν εὐρὺν ἔχουσιν;
>
> α 64-7

> «My child, what word has escaped the barrier of your teeth?
> How should I, then, forget godlike Odysseus,
> who is beyond all mortals in wisdom, and beyond all sacrifice
> has paid to the immortal gods, who hold broad heaven?
>
> Od. 1.64-7

The above references would be sufficient evidence to support the
conclusion that this wall, leading to the cave, was appropriately built
where it is, since it was constructed with the purpose of developing an
area of worship, possibly a road used for regal processions.

4. ἐστί: εὐρὺ. Loeb note.

One wonders what reader would not feel the need to find himself there, at the enchanting beach of the harbour, sit at the foot of the sacred olive tree and, travelling backward in time, reminisce about the greatness and glory of Odysseus. Millions of people, through the ages, have sought this joy but did not find it, since Ithaca was lost! Fortunate are those, however, who find themselves at the peaceful but imposing landscape of the Phorcys harbour. Without doubt, no other person in the world was loved as Odysseus was. Homer, through Odysseus, taught humanity the power of hope, through his belief that his return to Ithaca would become reality.

5. The Grotto of the Nymphs

ἔν τε τῇ Ἰθάκῃ οὐδέν ἐστιν ἄντρον τοιοῦτον, οὐδὲ Νυμφαῖον, οἷόν φησιν Ὅμηρος· βέλτιον δὲ αἰτιᾶσθαι μεταβολὴν ἢ ἄγνοιαν ἢ κατά- ψευσιν τῶν τόπων κατὰ τὸ μυθῶδες. τοῦτο μὲν δὴ ἀσαφὲς ὂν ἐῶ ἐν κοινῷ σκοπεῖν.

Στράβων Α-γ-18 (C60)

Further, in Ithaca there is no cave, neither grotto of the Nymphs, such as Homer describes; but it is better to ascribe the cause to physical change rather than to Homer's ignorance or to a false account of the places to suit the fabulous element in his poetry. Since the matter, however, is uncertain, I leave it to the public to investigate.

Strabo, 1.3.18 (C60)

Strabo did not succeed in locating the grotto of the Nymphs, because he visited an island other than true Ithaca, which was the same in Strabo's days as it is today. It was not the place he was seeking, since Cephallenia was Ithaca, and Homeric Samos today's Ithaca. This has been expounded in previous chapters. It will be strengthened, however, as more facts, correlation and proof are brought forth.

αὐτὰρ ἐπὶ κρατὸς λιμένος τανύφυλλος ἐλαίη,
ἀγχόθι δ᾿ αὐτῆς ἄντρον ἐπήρατον ἠεροειδές,
ἱρὸν νυμφάων αἳ νηιάδες καλέονται.

ν 102-4

At the head of the harbour is a long-leafed olive tree,
and near it is a pleasant, shadowy cave
sacred to the nymphs that are called Naiads.

Od. 13.102-4

Certain words used by the poet to describe the grotto of the Nymphs at the Phorcys harbour or today's Atheras are of assistance in locating the site. There is an olive tree (Od. 13.102) above the beach (Od. 13.102), in front of which (Od. 13.123) a cyclopean wall is found that runs toward the Atheras village, near which the pigsty of Eumaeus was located. This wall, on the opposite side, follows the water line and reaches the first opening of what is known locally as the 'Cave of Odysseus'. It is obvious that the wall was constructed to support the ground, thus forming a road (Od. 13.123). The poet uses the word 'road' ὁδὸν, and not 'path' ἀτραπόν, meaning that it was a constructed roadway used for travel purposes. The wall, leading directly from the olive tree to the cave, and the proximity of wall and cave, confirm the existence of all the elements synthesising the picture drawn by the Homeric description. The sandy beach, the olive tree, the road and the cave near by, are the elements of a broader landscape, that of the windless harbour of Atheras, corresponding to the finer points of the Homeric verses (Illus. 12).

[...] δύω δέ τέ οἱ θύραι εἰσίν,
αἱ μὲν πρὸς Βορέαο καταιβαταὶ ἀνθρώποισιν,
αἱ δ᾿ αὖ πρὸς Νότου εἰσὶ θεώτεραι· οὐδέ τι κείνη
ἄνδρες ἐσέρχονται, ἀλλ᾿ ἀθανάτων ὁδός ἐστιν.

ν 109-12

[...] Two doors there are to the cave,
one toward the North Wind, by which men go down,

but that toward the South Wind is sacred, and men do not
enter it; it is the way of the immortals.

Od. 13.109-12

It is noted here, that the poet speaks of two doors[5] toward the north
and two toward the south, meaning that there was one double entry
from one side and a double entry from the other. This is a matter of
some importance, given that the road from the olive tree to the water-
front of the Atheras harbour, some 50 to 100 meters away, leads to two
doors. That is, two places where cave entrances are formed, the entry
not being possible since cave-ins have blocked them. Thus, even
though from the outside the form of a cave entrance is outlined, entry
in it is impossible. The discovery that near, ἀγχόθι (Od. 13.103) the
olive tree two cave entrances ('apospílea' in the colloquial dialect) are
located, indicates that at some point in time they led to the interior of
a large cave. This corresponds precisely to Homer's description. These
entrances lead, it is certain, to a delightful, ἐπήρατον 'epératon' (Od.
13.103) grotto, because not only the landscape is lovely, but the posi-
tion of the entrance, facing north, would allow the sun's rays to fall
onto the waters of the harbour and reflect into the depth of the cove.
Furthermore, the word καταιβαταί 'cataevataé' (Od. 13.110), speaking
of the entrances, means that one is able to 'descend'. Consequently,
according to the text, in order to enter the cave one should 'step down',
the level of the outside ground being higher. It is also helpful to exam-
ine the exact meaning of the words used to describe the entrance to the
cave, starting with 'two' δύω in the verse «two doors there are» δύω δέ
τέ οἱ θύραι εἰσίν (Od. 13.109). The spelling of 'two' δύω with an ω rather
than ο, is an alternate spelling of the numeral two which, however, does
not exclude the verb, δύω or δύνω, 'dýo' or 'dýno' particularly since it is
related to the entrances of a cave that sinks into the earth. So we have,

δύω (dýo): causal tenses, cause to sink, sink, plunge in, and non-causal,
get or go into.

5. The Greek text uses the plural for each of the two entrances. The Murray trans-
lation, however mentions one door to the north and one to the south. Trans. note.

It is possible that the intent of the poet was to convey this latter meaning since the following verse, «by which men go down» καταιβα-ται ἀνθρώποισιν (Od. 13.110), expresses the same idea with the characteristic meaning of descend, καταιβαται 'cataevataé', inside a cave. The same meaning is attached to the word δῦνε 'dýne' (Od. 13.366). All the words used in reference to the entrance of the cave lead one to the conclusion that the opening, through which men entered the cave, was narrow and had a downward direction, forcing he who entered, to 'penetrate', as it were, into it. The goddess blocked this narrow entrance by positioning a stone in front of it.

καὶ τὰ μὲν εὖ κατέθηκε, λίθον δ' ἐπέθηκε θύρῃσι
Παλλὰς Ἀθηναίη, κούρη Διὸς αἰγιόχοιο.

ν 370-1

These things he carefully laid away, and a stone set she at the door,
by Pallas Athena, daughter of Zeus, who bears the aegis.

Od. 13.370-1

Keeping in mind that Homer specifies that the location of the cave started with the olive tree to be found on the edge of the harbour, it is reasonable to assume that the entrance of the cave was approximately at sea level. The road, therefore, described above, leading to the cave entrance is in agreement with the Homeric text, since it leads down toward the surface of the water and the floor of the cave entrance. The rising of the sea level, alluvial deposits, precipitations caused by earthquakes and the action of the waves transformed the original morphology blocking the entrance. It should be remembered that the goddess placed a rock in front and blocked the way in. In any case, the above sentence poses a question for the present.

Observing the colour of the rocks and the flutes that have been formed on the roof, being a type of stalactites, leads to the suspicion that these continue toward the inside and that a large cave is to be found therein. Generally, in the Atheras area, the subsoil presents many crevices, faults, chasms and other geological features of this

nature, which support the proposition of the existence of a cave in this location. Inside the cave, ever-flowing springs are found, Homer states. In fact, many small springs of brackish water are to be found throughout the region (Od. 13.109)[6].

[...] ἐν δ' ὕδατ' ἀενάοντα.

ν 109

[...] and in it are also ever-flowing springs.
Od. 13.109

Complete light is, thus, shed on the darkness in which true Ithaca has been hiding for all these thousands of years. Myths are demolished and the Homeric word 'lógos' is reborn through the rocks, the cave, the sea, this sacred place, which to this day kept hidden the secret of lost Ithaca, for which humanity was searching. The deep shadowy arched cave, the fabled grotto of the Nymphs, is right there, at the Atheras harbour, close to the olive tree, one entrance toward the north inside the harbour, a few meters from the beach toward Agios Spyridon's chapel and the other, the entrance of the gods, toward the south, to the west of the village, there, where the immense chasms are located, dark precipices which no one knows where they lead.

6. Following the presentation of the original study to the appropriate authorities, Services and Institutions, the author was informed by the inhabitants of Atheras, that the cave which was identified as that of the Homeric Grotto of the Nymphs, the one inside the harbour, was known to them through tradition. Their grandfathers, wanting to chastise them for being unruly when they were children, would threaten to «take and shut them in the cave of Odysseus». It is still said that Atheras was once called Odyssey (Ὀδύσσεια). Nevertheless, the competent authorities would be well advised to explore the precipices located in this area of Xerakas and Poros. They are part of, or are the entrance to a large geological underground complex of crevices, faults and so forth, which if explored would surely lead to the interior of the great cave of Ithaca.

6. The Phaeacian Ship Turned to Stone

In the course of the original research concerning the subject, it was realised that the only site that Homer does not mention is the islet Atheronísi. It is to be found in the open waters inside the Atheras bay. It seems quite strange that such a characteristic feature should not be noted by the poet. This islet was not included in the study simply because the poet states that the ship that brought Odysseus home was turned to stone by Poseidon, god of the sea, as it reached the Island of the Phaeacians. The top view of the islet resembles closely that of a hand with the palm turned downward. This fact convinced the writer that this was indeed the Phaeacian ship turned to stone. This conclusion, strengthened by an additional fact included in Homer's verses, follows naturally upon careful consideration of the poet's statement. It is to be found in one of the several descriptions of the harbour of Phorcys. The poet begins the description of the harbour and its features, with the Phaeacian ship's arrival (Od. 13.93-112). He continues with the landing of Odysseus and the immediate departure of the ship (Od. 13.125). There follows a brief discussion between Zeus and Poseidon concerning the conveyance of Odysseus by the Phaeacians to Ithaca without his consent. Here is Poseidon's statement:

νῦν αὖ Φαιήκων ἐθέλω περικαλλέα νῆα,
ἐκ πομπῆς ἀνιοῦσαν, ἐν ἠεροειδέι πόντῳ
ῥαῖσαι, ἵν᾽ ἤδη σχῶνται, ἀπολλήξωσι δὲ πομπῆς
ἀνθρώπων, μέγα δέ σφιν ὄρος πόλει ἀμφικαλύψαι.
 ν 149-52

But now I am minded to smite the beautiful ship of the Phaeacians,
as she comes back from her convoy on the misty deep,
that hereafter they may desist and cease from giving conveyance
to men, and hide their city behind a huge encircling mountain.
 Od. 13.149-52

So, Poseidon demands: «I want, right now, the ship that is returning from her escort and is out in the misty sea». He then came near her and

«turned her to stone, and rooted her fast beneath by a blow of the flat of his hand» (Od. 13.163-4). The poet's mention of the Phaeacians constitutes possibly an allegory, which is not of the present to examine. Odysseus, nevertheless, woke up from his deep slumber wondering where he was. He, finally, with the help of goddess Athena, discovered that he had indeed reached Ithaca. One can, therefore, conclude that the transformation of the ship into stone took place upon her departure from the harbour of Phorcys, and before Odysseus awakened. If the ship had reached the island of Scheria when Poseidon turned her into stone, she would have had to sail for as many hours as she had when sailing to Ithaca from the land of the Phaeacians. Odysseus, therefore, would have awakened during the night, whereas the poet states that he woke up immediately following the ship's transformation. Many questions needing answers are noted. For example, why did the Phaeacian sailors deposit Odysseus asleep on the beach and leave before he was awake? Is the small island, which is the first thing Odysseus saw through the fog upon waking up, the reason why he did not recognize his homeland? One should remember that the islet resembles indeed a ship and that Odysseus was unconscious of his landing. All this, however, is not of the present. The purpose at this time is to pinpoint all the places on the Pallis peninsula that correspond to those mentioned by Homer and to prove that the great poet, more than three thousand years ago, did in fact live on, walk on and know Ithaca intimately. His descriptions of it are as detailed and accurate as was his love for it. Only one's own land could be described in such minute detail and with such care. None of the cities which lay claim to being Homer's birthplace have been described in such vivid terms, as Ithaca was by Homer. Of the seven cities, Smyrna, Chios, Colophon, Pylos, Argos, Athens and Ithaca, only the latter filled the poet's heart, life, spirit and soul.

7. The First Approach to the Gates of the Immortals

[...] ἀλλ' ἀθανάτων ὁδός ἐστιν.

ν 112

[...] it is the way of the immortals.

Od. 13.112

The study on hand correlates the unexplored, unknown and dark precipices that penetrate the earth near the village and port of Atheras, at the northern part of the Pallis peninsula, with that of the cave of the Nymphs of Homeric Ithaca. It has roused the interest of the 'Hellenic Speleological Exploration Group' (SPELEO) and became the object of exploration by speleologist Mr. Iakovos Karakostanoglou and his associate, Miss Parthenia Tsekouras. The author wishes to express his sincere thanks to them both, for the many exhausting hours spent in exploring the caves at the above area, and the daring entries, and exits in late evening, which were followed with ceaseless interest and concern. The conclusions of the exploration of these faults in conjunction with the interpretation of the underground Karst of the general area are encouraging. We are under the obligation to pursue our collaboration further, so that the opening of Ithaca's grotto becomes a reality provided, of course, that the circumstances permit it. The pertinent Speleological Exploration Report is presented in appendix IV.

CHAPTER FIVE

FROM THE HARBOUR OF PHORCYS
TO EUMAEUS' SWINESTY

U pon waking up on the beach of Phorcys harbour, Odysseus wondered where he was. Athena told him that he was in Ithaca and she bid him to go to the swinesty of his faithful swineherd Eumaeus. So Odysseus started climbing the rough path, τρηχείαν ἀτραπόν (Od. 14.1), over the heights and through the woodland, δι' ἄκριας (Od. 14.2), which led to Eumaeus' place, as Athena had directed him, and found himself at a site near Coracopetra at the Arethousa Spring (Illus. 14).

δήεις τόν γε σύεσσι παρήμενον· αἱ δὲ νέμονται
πὰρ Κόρακος πέτρῃ ἐπί τε κρήνῃ Ἀρεθούσῃ,
ἔσθουσαι βάλανον μενοεικέα καὶ μέλαν ὕδωρ
πίνουσαι, τά θ' ὕεσσι τρέφει τεθαλυῖαν ἀλοιφήν.

ν 407-10

You will find him staying by the swine, and they are feeding
by the rock of Corax and the spring of Arethousa,
eating acorns to their hearts' content and black water[1]
drinking, things which cause the rich flesh of the swine to fatten.

Od. 13.407-10

Odysseus, climbing the rough path passed between the ridges of the Exo Koukoulas of the Atheras promontory and that of Mt. Neriton. On the side, that is, where the Lachties summit is and where Corakopetra is found. Under this mountaintop at the northeastern edge of the

1 The epithet 'black' is applied to water in deep places, where light cannot reach it, and to water trickling down the face of a rock covered with lichens (Il. 16.4). Note from Loeb translation.

Atheras village, about one hundred meters from the last house of the village, three wells are found and from under a loose rock a little water still flows. Over this rock there is a precipice. All features of the landscape remind one of the Corax and Arethousa myth. It appears that Corax, Arethousa's son, while out pursuing a hare, fell over the precipice and was killed. His mother coming near the spring found her son dead and in her grief hung herself. Ever since then the spring took Arethousa's name, while the rock was named Corakopetra after the young man. This is the place where these events took place. Under the Coracopetra and the Arethousa spring, a ditch is found in which there is running water even in the summertime. The same type of water can be found on the Atheras coast, at the harbour where they flow into the sea. On the other side, where the cave is located, more springs are found. This is the reason why the poet states that ever-flowing springs are found inside the cave. Reference to the rock of Corax and the spring of Arethousa occurs only once in *The Odyssey*. It is not possible, therefore, to correlate this to other information in order to locate with certainty the exact spot where the spring lies. It has been possible, however, to prove through analysis that both the rock and the spring are located within 100 meters from the last houses of the Atheras village toward the northeastern side of it. Based on this proximity, certain conclusions may be drawn. The nature and type of the two names, coupled with the close proximity of the two sites, indicate a certain synonymity and relation. If fact, the names Atheras and Arethouse are synonymous but, for reasons unknown, a transposition of letters occurred. This may be due to the rhyme of the spoken word and was, perhaps, established on the basis of harmony of acoustics and meter. As Aristotle states, in Rhetorica:

τῶν δ' ὀνομάτων τῷ μὲν σοφιστῇ ὁμονυμίαι χρήσιμοι [...] τῷ δὲ ποιητῇ συνωνυμίαι.

Ἀριστ. Ρητ. 1406239

As for nouns homonyms are useful to the sophist [...] but to the poet synonyms.

Arist. Rh., 140b39

The name Atheras derives from the noun Ἀϑήρ, Ἀϑέρος, 'Athér', gen. 'Athéros'. Quite possibly the site was thus named due to the geo-morphological formation of the twin promontories, i.e. Atheras and Lithari, which resemble the spikes (awns) of wheat. In fact, the two promontories, Atheras or Koukoula and Lithari or Kakata, protrude from the body of the Pallis peninsula into the sea, like the spikes of wheat. Examining a map of the island, or even better, visiting the area, one would get this distinct impression. The long and slender Atheras promontory is clearly seen across the water, from the road above Myrto. This significant relation of the proper nouns Arethousa and Atheras leads to the conclusion that the feminine name Arethousa means in fact «the woman who hails from Atheras» being, as such, the mother of Corax. In contemporary Greek use the inhabitants are called Ather-ianós (masc.) and Ather-riána (fem.). The existence of the spring of Arethouse to this day, and the relation to Atheras, confirms the proposition that Odysseus headed for this spring in order to find Eumaeus and, consequently, the harbour where he disembarked was the harbour of Atheras. Furthermore, the relation of the name Atheras and Arethousa, reveals that its origins go back to Odysseus' time and probably even before that.

CHAPTER SIX

FROM EUMAEUS' SWINESTY TO THE PALACE

TELEMACHUS returned to the palace after being acquainted with his father. Odysseus was to follow, so that together they could proceed with the slaughter of the suitors. Eumaeus urged Odysseus to proceed to the city before evening set in.

[...] ἀλλ' ἄγε νῦν ἴομεν· δὴ γὰρ μέμβλωκε μάλιστα
ἦμαρ, ἀτὰρ τάχα τοι ποτὶ ἕσπερα ῥίγιον ἔσται.»
ρ 190-1

[...] come now, let us go. Far spent is
the day, and soon you will find it colder toward evening.»
Od. 17.190-1

The time then, must have been about noon, since they had some way to go. Odysseus told Eumaeus to walk ahead and be his guide all the way, but to give him a staff to lean upon (Od. 17.194-5). The road, therefore, must have been narrow and slippery.

[...] σκηρίπτεσθ', ἐπεὶ ἦ φατ' ἀρισφαλέ' ἔμμεναι οὐδόν.»
ρ 196

[...] for truly you said that the way was treacherous.»
Od. 17.196

The entire north Pallis peninsula is very rocky and travel over it is carried out by means of narrow paths over the rocky ground. Travelling south from Atheras toward the Pallis villages, there is only one spring. It has, however, all the characteristics of the «fair-flowing» spring mentioned by the poet (Od. 17.206).

1. Katagous and the Treacherous Road

Homer describes in detail Odysseus' and Eumaeus' departure from the spring of Arethousa near Coracopetra, and the slippery and treacherous road they had to travel (Illus. 15). Further on, when they reached the «well-wrought fair-flowing fountain» he describes the morphology of the ground through which the road passed (Od. 17.204-7). The exact Homeric verses are quoted below, to emphasize that his intention was to present with clarity, using precise terms and expressions, a true picture of the authentic *démos* of Ithaca.

ἀλλ' ὅτε δὴ στείχοντες ὁδὸν κάτα παιπαλόεσσαν
ἄστεος ἐγγὺς ἔσαν καὶ ἐπὶ κρήνην ἀφίκοντο [...]
ρ 204-5

but when, as they went along the rugged path
they were near the city, and had come to the fountain [...]
Od. 17.204-5

But when (δή = ἤδη = already, by this time) as they went along (κατά = with gen. or acc. = downwards)[1] the rugged (παιπαλόεσσαν = of roads, rugged) path, they were near the city, and had come to the fountain.

At the point where the old road coming from Atheras nears the Pallis peninsula villages, close by Halkes and a little to the southwest of Paliés Strátes, it falls abruptly into the ravine. The site sinks in considerably, so that the preposition κάτα 'káta', corresponds to the morphology of the terrain, and is used to describe the route taken, to reach the fountain. This indicates that the site Homer intends to identify is up high at the point where Odysseus and Eumaeus started descending the steep side of the ravine, so that they could cross over to the opposite side. There, lies the rock at the base of which the fountain is found, and above it the altar where travellers offered sacrifice to the gods.

1. *Κατά* may follow both its cases, and is then written with anastr. κάτα see Lid & Sct. C. POSITION. Trans. note.

The toponym Katagous is noted on the map published by the Army Geographical Service (AGS), and is located to the north of Halkes. It is surprising, indeed, that the same term is used as in the Homeric text, describing, as it were, the abrupt downward inclination of the ground. It derives from the verb κατάγω (katágo) meaning to bring down to a place, a river or a canal (See Lid. & Sct.). Through Katagous passes the ἀρισφαλής 'arisphalés', slippery or treacherous road travelled by the King of Ithaca on his way home, after a twenty year absence. It is noted that the word κάθοδος 'cáthodos' = descend, derives from κατά + ὁδός 'catá + odós' the τ changing into ϑ before an aspirate breathing. The sense of a downward direction follows from this word as well. The name Katagous meaning, as stated, the downward direction of the road, relates in a surprising way to Odysseus' return to Ithaca. As noted, it also relates to the word 'cáthodos' meaning descend but it is also used to denote the repatriation of exiles or war prisoners. It is, therefore, reasonable to assume that the area across from and to the north of Halkes was named Katagous because the conqueror of Troy, exiled by Poseidon and held captive by Calypso, used this road on his return trip home.

2. Fair Flowing Fountain (Καλλίροος Κρήνη)

ἀλλ᾽ ὅτε δὴ στείχοντες ὁδὸν κάτα παιπαλόεσσαν
ἄστεος ἐγγὺς ἔσαν καὶ ἐπὶ κρήνην ἀφίκοντο
τυκτὴν καλλίροον, ὅθεν ὑδρεύοντο πολῖται,
τὴν-ποίησ᾽ Ἴθακος καὶ Νήριτος ἠδὲ Πολύκτωρ· [...]

ρ 204-7

But when, as they went along the rugged path,
They were near the city, and had come to the fountain,
well-wrought and fair-flowing, from which the townsfolk drew water –
this Ithacus had made, and Neritus and Polyctor, [...]

Od. 17.204-7

The spring is found to the west of the Halkes area, north of Petanoi
(Ortholithia), near the city, ἄστυ, and at the same elevation as the city.
It lies, however, westward toward the Ionian Sea, while the innermost
part of the Livadi bay lies to the east (Illus. 16).

*[...] ἀμφὶ δ' ἄρ' **αἰγείρων** ὑδατοτρεφέων ἦν ἄλσος,*
πάντοσε κυκλοτερές, κατὰ δὲ ψυχρὸν ῥέεν ὕδωρ
ὑψόθεν ἐκ πέτρης· βωμὸς δ' ἐφύπερθε τέτυκτο
νυμφάων, ὅθι πάντες ἐπιρρέζεσκον ὁδῖται· [...]

 ρ 208-11

[...] and around was a grove of poplars, that grow by the waters,
encircling it on all sides, and down the cold water flowed
from the rock above, and on the top was built an alter
to the nymphs where all passersby made offerings;[...]

 Od. 17.208-11

Many trees grow around the fountain to this day, not poplars, of
course, if that in fact is what is meant by the word αἰγείρων, 'aegeíron'.
The water of the Halkes source flows from within the tall rock, which
forms a small hill. The ground on the top is shaped by human inter-
vention. The fountain has all the characteristics described by Homer,
leaving little doubt as to this being the one meant. Stone water basins
are found where the water flows out of the rock. A large water basin,
two meters long by one meter high was visible at one time, but it is
now encased in the concrete cistern built recently.

The road leading from Atheras to the villages Vovykes, Vilatoria,
and Kondogenada, passes by the fountain and then continues on climb-
ing the side of the rock. This is the old rugged mule trail, as Homer
puts it, serving land communications between Atheras and the rest of
the Pallis peninsula up to recent times. It was the one that Odysseus,
along with Eumaeus, took to reach the «fair-flowing fountain.» On top
of the rock, there is a pile of stones indicating that at one time they
were part of some structure or other, possibly an altar. Access to the
altar is possible from the old rugged trail passing by the point where
the spring flows. A new motor road has by now been built. According

to locals and shepherds in the area, it takes two and one half hours from Atheras to reach the «fair-flowing fountain», Καλλίροος Κρήνη. Odysseus, then, must have taken over three hours to reach his destination, counting an extra one half hour from the fountain to the palace plus the delay caused by his encounter with Melantheus (Od. 17.212-6). It is logical, therefore, that he should have started his journey from Eumaeus' swinesty just after noontime. The sun set many hours later.

From the Halkes fountain to the Crikellos hill (Homeric Hermes hill) access is easy since the land is smooth and free of obstacles. Visibility between the fountain and the hill is good, and transportation of water from the fountain to the palace on the hill by the twenty servant girls was easy (Od. 20.158). Five water wells are still found on Crikellos hill today; possibly there were more in the past. What is of importance, however, is that the site where the palace was built had easy access to water, the Callirous fountain being able to supply increased water needs, as was the case with the suitors having been virtually established in the palace. Eumaeus' trips from the swinesty to the palace correspond in terms of travel time required, to that needed to cover the distance between Atheras and Crikellos hill. The time of Eumaeus' departure, the time spent for meals and the fact that he arrived before sunset should be taken into consideration. On reaching the port of Ithaca, Eumaeus met the sailor sent by Telemachus to announce his safe return from Pylos to his mother Penelope. That their arrival at Ithaca should coincide is quite realistic if one considers the time of Telemachus ship's departure from Phorcys harbour and that of Eumaeus from his swinesty.

HOMERIC HILL (CRIKELLOS) PALACE

CHAPTER SEVEN

THE PALACE ON THE HILL

THE TRIANGLE formed by the Atheras harbour, the fountain at the bottom of the rock on top of which lies the altar and the harbour of Livadi village, encloses the area within which all the elements of Homeric Ithaca should be located and where they should be sought. The harbours, the city of Ithaca, the palace, the altars, just as the poet, through his verses, moulded this landscape, form a harmonious sequence from one to the other. The author's last trip to Cephallenia in quest of new evidence which would complete the verification of Homeric descriptions with further finds, resulted in most surprising discoveries. The Sgouros or Crikellos hill has been identified with the Hermes hill, as mentioned, this being the most likely place where, logically, Odysseus would have built his palace. The ensuing visits to the long, flattop of the hill strengthened the author's conviction that he found himself on the palace grounds.

The precise location of Odysseus' palace and the features of the gates are stated with clarity in the opening verses of *The Odyssey*. The poet begins all his descriptions and dialogues with the palace, Odysseus' hearth, and ends his tale of Odysseus' adventures there. By the use of the term ἐνί, 'ení', he specifies that the propylaea, and therefore the palace, lie in the middle of the distance between the southernmost point of the Pallis peninsula, the Agios Georgios promontory, and Lithari, the northernmost point of the Kakata promontory. This observation is a fact, not a result of hypothetical or imaginary calculations. The geographical location and topographical data provided and their relation to surface finds, coupled with the intrinsic value of the term ἐνί, 'ení', do not allow room for error. This was, in fact, proven by the use of the term in describing the two entry port of Asteris (Od. 4.846).

Crikellos hill is an elongated rising 2,5 kilometres long and over 170 meters at the highest point. The ruins of the palace are located on the top at an elevation of 140 meters and approximately in the middle of it. The ruins of three contemporary buildings can be seen there

today, remnants of the great 1953 earth quake. The northern end of the hill reaches an elevation of 176 meters. From this vantage point one has a clear view of the surrounding area and this is where indications of the tower of Telemachus were found. The long hill ends at this point, the adjacent area below being Platiés Strátes. The road climbing toward Halkes, Petanoi and the villages of Vovykes, Vilatoria and Koudogenada, runs through this area.

1. The Great Wall, the Eastern Gate and the Propylaea

[...] μέγα τειχίον αὐλῆς, [...]

π 343

[...]the great wall of the court, [...]

Od. 16.343

The entire length of the Hermes hill summit is enclosed by a great double wall approximately 1500 m. long, which starts before the palace ruins, on the south side, and reaches the northernmost point, just under the place where Telemachus' tower is located (Od. 1.425-6). This is the great wall of the palace. Towers were erected at certain points that were used as observation posts. Walking along the wall, one can still observe the building stones with which they were constructed. The wall is, in fact, a fortification, protecting the palace court and the entire complex and is known as the ἑρκίον 'herkíon'. The palace itself and the palace court are located within the 'herkíon' on the western side of it. Between the two walls of the fortification, a path or corridor 1,50 m. to 2,00 m. wide is formed, which appears to have been paved with stones. It is, however, difficult to ascertain this due to its great length and the existence today of a thicket with it. It is quite probable that the wall has undergone many repairs in the ensuing millenniums following earthquakes, the original construction plan having been altered. The essential point, however, is that it has been preserved in its original place, awaiting the specialists who will study its architecture and determine its age.

Athena dashing from Mt. Olympus, stood at the gates of Odysseus' palace, the propylaea outer gate, προθύροις 'prothýres', which lay in the middle of the peninsula (*démos* of Ithaca), in the middle of the «spacious city» (Od. 24.468) under the long Hermes hill but in the middle of the hill as well. So the goddess stood at the threshold of the court gate through which one enters the courtyard.

βῆ δὲ κατ' Οὐλύμποιο καρήνων ἀίξασα,
στῆ δ' Ἰθάκης ἐνὶ δήμῳ ἐπὶ προθύροις Ὀδυσῆος,
οὐδοῦ ἐπ' αὐλείου· [...]

α 102-4

Then she went darting down from the heights of Olympus,
and took her stand in the land[1] of Ithaca at the outer gate of
Odysseus,
on the threshold of the court;[...]

Od. 1.102-4

A long road, starting on the southern side of the hill and progressing in a northward direction passes by the outer side of the great wall (Od. 16.343). It is built with a sidewalk lined with hewn curbstones that are an attractive element of the architecture of the site. Another road, starting from within the court, at the point where the chapel of Ascension is found today, crosses the one passing by the wall and reaches the Livadi village's main square. From there, it descends all the way to the sea, indicating that it was expressly built to provide access to the city that spread under it and to the coast. The antiquity of it is obvious from its retaining wall. As it crosses the palace grounds, it can be made out by the stoneworks that are still standing. The wall is interrupted at the road crossing, its two ends turning inward towards the court, giving the distinct impression that about this point the double-door gate of the courtyard should have been located. At the point

1. The ancient text indicates δήμῳ (démos). Trans. íote.

where the two roads cross, lies a large, long, flat inclined rock imbedded in the ground. This is the «threshold of stone», λάινον οὐδόν 'láenon oudón', mentioned in verse Od. 17.30. The huge threshold rock is unique, no other rock such as this is found on the hill. It is a sure sign, indicating with accuracy the position of the palace. The suitors were lying within the gates of the propylaea court stretched out on the solid ground. It is certain that the poet by «hard floor» means the rocky ground that covers the entire propylaea area, that is the flat rock mentioned above.

[...] οἱ δέ μιν ἀμφί, κραταίπεδον οὖδας ἔχοντες, [...]
ψ 46

[...] and they, stretched all about him on the hard floor, [...]
Od. 23.46

The road running along the wall passes by the foot of the rock. On it, other stones have been placed forming horizontal surfaces in the manner of stair-landings facilitating the entry into the court. Two trenches 1,5 m. x 1,5 m. and 80 cm. deep ten meters apart are cut at the bottom of the rock, to the east of it, at the point where it touches the road. These are the foundations of the pillars of the propylaea of the palace. Two pillars were erected on these foundations and stood on either side of the entrance. The existence of the pillars indicated by the two trenches mentioned above, is confirmed by the poet's following verses:

ὣς ἄρ' ἔφη, καὶ πεῖσμα νεὸς κυανοπρῴροιο
κίονος ἐξάψας μεγάλης περίβαλλε θόλοιο,
ὑψόσ' ἐπεντανύσας, μή τις ποσὶν οὖδας ἵκοιτο.
χ 465-7

So he spoke, and tied the cable of a dark-prowed ship
to a great pillar and cast it about the round house,
stretching it high up that none might reach the ground with her feet.
Od. 22.465-7

The description given in verses Od. 17.29-40 is also very characteristic. It provides details as to the position of the pillar against which Telemachus leaned his spear (it is the one mentioned in verse Od. 17.29). Having crossed the threshold of stone (Od. 17.30) he advanced toward the palace. At that point the maid Eurycleia and his mother Penelope came out of the palace to meet him. There was a roof over the pillars which, along with the court walls, created an arcade resembling a large room, or portico (Od. 22.466).

[...] ὁμῳὰς δ' ἐξαγαγόντες ἐυσταθέος μεγάροιο,
μεσσηγύς τε θόλου καὶ ἀμύμονος ἕρκεος αὐλῆς, [...]

χ 441-2, 458-9

[...] lead the women out of the well-built hall
to a place between the round house and the flawless fence of the
court, [...]

Od. 22.441-2, 458-9

[...] κὰδ δ' ἄρ' ὑπ' αἰθούσῃ τίθεσαν εὐερκέος αὐλῆς, [...]

χ 449

[...] and set them down beneath the portico of the well-fenced
court, [...]

Od. 22.449

Athena, at the outer gate of Odysseus' palace on the threshold of the court, found the suitors playing checkers. The great threshold, οὐδοῦ ἐπ' αὐλείου (Od. 1.104), of the propylaea is situated on a prominent site, harmoniously tying in with the surrounding area, having direct connection with the roads that pass by it. The gate of the palace, situated as it is on the top of the hill, is a vantage observation point covering the entire area around it. One can clearly see all of Mt. Neriton, the harbour of Ithaca and the deep Livadi bay in its entire length. A view of a rare beauty indeed.

εὗρε δ' ἄρα μνηστῆρας ἀγήνορας. οἱ μὲν ἔπειτα
πεσσοῖσι προπάροιθε θυράων θυμὸν ἔτερπον
ἥμενοι ἐν ῥινοῖσι βοῶν, οὓς ἔκταινον αὐτοί·
κήρυκες δ' αὐτοῖσι καὶ ὀτρηροὶ θεράποντες
οἱ μὲν οἶνον ἔμισγον ἐνὶ κρητῆρσι καὶ ὕδωρ,
οἱ δ' αὖτε σπόγγοισι πολυτρήτοισι τραπέζας
νίζον καὶ πρότιθεν, τοὶ δὲ κρέα πολλὰ δατεῦντο.

<div align="right">α 106-12</div>

There she found the proud suitors. They were
taking their pleasure at checkers in front of the doors,
sitting on the hides of oxen which they themselves had slain;
and of the heralds and busy squires,
some mere mixing wine and water for them in bowls,
others again the tables with porous sponges
they were washing and setting them out, while still others were
portioning out meats
in abundance.

<div align="right">Od. 1.106-12</div>

A large number of people participated in all this activity. One should count 108 suitors along with their followers, 120 in number, plus the numerous servants and heralds some mixing wine and water, others cleaning the tables or portioning out meat. They were all sitting, lying or moving on the stone threshold of the palace court οὐδοῦ ἐπ' αὐλείου (Od. 1.104). The rock (threshold) is so large that if it was rebuilt it could certainly admit on it as many people as the poet mentions.

νῦν δ' οἱ μεν δὴ πάντες ἐπ' αὐλείῃσι θύρῃσιν
ἀθρόοι, [...]

<div align="right">ψ 49-50</div>

And now the bodies are all at the gates of the court
gathered together, [...]

<div align="right">Od. 23.49-50</div>

And again,

ἐκ δὲ Μελάνθιον ἦγον ἀνὰ πρόθυρόν τε καὶ αὐλήν· […]

χ 474

Then they led Melanthius through the doorway and the court;[…]

Od. 22.474

It was through this gate, past the great wall of the court, that Amphinomus exited along with his companions. From there, one had a good view of the city's harbour.

*[…] ἐκ δ' ἦλθον μεγάροιο παρὲκ μέγα τειχίον αὐλῆς,
αὐτοῦ δὲ προπάροιθε θυράων ἑδριόωντο.*

π 343-4

*[…] and out they went from the hall past the great wall of the court,
and there before the gates they set down.*

Od. 16.343-4

And further,

*[…] ὅτ' ἄρ' Ἀμφίνομος ἴδε νῆα,
στρεφθεὶς ἐκ χώρης, λιμένος πολυβενθέος ἐντός,[…]*

π 351-2

*[…] when Amphinomus saw a ship,
turning in his place, in the deep harbour, […]*

Od. 16.351-2

Athena, when Telemachus was sailing for Pylos, called him asking him to come out to the court and told him that the ship was ready to sail.

*αὐτὰρ Τελέμαχον προσέφη γλαυκῶπις Ἀθήνη
ἐκπροκαλεσσαμένη μεγάρων ἐὺ ναιεταόντων, […]*

6 399-400

But to Telemachus spoke flashing-eyed Athene,
calling him forth before the stately hall, [...]

Od. 2.399-400

It has already been mentioned that outside the propylaea of Odysseus' palace large areas of prepared ground are found, fenced by well-built dry walls. These are obviously not the constructions of simple peasants, built to protect their fields.

μνηστῆρες δὲ πάροιθεν Ὀδυσσῆος μεγάροιο
δίσκοισιν τέρποντο καὶ αἰγανέῃσιν ἱέντες
ἐν τυκτῷ δαπέδῳ, ὅθι περ πάρος, ὕβριν ἔχοντες.

δ 625-7

but the suitors in front of the palace of Odysseus
were making merry, throwing the discus and the javelin
in a levelled place, as their custom was, in insolence of heart.

Od. 4.625-7

In fact, the area in question was outside the palace, precisely because Antinous and Eurymachus, the leaders of the suitors, were sitting near by watching the action.

Ἀντίνοος δὲ καθῆστο καὶ Εὐρύμαχος θεοειδής,
ἀρχοὶ μνηστήρων, ἀρετῇ δ' ἔσαν ἔξοχ' ἄριστοι.

δ 628-9

and Antinous and godlike Eurymachus were sitting there,
the leaders of the suitors, who in ability were far the best of all.

Od. 4.628-9

The suitors were made by their leaders to sit down and cease from their games, surprised and angered by Telemachus departure for Pylos (Od. 4.659). Then,

αὐτίκ' ἔπειτ' ἀνστάντες ἔβαν δόμον εἰς Ὀδυσῆος.

δ 674

And at once they rose up and went to the house of Odysseus.

Od. 4.674

From the above it is clear that the area outside the palace, from one end to the other, was large enough to allow games such as the throwing of the discus and the javelin, to be carried out.

2. The Palace Building and the Hand-mills

The main building installations were located on the inner side of the main wall gate, and extended for about 400 meters. The whole area, covering approximately four acres, is literally strewn with small and large stones lying in disarray, buried into the earth, barely protruding above the ground. They give the unmistakable impression that here, in times long past, there were many dwellings, built close to each other (Illus. 17).

ἐξ' ἑτέρων ἕτερ' ἐστίν, ἐπήσκηται δέ οἱ αὐλὴ
τοίχῳ καὶ θριγκοῖσι, θύραι δ' εὐερκέες εἰσὶ
δικλίδες· οὐκ ἄν τίς μιν ἀνὴρ ὑπεροπλίσσαιτο.

ρ 266-8

There is building upon building, and the court is built
with wall and coping, and well fenced are the
double gates; no man may scorn it.

Od. 17.266-8

On the inner side of the gate, a huge rock is observed, imbedded in the ground, following the inclination of the ground. It was obviously used to construct the great stairway leading to the main entrance of the hall, and this is apparent by the built-in stones that line up this flat and wide area. It gives the impression of an enormous stair landing.

Pieces of hand-mill stones, used to grind grain, are still found strewn around. One millstone lies on top of the west wall[2], the pieces

2. See The West Side Wall and Other Ruins on Crikellos Hill Chapter Seven note 6.

of another a few meters further. In the same general area, and near the «flawless fence of the court» (Od. 22.442), the foundation of a circular structure is seen, its outer perimeter built with hewn stones (Illus. 18, 19, 20). The proximity of the millstones to the circular structure leaves open the possibility that this is indeed the θόλος 'thólos', or round house, located near the hall and not far from the fence of the court (Od. 22.458-9, 466). Homer's statements recorded in the following verses confirm this view.

[...] ἐς μέγαρον κατέθηκεν ἐπὶ θρόνου, ἐκ δὲ βοείην
θῆκε θύραζε φέρων, Διὶ δ' εὔξατο χεῖρας ἀνασχών· [...]

υ 96-7

[...] and laid them on a chair in the hall, and the oxhide
he carried out of doors and set it down; and he lifted his hands
up and prayed to Zeus: [...]

Od. 20.96-7

And again,

φήμην δ' ἐξ οἴκοιο γυνὴ προέηκεν ἀλετρὶς
πλησίον, ἔνθ' ἄρα οἱ μύλαι ἥατο ποιμένι λαῶν, [...]

υ 105-6

And a woman, grinding at the mill, uttered a word of omen from
within the house nearby,
where the mills of the shepherd of the people were set. [...]

Od. 20.105-6

Apparently this round house, 'thólos', was the storehouse where grain was stored and then ground into flour, and obviously, the millstones found lying near by are related to it and identify its function. Cavities cut into the rock on the side of the circular structure were, most likely, used for storing food provisions. The poet states that twelve women were busy working at Odysseus' mills:

[...] τῆσιν δώδεκα πᾶσαι ἐπερρώοντο γυναῖκες [...]
υ 107

[...] At these mills twelve women in all plied their tasks, [...]
Od. 20.107

Ancient mills were operated manually. «They consisted of two superimposed circular flat stones, of which the upper one was called ὄνος 'ónos' or ὄνος ἀλέτης 'ónos alétis', and was turned by means of a lever (Kofiniotis Homeric Lexikon)». Under lemma μύλη, 'mýle', Dimitrakos' Lexikon notes, p.4804: «Hand mill consisting of two superimposed monoliths, the upper one turning on the lower by means of a lever, operated by one or two women». Quite likely, the millstone, one meter in diameter, found on the hill next to the circular building was part of a mill such as the one used by the women at Odysseus' palace. It is quite possible that due to its large size it was operated by two women. The circular shape of the building itself can be explained by the fact that inside it the grinding operation was performed, the millstones being turned by two levers. It is clear that the round house or round storehouse (thólos), the well-fenced court, and the portico of the gates, were located outside the palace. The great pillar mentioned in verse Od. 22.466 was obviously one of those supporting the roof of the propylaea, probably the one nearest the nearby 'thólos'. One end of the cable of the dark-prowed ship was tied around it and the other wrapped around the round 'thólos'. (See verses Od. 22. 465-7, quoted in Chapter VII-1.) One can, therefore, state with certainty that according to the configuration of the land, the location of the building foundations, the position of the millstones and the circular structure that, upon entering the palace court by the outer gate on the east, one would find the palace on the right, and on the left and toward the south the storehouse and other buildings. Two large stones are found lying along with the millstones. They are flat on one side, cut in such a way as to give the unmistakable impression of being part of a large threshold. There is every indication that a building existed there, close to the nearby palace and by the gate of the court, as one enters it from the road. Two more large millstones are found at the foot of the hill. One lies over a

house located at the point where the road from the palace crosses the one leading to Atheras, and the other under the road leading from the palace to the outskirts of the village of Livadi on the east side. No logical explanation could be offered for millstones lying at a site, unless a city, village or complex of buildings existed there at one time or another.

3. The Royal Estate, and the Court's Northern Gate

As mentioned above, the palace was built on a four-acre plot. The Royal Estate extended to the north of the palace grounds, was adjacent to it and was separated from it by a cross-wall running vertically to the long side of the property. There was a large gate on the wall allowing passage from the palace grounds to the estate and opened across from the palace (Illus. 21). Running along the outer side of this wall, double grooves are found 1,20 meters apart. Competent archaeologists have ascertained that these are impressions created by the wheels of passing carts and carriages. Telemachus, along with the maid Eurycleia, who was holding blazing torches to light the way (Od. 1.428-9) passed through this gate on his way to his chamber which was built in the beautiful court (Od. 1.425-6) on the northern, high end of the hill. It is quite obvious that they walked on the inner path of the enclosure ἑρκίον 'herkíon', for reasons of safety, since the enclosure extended all the way to Telemachus' tower.

After a brief stop at the Callirous fountain (at Halkes) and the incident with Melantheus (Od. 17.212-54), Odysseus and Emaeus continued toward the palace on the Hermes hill which was but a short distance away.

αὐτὰρ ὁ βῆ, μάλα δ᾽ ὦκα δόμους ἵκανεν ἄνακτος.

ρ 255

but himself strode forward and very quickly came to the palace of the king.

Od. 17.255

The road they followed led directly to the north gate of the palace which in turn led to the Royal Estate. «Heaps of deep dung of mules and cattle lay there till the slaves of Odysseus should take it away to manure his wide lands» (Od. 17.297-9). There lay neglected Argus, Odysseus' dog. On reaching the gate, the din coming from the palace was audible Odysseus stopped and grasping Eumaeus by the arm, gazed with admiration at the house which he had not seen for twenty years.

[...] ἀγχίμολον δ' Ὀδυσεὺς καὶ δῖος ὑφορβὸς
στήτην ἐρχομένῳ, περὶ δέ σφεας ἤλυθ' ἰωὴ
φόρμιγγος γλαφυρῆς· ἀνὰ γάρ σφισι βάλλετ' ἀείδειν
Φήμιος· αὐτὰρ ὁ χειρὸς ἑλὼν προσέειπε συβώτην·
«Εὔμαι', ἦ μάλα δὴ τάδε δώματα κάλ' Ὀδυσῆος,
ῥεῖα δ' ἀρίγνωτ' ἐστὶ καὶ ἐν πολλοῖσιν ἰδέσθαι.
ἐξ' ἑτέρων ἕτερ' ἐστίν, ἐπήσκηται δέ οἱ αὐλὴ
τοίχῳ καὶ θριγκοῖσι, θύραι δ' εὐερκέες εἰσι
δικλίδες· οὐκ ἄν τίς μιν ἀνὴρ ὑπεροπλίσσαιτο.
γιγνώσκω δ' ὅτι πολλοὶ ἐν αὐτῷ δαῖται τίθενται
ἄνδρες, ἐπεὶ κνίση μὲν ἀνήνοθεν, ἐν δέ τε φόρμιγξ
ἠπύει, ἣν ἄρα δαιτὶ θεοὶ ποίησαν ἑταίρην.»

ρ 260-71

[...] And Odysseus and the noble swineherd
halted as they drew near, and about them rung the sound
of the hollow lyre, for striking the chords to sing before the suitors
was Phemius. Then Odysseus clasped the swineherd by the hand
and said:
«Eumaeus, surely this is the beautiful house of Odysseus.
Easily might it be known, though seen among many.
There is building upon building, and the court is built
with wall and coping, and the gates are well fenced
and are double; no man may scorn it.
And I perceive that in the house itself many are feasting
men: for the savour of meat arises from it, and with it the voice
of the lyre
resounds, which the gods have made the companion of the feast.»

Od. 17.260-71

The question as to where was the double door in front of which they found themselves, may be considered by most as impossible to answer. However, most of Homer's descriptions regarding the main entrance of the palace are in reference to the view of the harbour from there. Nowhere does he suggest that dung was piled near it. Eumaeus walked ahead, entered the court (Od. 17.324-5) and then, walking straight into the hall among the suitors, he took a stool and set at the table of Telemachus. Close after him Odysseus entered the palace (Od. 17.336), and set down on the ashwood threshold within the doorway, and leaned upon the doorpost of cypress. Telemachus had returned earlier, entering the palace by the main entrance, that opened on the eastern side and had a view toward the sea and the port of Ithaca. Upon reaching the entrance, he leaned his spear on a tall pillar (Od. 17.29) and crossed the threshold of stone. Eurycleia, the nurse, busy at arranging the chairs, was the first to see him (Od. 17.31-2). Many other maids gathered around them, and out of the chamber came his mother Penelope and embraced him in tears. These events took place at the front gate of the palace (Od. 17.30, 17.167-8) where the suitors were making merry. It is evident from the above that the court gate, through which Odysseus passed, is the one that was to be found on the north side toward the Royal Estate. All other references to the palace gates concern the eastern main entrance which has a view toward the harbour. The verses of *The Odyssey* (rhapsody 17) that follow in translation, record the conversation between Odysseus and Eumaeus before they entered the palace and following their entry. The pertinent points will then be stressed and commented upon.

272 *To him then, swineherd Eumaeus, did you make answer, and say:*
 «Easily have you perceived it, for in all things you are ready-
 witted.
 But come, let us take thought how these things shall be.
275 *Either you go first into the stately palace,*
 and enter the company of the suitors, and I will remain behind here,
 or, if you wish, remain here and I will go before you.
 But do not linger long, for fear some man see you,
 and throw something at you or strike you. Of this I ask you to
 take thought.»

280 Then the much-enduring, noble Odysseus answered him:
 «I hear and take it to heart; you speak to one who understands.
 But go in before me, and I will remain behind here;
 for I am not at all unused to blows and misiles.
 Enduring is my heart, for much evil have I suffered
285 amid the waves and in war; let this too be added to what has gone
 before.
 But a ravening belly may no man hide
 an accursed plague that brings many evils upon men.
 Because of it, too, are benched ships made ready,
 that bring evil to hostile men over the unresting sea.»
290 Thus they spoke to one another.
 And a dog that lay there raised his head and pricked up his ears,
 Argus, steadfast Odysseus' dog, whom of old he had himself
 bred, but had no joy of him, for before that to sacred Ilium
 he went. In days past the young men were accustomed to take the
 dog to hunt
295 the wild goats, and deer, and hares;
 but now he lay neglected, his master gone,
 in deep dung, which before the doors
 lay in heaps, of mules and cattle, till they should take it away,
 the slaves of Odysseus to manure his wide lands.
300 There lay the dog Argus, full of dog ticks.
 But now, when he became aware that Odysseus was near,
 he wagged his tail and dropped both ears,
 but nearer to his master he had no longer strength
 to move. Then Odysseus looked aside and wiped away a tear,
305 easily hiding from Eumaeus what he did; and immediately he
 questioned him, and said:
 «Eumaeus, truly it is strange that this dog lies here in the dung.
 He is fine of form, but I do not clearly know
 whether he has speed of foot to match his beauty
 or whether he is merely as table dogs are,
310 which their masters keep for show.»
 To him then, swineherd Eumaeus, did you make answer and say:
 «Yes, truly this is the dog of a man who has died in a far land.

If he were but in form and action
such as he was when Odysseus left him and went to Troy,
315 you would soon be amazed at seeing his speed and his strength.
Nothing could escape him in the depths of the thick wood
no creature that he started, and in tracking too he was keen of scent.
But now he is in evil plight, and his master far from his native land,
has perished, and the heedless women give him no care.
320 Slaves, when their masters cease to direct them,
no longer wish to do their work properly,
for Zeus, whose voice is borne afar, takes away half his worth
from a man, when the day of slavery comes upon him.»
So saying, he entered the stately house
325 and went straight to the hall to join the company of the lordly
 suitors.

But as for Argus, the fate of black death seized him
once he had seen Odysseus in the twentieth year.
Now godlike Telemachus was far the first to see him,
as the swineherd came through the hall, and quickly
330 with a nod he called him to his side. And Eumaeus looked about
 him and took a stool
that lay near, on which the carver was accustomed to sit when the
 many joints of meat
he was carving for the suitors, as they feasted in the hall.
This he took and placed at the table of Telemachus,
opposite him, and there sat down himself. And a herald
335 took a portion of meat and set it before him, and bread from the
 basket.

Close after him Odysseus entered the palace
in the likeness of a woeful and aged beggar,
leaning on a staff, and miserable were the cloths that he wore
 about his body.
He set down upon the ashwood threshold within the doorway
340 leaning upon the doorpost of cypress, which of old a carpenter
had skilfully planed, and trued it to the line.
Then Telemachus called the swineherd to him and spoke to him
taking a whole loaf from the beautiful basket,
and all the meat his hands could hold in his grasp.

345 «*Take, and give this to the stranger, and bid him*
 go about himself and beg of the suitors one and all.
 Shame is no good comrade for a man that is in need.»
 Od. 17.272-347

This is what transpired when Odysseus and Eumaeus reached the gate and after they entered the hall. All events and comments recorded are important since they give precise information regarding the gate through which Odysseus entered and the layout of the palace. Studying the verses just quoted, the reader should keep the following in mind: Odysseus reached the palace coming from the Callirous fountain (the fountain at Halkes). The road taken led to the northwestern side of the palace that lay on the Hermes hill (Crikellos hill). The Royal Estate, the μεγάλο τέμενος, as well as Telemachus' tower lay on the exact same northern side of the hill. Odysseus, while conversing with Eumaeus by the gate, noticed Argus, his old dog, lying on top of a pile of dung (Od. 17.297). This is the first time the poet mentions the existence of dung by the palace gate. This, therefore, cannot be the main entrance to the palace mentioned on other occasions. This can only be the gate on the northern side, and this Odysseus crossed on his way to the palace.

4. The Great Altar of Zeus

There was a great altar, near Odysseus' palace in Ithaca, dedicated to Herkeios Zeus. It was thus named because it was erected near the ἑρκίον 'herkion' or fence of the courtyard.

In summary, 'Hérkos' or 'Herkíon' mean:
I. Enclosure, fence of gardens, vineyards; Il. 5.90.
II. The shell enclosing the pearl; Pl. Moralia., 980b.
III. Wall of defence, ἔρκει χαλκείῳ; Il. 15.567.
IV. Periph., ἕ ὀδόντων, the fence of the teeth; Il. 4.350.
V. Metaph. any barrier, fence, obstacle or means of defence.
 Also, defender, protector, bulwark for others.
VI. A net, toils, for birds; Od. 22.469.

Ἔρκίον 'herkíon', therefore, is any barrier, any enclosure, anything that barricades, defends, constitutes a rampart, a bastion, a battlement or defence from javelins and arrows, and offers the possibility of movement within it (Od. 18.102). The 'herkíon' mentioned in verse Od. 22.449 is the outer double wall that surrounded the courtyard of the palace, within which the members of Odysseus' family and the guards could move freely, without danger from attack from enemy arrows and javelins. It starts from the southern end of the palace court, advances along the entire length of the great wall on the eastern side, and reaches the end of the court where the last wall is found, built in a perpendicular direction to the estate. The northern gate is located there. It then continues and reaches the smooth top of the Hermes hill where the tower of Telemachus is located. The palace, thus, communicates with the tower by means of the double wall. Not more than 100 meters from the northern gate and very close to the 'herkíon', some ruins are standing alone. The only logical explanation for their existence is that they are the remnants of the altar of Herkeíos Zeus (Zeus defender of the walls). The altar took this name apparently because it was standing near the defensive wall that protected Odysseus' palace. The site outside the palace court was selected, most likely, because the area is large and free of obstacles, permitting the slaughter and sacrifice of victims and the gathering of large numbers of people.

[...] ἢ ἐκδὺς μεγάροιο Διὸς μεγάλου ποτὶ βωμὸν
ἐρκείου ἵζοιτο τετυγμένον, ἔνϑ' ἄρα πολλὰ
Λαέρτης Ὀδυσεύς τε βοῶν ἐπὶ μηρί' ἔκηαν, [...]
 χ 334-6

[...] whether he should slip out from the hall and by the well-built altar of great Zeus,
the god of the court[3], sit down, on which many,
Laertes and Odysseus had burned thighs of oxen, [...]
 Od. 22.334-6

3. Murray' s translation renders it as «&the well-built altar of great Zeus, the god of the court, &». Yet, ἐρκείου (gen.) means of the wall, or fence, and thus Zeus protector of the wall. Trans. note.

Again,

ἀλλ' ἐξελθόντες μεγάρων ἕζεσθε θύραζε[4]
ἐκ φόνου εἰς αὐλήν, [...]

χ 375-6

*But go out from the halls and sit down outside
in the court away from the slaughter, [...]*

Od. 22.375-6

And again,

[...] ἐζέσθην δ' ἄρα τώ γε Διὸς μεγάλου ποτὶ βωμόν,
πάντοσε παπταίνοντε, φόνον ποτιδεγμένῳ αἰεί.

χ 379-80

*[...] and set down by the altar of great Zeus,
gazing about on every side, constantly expecting death.*

Od. 22.379-80

Thus the poet describes the altar of great Zeus Herkeios, lying on Hermes hill, next to the great wall and near the northern gate of the palace court.

5. The Well-built Tower of Telemachus

Telemachus entered the palace following his discussion with Athena who, in the guise of Mentes, gave him advice regarding his planned voyage to Pylos. He remained there until a late hour, while the minstrel sang and the suitors conversed with each other. When night came, they all retired, each to his own house and Telemachus to his chambers.

4. θύραζε (thýraze): Adv. for θύρασδε, to the door, and so, out of doors, opp. ἔνδον éndon, within.

Τηλέμαχος δ', ὅθι οἱ θάλαμος περικαλλέος αὐλῆς
ὑψηλὸς δέδμητο περισκέπτῳ ἐνὶ χώρῳ,
ἔνθ' ἔβη εἰς εὐνὴν πολλὰ φρεσὶ μερμηρίζων.
τῷ δ' ἄρ' ἅμ' αἰθομένας δαΐδας φέρε κεδνὰ ἰδυῖα
Εὐρύκλει', Ὦπος θυγάτηρ Πεισηνορίδαο, [...]
α 425-9

But Telemachus, where his chamber was in the beautiful court,
built high, in a place with a surrounding view,
there he went to his bed, pondering many things in his mind;
and with him, bearing blazing torches, went true-hearted
Eurycleia, daughter of Ops, son of Peisenor, [...]
Od. 1.425-9

[...] καὶ ἑ μάλιστα
δμῳάων φιλέεσκε, καὶ ἔτρεφε τυτθὸν ἐόντα.
ὦιξεν δὲ θύρας θαλάμου πύκα ποιητοῖο, [...]
α 434-6

[...] for she of all
the handmaids loved him most, and had nursed him when he was
a child.
He opened to doors of the well-built chamber, [...]
Od. 1.434-6

[...] βῆ ῥ' ἴμεν ἐκ θαλάμοιο, θύρην δ' ἐπέρυσσε κορώνῃ
ἀργυρέῃ, ἐπὶ δὲ κληῖδ' ἐτάνυσσεν ἱμάντι.
α 441-2

[...] and then went forth from the chamber, drawing the door to
by its handle,
which was of silver, and driving the bolt home with the thong.
Od. 1.441-2

The above verses describe with accuracy where the tower (chamber) of Telemachus was to be found. The Royal Estate (témenos) lay to the north of the palace grounds, where the palace court was also

located. The ruins of Telemachus' tower are found on the edge of the hilltop and from there one has indeed an excellent view of the surrounding area. His quarters, then, faced the well-built court. The inhabitants of a place, moving within it on a daily basis, do not usually need a light to guide them, unless they traverse an extensive open space at night. This would be the case if one went from the palace to the top of the hill where the tower lay. Eurycleia, holding lighted torches and leading the way for Telemachus, proves that their destination was some distance away and that it took some time to reach it. The altar of 'Herkeios Zeus' occupied a pre-eminent spot near the double wall (hérkion), which leads to the top of the hill. Communication between the palace and the tower was possible by means of the path within the double wall passing through the fields. It was, most likely lined with stones so as to avoid the mud on rainy days. The distance between the northern gate of the palace and Telemachus' tower is about five hundred (500) meters. The existence of the double wall indicates that Telemachus' 'thálamos' was a large building. This can be verified by examining the fallen walls, the layout of the structure, and the great blocks of stone used in the construction of the building and the courts. Two large worked stones, possibly pilasters of a large door through which one entered the tower's court, are standing one across from the other six meters apart. They are joined at the base by a threshold built with a line of well-placed stones. To visualize what lay there at one time, in addition to the many remnants strewn around, one should take into consideration the poet's verses, on the basis of which one could rebuild the large and strong tower. The silver door handle (Od. 1.441) is also indicative of a carefully and well built structure (Illus. 22).

[...] πύκα ποιητοῖο, [...]

α 436

[...] well-built [...]

Od. 1.436

While talking about Eurycleia and how she was carrying the lighted torches, the poet interjects a short account regarding her purchase by Laertes, when she was in her first youth. Laertes, the poet states,

honoured her and never slept with her for he avoided the wrath of his wife. (Od. 1.429-34). This very elegant short transgression insinuates to the reader the feeling that he is actually there, following in the footsteps of Telemachus and Eurycleia, on their way to the tower, and that the story was told so as to pass the time until their destination was reached.

The view from the tower is unique. One can see all of southwestern Cephallenia, magnificent Mt. Aenos (Neriton) and the Megalo Soro all the way to Corakopetra (Lachties), above Atheras. One can practically see the entire Pallis peninsula and the deep (extended) Livadi bay in its entire length, from its southern entrance at the Vardiani isle to its inner reaches at the Skavdolitis precipice (the rock Leucas), the curving beach, the harbour of Livadi (Homeric Ithaca's harbour), the meadow of asphodel and the gates of the sun, above Agonas hill where Pylaros lies. The haunt of Eumaeus, near Corakopetra at the spring of Arethousa, is visible from there the swamp of Valtos (the entrance to Hades according to Od. 24.13-14), Laertes' estate and the Livadi village (Homeric Ithaca). A part of the Reithron inlet can be discerned and the spring at Halkes (Calliroos fountain) above which lay the altar where wayfarers offered sacrifice. All the peninsula's villages are visible from up there.

There, on the top of Crikellos hill, at Telemachus' tower, by the royal estate and the well-built court of the godly king who conquered the hearts of men, the most precious seed was planted, the seed of poetry, the miracle of the Greek language. It grew luxuriant, it bloomed and its blossoms were scattered by the winds of Aeolus to the four corners of the earth, its inebriating scent spreading over mountains and seas. Eurycleia's torches set the fires that illuminated the darkness of the world. It is a site that kindles the mind and, without hesitation, one could claim that the Homeric saga that enchanted and inspired humanity, was composed on this spot. Homer, son or grand son of Telemachus, lived and was raised there in the family house.

6. The West Side Wall and Other Ruins on Crikellos Hill

The complex of buildings on the Crikellos hill (Hermes hill), and the court of the palace, were protected by yet another wall, about four hundred (400) meters long, lying across from the first one, on the western side. This western wall is clearly of Mycenaean style, built with large worked stones of a rectangular shape, and of massive cyclopean type stones set in the distinct cyclopean manner[5]. Certain parts of it have been preserved almost intact, in spite of a few alterations and damage done by time. It was apparently reconstructed at a later date but earthquakes ruined a large part of it.

Where the central eastern gates are and to the west of them (in the rear), a wall is found built with large cut stones of Mycenaean style. This wall was most probably the foundation of a building. Again, on the south side of the large area, where the building installations were located, the foundations of another large building can be seen. They are quite wide and extensive. It was assumed at first that this was Telemachus' tower, because the site is elevated and flat. Later, however, this proved wrong, since Telemachus' tower is located further north, on the highest point of Crikellos hill.

Five wells, as mentioned, are found within the palace enclosure, and a long wall quite a bit lower than the tower of Telemachus is seen, extending towards the East beyond the boarders of the hill. The buildings were numerous, they were large, and they stood out from the rest of the houses. The large building blocks strewn all over the area bear witness to the severe damage they sustained and to the density of construction. Unfortunately, the hundreds of tons of rubble strewn around make the plotting of the palace foundations impossible. A careful survey of the hilltop in its entire length coupled with aerial photography would reveal the extent of ancient construction on the site. However, only a large-scale excavation project could possibly answer the many critical questions arising.

5. The Archaeological Directorate of Patras has shown keen interest in the wall given that its Mycenaean characteristics are quite clear.

7. Swiftly They Had Come Down to the Sea

[...] καρπαλίμως· ... ἐπὶ νῆα κατήλυθον ἠδὲ θάλασσαν, [...]
ε 406-7

[...] quickly, ... they had come down to the ship and the sea [...]
Od. 2.406-7

The swift manner in which Athena along with Telemachus dashed from the palace propylaea to the sea, is quite descriptive of the actual conditions of the locality. Whoever ventures a run down to the sea taking this route, will be overtaken by the exhilarating feeling of spreed and swiftness. The true meaning of the term *καρπαλίμως* 'carpalémos', or swiftly, would be experienced here. The narrow, rough, descending path, accelerates one's pace and turns it into an unbridled downward gallop. It gives the true essence of the Homeric verse in a most vivid way.

8. ^{14}C Radiocarbon Dating of Sample

The importance of the radiocarbon method of dating and its contribution to archaeological research is well known. The method is used whenever comparative information available to archaeologists is not sufficient to determine the age of the finds. The method is based on measuring the radioactivity of the archaeological sample produced by the radioactive isotope ^{14}C. This isotope, formed in the upper atmosphere by the action of cosmic rays and by that of photosynthesis, becomes part of all living organisms, men, animals and plants. In this respect, any sample of organic matter, bone, skin, food or fire remnants, can be dated. Unfortunately, regarding pre-historic Cephallenia, such material is not available. Particularly, samples from the Crikellos hill, where the ruins of Odysseus' palace are located.

Dr. N. Zouridakis, physisist at the 'Hellenic Center of Physical Research' «Demokritus», was approached on the matter. Dr. Zouridakis, some years ago, developed in his laboratory of 'Isotopic Hydrology II' a technique of dating wall plaster (lime mortar) originating with his-

torical buildings, by the radiocarbon method. He was able in this way to date a number of samples from pre-historic palaces at Pylos, Mycenae, Tiryns, Cnossos and the pre-historic site at Thera. The dating of samples from Pylos, Mycenae, Tiryns and Thera, correlated fully with the chronological evaluations of competent archaeologists, this being proof of the reliability of the technique as far as these samples were concerned. The specimens from Cnossos, however, yielded a much earlier date from that expected (6415 ± 80 years before our age). According to Dr. Zouridakis, this is due to the mixing of sea sand in the lime mortar, a practice carried out by Minoan craftsmen, while grass or manure was used in the mortar used in the other palaces mentioned.

In short, a sample taken from the presumed site of Odysseus' palace on Crikellos hill was supplied to the above laboratory. An X-ray analysis revealed the existence of sea sand in it, much like the Cnossian samples. It was thus expected that the dating of the Cephallenian specimen would yield an earlier date than the actual one. In fact the date obtained was computed to 4090 ± 80 years before our era, and is comparable to the Cnossian results. Dr. Zouridakis is of the opinion that it will be possible to correct this dating once the pertinent research concerning the sea sand content of the samples in question is completed. Nevertheless, the dating obtained for the Cephallenian sample does not exclude the possibility that the structure from which it came is contemporary with Odysseus' era or even earlier. In fact, initial scientific estimates strongly indicate such a dating, based on a comparison of the Cephallenian sample to those from Cnossos. The results of this dating were presented by Dr. Zouridakis at the 29th International Archaeometric Conference, held in May 1994 in Ankara, Turkey.

CHAPTER EIGHT

THE ESTATE OF LAERTES AT PLATIES STRATES

E UMAEUS came to the royal palace in the city of Ithaca from the
Phorcys harbour, situated at the northern end of the Pallis penin-
sula. As he set off, he was advised by Telemachus not to pass by the
fields, so as not to be seen by old man Laertes.

> ἀλλὰ σύ γ' ἀγγείλας ὀπίσω κίε, μηδὲ κατ' ἀγροὺς
> πλάζεσθαι μετ' ἐκεῖνον· [...]
>
> π 150-1

> *No; you must give your message and come back, and not over*
> *the fields*
> *straggle in search of Laertes; [...]*
>
> Od. 16.150-1

The estate of Laertes lay, therefore, between the hill of Hermes, or
between the city, and the fields lying towards Atheras. To locate, how-
ever, the estate, which lay somewhere to the north of the city, one
should examine the verses where the poet describes the direction in
which Odysseus travelled on his way to his father's farm.

> οἱ δ' ἐπεὶ ἐκ πόλιος κατέβαν, τάχα δ' ἀγρὸν ἵκοντο,
> καλὸν Λαέρταο τετυγμένον, ὅν ῥά ποτ' αὐτὸς
> Λαέρτης κτεάτισσεν, [...]
>
> ω 205-7

> *But Odysseus and his men, when they had gone down from the*
> *city, quickly came to the farm*
> *of Laertes, beautiful and well-ordered as it was, which in days*
> *past for himself*
> *Laertes had won, [...]*
>
> Od. 24.205-7

Odysseus, on his way to Laertes' farm, along with his companions, descended from the hill and reached it quickly. It, therefore, lay lower than the palace and was not far. Verses Od. 24.299, 308, 336, 361, 392 and 396 are relevant. The following verses also offer information useful in locating the farm:

ἔνθα οἱ οἶκος ἔην, περὶ δὲ κλίσιον θέε πάντῃ,
ἐν τῷ σιτέσκοντο καὶ ἵζανον ἠδὲ ἴανον
δμῶες ἀναγκαῖοι, τοί οἱ φίλα ἐργάζοντο.[...]
ω 208-10

There was his house, and all about it ran the sheds
in which they ate, and sat, and slept
the servants that were bondsmen, that did his pleasure, [...]
Od. 24.208-10

And again,

[...] ἐν δὲ γυνὴ Σικελὴ γρηὺς πέλεν, ἥ ῥα γέροντα
ἐνδυκέως κομέεσκεν ἐπ' ἀγροῦ, νόσφι πόληος.
ω 211-2

[...] but within it was an old Sicilian woman, who the old man
tended with kindly care there at the farm, far from the city.
Od. 24.211-2

Verse Od. 24.468 states that «they gathered together in front of the spacious, εὐρυχόριο 'eurychóroeo', city». The adjective 'eurychóroeo' stands for wide space or spacious. The toponym 'Platies Strates' means exactly that. The name, therefore, has a Homeric origin, deriving from the spacious site where the house of Laertes was located. There is additional evidence, however, which should help to locate Laertes' house as, for example, the well-built fence of the garden.

τὸν δ' οἶον πατέρ' εὗρεν ἐυκτιμένη ἀλωῇ, [...]
ω 226

> But he found his father alone in the well-ordered vineyard, [...]
> Od. 24.226

The term ἐυκτιμένη, 'eüktiméne', means well ordered, well cultivated, but it could possibly also mean well built fence or wall which would make the estate conspicuous. It is certain that elements of such structures (walls) are present in the area in question, however, to recognise the technique of such stone constructions one should have the pertinent expertise. A very significant piece of information regarding the site in question, comes from Athena who in the guise of Mentes told Telemachus:

> [...] ἐρπύζοντ' ἀνὰ γουνὸν ἀλωῆς οἰνοπέδοιο.
> α 193

> [...] as he creeps along the slope of his vineyard plot.
> Od. 1.193

The above description defines quite clearly the area referred to. It lies where the road climbs from Platies Strates towards Halkes. This steep climb, past Crikellos hill, is situated at a point where wells, necessary for watering the farm are found. Laertes' house can be easily identified since it lies on a flat piece of land where many ruins are to be seen. The area from the northern end of Crikellos hill (Hermes hill), to the plain of Livadi, the Valtos area and Platies Strates, was without doubt, Laertes' estate. There were fruit trees and vineyards of many types in the farm and this fact helps in selecting the proper site. A careful and close search of the area by competent archaeologists would, without difficulty, locate the place in question.

CHAPTER NINE

ITHACA, CITY OF DREAMS

1. The Landscape of the Homeric City of Ithaca

Homer's love for Ithaca was so great that he decided to paint a vivid picture of the island through the verses of the closing rhapsody of *The Odyssey*. At the beginning of book 24 (Od. 24.5-14) he describes the scene where Hermes leads the souls of the slaughtered suitors from the palace on the hill to Hades, the underworld. The course described is from the palace to the meadow of asphodel where souls dwell. The slaughter of the suitors, it is reminded, took place within the palace on the hill of Hermes by Odysseus assisted by Telemachus. The bodies of the dead suitors were then removed to the portico of the courtyard (Illus. 23).

πρῶτα μὲν οὖν νέκυας φόρεον κατατεθνηῶτας,
κὰδ' ἄρ' ὑπ' αἰθούσῃ τίθεσαν ἐυερκέος αὐλῆς, [...]

χ 448-9

First they carried out the dead bodies
and set them down beneath the portico of the well-fenced court [...]

Od. 22.448-9

And,

νῦν δ' οἱ μὲν δὴ πάντες ἐπ' αὐλείῃσι θύρῃσιν
ἀθρόοι, αὐτὰρ ὁ δῶμα θεειοῦται περικαλλές,
πῦρ μέγα κηάμενος· [...]

ψ 49-51

And now the bodies are all at the gates of the court
gathered together, but he is purging the beautiful house with sulphur,
and has kindled a great fire; [...]

Od. 23.49-51

The same day, during the evening, after everything was tided up in the palace, Odysseus lay with his wife Penelope in his much-loved bed (Od. 23.354). The following morning Odysseus girt his splendid armour (Od. 23.366), roused Telemachus, Philoetius and Eumaeus, and departed for Laertes' farmstead.

ἤδη μὲν φάος ἦεν ἐπὶ χθόνα, τοὺς δ' ἄρ' Ἀθήνη
νυκτὶ κατακρύψασα θοῶς ἐξῆγε πόληος.

ψ 371-2

By now there was light over the earth, but Athene
hid them in night, and swiftly led them forth from the city.

Od. 23.371-2

According to Homer, since the suitors died in the palace on the Hermes hill, Hermes should undertake the conveyance of their souls to Hades. The poet is honouring Hermes by having him perform this duty, since the Ithacians were careful to fulfil their obligations toward the dead. This act is repeated many times in *The Odyssey*.

[...] ἐκ δὲ νέκυς οἴκων φόρεον καὶ θάπτον ἕκαστοι, [...]

ω 417

[...] Out from the halls they brought each his dead, and buried
them; [...]

Od. 24.417

Describing the procession of the souls, the poet also describes the real landscape, where the overwhelming scene of the suitors' slaughter was acted out. One becomes, through the Homeric verse, part of a procession which belongs to the world of fantasy, yet coexists with the real world, the real landscape, the real site, the city of Ithaca, or, more aptly, the «démos of dreams». Here are the verses in the original text:

Ἑρμῆς δὲ ψυχὰς Κυλλήνιος ἐξεκαλεῖτο
ἀνδρῶν μνηστήρων· ἔχε δὲ ῥάβδον μετὰ χερσὶν
καλὴν χρυσείην, τῇ τ᾽ ἀνδρῶν ὄμματα θέλγει
ἐθέλει, τοὺς δ᾽ αὖτε καὶ ὑπνώοντας ἐγείρει·
5 τῇ ῥ᾽ ἄγε κινήσας, ταὶ δὲ τρίζουσαι ἔποντο.
ὡς δ᾽ ὅτε νυκτερίδες μυχῷ ἄντρου θεσπεσίοιο
τρίζουσαι ποτέονται, ἐπεί κέ τις ἀποπέσῃσιν
ὁρμαθοῦ ἐκ πέτρης, ἀνά τ᾽ ἀλλήλῃσιν ἔχονται,
ὣς αἱ τετριγυῖαι ἅμ᾽ ἤισαν· ἦρχε δ᾽ ἄρα σφιν
10 Ἑρμείας ἀκάκητα κατ᾽ εὐρώεντα κέλευθα.
πὰρ δ᾽ ἴσαν Ὠκεανοῦ τε ῥοὰς καὶ Λευκάδα πέτρην,
ἠδὲ παρ᾽ Ἠελίοιο πύλας καὶ δῆμον ὀνείρων
ἤισαν· αἶψα δ᾽ ἵκοντο κατ᾽ ἀσφοδελὸν λειμῶνα,
14 ἔνθα τε ναίουσι ψυχαί, εἴδωλα καμόντων.

ω 1-14

But Cyllenian Hermes was calling forth the ghosts
of the suitors. He held in his hands his wand,
a beautiful wand of gold, with which he lulls to sleep the eyes
of whom he will, while others again he wakens out of slumber as well;
5 *with his wand he roused and led the ghosts and they followed gibbering.*
And as in the innermost recess of an eerie cave bats
flit about gibbering, when one has fallen
off the rock from the chain in which they cling to one another,
so these went with him gibbering, and he led them,
10 *Hermes the Helper, down the dank ways.*
Past the streams of Oceanus they went, past the rock Leucas,
past the gates of the sun and the land of dreams,
and quickly came to the meadow of asphodel,
14 *where the ghosts dwell, phantoms of men who have done with toils.*

Od. 24.1-14

One is forced at this point to define the meaning of the terms used
in the ancient text so as to give a clear picture of the city's landscape
and of the broader area of Ithaca, around the deep end of the Livadi
bay.

2. Ocean Currents ('Ωκεανοῦ 'Ροαί)

Hermes passed by the «streams of Oceanus» ('Ωκεανοῦ ῥοάς, Od. 24.11), as the poet calls the abundant streams of water that cross the land which Hermes travelled as he led the ghosts of the dead suitors.

3. The Rock Leucas (Λευκάδα πέτρη)

The procession of the ghosts continued, passing by the «rock Leucas» or white rock (Λευκάδα πέτρη, Od. 24.11) as the poet calls it. The rock rises steeply on the inner end, of the neck of the deep Livadi bay. This pure white cliff, tall and precipitous, can be seen from the entrance of the bay, twenty kilometres way. The public road that leads from Lixouri to the main landmass of Cephallenia across the bay, passes over the rock. The cliff today is called Skavdolitis. It holds a commanding position over the site where ancient Ithaca lay. Our harbour (λιμέν' ἡμέτερον, Od. 16.473), the deep harbour (λιμήν πολυβενθής, Od. 16.352), the curving beach (κοῖλος αἰγιαλός, Od. 22.385), are some of the epithets Homer uses to describe this very same region, the same landscape that one knows today. This is the landscape of the harbour of ancient Ithaca. The story of the white cliff goes further back and shall be discussed in a later chapter. There are in fact two precipitous rocks close to each other on the site described. Skavdolitis, which means chiselled rock, and Pani, meaning ship's sail, because from afar it resembles an open sail in shape and whiteness. Both names express the same characteristic as that of the Homeric «white rock», having thus retained in essence their name since Homeric times.

4. Agonas – Pylaros: The Gates of the Sun ('Ηελίοιο πύλαι)

Mt. Aenos (Homeric Mt. Neriton), extending north all the way to the region known as Pylaros, slopes down towards the isthmus that connects the main bulk of Cephallenia to the Pallis peninsula. On these western slopes, facing the isthmus, lies the beautiful village of Agonas

•

and the other villages of the Thinea municipality. The Skavdolitis precipice (rock Leucas) lies on the extreme southern end of the above isthmus. Observing the rising sun from the ruins of the palace on Crikellos hill, in the spring or summer of the year, it appears over the Agonas village and over the mountain summit, right on the boarder of the Agonas and Pylaros regions. The site is known as Omales and lies on a straight line to Skavdolitis' white cliffs and the palace. This is the point where the sun rose over the horizon at the time of Odysseus' return to Ithaca. Homer calls it «the gates of the sun» (Ἡελίοιο πύλας, Od. 24.12) Hermes' route, as he led the ghosts of the dead suitors from the palace down «the dank ways», passed by the white cliffs (the rock Leucas) and «the gates of the sun».

*[...] ἠδὲ παρ' Ἡελίοιο πύλας καὶ δῆμον ὀνείρων
ἤισαν· [...]*

ω 12-13

*[...] past the gates of the sun and the land of dreams,
they went [...]*

Od. 24.12-13

The people of Ithaca revered the sun and, for that reason, Odysseus' companions wanted to «built a rich temple ... and put in it many choice offering» (Od. 12.347), in honour of the fearful god, Helios Hyperion.

The proper name Pylaros, having its origin in Homeric times, fits exactly the site. She, Πυλαωρός 'Pylaorós', was the guardian of the «gates of the sun», and remains so to this day.

The word πυλαωρός, 'pylaorós', thus means gate keeper, and became πυλωρός, 'pyloros' and later and to this day, Πύλαρος, 'Pýlaros'[1], a toponym

1. The noun was used until recently, and strangely was not picked by other regions, in spite of the fact that it was known throughout Greece due to the saying «Anyone else for Pylaros?». There was, it seems, a coaster ship by that name operating in the islands much favoured by the passengers and the calling «Anyone else for Pylaros?» was familiar in all ports in the area.

that did not lose its meaning through the ages. The poet's marvellous descriptions of the setting, determined the orientation of Odysseus' house, just as the geographical information and descriptions of the features of the land that he furnished, led to the identification of his beloved Ithaca. The terms used by Homer in verses Od. 24.1-14, that is the dank way, the rock Leucas, the city of dreams, the meadow of asphodel, added to the locations related to these, such as the curving beach, the Hermes' hill, and so forth, reveal the enchanting homeland of Odysseus, in the landscape of Cephallenia.

5. The Land of Dreams (Δῆμος Ὀνείρων)

The ghosts, along with Hermes, went beyond the city of Ithaca, the land of dreams. They left behind them the city about which they dreamed so many dreams. The city they hoped to rule becoming kings: Odysseus' Ithaca! Ithaca lay on the foot of the Hermes hill, spreading all the way to the end of the bay, and the rock Leucas, a total distance of over two kilometres.

6. The Meadow of Asphodel (Ἀσφοδελός Λειμῶν)

[...] αἶψα δ' ἵκοντο κατ' ἀσφοδελὸν λειμῶνα, [...]
ω 13

[...] and quickly came to the meadow of asphodel, [...]
Od. 24.13

All of Homer's descriptions have a common point of reference: the meadow of asphodel. The toponym Livadi (meadow) remains unchanged for at least thirty-five centuries now, and has come down to this day through the local tradition and Homer's verse. The features of the region are the same today as they were in antiquity regarding both the landscape and the vegetation. Livadi is the only locality where asphodels grow in profusion. They are locally known as 'spherthoúglia'

and are a genus of the lily family². Livadi and the surrounding area in a radius of approximately two kilometres is covered with them. The plant flourishes in no other location in the Pallis peninsula, from Atheras to Gerogombo, but neither does it grow in the regions of Thinea, Pylaros, Eryssos, Same, Poros, Leivathos or Mt. Aenos.

7. The Dank Ways (*Εὐρώεντα Κέλευθα*)

The poet characterizes the paths that lead to Hades as being dank. The interpretation of the word *εὐρώες*, 'euróes', indicates that the term refers to muddy, moldy, slimy places or things. This is exactly the nature of the ground in the northern part of the Livadi valley where the well-known marsh is found. The entire coast, from Livadi to the end of the bay toward its neck, receives the slimy waters that drain from the marshes, the colour of the ground having turned dark, moldy like and really rotten. The continuous underground flow of the marsh waters to the sea has discoloured the white pebbles and rocks giving them a dull unsightly look (Illus. 24).

Thus the poet leads the souls of the dead suitors to the dark swamp, creating in man's imagination a frightful picture of Hades. The rotten, crumbling, wet ground turns the mind of men to the final trip, the one without return. This is the site the poet selected in which to place the underworld, in the mud of the swamp, a short way from Ithaca, his beautiful homeland, the sweetest thing in the world as he describes it to Alcinous, the king of the Phaeacians (Od. 9.28).

The city of dreams next to Hades. Evil's end and death in the repulsive and dark swampy waters. The meadow of asphodel under the enormous white cliff on which the Gates of life-giving sun are propped. Good and evil, life and death, light and darkness, God and the soul of men, king and pauper, the blue sea and the mud of the swamp come together. The real world lives out its destiny hand in hand with the world of fantasy, while the poet creates his magnificent epic inspired by the sight confronting him and the vain deeds of man.

2. The asphodel of the early English and French poets was the daffodil, that of the ancient Greek poets is supposed to be the narcissus. Trans. íote.

8. The Ghosts Followed Gibbering (ταὶ δὲ τρίζουσαι ἕποντο)

One more characteristic of the region, immediately noticed by the passers by, is the deafening noise produced by the millions of chirping crickets[3] living in the reed-beds and bulrush that grow abundantly in the swamp. The poet uses the term τρίζουσαι, 'trízousae', meaning squeaking and gibbering, to describe the noise made by the ghosts of the dead suitors (Od. 24.5). He likens it to that produced by bats in a cave, as if these were souls flitting around in the dark ways of Hades.

The ghosts of the suitors proceeded «gibbering» toward Hades. Homer's genius conceived the swamp as Hades and the chirping of the crickets as the gibbering of the marching ghosts. This obvious connection would have escaped notice, had the author not had the good fortune, when very young, to pass by the swamp while on a nocturnal march to Lixouri. Most travelling on the island was done on foot in those days, and since electric lighting was unknown to Cephallenia, the villages and roads were covered by darkness at night. Only the stars and the moon illuminated dimly the way. The recollection of this march by the swamp under the starlit sky and the deafening chirping of the crickets, has been one of the most vivid and unique memories of the writer's youth. Perhaps, such an experience at such a tender age impresses a young mind allowing it to comprehend the allegorical references of a great poet. As such, the verses of the poet, in their mythological context, describe a reality as far as the gibbering noises made by the ghosts of the dead suitors are concerned. The phantoms shall remain there, «ἔνθα τε ναίουσι», where they dwell, in the meadow of asphodel. They shall continue to remain images reflected in man's fantasy, exciting forever his imagination.

3. Cricket, a leaping orthropterous insect (family of Cryllidae, esp. genus Cryllus) noted for the chirping notes produced by the male rubbing together specially modified parts of the forewings.

[...] ἔνθα τε ναίουσι ψυχαί, εἴδωλα καμόντων.

ω 14

[...] where the ghosts dwell, phantoms of men who have done with toils.

Od. 24.14

Telemachus' tower, as has already been described, was situated on the northernmost end of Crikellos hill. The site, being the highest point on the hill, commands an excellent view of the surrounding area. One can survey the entire region around it; the swamp, and the meadow in its entire length. On calm nights, one can hear clearly the chirping of the crickets. Homer, having composed *The Odyssey* in such detail, must have been aware of the cricket chirping so that, as a modern stage manager would, completed the picture he painted with his verses, with the sounds of the surrounding area. He must have been there to do that. It is completely within the realm of possibility to visualize Homer, composing his epic, while sitting by Telemachus' tower from which point he had a clear view of the area through which the procession of the dead suitor's ghosts marched (Od. 24.1-14).

CHAPTER TEN

THE ROCK LEUCAS AND THE ALTAR OF APOLLO

S APPHO, Cephalus, Homer, three names, three personalities that inspired the artists of antiquity, apparently lived a part of their lives in the same locale where Homer was born, at the enchanting harbour of ancient Ithaca, near the meadow of asphodel.

1. Cephalus, the Patriarch of Cephallenians

Cephalus, a handsome young man, inspired a great passion in Eos (Dawn). He, however, did not respond to her feelings and she, in revenge, cast jealousy and hate between Cephalus and his wife Procris. As a result, Procris was killed in a hunting accident.

Cephalus descended from Deucalion who begot Helenus by Pyrrha, who in turn begot Aeolus by Orseis, who begot Deïon, whose son was Cephalus. Following his adventure with his wife, Procris, daughter of King Erechteus of Athens, and after her accidental death, he was banished from the city by the court sitting at the Hill of Ares. Later, he took part in Amphitryon's expedition, expelled the Teleboans from Cephallenia and settled there along with his sons Pallis, Samius, Pronus, Cranius and his son Arceisius, Odysseus' grandfather. According to other sources Cephalus was abducted by Eros who had fallen in love with him, and taken to heaven. This event inspired many artists in antiquity, which depicted the scene on many monuments, and particularly on Attic pottery. Strabo says that Cephalus, in love with Pterelas, flung himself from the rock Leucatas and was killed. Sappho is also said to have been the first to fling herself from the rock. As Medander said:

> When she was chasing the haughty Phaon through frantic long-
> ing, to fling herself with a leap from the far seen rock calling in
> prayer upon thee, O lord and master.

Str. 10.2.9

It is not clear from the above as to who took the leap first. The question is perhaps important as far as establishing their respective ages, but what is important to this study is the fact that both Cephalus and Sappho allegedly flung themselves from the rock. Also of importance is the question of the exact location of the rock, given that Cephalus was the patriarch and king of the Cephallenians and pre-dates Sappho. Studying Strabo in more detail one could draw certain interesting conclusions.

> *In early times Leucas was a peninsula of Acarnania, but the poet calls it «shore of the mainland», using the term 'mainland' for the country which is situated across from Ithaca and Cephallenia; and this country is Acarnania. And therefore, when he says «shore of the mainland», one should take it to mean «shore of Acarnania.» And to Leucas also belonged, not only Nericus, which Laertes says he took*
> *verily I took Nericus, well built citadel, shore of*
> *the mainland, when I was lord over the Cephallenians,*
> *but also the cities which Homer names in the catalogue*
> *and dwelt in Crocyleia and rugged Aegilips*
> *But the Corinthians sent by Cypselus and Gorgus took possession of this shore and also advanced as far as the Ambracian Gulf; and both Ambrasia and Anactorium were colonised at this time; and the Corinthians,*
> *dug a canal through the isthmus of the peninsula and made Leucas an island; and they transferred Nericus to the place which, though once an isthmus, is now a straight spanned by a bridge, and they changed its name to Leucas, which was named as I think, after Leucatas; for Leucatas is a rock of white colour jutting out from Leucas into the sea and towards Cephallenia, and, therefore, it took its name from its colour.*
>
> <div align="right">Str. 10.2.8</div>

> *It contains the temple of Apollo Leucatas, and also the «Leap», which was believed to put an end to the longing of love.*
>
> <div align="right">Str. 10.2.9</div>

Following the above Strabo explains:

> *It was an ancestral custom among the Leucadians, every year at*
> *the sacrifice performed in honour of Apollo, for some criminal*
> *to be flung from this rocky look-out for the sake of averting evil,*
> *wings and birds of all kinds being fastened to him, since by their*
> *fluttering they could lighten the leap and, also, for a number of*
> *men, stationed all around below the rock in small fishing boats,*
> *to take the victim in and, when he had been taken on board, to*
> *do all in their power to get him safely outside their borders.*
> *The author of the Alcmaeonis[1] says that Icarius, the father of*
> *Penelope, had two sons, Alyzeus and Leucadius, and that these*
> *two reigned over Acarnania with their father; accordingly Epho-*
> *rus thinks that the cities were named after these.*
>
> Str. 10.2.9

These erroneous assessments of Strabo, among others (e.g. πανυπε-
ρτάτη 'panhypertáti': northern), led many scholars to search for pre-
historic Ithaca in Leucas, and for some to argue that the Cephallenians
were Acarnanians. It is not unlikely that the peninsula took its name
from Leucadius if, in fact, he was Penelope's brother. Leucadius, along
with his father Icarius and his brother Alyzeus, as stated above, reigned
over Acarnania. However, the misconception regarding Leucas should
come to an end, since nothing connects it to Homer save the one verse
where he mentions that it is the mainland across from Same (today's
Ithaca).

> *[...] οἵ τε Ζάκυνθον ἔχον ἠδ' οἳ Σάμον ἀμφενέμοντο,*
> *οἵ τ' ἤπειρον ἔχον ἠδ' ἀντιπέραι' ἐνέμοντο· [...]*
>
> B 634-5

> *[...] and those who held Zacynthus, and who dwelt about Samos,*
> *and held the mainland and dwelt on the shores opposite the isles.*
>
> Il. 2.634-5

1. The author of this epic poem on the deeds of Alcmaeon is unknown. Loeb. note.

The relations between the peninsula of Leucas and the Acarnanian coast all the way to Thesprotia were commercial in nature. They concerned the exchange of goods and animals, and traffic from Atheras to Vasiliki. Odysseus, a hero of the Cephallenian tribe in Homeric poetry, has a place in the Thesprotian folklore, centred in Mt. Pindus and the borders between Epirus and Macedonia. Relations between Cephallenians and Thesprotians, who dwelt in the coastal regions of Epirus, were good. Since the Greek tribes had a tendency to migrate from North to South, the theory that the Cephallenians came from Epirus is quite plausible. As a result, they were considered to be one of the tribes belonging to the western dialectal group, which migrated south, before the end of the Mycenaean period[2].

This dialectical kinship of the inhabitants of these regions does not, on the other hand, permit the misinterpretation of facts. Drawing conclusions lightly without close scrutiny is unacceptable. To accept the proposition that Leucas was named after the rock Leucas based on the pertinent Homeric verse (Od. 24.11) is, to say the least, arbitrary. It is not valid if the remaining elements of the Homeric description are not covered. By this it is meant that one should be able to demonstrate the existence of a meadow of asphodel, the Gates of the Sun and the remaining items presented in the pertinent chapters of this volume. Close scrutiny of the information available is, therefore, needed in order to refute Strabo's arguments and establish the truth based on sound evidence.

In the first place, the issue of «ἀκτὴν ἠπείροιο», on the shore of the mainland (Od. 24.378) and the city of Nericus (Od. 24.377) have been adequately covered and solved[3]. Ἀκτή 'Acté': wheat or corn, Nericus: the cyclopean walls at Cranea in Cephallenia. Therefore, there is no connection of Leucas and Acarnania to Strabo's theory that the city of Nericus was transferred to the place that was once an isthmus and was

2. These assessments are noted in the article The Western Tribes, History of the Hellenic Nation, Ekdotiki Athinon, Vol.1.
3. See Chapter XII, *The Legendary City of Nericus.*

renamed Leucas from the Leucatas rock, which lies in the wild open sea. Quite possibly, Leucas was thus named after the rock in question, but there is no connection to the rock Leucas mentioned by Homer (Od. 24.11) which, in fact, is the Sklavdolitis precipice.

Strabo says that according to Menander, «Sappho was first to take the leap, yet those who are better versed than he in antiquities say that it was Cephalus.» He gives no indication as to who those better versed in antiquities may be. In the first place, Cephalus was the patriarch of the Cephallenians, the king of the islands and lived along with his children in Cephallenia (Od. 24.355, 376-7, 20.210). His kingdom lay across from the *démos* of Ithaca, that is, at the neck of the Kouttavos bay where Argostoli is found today. It makes, therefore, no sense for Cephalus to go to Leucas to commit suicide. Secondly, the ancient custom of flinging a criminal from the rock into the sea, was not intended to kill him. A number of men were stationed all around below the rock in small fishing boats to take the victim in. They did all in their power to get him safely outside their borders. It is not reasonable, then, that they would fling a man into the sea from cape Leucatas, which lies in the open sea and is almost always dangerously turbulent, and put themselves in danger as well. The sea depth in these waters starts at 24 m., very quickly reaches 148 m. and a short distance further 238 m. Small fishing boats are not fit to take part in such proceedings. The ancestral custom described by Strabo cannot have taken place at cape Leucatas. The rock Leucas mentioned by Homer (Od. 24.1-14) lies at the deep end of the Livadi bay and is known today as Skavdolitis. This precipitous cliff meets all the requirements for the performance of such a ritual, given that the water is shallow (1 to 2 m.) and calm, and small fishing boats can easily manoeuvre in them. Finally, the rescuers were expected to conduct the victim safely outside their borders. This could be done quite easily if the rock in question was in fact the rock Leucas of Homer, since it is located in the center of the deep end of the bay. All activity took place within it and on the two opposite sides of it. All they would have to do was to take him outside the bay. Conversely, there was nowhere to take the man if the rock was that of Leucatas in Leucas, since cape Leucatas lies virtually outside the island.

2. Sappho, the Tenth Muse[4]

Which island did Sappho visit; Leucas or Homer's Ithaca? This is a question that needs to be answered, and to do this one should first investigate the facts known about her life.

Sappho[5], aeol. Psappho or sometimes Saphpho. Greek lyric poetess, born on the island of Lesbos, probably towards the end of the 7th century B.C. She flourished during the first half of the 6th century B.C. and was a contemporary of Stesichorus, Alcaeus with whom she became friends and Pittakus. It appears that she begot a daughter Cleida at an advanced age. She took no interest in the turbulent political affairs of her time. Even so, as reported, she was forced to take refuge in Sicily for a number of years, following the eruption of internal political strife. She dedicated herself to her school of music and poetry that she organised at her house. The themes of her poetry, as inferred from her extant poems and fragments, was her passionate love for her students, hymns to the deities, epigrams, bridal hymns and odes. Menander's and Strabo's reports of her suicide due to her rejection by Phaon, a marine demon, were proven to be unfounded. Nevertheless, the event inspired dramatist Franz Grillparzer to compose Medea.

Sappho's poetry, composed in the aeolic dialect, was organised by the Alexandrine scholars into nine books according to meter, but most of these were lost. A few of her stanzas were discovered on Egyptian papyri, best known being the invocation to Aphrodite. Her verse, the classic example of the «pure love lyric», is characterised by passion, a love of nature, a direct simplicity, and perfect control of meter. The admiration in which she was held in antiquity was amply justified. Various aeolic meters were named 'Sapphic' after her, either because they were introduced by her or because they were often used in her compositions. Among them the Sapphic endecasyllabus (eleven-syllabled), the Sapphic eccedecasyllabus (sixteen-syllabled), the four-syllabled choriambic meter and the Sapphic hexameter.

4. Attributed to Plato. Trans. note.
5. See Great American Encyclopedia, Greek Edition 1968, Vol.19, p.228.

From another source[6] one is informed that Sappho was born in Eressos on the island of Lesbos in the year 715 B.C., of aristocratic parentage. Following her return from Sicily, she established a school where young girls of good families learned music and dance. From her verses one learns that there were other similar institutions in Lesbos. The story of her suicide by leaping off a rock into the sea is not historically confirmed.

Sappho's language was that of the spoken aeolic dialect of the day. Her descriptions are simple, devoid of embellishments. She bequeathed to Greeks and Romans various meters principle among which was the so-called Sapphic meter. The combination of intense feeling and simple expression gave to her poetry that unique quality that charmed antiquity. Sappho, never addresses herself directly to the 'intellect'. She knew well that great poetry does not seek 'intellectuality' but rather feeling and impressions, which would cause the listener's intellect to react by forming ideas. No woman in the entire poetical tradition of Greece attained the fame or influenced poetry as Sappho did. She was named the tenth muse[7] and her busts decorated various cities from Athens to Syracuse. The ship conveying her to Sicily and back, must have by necessity sailed by the coast of Homeric Ithaca. The story of her suicide connecting her, though indirectly, to Cephalus points to an obvious assumption. She followed a course that led her to the same spot where the Cephallenian patriarch was lifted by Eos, the rosy-fingered early Dawn, into the heavens: To the rock Leucas.

῏Ημος δ' ἠριγένεια φάνη ῥοδοδάκτυλος ῾Ηώς [...]
6 1 – A 477

And as soon as early Dawn appeared, the rosy fingered, [...]
Od. 2.1 – Il. 1.477

6. History of the Hellenic Nation, Ekdotiki Athinon, Vol.2, p.416.
7. By Plato. Strabo calls her an awesome creature while Dionysius Halicarnassus counts her among the masters of the melodic style.

Legend locates the rock toward the east, in relation to Homeric Itha-
ca and her harbour, where Skavdolitis lies. Sappho, wished apparently
to visit the land where great poetry was born and pay homage to the
greatest poet of all time. She was, no doubt, aware of the legend of
Cephalus, his passion for his wife and his songs to nature and the hunt.
She thus leaped and was lifted, allegorically, into the silver and gold
horizons of sunny Ithaca, spreading the light of Greece over the earth.
In this way only can one interpret the story of Sappho's heterochronic
presence in Cephalus' time, at the rock Leucas over which the light of
rosy-fingered early Dawn first appears.

[…] ἦρχε δ' ἄρα σφιν
Ἑρμείας ἀκάκητα κατ' εὐρώεντα κέλευθα.
πὰρ δ' ἴσαν Ὠκεανοῦ τε ῥοὰς καὶ Λευκάδα πέτρην,
ἠδὲ παρ' Ἠελίοιο πύλας καὶ δῆμον ὀνείρων
ἤισαν· αἶψα δ' ἵκοντο κατ' ἀσφοδελὸν λειμῶνα,
ἔνθα τε ναίουσι ψυχαί, εἴδωλα καμόντων.
<div align="right">ω 9-14</div>

[…] and he led them,
Hermes the Helper, down the dank ways.
Past the streams of Oceanus they went, past the rock Leucas,
past the gates of the sun and the land of dreams,
and quickly came to the meadow of asphodel,
where the ghosts dwell, phantoms of men who have done with toils.
<div align="right">Od. 24.9-14</div>

This is where Sappho came. To the rock Leucas, the white rock near
the gates of the sun, at the sanctuary of Apollo, whom the descendants
of Cephalus worshipped at the temple of harmony and poetry, near the
calm waters of the curved beach, to Laertes' and Odysseus' palace, and
the tower of Telemachus that stood out, to the poet's home, to the
world of Homer, beloved to men of all ages.

[...] οὗ δὴ λέγεται πρώτη Σαπφώ
(ὥς φησιν ὁ Μένανδρος)
τὸν ὑπέρκομπον θηρῶσα Φάων',
οἰστρῶντι πόθῳ ῥῖψαι πέτρας
ἀπὸ τηλεφανοῦς ἅλμα κατ' εὐχὴν
σήν, δέσποτ' ἄναξ'.

Στράβων, Χ 2.8

[...] Where Sappho is said to have been the first,
(as Menander says)
when she was chasing the haughty Phaon
through frantic longing, to fling herself
with a leap from the far seen rock calling in prayer
upon thee, O lord and master.

Str. 10.2.9

This is where she came. To the place where the Muse inspired the
giant of poetry to surpass human intellect and travel roads unknown.

τῶν ἁμόθεν γε, θέα, θύγατερ Διός, εἰπὲ καὶ ὑμῖν.

α 10

Of these things, goddess, daughter of Zeus, beginning where you
will, tell us in our turn.

Od. 1.10

Then Athena, following her conversation with her father Zeus, told him:

[...] αὐτὰρ ἐγὼν Ἰθάκηνδ' ἐσελεύσομαι ὄφρα οἱ υἱὸν
μᾶλλον ἐποτρύνω καί οἱ μένος ἐν φρεσὶ θείω,
εἰς ἀγορὴν καλέσαντα κάρη κομόωντας Ἀχαιοὺς
πᾶσι μνηστήρεσσιν ἀπειπέμεν, οἵ τέ οἱ αἰεὶ
μῆλ' ἀδινὰ σφάζουσι καὶ εἰλίποδας ἕλικας βοῦς.
πέμψω δ' ἐς Σπάρτην τε καὶ ἐς Πύλον ἠμαθόεντα
νόστον πευσόμενον πατρὸς φίλου, ἤν που ἀκούσῃ,
ἠδ' ἵνα μιν κλέος ἐσθλὸν ἐν ἀνθρώποισιν ἔχῃσιν.»

ω 88-95

[...] I will go to Ithaca, that I may his son
arouse the more, and set courage in his heart
to call to an assembly the long-haired Achaeans,
and speak his word to all the suitors, who continue
to slay his thronging sheep and his spiral-horned shambling cattle.
I will guide him to Sparta and to sandy Pylos,
to seek tidings of the return of his staunch father, if perchance he
may hear of it
that good report among men may be his.»

<div align="right">Od. 1.88-95</div>

And then,

ϐῆ δὲ κατ᾽ Οὐλύμποιο καρήνων ἀΐξασα,
στῆ δ᾽ Ἰθάκης ἐνὶ δήμῳ ἐπὶ προθύροις Ὀδυσῆος,
οὐδοῦ ἐπ᾽ αὐλείου· [...]

<div align="right">α 102-4</div>

Then she went darting down from the heights of Olympus,
and took her stand in the land of Ithaca at the outer gate of Odysseus,
on the threshold of the court;[...]

<div align="right">Od. 1.102-4</div>

The story of Sappho's suicide is unfounded as stated. She returned to Lesbos from Sicily stopping over somewhere in the Ionian Sea. Regarding, however, her visit to Ithaca and in particular to the rock Leucas, there is evidence that she came as a pilgrim to the poet's land thanks to the existing legend about Apollo's sanctuary, Cephalus and Homer himself. As far as **Phaon** is concerned, legend has it that he was a marine demon, the son of Cephalus and Eos, belonging to Aphrodite's entourage and was transformed from an ugly old man to a beautiful youth. His beauty was extolled by Sappho who, being rejected, committed suicide.

3. Lesbos – Cephallenia

Eressos (Sigri promontory) and Eryssos (Assos). Two places in two different islands, Eressos in Lesbos and Eryssos in Cephallenia having, as indicated by the similarity of their names, common historical connections. These were, most likely, responsible for the transference of the toponym Eressos to the peninsula in northern Cephallenia, which originally must have been named Eressos but the name was eventually changed to Eryssos. The main characteristics common to both areas are listed below.

CHARACTERISTIC	LESBOS	ITHACA
Name	Eressos	Eryssos (Aegilips, Il. 2.633)
Peninsula	Sigri	Assos
Land nature	Unproductive	«Τρηχεία» (Rough, Stony, Il. 2.633)
Odysseus at	Lesbos (Od. 17.133)	Eryssos (Aegilips, Il. 2.631-3)
Sappho at	Eressos (birth place)	Visit to Ithaca

Homer must have had a deep influence on the famous poetess, who was, historically, relatively close to the events he described. It was, thus, quite natural that she would wish to visit the land of Odysseus of many crafts, while on her way home from Sicily. In fact, Odysseus himself, some years earlier, had travelled to Lesbos (Od. 17.133).

As suggested in previous chapters, in Homeric times and in the times of the Trojan war, the name of the northern peninsula of Cephallenia was most likely Aegilips (Il. 2.633). it was perhaps re-named Eressos on the occasion of Sappho's visit there, taking thus the name of her home city. The famous coast in northern Cephallenia today is still carrying the almost identical name Eryssos, probably a corruption of Eressos. As pointed out above, Cephallenian Eryssos and Eressos in the island of Lesbos, have certain similarities as for example the rough and unproductive nature of the land. In Hari Patsi's Encyclopedia the

following are stated regarding Eressos in Lesbos[8]. The Eressos land-scape is wild and barren. One should think the earth was convulsed all life being swept away. Witnesses to this catastrophy are the remains of petrified tress that can be found even in the bottom of the sea (similar to the area between Eressos – Sigri – Antissa). The inhabitants are hard working, stubborn men, who live from cattle breeding and by cultivat-ing what land there is that contains earth. They manage to produce cer-tain good crops such as the famous Eressos figs.

Homer gives the same characteristics when mentioning that Aegilips is τρηχεία 'trecheía' (rough, stony, II. 2.633), this area being in fact contemporary Eryssos in northern Cephallenia. Eryssos is the most un-productive area on the island. In addition, there are similarities between the small peninsula at the Sigri bay in Lesbos and the Assos peninsula in Cephallenia. In antiquity the Lesbos peninsula was called Σίγριον ἄκρον, 'Sígrion ácron' (Sigris point), and has retained the name to this day. It appears, then, that either Sappho, during her passage from Homer-ic Ithaca, or Odysseus, following his return to his homeland, gave the name Eressos to the then named Aegilips peninsula, and the name was retained to this day as Eryssos. The above proposition strengthens the view that Sappho visited Cephallenia and therefore the rock Leucatas is in fact the Skavdolitis rock where ostensibly Sappho's Leap took place, near the altar of Apollo.

4. Apollo, Ithaca's Patron God

I. Apollo the Purifier

Searching for the altar of Apollo in Ithaca, it is necessary to keep in mind that Apollo, son of Leto and Zeus, was the god of light, of div-ination, of poetry and had many special attributes and qualities. His

8. Hari Patsi Encyclopedia, Vol.VII, p.238.

most common epithet was Pheobus, derived from φάος 'phaós' (light) or from the verb φέβομαι 'phébomae' (to be put to flight), denoting his quality of putting ill to flight, ἀλεξίκακος 'alexícacos'. He was the personification of the sun, of harmony of the universe, of peace of the soul, of balance and purification. Apollo was surnamed Δελφίνιος 'Delphínius' (of the dolphins) an epithet later attached to Poseidon, Νόμιος 'Nómius' from νομή 'nomé' or pasturage, Μαλεάτας 'Maleátas' possibly from μῆλον 'mélon', sheep, Ποίμνιος 'Poémnius' from ποιμήν 'poemén', shepherd (i.e. of people), Ἀγρεύς 'Agréus' or hunter, Ἀποτρόπαιος 'Apotrópaeus' (averting evil), Ἀγνιεύς 'Agnieús' (purifier), Προστατήριος 'Prostatérius' (protector), Καθάρσιος 'Catharsius' (cleanser of guilt), Σωτήρ Σοτάς 'Sotér' (savior, deliverer), Θέσμιος 'Thesmius' (keeper of laws, customs, rites), Πατρώος 'Patróus' (descending from the father), Ἀρχιγέτας 'Archigétas' (first leader), Κουροτρόφος 'Kourotrófos' (raiser of children), Δρομαιεύς 'Dromaeus' (patron of racing), Πύκτης 'Pýctes' (boxer), Ἀργυρότοξος 'Argyrótoxos' (of the silver bow), Ἑκατεβόλος 'Hecatebólos' (far shooter), Βοηδρόμιος 'Boedrómius' (Helper), Λοξίας 'Loxíus' (of crooked, ambiguous oracles), Μουσαγέτης 'Mousagétes' (leader of the Muses), Ξανθός 'Xanthós' (yellow haired), Χρυσοκόμας 'Chrysocómas' (golden haired), Ἀειγενέτης 'Aeigenétes' (everlasting), Λύκειος 'Lýceus' (of light), Ἑκάεργος 'Hecáergus' (who works from afar), Κλυτότοξος 'Clytótoxus' (famed archer). Still an infant, he was named Πύθιος 'Pýthian' (i.e. Delphic), and later, when searching for a site to establish his sanctuary, he came to Delphi in Beotia and killed the terrifying serpent Pytho. Another myth has it that he descended from Mt. Olympus, passed by Pieria, arrived at the Cryssa valley, killed Pytho who guarded the Oracle of Themis, named the site Pytho, established his sanctuary and the Pythian games, and returned to the valley of Tembi to be purified of the killing of Pytho. Killing always brought disaster. This ancient superstition was elevated by the god to being an ethical law. He returned cleansed, crowned by branches of laurel holding a branch in his land. As men become more and more civilised, they developed ethical values, and Apollo became the one who personified for humanity harmony, peace and balance.

Along with Zeus and Athena, Apollo constituted a trinity that represented for the ancient Greeks divine power in all its perfection. He

was the personification of the Greek sky's brightness, the expression of the beauty and harmony of Greek nature, and the incarnation of the genius of Greece. For these reasons he became a pan-Hellenic divinity and was worshipped throughout Greece and later Rome. As god of light, he personified the sun, while the epithets Phoébus, Chryxocómas, Xanthós, Aeigenétes and Lýceus are related to sunlight. He was worshipped in Ithaca where the clear sky induces man to revere the beautiful landscape whose natural beauty is not found anywhere else. Apollo was named Leucatas because he fell in love with a handsome youth by that name who, to avoid disgrace, leaped from the rock subsequently named after him, and drowned in the sea. According to tradition, the god being 'Alexícacos' (he who keeps off evil), had his sanctuary built on the site. The rites described by Strabo were performed there as a means of purification designed to avert evil. It was also believed that leaping from the rock put an end to the longing of love.

II. Apollo Clytotoxus

Κλυτότοξος 'Clytótoxus', an epithet attached to Apollo, is found only twice in *The Odyssey*, even though the god's name appears twenty eight times. The first occasion was when Penelope cursed Antinous for hitting Odysseus, in his beggar's disguise, and invoked the god.

«αἴθ᾽ οὕτως αὐτόν σε βάλοι κλυτότοξος ᾿Απόλλων.»
ρ 494

«Even so may your own self be struck by the famed archer Apollo.»

Od. 17.494

The second time, the epithet is used in a conversation between Antinous and Eurymachus, concerning the feast that was taking place that day in Ithaca, in honour of the god:

[...] ὄφρ᾽ ἐπὶ μηρία θέντες ᾿Απόλλωνι κλυτοτόξῳ [...]
φ 265-8

[...] that we may lay thigh pieces on the altar of Apollo the famed archer, [...]

Od. 17.265-8

These two references to Apollo indicate clearly that he was considered patron god of the city and that there was an altar where they offered sacrifice to him. One gets the clear impression that a sanctuary dedicated to the god was to be found near by, and quite obviously the reference to the altar is related to the one located on the top of the rock Leucas, today's Skavdolitis precipice. Patron saints or gods have, through the ages, been given epithets by the common folk because of some outstanding event or because of the morphology of the place. In the case of 'Clytótoxus' Apollo, one can quite safely attribute the epithet to the morphology of the land where the sanctuary and altar lie, on the top of the sacred white rock. The rock in question, as already described, is located on the tangent of the great circle described by the «curving beach» (Od. 22.385), where the neck of the «deep harbour» is formed (Od. 16.324), the deep bay of Livadi. The epithet 'Clytótoxus' is a compound word formed by the words κλυτός 'clytós' and τόξον 'tóxon' where 'clytós' stands for famed and 'tóxon' for bow.

The reason why the Ithacians gave the god the above epithet is quite obviously due to the site selected to erect his sanctuary, at the neck of the great curving coast. The beauty and brightness of the landscape will be remembered by any visitor who would undertake a walk from Kritonou, through the fields of Ammourdes, to the edge of the Skavdolitis precipice. In *The Iliad*, the poet uses the epithet to characterise Apollo only three times out of one hundred and thirty seven times the name of the god comes up (Il. 4.101, 119, 15.55). All three occasions relate to sacrifices at his altar and to the brightness, λυκηγενι 'lykegenéi', of the sun and the sky. Through epithets the poet adorns and honours the god of the silver bow, the famed archer, the far shooter of golden rays, whose altar lies at the majestic bow of the curving beach of the harbour of Ithaca. To this day the area goes by the name Crikellos, meaning circle, ring, round, having the shape of a bow, a toponym confirming the above theory.

5. The Sacred Hecatomb

Re-examining Homer's verses describing the procession of the
dead suitors' ghosts should shed some light on the location of the altar
where the sacred hecatomb was offered in sacrifice. As the poet states:

πὰρ δ' ἴσαν Ὠκεανοῦ τε ῥοὰς καὶ Λευκάδα πέτρην,
ἠδὲ παρ' Ἡελίοιο πύλας καὶ δῆμον ὀνείρων
ἤισαν· αἶψα δ' ἵκοντο κατ' ἀσφοδελὸν λειμῶνα,
ἔνθα τε ναίουσι ψυχαί, εἴδωλα καμόντων.

ω 11-4

Past the streams of Oceanus they went, past the rock Leucas,
past the gates of the sun and the land of dreams,
they went; and quickly came to the meadow of asphodel,
where the ghosts dwell, phantoms of men who have done with toils.

Od. 24.11-4

The souls went, were walking, near the streams of Oceanus (Sea)
and the rock Leucas (White Rock), and also by the gates of the sun,
and reached the meadow of asphodel. The rock Leucas and the gates
of the sun constitute two elements that relate to the Skavdolitis pre-
cipice and the rising sun behind it. This description corresponds to the
actual landscape and the orientation of the site in relation to the posi-
tion of Crikellos hill (the hill of Hermes) where lay the palace of
Odysseus. The verses that follow supplement those above giving a
complete pictorial description of the site in question.

κήρυκες δ' ἀνὰ ἄστυ θεῶν ἱερὴν ἑκατόμβην
ἦγον· τοὶ δ' ἀγέροντο κάρη κομόωντες Ἀχαιοὶ
ἄλσος ὕπο σκιερὸν ἑκατηβόλου Ἀπόλλωνος.

υ 276-8

Meanwhile the heralds through the city the holy hecatomb of the gods
were leading, and the long-haired Achaeans gathered together
beneath a shady grove of Apollo, the archer god.

Od. 20.276-8

The heralds were to perform a sacrifice and the people gathered under the trees of the grove of Apollo. This is the interpretation given by all translators of the verses. The real meaning of the verses has escaped them, thus not transmitting the essential point of the verses. The heralds, as it were, were leading the animals ἀνὰ ἄστυ, over the city, where they were to be sacrificed. It is quite obvious that the sacrifice was taking place on another level, somewhere above the city of Ithaca. The site was sacred since the altar of Apollo was situated there. By the same token, the Alsos (grove) was also considered as being sacred since it was dedicated to the god[9]. This clarification pinpoints the location of Apollo's altar where the sacrifice was to take place as well as the grove where the Ithacians gathered.

6. The Shady Grove of Apollo

The heralds led the sacrificial animals to a site above the city and the long-haired Achaeans gathered there to observe the ceremony. This statement of Homer gives a quite clear image of a site high up above the city and a shady grove that lies near by. The verses that follow indicate that the poet situates Apollo at a site from which it is possible to survey the goings on at the palace and the entire region of the *démos* of Ithaca as well as the deep bay of Livadi.

αἲ γὰρ Τηλέμαχον βάλοι ἀργυρότοξος Ἀπόλλων
σήμερον ἐν μεγάροις, ἢ ὑπὸ μνηστῆρσι δαμείη, [...]
ρ 251-2

Would that Apollo of the silver bow might strike down Telemachus today in the halls, or that he might be slain by the suitors, [...]
Od. 17.251-2

9. «ὄψεις ἀγλαὸν ἄλσος Ἀθήνης», Od. 6.291; «ὅς νῦν κεκληγὼς περιμαίνεται ἱερὸν ἄλσος Φοίβου Ἀπόλλωνος,», Hes. Sc. 99.

Again,

«αἴθ' οὕτως αὐτόν σε βάλοι κλυτότοξος Ἀπόλλων.»
ρ 494

«*Even so may your own self be struck by the famed archer Apollo.*»

Od. 17.494

And again,

νῦν μὲν γὰρ κατὰ δῆμον ἑορτὴ τοῖο θεοῖο
ἀγνή· [...]
φ 258-9

For today throughout the land[10] *is the fest of that god*[11]
a holy feast.[...]

Od. 17.258-9

The feast was taking place in the *démos*, that is, in the greater Ithaca area, not in the city itself. The suitors, at the same time, were preparing to offer their own sacrifice on the following day.

[...] ἠῶθεν δὲ κέλεσθε Μελάνθιον, αἰπόλον αἰγῶν,
αἶγας ἄγειν, αἵ πᾶσι μέγ' ἔξοχοι αἰπολίοισιν,
ὄφρ' ἐπὶ μηρία θέντες Ἀπόλλωνι κλυτοτόξῳ
τόξου πειρώμεσθα καὶ ἐκτελέωμεν ἄεθλον.»
φ 265-8

[...] And in the morning bid Melantheus, the goatherd,
to bring she-goats, far the best in all the herds,
that we may lay thigh pieces on the altar of Apollo the famed archer,
and so try the bow and complete the contest.»

Od. 17.265-8

10. The ancient text indicates «κατὰ δῆμον», through the *démos*. Trans. note.
11. Apollo, the archer god. Loeb Ed. note.

The impression created by the above verses is that Apollo is to be found somewhere near, at a site that overlooks the region, from which he could easily shoot his arrows, since no one could hide from him.

7. The Sacred Altar of Apollo.

In general, an altar in ancient times was built of earth, cinders, wood or stone. The shape could be circular, square or rectangular, and it was usually decorated with reliefs. It was erected facing the statue of the god or the temple, so that he who offered sacrifice would also face the same way. Of great repute was the altar of Apollo at Delos.

The remnants of the Doric temple found in the center of the Livadi village, were the first indication as to the location of Apollo's altar. This sanctuary, even though it dates from a later period, points to the existence of a center of worship on the site, most likely dedicated to this god. Homer's verses quoted above showed the way to the place being sought. Logically, it should lie towards the rising sun, towards the point whence the light of Phaethon, of Phaon, comes, where the gates of the sun and the rock Leucas are located, by which Hermes passed when leading the souls of the dead suitors. Consequently, in relation to the site where Odysseus' palace was built and the city of Homeric Ithaca was located, the altar should be found on the top of Skavdolitis.

The distant voices murmuring softly, in mind's ear, the magical pictures painted by the poet's verses led the author to explore the site where he estimated the sacred place should lie. On Sunday, July 23, 1995, starting from the village of Agonas and following the narrow paths on the edge of the rugged mountains of the area, he reached the top of Skavdolitis, by the way of the Kritonou site. The search started on the eastern side of the rock, walking along the edge of the precipice and reaching the middle of it where big white rocks are standing straight up, imbedded in the ground, resembling small towers. There was no sign of any structure and thus continued walking along this nearly flat summit toward the west, to the edge that overlooks the Livadi swamp.

Just about where it should logically lie, one finds a structure 17,0 m. x 5,0 m. forming a rectangle, built with great boulders about one cubic meter in size. The long axis of it points from Odysseus' palace

towards the rising sun. The passage of time, earthquakes and the elements have left their unmistakable marks. Stones strewn around show clearly that they were part of the altar, while the area around indicates that it was arranged to accommodate its construction. Its perimeter is about 45 meters, which is even bigger than the famous altar of Zeus at Olympia (Illus. 25). It was probably built at the time of the Taphian Pterelaus and perhaps, if tradition could be trusted, even earlier, given that Cephalus, Arceisius' father and Laertes' grand father, leaped to his death from this same rock.

> *«With a fluttering heart I confronted exactly what I was contemplating for so long and hoped to find on this spot. I had arrived there a pilgrim to the most venerable remains of the brightest spiritual beacon in the history of humanity. I was in front of the altar of Apollo, the same stones still standing next to each other, as they were then, at the time when the hecatomb was sacrificed by the heralds and the Achaeans of Ithaca. The mere thought that I was the first to visit the altar of the god at Leucas since its heyday deeply moved me. It was a most unique and thrilling experience in my life.»*

The most exalted names in ancient poetry, Apollo, Homer, Cephalus and Sappho come together spiritually at the altar on the rock Leucas where blinding light averts evil and man, finding peace of mind, cleanses himself of evil and his own passions, and venerates god for the miracle of life.

8. The Leap

A great rock, imbedded in the ground, rises like a tower in the middle of the precipice's edge, about 300 meters to the east of the altar. This is the ἄλμα, 'álma' (Leap), from which a criminal was flung over every year to purify the community from evil. One should be reminded that following the burial of the suitors, Odysseus purified his palace with sulphur. This was followed by the procession of the ghosts of the

dead suitors toward the gates of the sun and the rock Leucas, the journey ending at the meadow of asphodel. It appears that the poet, keeping in line with tradition, leads the souls by Apollo's sanctuary where they allegorically take the leap from the white rock into the meadow, thus propitiating the god for the slaughter that took place at the palace.

The small grove of Apollo is found below the point where the altar lies. Big pine trees grow there that can be seen around the first turn of the road that climbs up from the Livadi swamp. It is not known whether there was a temple or sanctuary or a statue of Apollo near the altar. The verses quoted on the subject, however, (Od. 24.11-14, 20.251-2, 494, 21.258, 267-8) show a deep religious feeling and the god's location at a point situated high above, from which he could survey everything. Indeed, viewing the rock from the palace, one has the feeling that he is within the range of an arrow. So, nothing preludes conjecture.

All societies have traditions and beliefs about ghosts and spirits and other supernatural beings, connected to the history of the land, the deeds and passions of the ancestors. The villagers at Livadi are not an exception. Without being aware of the turbulent events of thirty-five centuries ago, they believe the local legend according to which, phantoms wander at night at Skavdolitis. This is a belief that originates in the remote past and is kept alive by the unfailing instinct of a proud people. It brings to mind Homer's verses:

[...] ἔνθα τε ναίουσι ψυχαί, εἴδωλα καμόντων.
ω 14

[...] where the ghosts dwell, phantoms of men who have done with toils.

Od. 24.14

CHAPTER ELEVEN

DULICHIUM

1. The Lost Homeric Island

Humanity has been seeking Ithaca in vain since antiquity, in spite of the many Homeric descriptions and references available, on the basis of which, however, it was possible to identify it with the island of Cephallenia. Along with Ithaca, the location of Dulichium has remained a mystery; the information regarding it being so scanty that no thought has ever been given to the possibility of identifying it. It is an island that has completed vanished. There are nine references to Dulichium in the Homeric text. The pertinent verses of *The Odyssey* are transcribed below in translation, in order to present the analysis, which should help the reader to understand the proposition put forth regarding the lost island.

For all the princes who hold sway over the islands –
Dulichium, and Same, and wooded Zacynthus –
and those who lord it over rocky Ithaca,
all there woo my mother and lay waste my house.
<div align="right">Od. 1.245-8</div>

[...] and around it many islands
lie close by one another,
Dulichium, and Same and wooded Zacynthus.
<div align="right">Od. 9.22-4</div>

But me he sent forth first, for a ship chanced to be setting out,
that belonged to Thesprotians, for Dulichium, rich in wheat.
<div align="right">Od. 14.334-5</div>

If your master returns to this house,
cloth me in a cloak and tunic to wear, and send me
on my way to Dulichium, where I desire to be.
<div align="right">Od. 14.395-7</div>

[...] for all the princes that hold sway over the islands –
˙ Dulichium, and Same, and wooded Zacynthus –
and those who lord it over rocky Ithaca,
all these woo my mother and lay waste my house.

Od. 16.122-5

From Dulichium there are two and fifty chosen youths,
and six serving men attend them; [...]

Od. 16.247-8

He (Amphinomus) came from Dulichium, rich in wheat and in grass,
and led the suitors [...]

Od. 16.396-7

For all the princes who hold sway over the islands –
Dulichium, and Same, and wooded Zacynthus –
and those who dwell in clear-seen Ithaca itself, [...]

Od. 19.130-2

But he sent me forth first, for a ship chanced to be setting out,
that belonged to Thesprotians, for Dulichium, rich in wheat.

Od. 19.291-2

Dulichium is referred to as an island in four of the above nine descriptions (Od. 1.245, 9.22, 16.122, 19.130) and is in all cases placed first among the four islands, that is Dulichium, Same, Zacynthus and Ithaca. While already in Ithaca, Odysseus repeated twice the fact that he came from Thesprotia (Od. 14.334-5, 19.291-2). Amphinomus, the leader of the suitors, who hailed from Dulichium is also mentioned four times in verses other than the above nine (Od. 16.396, 18.127, 395,424).

When Odysseus, sailing on the Phaeacian ship, reached the leeward harbour of Phorcys and after he recognised where he was he set off for the swinesty of Eumaeus, his faithful swineherd. It lay a little ways over the harbour of Phorcys, near Coracopetra and the Arethousa spring. There, he found the swineherd, but for obvious reasons he did

not wish to reveal his identity and avoided at all costs to be recognised by him. To accomplish his purpose he invented a fantastic story, stating that King Pheidon of the Thesprotians had seen Odysseus, who had gone to Dodona[1]. According to the story told Eumaeus (Od. 14.331-60) and Penelope later on (Od. 19.287-302), the ship set off from Thesprotia, and came to Ithaca, because it chanced to be going to Dulichium. The implications of the story as to the place where the ship landed and the place where it was told are enlightening. It is worth transcribing the entire tale both because of the beauty of the Homeric description, but also because these verses are so revealing regarding the location of Ithaca and Dulichium. In fact they were the primary source of information in the effort to locate the lost island. In translation, from rhapsody 14, (ξ) we copy:

321 «*There I learned of Odysseus, for the king said*
 that he had entertained him, and given him welcome on his way
 to his native land.
 And he showed me all the treasure that Odysseus had gathered,
 bronze, and gold, and iron, wrought with toil;
325 *and up to the tenth generation would it feed his children after him,*
 so great was the wealth that lay stored for him in the halls of the
 king.
 But Odysseus, he said, had gone to Dodona, to hear
 the will of Zeus from the high-crested oak of the god,
 how he might return to the rich land of Ithaca
330 *after so long an absence, whether openly or in secret.*
 And moreover he swore in my own presence, as he poured libations
 in his house,
 that the ship was launched, and the men ready,
 who were to convey him to his own native land.
 But me he sent forth first, for a ship chanced to be setting out,

1. Dodona: The oldest oracle, in inland Epirus, about 80 km E of Corcyra, sacred to Zeus and Diona. Trans. note.

335 *that belonged to Thesprotians, for Dulichium, rich in wheat.*
 He told them to convey me there to king Acastus,
 with kindly care. But an evil counsel found favour in their hearts
 regarding me, that I might even yet be brought into utter misery.
 When the seafaring ship had sailed far from the land,
340 *they soon sought to bring about for me the day of slavery.*
 They stripped me of my garments, my cloak and tunic,
 and put about me instead a vile rag and shirt,
 the tattered garments which you see before your eyes;
 and at evening they reached the tilled fields of clear-seen Itha-
ca.
345 *Then they bound me fast in the benched ship*
 with a twisted rope, and themselves went ashore,
 and made haste to take their supper by the shore of the sea².
 But as for me, the gods themselves undid my bonds
 easily, and wrapping the tattered cloak about my head,
350 *I slid down the smooth lading plank, and brought to the sea*
 my breast, and then struck out with both hands,
 and swam, and very soon was out of the water, and away from them.
 Then I went to a place where there was a thicket of leafy wood³,
 and lay there cowering. And they lamenting
355 *went hither and thither; but as there seemed to be no profit*
 in going further in their search, they went back again on board
 of their hollow ship. And the gods themselves hid me
 easily, and led me, and brought me
359 *to the farmstead of a wise man; for now, it seems, it is still my lot to*
 live.

Later on, when Odysseus saw Penelope, he repeated the same story, intending to mislead her as well and keep his presence in Ithaca a secret. Among other things he told her:

2. The Homeric text states «ῗνα θαλάσσης» or sandy beach. Trans. note.
3. The Homeric text states «ὁρίος ἢ πολυανθέος ὕλης» or blooming oak wood. Trans. note.

Thus Pheidon, king of the Thesprotians, told me the tale.
Moreover he swore in my own presence, as he poured librations
in his halls,
that the ship was launched and the men ready
who were to convey him to his own native land.
But me he sent forth first, for a ship chanced to be setting out,
that belonged to Thesprotians, for Dulichium, rich in wheat.
Od. 19.287-92

And he concluded thus:

Be Zeus my witness first, highest and best of gods,
and the hearth of flawless Odysseus to which I have come,
that in very truth all these things shall be brought to pass even as
I tell you.
In the course of this very month[4] shall Odysseus come here,
between the waning of this moon and the waxing of the next.»
Od. 19.303-7

Odysseus' convincing words, as transmitted through the verses of
the great poet, excite the imagination, when one confronts the living
truth in the beautiful landscape. It took great faith in Homer's word, in
order to reach this crucial conclusion and approach the 'non-existent'
truth. Odysseus, while in his own home in Ithaca (Od. 19.304), was able
to convince everyone that he arrived there by chance on a Thesprotian
ship bound for Dulichium (Od. 14.334-5). The ship had made a stop
upon «reaching the tilled fields of clear-seen Ithaca» (Od. 14.344),
where the sailors disembarked hastily on the sand banks of the shore
(Od. 14.346-7)[5]. He concocted this fictitious story in order to conceal
his arrival at Ithaca. A credible lie, on the other hand, has to be built

4. Λυκάβαντος: gen. of λυκάβας, year. But mouth according to Dio Chrysostomus
 7.84. Trans. note.
5. The place is known as Ἄμμος: sand. See chapter on PHORCYS, «Kaktos» Ed.
 note.

upon real facts so that it will be believed. These facts, upon which the tale was based, should have been known both to Eumaeus and Penelope the arrival of ships to Dulichium and Ithaca from Thesprotia, was a real event in the daily routine of the islands, and was a known fact to the inhabitants of these distant places. So was the sandy beach where the ship landed (Od. 14.347) and the blooming wood of oak (ὁρίος ἢ πολυανθέος ὕλης, Od. 14.353). The key verses that reveal the location of Dulichium are as follows:

[...] ἑσπέριοι δ' Ἰθάκης εὐδειέλου ἔργ' ἀφίκοντο.
ἔνθ' ἐμὲ μὲν κατέδησαν ἐυσσέλμῳ ἐνὶ νηὶ
ὅπλῳ ἐυστρεφέι στερεῶς, αὐτοὶ δ' ἀποβάντες
ἐσσυμένως παρὰ θῖνα θαλάσσης δόρπον ἕλοντο.
 ξ 344-7

[...] and at evening they reached the tilled fields of clear-seen Ithaca.
Then they bound me in the benched ship
fast with a twisted rope, and themselves went ashore,
and made haste to take their supper by the shore[6] of the sea.
 Od. 14.344-7

It is on the basis of this fictitious tale that one should seek to locate the place where he and his abductors disembarked. The ship on its way to Dulichium put in temporarily at Ithaca's coast. The point of landing selected should, therefore, afford a speedy passage to Dulichium. Assuming that Dulichium was in fact the Argostoli headland as originally proposed, then the exact point mentioned in *The Odyssey*, the cultivated fields of Ithaca, was somewhere across from the light house of Argostoli on the side towards the Pallis peninsula. The points that need clarification are as follows:

6. See note 2 above.

[...] τύχησε γὰρ ἐρχομένη νηῦς [...]
ξ 334

[...] a ship chanced to be setting out [...]
Od. 14.334

[...] ἑσπέριοι δ' Ἰθάκης εὐδειέλου ἔργ' ἀφίκοντο.
ξ 344

[...] at evening they reached the tilled fields of clear-seen Ithaca.
Od. 14.344

[...] ἐσσυμένως παρὰ θῖνα θαλάσσης δόρπον ἕλοντο.
ξ 347

[...] and made haste to take their supper by the shore of the sea[7].
Od. 14.347

ἔνθ' ἀναβάς, ὅθι τε δρίος ἦν πολυανθέος ὕλης, [...]
ξ 353

Then I went[8] to a place where there was a thicket of leafy wood[9], [...]
Od. 14.353

The first obvious observation is that since all this takes place in Ithaca and the ship was bound for Dulichium, the latter should lie within the bay of Livadi as well. Also, by carefully examining the pertinent verses, the exact point where the ship beached and where the tilled fields of Ithaca were found near the sea, needed to be identified with

7. See note 2 above.
8. The text indicates ἀναβάς, mount, go up. Burry renders it go through. Trans. note.
9. See note 3 above.

precision, and also the point from which, hypothetically, Odysseus went up to a wood of blooming oaks. The first approach was to consider the site across from the light house of Argostoli as being the general area where the ship put in, since this is the point, near Ithaca's cultivated fields, from which one could swiftly sail to Dulichium. The next consideration was to define the term *θῖνα*, 'thína', since it carries the main burden of the identification of the exact location of the Thesprotian ship's landing.

The word *θίς*, 'thís', *θῖνα*, 'thína' refers to a sandy stretch or to heaps of sand or earth as «*παρὰ θῖνα θαλάσσης*», or by the sandy heaps of the sea (the beach). It also refers to the mouth of a river or the banks of a stream, or their estuary. A search to locate a site that would fit the Homeric description was undertaken all along the entire coast of the Pallis peninsula from the village of Livadi to Lixouri. The place should have the characteristics of cultivated land, that is, be of ample size and be well irrigated by irrigation ditches. In addition it should lie near a sandy beach and there should be a river or stream in the general vicinity. The search came to an end at the Lixouri plain, the plain that fed generations of Cephallenia's people with its excellent produce, its wines and currants. A perusal of the map published by the 'Geographical Service of the Army' and a study of the details noted on it, revealed the unexpected. The name *Ἀμμουδαρές*[10], 'Ammoudarés', is printed across the map and covers the entire cultivated area of the Lixouri plain.

Thus, what the Lixouri inhabitants call Ammoudarés, Homer refers to as «*παρὰ θῖνα θαλάσσης*» (Od. 14.347) or by the (sandy) shore of the sea. Homer's cultivated land is right there. Who would have thought that the Lixouri plain was part of the landscape of *The Odyssey* and that the poet himself, Odysseus and the other personages of the saga had walked over this land! The writer would have liked to pause at this point, so as to express his surprise and delight that it was possible to

10. *Ἀμμουδαρές* (Ammoudarés): Demotic Greek; of sandy land.

describe entire areas and localities in so few and scattered verses. However, time is of essence and one must carry on. These are the cultivated fields by the sea, at the mouth of the river, where the Thesprotian ship supposedly landed, and where the sailors disembarked. In order to be convincing he claimed to have swum ashore, and after walking a short distance to have climbed a little and to have hid himself in a wood of blooming oaks. It must have been the end of April or the beginning of May, since that is the time when oaks are in full bloom. The story was told by Odysseus, in the guise of an old beggar, to Eumaeus the swineherd, a man who knew the area like the back of his hand. He said that after he untied his bonds, to save himself, he had to get away as fast as possible and hide. The hill mentioned is, in fact, there and is covered by oaks. The land rises at that point and Odysseus would have had to follow this direction, since by continuing to climb he would have passed by Kechriona, then Loukerata, Vlychata, Schinia, the villages Vilatoria, Vovykes, the spring at Halkes, and from there straight onto the road to Atheras, where the swinesty was located. It was, therefore, quite plausible that he should have followed this route, one that was familiar to Eumaeus, convincing him that he had been told a true story. It is thus through a lie that a great truth is discovered the location of the long lost island of Dulichium.

2. Dulichium Facing Ithaca

[...] οἳ δή μιν πέμψουσι φίλην ἐς πατρίδα γαῖαν.
ἀλλ' ἐμὲ πρὶν ἀπέπεμψε· τύχησε γὰρ ἐρχομένη νηῦς
ἀνδρῶν Θεσπρωτῶν ἐς Δουλίχιον πολύπυρον.
 τ 290-2

[...] who were to convey him to his own native land.
But he sent me forth first, for a ship chanced to be setting out,
that belonged to Thesprotians, for Dulichium, rich in wheat.
 Od. 19.290-2

[...] ἱστίη τ' Ὀδυσῆος ἀμύμονος, ἣν ἀφικάνω· [...]

τ 304

[...] and the hearth of flawless Odysseus to which I have come, [...]

Od. 19.304

The Thesprotian ship landed near the cultivated fields of Ithaca. Odysseus, disembarked and from there moving in a northward direction, reached Eumaeus' swinesty. The distance between the cultivated fields (the Hypapandi plain) and the swinesty is about twelve kilometres as the crow flies. The Thesprotian ship was moored about five kilometres further, to the south of the palace. There are many reasons why Homer placed the ship where he did. Firstly, because at that distance Eumaeus, but also Penelope, had no visual contact with the place. Secondly, because the lands there are characteristically sandy. They are «παρὰ θῖνα θαλλάσης», by the sandy shore of the sea or, as it is known today, Ammoudarés, so that it would be obvious what area he was referring to. Thirdly, because the area of the Hypapandi plain lies across from the headland which forms the small bay and harbour of today's Argostoli, or Homeric Dulichium. Placing the ship in this location is quite sensible, since the Thesprotians ostensibly stopped there temporarily, in order to consider what to do with their passenger and how they could possibly sell him off as a slave. Following this, they would have sailed right across, to Dulichium, which was their original destination. Furthermore, there would have been no reason to sail past the Vardiani isle and continue along the Livadi bay for a distance of seven kilometres, unless the harbour of Dulichium was to be found near by. One should also consider why Odysseus should be sent to his beloved homeland on a ship that was sailing by chance for Dulichium, unless Dulichium was also near where the fatherland was. Dulichium, then, was in Ithaca, it was part of the same island and this can be proven on the basis of irrefutable evidence, as will be shown in what follows.

One should keep in mind that the sailors of the Thesprotian ship disembarked hastily (Od. 14.347) and set immediately to have their dinner. They had reached the tilled fields of Ithaca in the evening (Od. 14.344) and were eager to continue on their trip to Dulichium which

lay a little further, on the other side of the extensive bay. The key characteristics of Dulichium, as noted in *The Odyssey*, are as follows:

I. Each time the poet refers to the four islands, Dulichium is mentioned first. This indicates that it was the largest of all, both in terms of size and population.

II. Dulichium produced great quantities of wheat, therefore, large cultivated areas must have been available.

III. The island was covered with vegetation. Consequently, water resources were abundant.

IV. About one half of the suitors came from Dulichium. As stated in verse Od. 16.247-52, their numbers were as follows:

> 52 from Dulichium
> 24 from Same
> 20 from Zacynthus
> 12 from Ithaca

V. Dulichium supplied more ships to the Troy expedition than all the other islands put together. Twelve ships were from Zacynthus, Same, Ithaca, Aegilips, Crocyleia and Neritum. Dulichium alone, under Meges, sent forty ships. (Il. 2.631-7).

This naval superiority establishes Dulichium among the great powers of the time, equal to the Epeians, Myrmidons, Athenians and so forth. This imposing armada, setting off from western Greece for Troy, was assembled by the familiar four Homeric islands. Since these islands lay close to each other, it is reasonable to assume that Dulichium was part of one of these, namely Cephallenia, which is the largest one. A prerequisite for such an imposing naval force as Dulichium was able to assemble, was the existence of a large and secure harbour. Of course, besides the forty ships sent to Troy, there must have existed other ships such as war ships, fishing vessels, merchantmen and small boats. Thus Dulichium, first among the Homeric islands, was also first in population, wheat production and, of course, shipping. In addition to the above, Dulichium was an attractive, verdant place (Od. 16.396), possessing a large and secure harbour. It was, therefore, an enclosed area, protected from the tempestuous sea and the winds.

[...] Δουλίχιονδ' ἰέναι, ὅθι μοι φίλον ἔπλετο θυμῷ· [...]

ξ 397

[…] and send me on my way to Dulichium, where I desire to be.

Od. 14.397

Send me, then, to Dulichium that I love, that stirs my heart. These words uttered by the much-enduring Odysseus, are used by the poet so as to show how sensitive and sentimental this hard man was, a man who suffered more than any other. In fact, the landscape which Odysseus so admires, is unique in physical beauty. It is conducive to calmness and serenity transmitting these qualities to the beholder. One should seriously consider that Odysseus was possibly trying to convince Eumaeus of something very important. He told him that his master, gone for twenty years, shall return to Ithaca. This he swore by the gods to be true. He then asked him to make a covenant, the Olympian gods being their witnesses, that if his master returned to his home, he should cloth him (the beggar) in a cloak and tunic, and send him to Dulichium. Otherwise, he should fling him down from a great cliff (Od. 14.391-9). In other words, he should either live in an enchanted place such as Dulichium (this possibly denoting an innermost wish) or perish falling from a precipitous rock, ending in Hades. Thus, the man that wandered to the end of the world did not hide his feelings and his deep love for two places only. Ithaca and Dulichium. Regarding Ithaca, he states:

[...] οὔ τοι ἐγώ γε
ἧς γαίης δύναμαι γλυκερώτερον ἄλλο ἰδέσθαι.

ι 27-8

[…] and for myself
no other thing can I see sweeter than one's own land.

Od. 9.27-8

Regarding Dulichium, he exclaims:

[...] ἔσσας με χλαῖνάν τε χιτῶνά τε εἵματα πέμψαι
Δουλίχιονδ' ἰέναι, ὅθι μοι φίλον ἔπλετο θυμῷ· [...]
 ξ 396-7

[...] cloth me in a cloak and tunic to wear, and send me
on my way to Dulichium, where I desire to be;
 Od. 14.396-7

So much from Homer, regarding the two lovely rival cities, that today are known as Lixouri and Argostoli. As the contemporary folk song puts it:

«*My pretty little Argostoli,*
Renowned Lixouri through the world,
Now you're lost in the waves,
Now you surface through the foam.»

So, Lixouri renown through the world! Who indeed doesn't know the lovely town of Lixouri. It was known since antiquity, since the time of the Trojan War as was Ithaca itself. In the words of goddess Athena:

τῷ τοι, ξεῖν', Ἰθάκης γε καὶ ἐς Τροίην ὄνομ' ἵκει,
τήν περ τηλοῦ φασὶν Ἀχαιίδος ἔμμεναι αἴης.»
 ν 248-9

⁻ *Therefore, stranger, the name of Ithaca has reached even the land of Troy,*
which they say, is far from this land of Achaea.»
 Od. 13.248-9

Many scholars in the past held the view that Homeric Dulichium was part of the island of Cephallenia, while others rejected such propositions. Neither the supporters nor those who opposed this view were able to back their claims with credible arguments. Nothing, therefore, prohibits the adoption of one of them, and particularly the one that places Dulichium in Cephallenia. Moreover, the position maintained in

the present work, is based on positive data gathered from Homer's statements, placing Dulichium where the city of Argostoli lies today. The finds, upon which this historically important discovery is founded, cannot be disputed. This fact, along with the proven location of all other Homeric sites on the island of Cephallenia, settles a most crucial problem, the ramifications thereof being of great importance to civilization.

3. The Island of Dulichium

Another dimension of the problem of Dulichium is the question of whether it was an island, that is, surrounded by the sea, or a peninsula such as the *démos* of Ithaca (Pallis). The word νῆσος, 'nésos', meaning island, has the same Doric root, νάς, 'nas', as the word ναύς, 'náus', meaning ship. One can, therefore, surmise that an island, νῆσος, is the land that can be easiest approached by ship. It is not necessary that it be completely cut-off from the mainland. For example, Πελοπόννησος, 'Pelopónnesus', is a compound word stemming from Πέλοπος-νῆσος, 'Pélopos-nésos', the island of Pelops or, Peloponnesus. It is today, as it was then, easier to reach Dulichium from Ithaca by ship than by land. The peninsula of Argostoli, according to the above, meets all the requirements of Homeric Dulichium, just as the Pallis peninsula meets those of the Homeric *démos* of Ithaca. Dulichium, on the other hand, is not mentioned in verses 2.631-7 of *The Iliad*, in which Homer details the cities and localities, the men of which Odysseus led to Troy. This can be attributed to the fact that Dulichium was included in the greater area to which Homer refers as Neritum, since it was part of it. It is clear why, in this instance, the poet does not mention the island, which usually occupied the first place when he enumerates the islands of Odysseus' realm.

[...] καὶ σφιν ὑπὲκ νεφέων Ἰθάκης τ' ὄρος αἰπὺ πέφαντο
Δουλίχιόν τε Σάμη τε καὶ ὑλήεσσα Ζάκυνθος.

Εἰς Πύθιον Ἀπόλλωνα, στ. 427-8

> *[…] there appeared to them below the clouds the steep mountain*
> *of Ithaca,*
> *and Dulichium and Same and wooded Zacynthus.*
> To Pythian Apollo 427-8

Through these verses of the Homeric Ode to Pythian Apollo the poet, quite obviously, intends to underline the fact that the mountain in question is the biggest mountain in the area. He refers, of course, to Mt. Neriton, today Cephallenia's Mt. Aenos.

4. Dulichium and the Dolichus Race

Dolichus, much like the marathon race from Marathon to Athens, is a long distance race. One dolichus equals 24 stadia, one stadium measuring 184.87 m. Thus, 24 stadia x 184.87 m. = 4,436.88 m. or one dolichus.

Drawing a line from the tip of the Argostoli headland, where the lighthouse lies, tangent to the neck of Kouttavos bay, one finds that the distance thus covered is 4,437 meters, that is 24 stadia or one dolichus. This is confirmed by studying the map of the 'Army Geographical Service'. This precise measurement constitutes indisputable proof of the origin of the name 'Dulichium' as it came down to us through the Homeric verses of *The Odyssey* and *The Iliad*, since the distance is that of one 'dolichus'. The same name 'Dolicha' or 'Doulicha' was retained by two other sites in Cephallenia rather distant from Argostoli where Homeric Dulichium is located.

One of the sites is found on the northeastern edge of Eryssos and the other on the southeastern end of the island at Keteleio. The name of these two sites posed a problem indeed, since nothing connects them to each other, or to Dulichium, today's Argostoli. When the distance from Argostoli to Kouttavos was measured and the distance turned out to be 24 stadia, then the answer to the problem of the connection with the other two sites became obvious. In the first case, the distance from the Paliokaravo bay or 'Dolicha' lying north of the villages Eureti and Mattheata of Eryssos and a little to the north of the Asteris or Dascalo islet, and the northernmost point of Cephallenia and Eryssos at the

Vliotis promontory, was measured and found to be 4,437 meters or 24 stadia. Thus, from the Vliotis promontory to the neck of the Dolicha bay, on a straight line, the distance is exactly one dolichus. The site carries the name since Homeric times, while a *démos* of Dolicha existed at Eryssos until recently[11]. The second site that carries the name 'Dolicha', at Kato Kateleio, lies at a distance of 24 stadia (4,437 meters) from Mounta, the southeastern promontory of Cephallenia. Thus, the two sites mentioned above, were named on the basis of their distance of one 'dolichus' from the two extreme ends of the island of Cephallenia. The location of Homeric Dulichium is, therefore, confirmed by the happy coincidence of discovering two more sites known by the name of 'Dolicha'.

Verdant Dulichium, where Odysseus desired to be, was beautiful as Argostoli is today. It is a lovely city indeed that touched the heart of all. In the original study regarding the location of Dulichium, the author had stated that he freed his imagination for a while letting it run over the beautiful beaches of Lixouri and Argostoli in order to approach the Homeric spirit, and thus let unknown Dulichium find its own harbour. So it happened. This unburdened flight of the mind, accompanied by a burning faith showed the correct way. The expectations proved to be completely true.

5. Dulichium and the Epeians

The Epeians hailed from Elis having been settled in southern Cephallenia by Cephalus and Eleius at the time of Amphitryon's expedition. Apparently, Eleius settled in the southeastern extreme end of the island, since a village by the name 'Eleios' is located there even in our day. A little further down along the coast there in another village by the name 'Kateleios'. At the time of Odysseus' return to Ithaca the Epeians inhabited Dulichium, their king being Acastus.

11. The names of districts and municipalities have, in recent years been occasionally changed. The area, however, is still known as démos of Dolicha and is so called by the inhabitants.

ἔνϑ' ὅ γέ μ' ἠνώγει πέμψαι βασιλῆι Ἀκάστῳ
ἐνδυκέως· [...]

ξ 336-7

He told them[12] to convey me there to king Acastus,
with kindly care; [...]

Od. 14.336-7

This bit of information came from Odysseus when he related to
Eumaeus the fictitious story of his arrival in Ithaca. During the same
period king, ἄναξ, 'ánax', at Dulichium was Aretias whose son was Nisus
and grandson Amphinomus. This is testified by Odysseus' discourse
with Amphinomus following his return to Ithaca (Od. 18.125-9), and
from the poet himself who states:

τοῖσιν δ' Ἀμφίνομος ἀγορήσατο καὶ μετέειπε,
Νίσου φαίδημος υἱός, Ἀρητιάδαο ἄνακτος, [...]

π 394-5

Then Amphinomus addressed their assembly and spoke among
them,
the glorious son of prince Nisus, son of (ánax) Aretias.

Od. 16.394-5

Aretias was 'anax' at Dulichium while his grandson Amphinomus
was the leader of the suitors and claimed for himself the wife and
house of Odysseus. In the catalogue of the ships that sailed for Troy (Il.
2.625-9), it is stated that «And those from Dulichium and the Echinae,
the holy isles, who lie beyond the sea across from Elis, of these in turn
Meges, the peer of Ares, the son of Phyleus, was leader, whom the
horseman Phyleus, dear to Zeus, begot – he who had long ago gone to
live in Dulichium angered against his father. And with Meges there
followed forty black ships.»

12. The Thesprotian King Pheidon.

[...] αὐτὰρ Ἐπειῶν
Φυλεΐδης τε Μέγης Ἀμφίων τε Δραχίος τε, [...]
N 691-2

[...] while the Epeians,
were led by Meges, son of Phyleus and Amphion and Dracius, [...]
Il. 13.691-2

These observations are noted so that the reader may form a clear picture regarding the form and practice of political power in Dulichium and determine whether Dulichium was independent and sovereign, governed by its own rulers, or if it came under the jurisdiction of Odysseus' house. Based on the above, two kings are mentioned as ruling over Dulichium at the time of Odysseus' return, Acastus (Od. 14.336) and Aretias (Od. 16.395). The first carried the title of king, while the second, that of ἄναξ, 'ánax'. The strongest house ruling in Ithaca was that of Odysseus. This superiority in the exercise of power is testified by Theoclymenus when, addressing Telemachus, told him:

ὑμετέρου δ' οὐκ ἔστι γένος βασιλεύτερον ἄλλο
ἐν δήμῳ Ἰθάκης, ἀλλ' ὑμεῖς καρτεροί αἰεί.»
 ο 533-4

No other decent than yours is more kingly
in Ithaca; you are supreme for ever.»
Od. 15.533-4

Moreover, the same conclusion may be drawn from the verses of *The Odyssey* (Od. 24.377-8) where Laertes states that he «took Nericus, the well-built citadel on the shore of the mainland.» This is the castle at Crane where Dulichium lies. Again, in verses Od. 24.508-9, Odysseus tells Telemachus about his «fathers, who in times past have excelled in strength and in valour over all the earth», meaning that they conquered the entire island. One should also keep in mind the words of Athena, addressing Odysseus when he arrived at the harbour of Phorcys from the land of the Phaeacians, assuring him that he had

indeed reached Ithaca and showing him, among the other features of
the land, wooded Mt. Neriton. (Od. 13.351). This can only mean that
the entire island was named Ithaca and that Dulichium was a part of it.
Furthermore, all the descriptions mentioned, refer to the *démos* of Itha-
ca and that of Cephallenia and point to the same conclusion. It is also
noted that Athena talked about corn and cattle and herds of goats apart
from those found in the remote area of Phorcys where Odysseus and
Eumaeus were conversing.

> ἦ τοι μὲν τρηχεῖα καὶ οὐχ ἱππήλατός ἐστιν,
> οὐδὲ λίην λυπρή, ἀτὰρ οὐδ᾽ εὐρεῖα τέτυκται.
> ἐν μὲν γάρ οἱ σῖτος ἀθέσφατος, ἐν δέ τε οἶνος
> γίγνεται· αἰεὶ δ᾽ ὄμβρος ἔχει τεθαλυῖά τ᾽ ἐέρση·
> αἰγίβοτος δ᾽ ἀγαθὴ καὶ βούβοτος· ἔστι μὲν ὕλη
> παντοίη, ἐν δ᾽ ἀρδμοὶ ἐπηετανοὶ παρέασι.
> τῷ τοι, ξεῖν᾽, Ἰθάκης γε καὶ ἐς Τροίην ὄνομ᾽ ἵκει,
> τήν περ τηλοῦ φασὶν Ἀχαιΐδος ἔμμεναι αἴης.
>
> ν 242-9

> *It is a rugged island, not fit for driving horses,*
> *yet it is not utterly poor, narrow though it is.*
> *In it grain beyond measure, and the wine grape as well*
> *grows; and the rain never fails it, nor the rich dew.*
> *It is good land for pasturing goats and cattle; there are trees*
> *of every sort, and in it are watering places that never fail.*
> *Therefore, stranger, the name of Ithaca has reached even the land*
> *of Troy,*
> *which they say, is far from this land of Achaea.*
>
> Od. 13.242-9

The conclusion drawn from these statements is that Athena includ-
ed to the Kingdom of Ithaca the land lying across from the Pallis
peninsula, that is the area of Argostoli, which produces abundant
wheat and where the cattle grazed. Philoetius said as much regarding
the place where the cattle grazed (Od. 20.219-10). It appears, there-
fore, that there were two kings at Dulichiumm, that is Acastus, to

whom the Thesprotian sailors were to convey Odysseus, and Aretias, the father of Nisus and grand-father of Amphinomus. These and other nobles as well as Meges, the peer of Ares, lived in Dulichium. But Odysseus was over all of these including those in Zacynthus and Same, and across the water in Leucas and the coast of Acarnania, all the way to Epirus and Thesprotia. The Dulichian suitors took part in the deliberations aimed at taking over the house of Odysseus through marriage with Penelope, because their land was part of Odysseus' kingdom. Otherwise, had they been heirs to independent kingdoms, they would not have been eligible to marry Penelope and thus succeed Odysseus. Besides, kings, aristocrats and other nobles were present in other areas of Greece. For example, in Scheria, the island of the Phaeacians, there were twelve kings holding sway over the land, but Alcinous, being the thirteenth, ruled over them (Od. 8.390). Ithaca, along with the remaining complex of islands, Dulichium, Same and Zacynthus, had a similar administrative structure.

As stated in *The Iliad* Meges, the son of Phyleus, was among the leaders of the Epeians who fought in the Trojan War (Il. 13.691-2). He had come to Dulichium from Elis along with forty ships. It is clear that in Dulichium, which was the center of the *démos* of Cephallenians, there existed a population which had emigrated there from Elis. It appears also that the presence of these people was necessary for the cultivation of the land. Such a conclusion follows from Eumaeus' statement regarding the foreigners that worked on the land across (the *démos* of the Cephallenians) for a wage, while the others were Odysseus' own people.

δώδεκ᾽ ἐν ἠπείρῳ ἀγέλαι· τόσα πώεα οἰῶν,
τόσσα συῶν συβόσια, τόσ᾽ αἰπόλια πλατέ᾽ αἰγῶν
βόσκουσι ξεῖνοί τε καὶ αὐτοῦ βώτορες ἄνδρες.
ἐνθάδε δ᾽ αἰπόλια πλατέ᾽ αἰγῶν ἕνδεκα πάντα
ἐσχατιῇ βόσκοντ᾽, ἐπὶ δ᾽ ἀνέρες ἐσθλοὶ ὄρονται.
 ξ 100-4

[...] twelve herds of cattle has he on the mainland; as many flocks of sheep;

as many droves of swine; as many wide-ranging herds of goats
do herdsmen, both foreigners and his own people, pasture.
And here too wide-ranging herds of goats, eleven in all,
graze on the borders of the island, and over them trusty men
keep watch.

<div align="right">Od. 14.100-4</div>

Eumaeus differentiated the herdsmen into foreigners and those who were Odysseus' own people. The foreigners, working for a wage, were located on the mainland, while his own people were on the borders of Ithaca (at Atheras), where Eumaeus and Odysseus were carrying on their discussion. It is, therefore, obvious that the Epeians did not wield power in Dulichium, but simply shared in the corn crops produced and the cattle raised. In fact the land belonged to Odysseus. The above verses provide an explanation regarding the Epeians whom Meges brought over from Elis along with his forty ships, and for those who remained on the island following Amphitryon's and Cephalus' expedition. A more general conclusion based on the above is that the population of the *démos* of Cephallenia and of Dulichium was to a great extend homogeneous.

6. Invocatory Inscription at Demeter's Temple

The deep conviction that the Homeric verses reflect the ancient truth, has caused the darkness of millenniums to be lifted and, step by step, led to the calm waters of the Argostoli bay, so that Homeric Dulichium has come to light. Since the proposition that Dulichium lay in the area of Argostoli was put forth, much new supportive evidence has come to light. The unknown island, whose disappearance has baffled scholars all over the world, has been finally located, thus completing the Homeric map.

A Doric style sanctuary dedicated to Demeter, patroness goddess of corn and agriculture, and her daughter, was excavated in the area lying back of the bay of Kouttavos, and a slab was found there carrying the following inscription:

1. *Cephallenia's Mount Aenos (Homeric Mount Neriton).*

2. Crikellos hill (Homeric Hermes hill).

3. *Odysseus' ships with vermilion prows.*

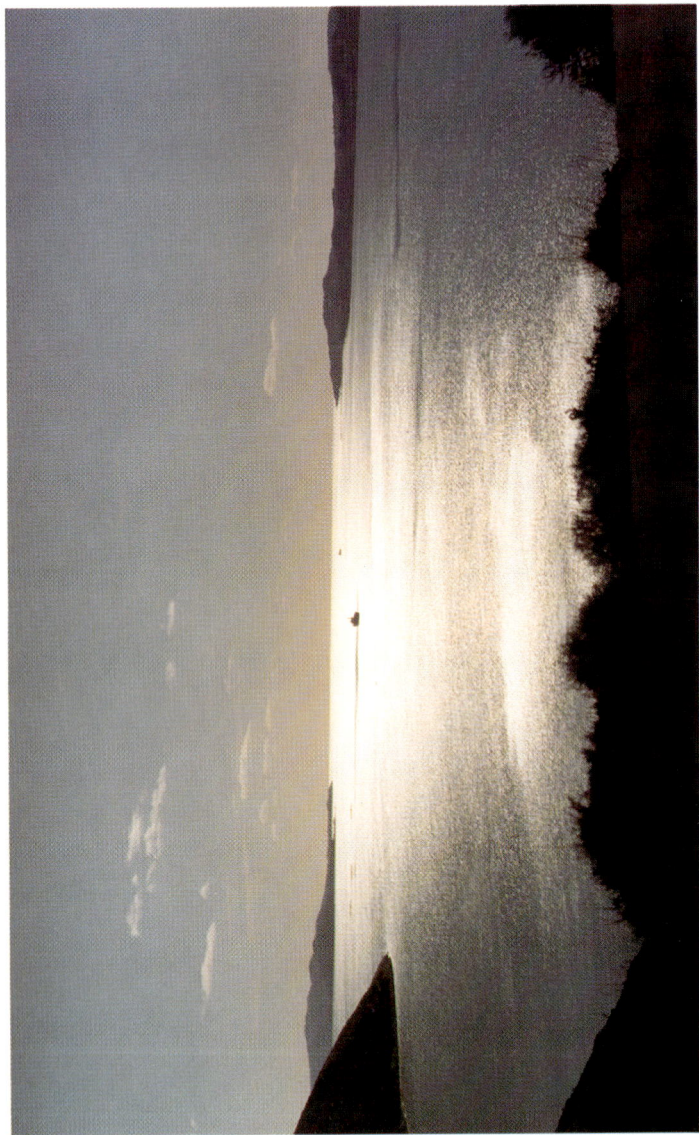

4. *The Livadi village harbour in the deep Livadi bay (Homeric Ithaca's harbour).*

5. *Panoramic view of the leeward harbour of Atheras (Phorcys harbour).*

6. Reithron at Samoli village and Crikellos hill in the background.

7. Doric temple remnants in the center of Livadi village.

8. *The windless harbour of Atheras (Phorcys harbour).*

9. Atheras' sandy beach, where Odysseus disembarked (*Phorcys harbour*).

10. Mycenaean retaining wall of the road passing by the olive tree at Atheras harbour.

11. The coast of Atheras' harbour: The entrance of the grotto of the nymphs can be seen in the background.

12. *The entrance to the grotto of the nymphs.*

13. *The two wharves at the Atheras harbour* (*Phorcys harbour*).

14. The circular court of Eumaeus' hut.

15. *The treacherous road at Katagous.*

Kefalos. Lekithos 480 BC.

Odysseus. Lekithos 440 BC.

16. Callirous fountain.

17. View of the general area of the palace. Ruins of contemporary chapel built on the entrance of the main palace building.

18. *The circular Mycenaean foundation of the storehouse to the left of the eastern gate.*

19. Mycenaean foundation of the palace's storage house.

20. *The millstone in the ruins of the palace's storehouse.*

21. The Royal Estate on Crikellos hill (Hermes hill).

22. *Standing stones indicating the entrance*
to Telemachus' tower on Crikellos hill.

23. *Panoramic view of Livadi, the circular beach,*
the meadow of asphodel, and the rock Leucas (Homeric Ithaca).

24. The dank ways at the Livadi swamp.

25. *The altar of Apollo on Skavdolitis.*

26. *The cyclopean walls of the Homeric city of Nericus.*

27. *Myrtos coast (Homeric Aegilips).*

28. *The eastern coast of Cephallenia (Homeric Crocyleia).*

29. Kounopetra or Homeric Planctae Rocks.

30. The Argostoli whirpools (Charybdis).

«ΤΡΙΟΠΙΣ ΔΑΜΑΤΡΙ ΚΑΙ ΚΟΡΑ»
Triopis to Demeter and Core[13]

Τριοπίς (triopís): v. *τριοπίς*, neckless with three pendants like eyes. Also, bird, Phot. (s. v. l.); animal resembling a grass hopper, Hsch. *Δαμάτρι* (damátri): fem. dat. of *Δαμάτηρ* or *Δημήτηρ*, Demeter, Il. 2.696, al. once in Od. 5.125. **2**. appell., as a name for bread; *ἀκτή*, poet. word for corn, *Δημήτερος ἀκτή*, Il. 13.322, 21.76; of standing crop, of unthreshed corn; of seed.

The inscription invocates the goddess to protect the crops of corn from harmful animals such as locust if indeed this is what is meant by *Τριοπίς* 'Triopís'. This find was excavated at the par excellence corn producing area of Argostoli (Homeric Dulichium), for which Homer provides only one characteristic, that it produced indeed large quantities of wheat. It is, therefore, quite reasonable that such a sanctuary and invocative inscription should be found there. The slab is kept at the Argostoli museum, but as yet it has not been connected to Dulichium, its provenance and the invocation on the slab remaining unexplained. These finds, however, provide indisputable evidence for the location of Dulichium. They should, therefore, be given careful consideration and be evaluated for their historical significance.

This entire area from the bridge to the neck of the bay (i.e. the lagoon), must have been a beautiful wet land which was inundated as the sea level rose by two to three meters (perhaps more) since Homeric times. In summary, there is a large harbour in the bay of Argostoli, which could accommodate the large fleet of verdant Dulichium. The area of Kouttavos has abundant water. The Argostoli area lies East of Ithaca (Pallis) and this, as well as the closeness to each other, agrees with the Homeric descriptions. A careful study of these characteristics and the analysis of the Homeric verses, terms and meaning of the events described, reveal at last the incontestable truth.

13. Core: Demeters beloved daughter Persephone, abducted by Pluto, god of the underworld, and carried there. She remained with him half the year and the other half she returned to earth and her mother. Trans. note.

CRANE TOWN WALLS (CITY OF NERICUS)

CHAPTER TWELVE

THE LEGENDARY CITY OF NERICUS

O NE OTHER of the mysterious localities mentioned in *The Odyssey* is the city of Nericus. All scholars, without exception, have been searching for it on the Acarnanian coast of the mainland. The information that can be extracted from *The Odyssey* is scarce while no other sources are available so that the descriptions regarding the city may be cross-referenced. The pertinent verses in *The Odyssey* are as follows:

> [...] τὸν δ' αὖ Λαέρτης πεπνυμένος ἀντίον ηὔδα·
> «αἲ γάρ, Ζεῦ τε πάτερ καὶ Ἀθηναίη καὶ Ἄπολλον,
> **οἷος Νήρικον εἷλον, ἐυκτίμενον πτολίεθρον,**
> ἀκτὴν ἠπείροιο, Κεφαλλήνεσσιν ἀνάσσων,
> τοῖος ἐών τοι χθιζὸς ἐν ἡμετέροισι δόμοισιν,
> τεύχε' ἔχων ὤμοισιν, ἐφεστάμεναι καὶ ἀμύνειν
> ἄνδρας μνηστῆρας· τῷ κε σφέων γούνατ' ἔλυσα
> πολλῶν ἐν μεγάροισι, σὺ δὲ φρένας ἔνδον ἐγήθεις.»
>
> ω 375-82

> *[...] Then wise Laertes answered him:*
> « *I would, Father Zeus, and Athene, and Apollo,*
> *that in such strength as when I took Nericus, the well-built citadel*
> *on the shore of the mainland, when I was lord of the Cephal-*
> *lenians,*
> *in such strength I had stood by your side yesterday in our house*
> *with my armour about my shoulders, and had beaten back*
> *the suitors. So should I have loosened the knees*
> *of many of them in the halls, and your heart would have been*
> *made glad within you.»*
>
> Od. 24.375-82

Laertes, in the above verses, expressed the wish to have been able to fight along with Odysseus against the suitors, as he did when, as a young king of the Cephallenians, he had conquered the citadel of Nericus, which lay on the coast of the mainland. The basic facts expressed by this statement are that Laertes was once king of the Cephallenians and that he had captured the well fortified city of Nericus, which lay on the coast of the mainland. The brief statement regarding the location of the city of Nericus contained in the above verses, gives only a vague indication as to where it lay. Historians and researchers alike, place it usually in the general area of the coast of Leucas and Acarnania across from Cephallenia. The lack of any evidence of wall remnants, however, has not helped to identify the site in question. The controversial verse is the following:

[...] οἶος Νήρικον εἶλον, ἐυκτίμενον πτολίεθρον, [...]
ω 277

[...] that in such strength as when I took Nericus the well built citadel [...]

Od. 24.277

Laertes was boasting by saying that when he was young and strong he took the well built citadel of Nericus (Od. 24.377) which had strong walls, being until then impregnable (Illus. 26). This happened when he was king of the Cephallenians. It would be more correct to say that he became king of the Cephallenians after conquering Nericus, which was part of the *démos* of the Cephallenians. This is quite likely, since until that time he was king of Ithaca, the former city of Ithacus, son of Pterelaus. The poet in fact mentions the existence of two municipalities, 'démoe' on the island. The *démos* of Ithaca (Od. 1.103, 24.284, 13.97) which he mentions quite often, but he also describes another area as *démos* that of the Cephallenians (Od. 20.210). There is a clear reference regarding this *démos͵* at the point where the cattleherder Philoetius related to Odysseus how he was a sheepherder since childhood at the *démos* of the Cephallenians.

[...] εἶσ' ἔτι τυτθὸν ἐόντα Κεφαλλήνων ἐνὶ δήμῳ.
 υ 210

[...] when I was yet a boy, in the land of the Cephallenians.
 Od. 20.210

This shepherd, as already stated, brought animals every morning from the coast across from Ithaca, intended to be slaughtered for the feasting of the suitors. The transport was carried out by πορθμεῖες, ferrymen (Od. 20.187).

It is not necessary, however, for these transports to be carried out by ferrymen only where there is a strait, πορθμός, but can be carried out between any two opposing coasts. Such ferries operate in many ports, carrying out transports in narrow seas, rivers, etc., as for example, the ferries plying the Ionian Sea between Patras and Brindisi. The above clarification is made in order to point out that the claim of certain Homeric analysts that the Homeric ferrymen, πορθμεῖες, were operating in a strait, πορθμός, is not valid. Transportation, within the bay of Livadi, was carried out by boats since the time of Homer and as late as 1824. This fact is quite evident from a map and excerpts from letters of British officials in Cephallenia, quoted in El. Cosmetatos' book 'Report on Cephallenia's ports.' They describe quite eloquently the state of the roads in Cephallenia at that time. To a large extent, the same situation prevails to this day. Salomon[1] describes one of the main roads, which presented continuous problems particularly at Farsa:

> «One of the most interesting roads which Kennedy[2] laid out starts from the bridge of Drapanos, follows the coastline and climbs the hill to the north of the Argostoli harbour and the Livadi bay, with a wonderful view of Pallis. It continues under Farsa and Kourouklata and rounding two great bends enters the area

1. Dr. Marino Salomon.
2. Captain John Pitt Kennedy R.E., Director of Public Works and Secretary to the Resident of Cefalonia, 1822 - 1832.

of Thenias. The road connects all the villages of the general area, some to the right and some to the left, reaches Agona – the last village – continues over the Skavdolitis mountain and joins the two roads coming from Pylaros: One from Agia Euphemia, and the other from Fiscardo.»

«But the Thenias road, which Napier[3] had widened at the most dangerous points and was accessible to beasts of burden at the time he left, was already in ruin due to abandonment since 1824. At that time, baron d' Everton[4] completed the parts that were left unfinished and rebuilt the road following the original line, while he constantly stressed to the Government the urgent need of a speedy repair of this vital transportation network. He succeeded in building a perfect construction to Farsa, about half of the road. The rest he did not have time to finish. Today, after so much effort and expense, it has again been abandoned and the inhabitants of the area are forced, as previously, to use with difficulty the precipitous descent to the little harbour of Sotira – the little chapel on the east coast of the Livadi bay – and transport their goods to Argostoli or Lixouri, under any type of weather conditions and at a great cost.»

« January 30, 1824.

The inhabitants of Thenias have again sent a memorandum and I believe that we will be able to satisfy them within a month. I passed through the area among the mountains and I found it the most abject condition due to lack of communications. As you might have guessed, Colonel Wright[5] keeps up a constant grumble about the road, to Sir Hudson Lowe[6].»

«July 23, 1830.

3. Colonel Charles James Napier, Commandant of Cefalonia, 1822 - 1830.
4. Charles Sebright, Baron d Everton.
5. Colonel Th. Wright.
6. Lt. Colonel Sir Hudson Lowe.

The general says that he will appoint foresters and will begin work on the Crania lagoon. The new road law will be put into force on August 1st and I believe that our funds will allow us to employ 100 labourers per day. The Thenias road through Farsa has been opened for beasts of burden: The Agia Euphemia road is accessible to carriages all the way to the sea. The customs house will be moved to the city again ...»

One should carefully study the events taking place in rhapsody 24 (ω) and correlate these to the poet's reports regarding the Cephallenians, whom he only mentions in verses 20.210, and 24.355, 378, 429. When Odysseus found his father Laertes at his farm, and finally convinced him that he was indeed his son returned from his adventures overseas, he also announced that he killed all the suitors. Old man Laertes, overcome by emotion, fainted and Odysseus had to catch him to himself. But when he revived, and the spirit returned again into his breast, once more he answered and spoke, saying:

«Ζεῦ πάτερ, ἦ ῥα ἔτ' ἔστε θεοὶ κατὰ μακρὸν Ὄλυμπον,
εἰ ἐτεὸν μνηστῆρες ἀτάσθαλον ὕβριν ἔτισαν.

ω 351-2

«Father Zeus, truly you gods still hold sway on high Olympus, if indeed the suitors have paid the price of their wanton outrage.
Od. 24.351-2

And then he continued expressing his terrible fear:

νῦν δ' αἰνῶς δείδοικα κατὰ φρένα μὴ τάχα πάντες
ἐνθάδ' ἀπέλθωσιν Ἰθακήσιοι, ἀγγελίας δὲ
πάντῃ ἐποτρύνωσι Κεφαλλήνων πολίεσσι.»

ω 353-5

But now I have a terrible fear at heart, that immediately all the men of Ithaca will come here against us, and send messengers everywhere to the cities of the Cephallenians.»
Od. 24.353-5

Following this scene, Odysseus along with Laertes went inside the farm house and Laertes related how he conquered the well-built citadel of Nericus (Od. 24.377-8). While all this was taking place at Laertes' farm, the Ithacians assembled together and discussed the calamity that befell them. In their discussion it was mentioned that Odysseus had killed by far the best of the Cephallenians. They also expressed their fear least he escaped either to Pylos or to splendid Elis (Od. 24.420-32). Vengeance and reprisal on the part of the Cephallenians is what concerned Laertes, that being an important issue, one that would determine developments in Ithaca. An attack by the Cephallenians was considered imminent because the *démos* of Ithaca and that of the Cephallenians were neighbouring municipalities. The prevailing attitude was influenced by the proximity of the Cephallenians, and everyone's thoughts were turned to the coast across, to the *démos* of the Cephallenians. Laertes' heroic exploit in capturing the city of Nericus, is confirmed a little further by Odysseus when he told Telemachus:

> [...] μή τι καταισχύνειν πατέρων γένος, οἳ τὸ πάρος περ
> ἀλκῇ τ' ἠνορέῃ τε κεκάσμεθα πᾶσαν ἐπ' αἶαν.»
> ω 508-9

> [...] to bring no disgrace on the house of your fathers, who in times past
> have excelled in strength and in valour over all the earth.»
> Od. 24.508-9

It is obvious that Odysseus referred to battles that took place in the past, such as the one that resulted in conquering the city of Nericus. By their strength and bravour they had prevailed over the island, the land of the Cephallenians, the land, ἠπείροιο, 'epeíeroeo', across from Ithaca (Od. 24.378), the eastern part of the bay of Argostoli. To this point, all the aspects of this mystery have been clarified, with the exception of one word. One that has been misconstrued, and upon which it has been impossible to shed any light. Laertes' sentence is repeated so as to identify the key word that leads to the city of Nericus.

*[...] οἷος Νήρικον εἷλον, ἐυκτίμενον πτολίεθρον,
ἀκτὴν ἠπείροιο, Κεφαλλήνεσσιν ἀνάσσων, [...]*

ω 377-8

*[...] that in such strength as when I took Nericus, the well-built citadel
on the shore of the mainland, when I was lord of the Cephallenians, [...]*

Od. 24.377-8

The word in question, ἀκτή 'acté', has been misinterpreted, so that the meaning intended by the poet, in his effort to indicate the exact location of the city of Nericus, was not conveyed. The meaning of the word «ἀκτή» has been preserved to this day, three and one half thousand years later, and conveys the idea of the coast, the edge of the land bordering the sea. Several other interpretations are available, denoting the seacoast, the shape of the coasts, etc. When, however, Homer defined the location of the city of Nericus, he used the term ἀκτή in another poetical meaning.

ἀκτή (acté): fem. poetic word for corn, Δημήτερος ἀκτή, Il. 13.322, 21.76, cf. E. Hipp. 130 (lyr.), Epin. 1.9; μυληφάτου ἀλφίτου ἀκτή, Od. 2.355, cf. 14.429, Il. 11.631: in Hes. of corn generally, ὡσεὶ Δημήτερος ἀκτή, of standing crop, Sc. 290, of unthreshed corn, Op. 597, 805; of seed, οὐ σπόρον ὀλκοῖσιν Δηοῦς ἐνιβάλλομαι ἀκτή. A. R. 3.413. (The connection with ἄγνυμι is doubtful).

[...] ὃς θνητός τ' εἴη καὶ ἔδοι Δημήτερος ἀκτήν, [...]

Ξ 322

[...] to any man that is mortal and eats the grain of Demeter [...]

Il. 13.322

One can now translate the ancient text using the term ἀκτή, 'acté', with its intended meaning that of ear of corn, wheat, corresponding to the wheat producing land, ἠπείροιο, across from Ithaca, where the

Doric sanctuary was situated, that is Dulichium[7]. The ramifications of this interpretation of the word, are indeed surprising and one is moved seeing the Homeric verse come to life in the enchanting landscape of Argostoli, a wonderful city of unique beauty, about which even Odysseus expressed his admiration (Od. 14.397). There is not a shadow of doubt that the poet intended to lead the listener to the Crane area behind the neck of the Kouttavos bay, because the cyclopean city of Nericus lay there. In fact, the well-built cyclopean walls of ancient Crane are there, but no one to this day has been able to determine the name of the city they protected, its builders, or the period in which they were built. These are indeed huge walls, their perimeter being nearly five kilometres long. On many points they are preserved in excellent condition. This is the city built by the lord of the area, Neritus, who was the son of Pterelaus, king of the Taphians. Ithaca, on the other hand, was built by Pterelaus' other son, Ithacus. There was a third son, Polyctor, but no one knows what happened to him, and it is not certain whether he is the father of the messenger Argeiphontes who speaks with Priam (Il. 24.397). What is certain regarding Ithacus, Neritus and Polyctor is that together they built the 'Callirous' (fair-flowing) fountain (at the Halkes site, west of the hill of Hermes in the Pallis peninsula). Homer testifies to this in the following verses:

[...] ἄστεος ἐγγὺς ἔσαν καὶ ἐπὶ κρήνην ἀφίκοντο
τυκτήν καλλίροον, ὅθεν ὑδρεύοντο πολῖται,
τὴν ποίησ' Ἴθακος καὶ Νήριτος ἠδὲ Πολύκτωρ· [...]
ρ 205-7

*[...] they were near the city, and had come to a fountain
well-wrought, fair-flowing, from which the townsfolk drew water –
this Ithacus had made, and Neritus, and Polyctor, [...]*
Od. 17.205-7

7. The proposition regarding the location of Homeric Dulichium on the side of Argostoli in Crane has been already expounded upon. When Dulichium is mentioned, one should remember that its most prominent characteristic is that it is verdant and «wheat producing». The poet always attaches this epithet, when he mentions the city. Moreover, this is testified by the presence on Cranea, at the neck of the Kouttavos bay, of the remnants of a Doric sanctuary dedicated to the goddess Demeter and Core, Demeter being the protectress of the harvests.

Pterelaus' children left indelible marks on the island of Cephallenia. Ithacus built the city of Ithaca on the hill of Hermes, the Mycenaean wall surrounding Odysseus' palace being visible to this day. Neritus built his own fortified city, Nericus, on the Argostoli side across from Ithaca, where Mt. Neriton lay. It is not known whether Pterelaus' children were named after Ithaca and Neriton or whether the peninsula and the mountain were named after them.

WESTERN ACHAEAN TRIBES - TAPHIANS - CEPHALLENIANS

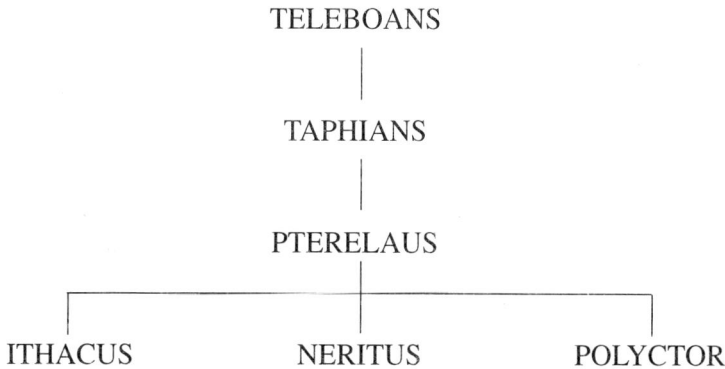

TELEBOANS
|
TAPHIANS
|
PTERELAUS
|

ITHACUS	NERITUS	POLYCTOR
Founder of the city of Ithaca found in the area of Krikelos at the Livadi village of the Palis peninsula	Founder of the city of Nericus (ἀκτὴν ἠπείροιο) Od. 24.378, found at the cyclopean walls of the Crane district of the city of Argostoli, in Cephallenia	

The expedition of Amphitryon took place later, when along with Cephalus and Eleius the Epeian, attacked the Taphians. In the end, Cephalus and his four sons became masters of the island, while Eleius established himself on the southeastern side of the island. Amphitryon gave Cephallenia, and the areas which had a homogenous population, to Cephalus and these people assumed the name Cephallenians. The Cephallenians are among the oldest Greek tribes. During the reign of Cephalus, Cephallenia was divided into four autonomous districts which were ruled by Cephalus four sons, Pallis, Cranius, Pronus and Samius. Pallis established himself in the Pallis peninsula, in the area which was previously ruled by Ithacus, Cranius in the Crane area, where Neritus had built the city of Nericus. Pronus built his kingdom at Pronoe, todays Poros, and finally Samius settled in todays Same. Eleius, one of Amphitryons companions in the expedition, established himself at Eleios and lower Eleios, in southeastern Cephallenia. Ostensibly, Pallis expelled Samius and it is not unlikely that the latter established himself in what came to be known as Same (todays Ithaca), which was named after him. Following Cephalus death, his other son, Arceisius, came forth and claimed the kingdom. He was the offspring of Cephalus who, with the permission of Zeus, came into union with Arctus. Arceisius became king of the Cephallenians and remained the uncontested ruler until his son Laertes prevailed and ruled over the Cephallenians (Od. 24.375-8).

An event worth noting is the capture of the city of Nericus by Laertes. It is obvious that Laertes seat was the city of Ithaca at the démos of Ithaca. He conquered Nericus, a city built by the Taphians (Pterelaus) who had been expelled by Amphitryon and Cephalus. Following the expulsion of the Taphians and, therefore, of Pterelaus, Ithacus and Neritus, Cephalus and his sons were established in the area while one of his sons, Cranius, became ruler of Crane, that is of the city of Nericus. Laertes conquered the city of Nericus by force (Od. 24.375-8), even though Arceisius was Cephalus son and his own father. One could, therefore, assume that Pallis expulsion from Ithaca took place following the establishment of Arceisius, followed by Laertes, to power. Later on Cranius was also expelled from Crane (formerly Nericus). These events were decisive in determining Ithacas administrative structure as presented by the Homeric descriptions. It is thus ascertained, by the Homeric text,

that at the time of Odysseus and Homer, all other centers of power on the island were neutralised, that is the Teleboans, the Taphians, and Cephalus four sons. The Teleboans and Taphians were expelled at the time of Amphitryons expedition and Cephalus sons by Arceisius, Laertes and Odysseus. Odysseus family took over the entire island and extended its realm to the neighbouring islands and the Acarnanian coast, where they had family ties, and which had a homogenous population and were commercially and militarily dependent on them (Il. 2.631-5).

AMPHITRYON'S EXPEDITION AGAINST THE TAPHIANS

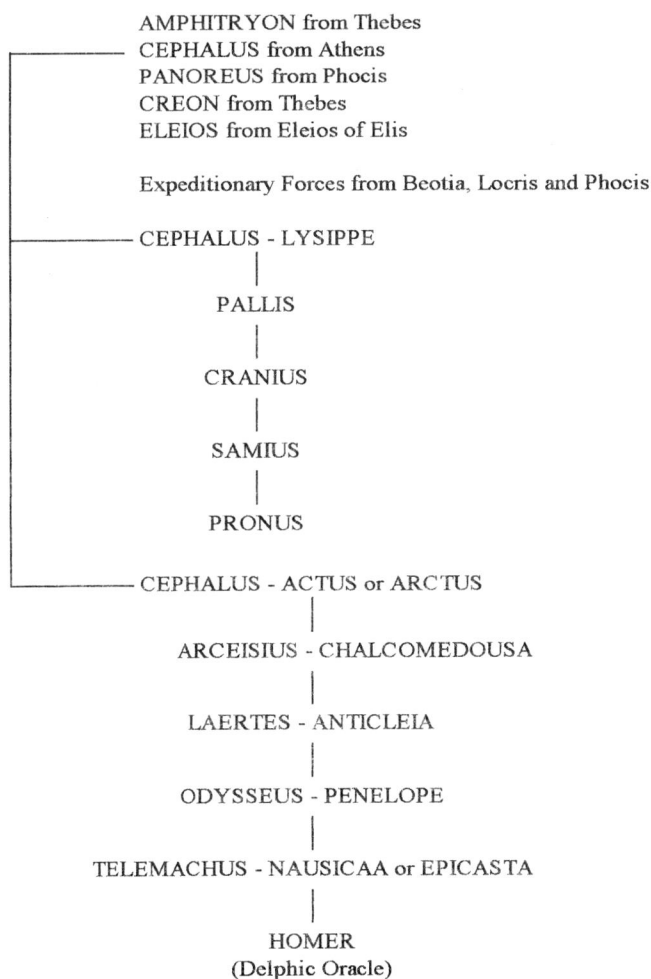

AMPHITRYON from Thebes
CEPHALUS from Athens
PANOREUS from Phocis
CREON from Thebes
ELEIOS from Eleios of Elis

Expeditionary Forces from Beotia, Locris and Phocis

CEPHALUS - LYSIPPE
|
PALLIS
|
CRANIUS
|
SAMIUS
|
PRONUS

CEPHALUS - ACTUS or ARCTUS
|
ARCEISIUS - CHALCOMEDOUSA
|
LAERTES - ANTICLEIA
|
ODYSSEUS - PENELOPE
|
TELEMACHUS - NAUSICAA or EPICASTA
|
HOMER
(Delphic Oracle)

Note: - Ithacus (Od. 17.207): Ithaca and Pallis: Pallis peninsula at the time of Laertes: Ithaca again.
- Neritus (Od. 17.207): Nericus and Cranius: Crane, at the time of Laertes: Nericus again and Dulichium.

The testimony concerning these battles and conquests comes from Odysseus himself, who, addressing his son Telemachus, confirms what his father Laertes had previously stated:

«Τηλέμαχ', ἤδη μὲν τόδε γ' εἴσεαι αὐτὸς ἐπελθών,
ἀνδρῶν μαρναμένων ἵνα κρίνονται ἄριστοι,
μή τι καταισχύνειν πατέρων γένος, οἳ τὸ πάρος περ
ἀλκῇ τ' ἠνορέῃ τε κεκάσμεθα πᾶσαν ἐπ' αἶαν.»

ω 506-9

«Telemachus, now shall you learn this having yourself come to the place where
battle distinguishes those who are bravest
to bring no disgrace on the house of your fathers, who in times past
have excelled in strength and in valour over all the earth.»

Od. 24.506-9

Odysseus lineage had prevailed over the island after hard and heroic battles were fought. In this instance, the responsibility for the family affairs was passed over by worn out Odysseus, to the young and strong Telemachus, who agreed to assume and continue the glorious path of his father and his family.

«ὄψεαι, αἴ κ' ἐθέλῃσθα, πάτερ φίλε, τῷδ' ἐπὶ θυμῷ,
οὔ τι καταισχύνοντα τεὸν γένος, ὡς ἀγορεύεις.»

ω 511-2

«You shall see me, if you wish, dear father, as far as my present mood goes,
bringing no disgrace whatsoever on your lineage, as you suggest.»

Od. 24.511-2

Laertes was happy with Telemachus reply and evoked the gods:

ὣς φάτο, Λαέρτης δ' ἐχάρη καὶ μῦθον ἔειπε·
«τίς νύ μοι ἡμέρη ἥδε, θεοὶ φίλοι; ἦ μάλα χαίρω·
υἱός θ' υἱωνός τ' ἀρετῆς πέρι δῆριν ἔχουσιν.»
ω 513-4

So said he, and Laertes was glad, and spoke, saying:
«What a day is this for me, king gods! I utterly rejoice:
my son and my sons son are quarreling over which is the bravest.»
Od. 24.513-4

In closing the cycle, the poet mentions their progenitor Arceisius and patroness goddess Athena Pallas, who addressed Laertes as follows:

τὸν δὲ παρισταμένη προσέφη γλαυκῶπις Ἀθήνη·
«ὦ Ἀρκεισιάδη, πάντων πολὺ φίλταθ' ἑταίρων,
εὐξάμενος κούρῃ γλαυκώπιδι καὶ Διὶ πατρί,
αἶψα μάλ' ἀμπεπαλὼν προΐει δολιχόσκιον ἔγχος.»
ω 516-9

Then flashing-eyed Athene came near him and said:
«Son of Arceisius, far the dearest of all my friends,
make a prayer to the flashing-eyed maiden and to father Zeus,
and then instantly raise aloft your long spear and hurl it.»
Od. 24.516-9

These are beautiful words, and thus, to conclude the scene, the remaining closing verses of The Odyssey are transcribed in translation.

520 *So spoke Pallas Athene, and breathed into him great strength.*
Then he prayed to the daughter of great Zeus,
and instantly raised aloft his long spear, and hurled it
and struck Eupeithes through the helmet with cheek piece of bronze.
This did not ward off the spear but the bronze passed through,

525 *and he fell with a thud, and his armour clanged about him.*
Then on the foremost fighters fell Odysseus and his glorious son
and thrust at them with swords and double-edged spears.
And now they would have killed them all, and cut them off from returning,
Had not Athene, daughter of Zeus, who bears the aegis,
530 *shouted aloud, and held back all the fighters, saying:*
«Cease from painful war, men of Ithaca,
so that without bloodshed you may speedily be parted.»
So spoke Athene, and pale fear seized them.
Then in their terror the arms flew from their hands
535 *and fell one and all to the ground, as the goddess uttered her voice,*
and they turned toward the city, eager to save their lives.
Terribly then shouted the much-enduring, noble Odysseus,
and gathering himself together he swooped upon them like an eagle of lofty flight,
and at that moment the son of Cronos let go a flaming thunderbolt,
540 *and down it fell before the flashing-eyed daughter of the mighty sire.*
Then flashing-eyed Athene spoke to Odysseus saying:
«Son of Laertes, sprung from Zeus, Odysseus of many devices,
hold your hand, and stop the strife of war, common to all,
for fear Zeus whose voice is born afar may perhaps become angry with you.»
545 *So spoke Athene, and he obeyed and was glad at heart.*
Then for the future a solemn truce between the two sides was made
by Pallas Athene, daughter of Zeus, who bears the aegis,
in the likeness of Mentor both in form and in voice.

From the above verses, one can clearly discern the transition of power from generation to generation within the family, from Arceisius to Telemachus. Apart from the reference to the builders of the Callirous (fair-flowing) spring, Homer does not mention their father Pterelaus and the Taphian progeny from which they issued. Also no mention is made of Cephalus, the forefather of the clan, and his children Pallis, Cranius, Samius and Pronus, even through he (Cephalus) was Arceisius father. Cephalus, as mentioned previously, begot Arceisius by Arctus

and his other children by Lysippe. Laertes, furthermore, was a contemporary of his fathers brothers. Thus, no personages that did not belong to the Arceisius branch of the family, even if they were closely related, are mentioned in The Odyssey, not even Arceisius own father, Cephalus. Homer, being himself a descendent of this house, avoids mentioning even the names of those who were his ancestors adversaries. His forefathers, through hard struggles, kept high the honour and reputation of his family.

The predominant population elements residing on the island at the time when these events transpired were the inhabitants of the démos of Ithaca, the Cephallenians, and the Epeians of Dulichium, who were immigrants from Elis. Sovereignty, however, was exercised indisputably by the King of Ithaca. Eleian, a friend and fellow combatant of Cephalus in his campaign against the Taphians, as well as Cephalus children had been neutralised and possibly expelled. Obviously their names were not even needed as points of reference.

CHAPTER THIRTEEN

AEGILIPS AND CROCYLEIA

TWO ADDITIONAL localities are mentioned in *The Iliad*, whence came men who Odysseus led to Troy: Aegilips and Crocyleia.

Αὐτὰρ Ὀδυσσεὺς ἦγε Κεφαλλήνας μεγαθύμους,
οἵ ῥ' Ἰθάκην εἶχον αἱ Νήριτον εἰνοσίφυλλον,
καὶ Κροκύλει' ἐνέμοντο καὶ Αἰγίλιπα τριχεῖαν,
οἵ τε Ζάκυνθον ἔχον ἠδ' ἀντιπέραι' ἐνέμοντο·

B 631-5

And Odysseus led the great-hearted Cephallenians
who held Ithaca and Neritum, covered with waving forests,
and who dwelt in Crocyleia and rugged Aegilips;
and those who held Zacynthus, and who dwelt about Samos,
and held the mainland and dwelt on the shores opposite the isles;
Il. 2.631-5

The poet, in the above first three verses, defines quite clearly the regions where Cephallenians dwelt. Ithaca and the Neritum area are mentioned first. That is, the Pallis peninsula where the démos and city of Ithaca lay, and Neritum where the démos of the Cephallenians was located. The cities and villages of the latter were built on the slopes of Neritum (Mt. Aenos). This area starts from the boarders of the Agonas and Pylaros regions on the northern end of the island and covers the entire ridge, Farsa, Argostoli, Crane and Leivatho, all the way to the southeastern end of Cephallenia at Scala. Dulichium was located about the middle of this region where Argostoli, Cephallenia's capital, is found today. As mentioned previously, Meges had settled at Dulichium coming with his forty ships from Elis (Il. 2.625-30), and these ships he led to Troy. The regions just described lay on the southwestern side of the island. Two more areas are however mentioned, Crocyleia and Aegilips which, logically, should correspond to the eastern

and northern side of the island. The word αἰγίλιψ-ιπος gen. 'aegilipos' means destitute even of goats, hence, steep, sheer.

[...] ἥ τε κατ' αἰγίλιπος πέτρης ὀνοφερὸν χέει ὕδωρ· [...]
I 15

[...] that down over the face of a sheer cliff pours its dusky steam; [...]
Od. 9.15

The word is in fact a compound composed of αἰγίς + λίψ 'aegis + lips'. Aegis is the shield of Zeus, Athena, Apollo. It also means rushing storm or hurricane. Λίψ 'lips' is the southwest wind[1].

The northern part of the island of Cephallenia projects out from the bay of Myrtos and the Agia Kyriaki headland, at the boarders of Agonas, to the Daphnoudi promontory. It runs for about 30 km northward from Myrtos, is sheer to the sea and rises to a height of over 300 m. It is the only place in Cephallenia that has all attributes relating to the terms αἰγίς 'aegis' and λίψ 'lips', which define the location of Aegilips. This entire Eryssos swelling faces the open Ionian Sea and is battered by the rushing western winds and the violet sea waves crushing on it. The precipitous mountain side, cut vertically, truly stands up like a huge shield just as the word itself describes it, a shield rising to the heavens, withstanding the violence of wind and sea. This, in the final analysis is Aegilips, rugged and barren as the poet describes it. Everything today is the same as it was then. A strong, wild, beautiful landscape, where the soul is enchanted, where man is lost in his insignificance in the presence of the immense height of the rising cliffs, by the wine-coloured sea and the violet horizon. Everything there is divinely created. Man's mind and soul stand in awe confronted by chaos and beauty. This is Ithaca's, Homer's and Odysseus' Aegilips in all its magnificence. (Illus. 27) A run from Agonas to Fiscardo and a climb to the castle at Assos, should be sufficient to cause the visitor to stop short, stunned by the immense shield formed by the sheer cliffs of Myrtos, Charakas and Aspros Yalos, that have been standing there since time immemorial, marking the existence and location of Homeric Aegilips.

1. In Contemporary Greek Λίβας 'Livas' is the southwestern hot wind coming from Libya or, Africa. Tans. note.

Another area in Cephallenia that needs to be identified, in Homeric terms, is the eastern side of the island. This side, from the Scala promontory to the Agriosyko promontory at the bay of Same should, logically, correspond to Homeric Crocyleia. (Illus. 28) It is a large area, covering the entire eastern Aenos side, all the way to Agia Dynati and the Pylaros villages. The poet, describing the lands where the Cephallenians dwelt, mentions them in a sequence which points directly to their location (Il. 2.631-5 above). He states that Odysseus «led the Cephallenians who held Ithaca and Neritum, and who dwelt in Crocyleia and Aegilips». Starting from Ithaca (Pallis), he continues to the side across the bay where Neritum lay (Argostoli – Crani – Leivatho), passes over to Crocyleia on the eastern side of the mountain (Scala – Pores – Same – Agia Euthemia), and completes the circumference of the island ending in Aegilips (Eryssos peninsula)[2]. Following the above, the poet mentions the islands and lands lying outside Cephallenia, that is Zacynthus, Same (today's Ithaca) and the regions across on the mainland, i.e. Leucas and Acarnania.

The identification of the two above regions mentioned in *The Iliad* and the other places mentioned in *The Odyssey*, completes the search and identification of the Homeric islands and cities. Following an adventure of over 3,000 years, it is quite gratifying to note that contemporary man can now fulfil his dream of returning home to Odysseus' Ithaca.

2. The toponym Crocyleia is mentioned in the archives of the Cephallenian Roman-Catholic episcopate in the year 1264. The episcopate was located south of Eryssos near Kalon Oros. This strengthens the view that the statement in *The Iliad* (2.631-5), refers exclusively to areas in the island of Cephallenia.

CHAPTER FOURTEEN

LIXOURI AND THE PLANCTAE ROCKS

ἔνθεν μὲν γὰρ ἐπηρεφέες προτὶ δ' αὐτὰς
κῦμα μέγα ῥοχθεῖ κυανώπιδος Ἀμφιτρίτης·
Πλαγκτὰς δή τοι τάς γε θεοὶ μάκαρες καλέουσι.

μ 59-61

On the one side are beetling crags, and against them
roars the great wave of dark-eyed Amphitrite;
the Planctae1 the blessed gods call these.

Od. 12.59-61

The Planctae Rocks or Beetling Crags or Wandering Rocks1 are rocks found in coastal areas, extending into the sea, and on them the great waves crash with a roar. They generally face one another and when they move they collide. Generally, it appears that the Planctae Rocks (Symplegades)[1] was the name by which certain twin reefs were known in antiquity. According to mythology, they were located at the exit of the Bosporus toward the Black Sea. They would move toward each other and then pull apart. Thus ships passing through were crashed by the clashing rocks. Jason sailed by them but managed to escape in his swift ship Argo. The rocks remained motionless thereafter. The myth originates with the danger faced by ships sailing through narrow sea passages during a storm. According to other traditions the Planctae Rocks were located at the Gilbratar strait or the strait of Messina, where the monster Scylla dwelt on one side and Charybdis on the other.[2] Concerning the passage of the ship Argo between the Rocks, Apollodorus states the following:[3]

1. Also known as Symplegades, and Blue Rocks (Cyaneae). Trans. note.
2. Hari Patsis Encyclopedia.
3. Apolloduorus, The Library I. IX.21-2

Sailing in the Argo Jason and his companions came to land at Salmydessus in Thrace where they met the seer Phineus, who being blind of both eyes was harassed by the winged female creatures, the Harpies. They would fly down from the sky and snatch most of the victuals, and what little was left stank so badly that no one could touch it. When the Argonauts would have consulted him about the voyage, he said that he would advise them about it if they would rid him of the Harpies. Then Zetes and Calaïs, the sons of Boreas, drew their swords and, being winged, pursued them through the air. One of them called Ocypete, fled by the Propondis till she came to the Echinadian Islands, which are now called Strophades after her; for when she came to them she turned, ἐστράφη, 'estráphe', and being at the shore fell for very weariness with her pursuer. But Apollonius in the 'Argonautica' says that the Harpies were pursued to the Strophades Islands and suffered no harm, having sworn an oath that they would wrong Phineus no more.

Being rid of the Harpies Phineus revealed to the Argonauts the course of their voyage, and advised them about the Clashing Rocks in the sea. These were huge cliffs in the sea which, dashed together by the force of the winds, closed the sea passage. So he told them to let fly a dove between the rocks and, if they saw it pass safe through, to thread the narrows with an easy mind, but if they saw it perish, not to force a passage. They did that, and as she flew the clash of rocks nipped off the tip of her tail. So, waiting till the rocks had recoiled, with hard rowing and the help of Hera, they passed through, the extremity of the ship's ornamental poop being shorn away right around. Henceforth the clashing rocks stood still; for it was fated that, so soon as a ship had made the passage, they should come to rest completely.

The above excerpts are quoted because they are the commonly accepted versions and constitute valid scientific and historical facts or, even if they do not, they express accurately the tradition and beliefs of ancient writers. The belief that one could reach the Mediterranean Sea

from the Black Sea sailing the Ister[4] river, was quite widespread in historical times[5]. The Argonauts, after their purification by Circe for the murder of Apsyrtus, sailed by the island of the Sirens, by Scylla and Charybdis and the Wandering Rocks and the island of Thrinacia (Sicily), and finally came to Corcyra, the island of the Phaeacians. Then they sailed by Crete, put in to the island of Aegina and sailed between Euboea and Locris and ended up at Iolcus[6]. The ship Argo sailed in the vicinity of the Ionian Sea by way of central Europe. From the Black Sea it entered the Mediterranean (perhaps the Adriatic Sea) and reached Corcyra, where the Argonauts disembarked. In the description of the event, two familiar islands are mentioned, Corcyra and Strophades which constitute important reference points regarding the course of the ship. The area between the above two islands may be of importance because certain events took place within it, which one should carefully consider. It should be remembered that after the purification by Circe the Argonauts sailed by the island of the Sirens, by Scylla and Charybdis, by Thrinacia (Sicily) and reached Corcyra. This is the exact itinerary of Odysseus who arrived at the island of the Phaeacians before proceeding to Ithaca.

At about the middle of the southern part of the Pallis peninsula there is a headland known as Acrotiri. This is where the so called Kounopetra (Moving Rock) is found. The headland itself extends underwater forming a reef one kilometre long lying about 2 to 4 meters below the surface of the sea. The reef stretches for one more kilometre at a depth of 6 to 9 meters below the surface. After this the water deepens and reaches 10-17 meters, the sea floor forming a plateau extending over the entire area of the south-southeastern side of the Pallis peninsula. It reaches the coast at Xi and Mega Lakkos, a distance of 4 kilometres, within which lies the Vardiani island. On the other side of Acrotiri, in

4. Ancient name for the river Danube. Trans. note.
5. Apollodorus, The Library, I. IX. 26. Trans. note.
6. Strabo, I. 3.15. Trans. note.

a southwestern direction and very close to the coast, the depth of the water increases rapidly and reached 40, 100, 200, 300 and even 1000 meters. The reef that connects the Vardiani Island with the coast of Mega Lakkos is found at this point.

There are two moving rocks known as Kounopetra (Illus. 29). The New and the Old, lying two to three meters apart. The New Kounopetra is a large flat rock washed by the sea on all sides, protruding 1.5 meters above the water, its surface area not exceeding 20 square meters. The side of the rock facing the coast appears to have been detached from the main rock formation, there being now a fissure about 20 cm. wide. The visitor can easily verify its ceaseless movement by placing a thin stick of word in the fissure and watch it by turns bend and straighten out. The Old Kounopetra is still to be seen near by, half submerged in the water. It is said that its movement was more pronounced than that of the New and that it would collide with the rock opposite it with force producing a loud noise. The movement was slow and the fissure would open and close like the Planctae Rocks were said to do. For many years this was one of the sights of interest for visitors and became known throughout the world. It is said that the phenomenon was investigated by the crew of a visiting man of war soon after the end of the Second World War. Frogmen explored the reefs at the base of the rock to determine the cause of its movement. In fact, they are said to have attached a steel cable to it in an attempt to stop its movement, but to no avail. The rock appears to have sunk in the sea slightly during the last several decades and the locals claim that there is a continuous outward movement, so that the whole thing sinks, slowly sliding into deeper water. A local inhabitant confirms this, having observed the rock's movement since childhood. It appears that it moves into the sea in a southern direction at a rate of 1.0 meter per 100 years. Assuming that this rate of movement has been steady, then the reefs found outside the Acrotiri headland must have been 30 to 40 meters high 3,000 years ago. The rock stopped moving following the big 1953 earthquake, in similar fashion to the Planctae Rocks which stopped crashing against each other after Jason and his crew managed to sail through the opening. Thus an ancient phenomenon repeats itself in our day with the Lixouri Kounopetra.

There are many rocks in the general vicinity that are morphologically similar both in colour and shape (large rectangulars). They are battered by the fierce waves of the open sea, as the ones under discussion. Some people claim that the Old Kounopetra still moves but at a slower pace. Perhaps the same thing happens with other rocks in the area, but their movement has not been noticed. The rupture of the rock formations in the area of Acrotiri indicate a continuous movement of the tectonic sub-soil resulting in rifts and fissures such as the ones associated with the Kounopetras. The phenomenon, at any rate, is worth careful and in depth study by competent geologists, who would undertake the establishment of a program of continuous observation and the recording of vibrations by appropriate instruments. Then, perhaps, an answer regarding the origin and the causes of the behaviour of the moving rocks may be given, which would also make it possible to determine the morphology of the land in the past.

The true location of the Beetling Rocks mentioned by Homer in Odysseus' conversation with Circe (Od. 12.61), has not been identified. There are possibly many such moving rocks to be found in the Mediterranean basin, the main ones being those at Gibraltar. The Lixouri Kounopetra, therefore, cannot be dismissed. Moreover, such identification would vindicate Homer's word. The object, of course, of the present study is not to search for the places where Odysseus wandered, but rather to identify Homeric Ithaca and the islands lying around it. Having accomplished the latter task, it is felt that the search should continue seeking to identify the places where both the Argonauts and Odysseus later, wandered. The proposition that Homer's descriptions are not a figment of his imagination was proven by the evidence so far provided, but also by the real existence of the fear inducing geothermic and geodynamic phenomena, which he so aptly uses when describing the adventures of his heroes. Moreover, the moving rocks in this corner of the Pallis peninsula strengthen the view that Homer was intimately acquainted with the land to the last detail, as a native inhabitant would.

CHAPTER FIFTEEN

CHARYDBIS AT ARGOSTOLI

ODYSSEUS and his companions, having burned the body of their dead comrade Elpenor, came back from the house of Hades (the underworld), and were met by Circe who, aware of the event, stood in their midst, and spoke saying:

«σχέτλιοι, οἳ ζώοντες ὑπήλθετε δῶμ᾽ Ἀίδαο,
δισθανέες, ὅτε τ᾽ ἄλλοι ἅπαξ θνῃσκουσ᾽ ἄνθρωποι.
μ 21-2

«Stubborn men, who have gone down alive to the house of Hades to meet death twice, while other men die but once.
Od. 12.21-2

And then she continues thus:

« 'ταῦτα μὲν οὕτω πάντα πεπείρανται, σὺ δ᾽ ἄκουσον,
ὥς τοι ἐγὼν ἐρέω, μνήσει δέ σε καὶ θεὸς αὐτός.
μ 37-8

« '*So did all that come to pass; and now listen to what I shall tell you, and god shall himself bring it to your mind.*
Od. 12.37-8

«Once you have rowed past these maidens, at that point I shall no longer tell you fully on which side your course should lie, but you must yourself decide in your own heart, and I will tell you of both ways.» (Od. 12.57). The site described by Circe has two parts (Od. 12.58, 71). On one side lie the Planctae Rocks (Od. 12.73), one of which reaches with its sharp peak to the broad heaven (Od. 12.74). In it dwells Scylla (Od. 12.85). The other cliff is lower and on it is a large fig tree, but beneath this divine Charybdis sucks down the black water (Od. 12.104).

«'τὸν δ' ἕτερον σκόπελον χθαμαλώτερον ὄψει, Ὀδυσσεῦ.
πλησίων ἀλλήλων· καί κεν διοϊστεύσειας.
τῷ δ' ἐν ἐρινεὸς ἔστι μέγας, φύλλοισι τεθηλώς·
τῷ δ' ὑπὸ δῖα Χάρυβδις ἀναρροιβδεῖ μέλαν ὕδωρ.
τρὶς μὲν γάρ τ' ἀνίησιν ἐπ' ἤματι, τρὶς δ' ἀναροιβδεῖ
δεινόν· μὴ σύ γε κεῖθι τύχοις, ὅτε ῥοιβδήσειεν· [...]
μ 101-6

«But the other cliff, you will observe, Odysseus, is lower –
they are close to each other; you could even shoot an arrow across –
and on it is a large fig tree with rich foliage,
but beneath this divine Charybdis sucks down the black water.
Three times a day she belches it forth, and three times she sucks
it down
terribly. May you not be there when she sucks it down, [...]
Od. 12.101-6

Again,

«ἡμεῖς μὲν στεινωπὸν ἀνεπλέομεν γοόωντες·
ἔνθεν μὲν Σκύλλη, ἑτέρωθι δὲ δῖα Χάρυβδις
δεινὸν ἀνερροίβδησε θαλάσσης ἁλμυρὸν ὕδωρ.
ἦ τοι ὅτ' ἐξεμέσειε, λέβης ὣς ἐν πυρὶ πολλῷ
πᾶσ' ἀναμορμύρεσκε κυκωμένη, ὑψόσε δ' ἄχνη
ἄκροισι σκοπέλοισιν ἐπ' ἀμφοτέροισιν ἔπιπτεν·
ἀλλ' ὅτ' ἀναβρόξειε θαλάσσης ἁλμυρὸν ὕδωρ,
πᾶσ' ἔντοσθε φάνεσκε κυκωμένη, ἀμφὶ δὲ πέτρη
δεινὸν ἐβεβρύχει, ὑπένερθε δὲ γαῖα φάνεσκε
ψάμμῳ κυανέη· τοὺς δὲ χλωρὸν δέος ᾕρει.
ἡμεῖς μὲν πρὸς τὴν ἴδομεν δείσαντες ὄλεθρον·
μ 234-44

«We then sailed up the narrow strait with wailing.
For on one side lay Scylla and on the other divine Charybdis
terribly sucked down the salt water of the sea.
Indeed whenever she belched it forth, like a cauldron on a great fire

she would seethe and bubble in utter turmoil, and high overhead the spray
would fall on the tops of both the cliffs.
But as often as she sucked down the salt water of the sea,
within she could all be seen in utter turmoil, and round about, the rock
roared terribly, while beneath, the earth appeared,
black with sand; and pale fear seized my men.
So we looked toward her and feared destruction; [...]

Od. 12.234-44

And again,

«αὐτὰρ ἐπεὶ πέτρας φύγομεν δεινήν τε Χάρυβδιν
Σκύλλην τ', αὖντικ' ἔπειτα θεοῦ ἐς ἀμύμονα νῆσον
ἱκόμεθ'· [...]

μ 260-2

«Now when we had escaped the rocks, and dread Charybdis
and Scylla, soon then to the perfect island of the god
we came, [...]*

Od. 12.260-2

Dreaded Charybdis sucks the seawater down. And Circes wishes Odysseus not to be there when she does, for no one could save him from ruin. When she sucked the seawater, within she could be seen in utter turmoil, and around the rock there was a terrible roar, and under the earth appeared black with sand. On the lower cliff grew a large wild fig tree and under it dwelled dark Charybdis. The above description gives clearly the picture of a large whirlpool, which sucked the sea water in with great force, carrying along with it the sand. The great rush of the water produced a deafening noise shaking the area around it. The chasm into which the water flowed was dark and terrifying and apparently the water, after reaching a certain point, would return and would be ejected with a great roar as if from a cauldron full to the brim with boiling water. According to geological theory certain phenomena were much more pronounced 3,000-4,000 years ago. For example, the lateral displacement of the ground caused by an earthquake at present

amounts to a few centimetres while, several thousand years ago, it reached several meters. Even earlier, the displacement was of the magnitude of 100 meters or more. In the same manner, volcano activity is different today. Therefore, Charybdis' behaviour must have changed accordingly.

The Charybdis phenomenon appears in the Argostoli area (Illus. 30). The whirlpools (katavothres) are located near the coastal road, just before the Light House. The first sign of them is a huge turning paddle wheel put in motion by the force of the rushing sea water, and it is, of course, used to attract the attention of visitors who watch this marvel of nature with wonder, unable to give an explanation. The volume of the water entering the whirlpools is not known since the number and size of the fissures are not known. It is certain, however, that it amounts to thousands of cubic meters per hour. The mystery, that baffled naturalists and hydro-geologists for a century or more, was finally solved by two German scientists, who arrived on the island as a result of the tireless efforts of Socratis Mattheou, formerly of Mattheata of the Dolichio *démos* in Cephallenia. Mattheou's passion for Cephallenia, succeeded in rousing the interest of renowned scientists from Germany and Austria, who conducted certain geological, geobotanical and hydrogeological studies on site. In his book, Socratis Mattheou writes:[1]

> *The mystery of the whirlpools of Argostoli remained unsolved until 1963. On February 26, 1963, Professor Maurin and Professor J. Zoetl of the University of Karlsruhe and Graz respectively, investigated the phenomenon. A quantity of uraninite (pitchblende) in powder form readily soluble in water, was dumped into the vortex of the whirling water. On March 12, 1963, that is fourteen days later, the first greenish traces were observed in the water of a spring located 15 kilometres away, as the crow flies, between Vlachata and Agia Euthemia. The points of exit of the Argostoli whirlpool water current were thus determined, thanks to the efforts of the above scientists, specialists on Karstic Hydrology.*

1. 'CEPHALLENIA, for a better future', Athens 1978, p.21-2.

The author continues reporting that as a result of the above investigation, stalactite fragments found in lake Melissani, were examined and dated by the 14C method. One fragment found at a depth of three meters was determined to be 16,000 years old, while another, found at a depth of 26 meters, was measured to have been formed 20,000 years ago. Mattheou also reports the conclusions of Dr. Zoetl's study.

It is interesting to note that all spring water in the gulf of Same of Agia Euthemia, is brackish (saltish). We now know that this, at least partly, is due to the fact that seawater from the Livadi bay penetrates into the sub-soil, traverses the island underground, and resurfaces through the springs on the eastern side, mixed with fresh water. The renowned Argostoli whirlpools are some of the points where this penetration takes place. Large underground springs located on the coast near Vlachata and Same, are part of this rather complex mechanism of water movement. The development of this system can be explained by referring to the hydrological conditions and changes that took place during the Ice Age. The sea level, at the time of the last two ice periods, was at least 100 meters lower than it is today. At that time the Livadi bay, whose maximum depth is now 28 meters, was a flat dry basin. In this area, surface furrows would form on the non-carboniferous rock formations, the water conveyed in them penetrating and disappearing in the eddies created on the edge of these rock formations. Through the fissures of the cretaceous rocks it would seek an exit on the eastern coast of the island which, at the time, was 70 meters lower than at present. This phenomenon is not unique nor is it unusual. It takes place in the Bjelo Poje region of Monte Negro and, in fact, the distance traversed by the underground course of the water is much greater. When the sea level rose, the Livadi bay was inundated. The underground streams of fresh water, however, acted as outlets and caused the water to flow through the naturally created channels. Thus, seawater continues to this day to flow, crossing the island underground.

At any rate, Dr. Zoetl's study confirms that the most abundant fresh water springs in Cephallenia are found on the eastern coast at Kouttavos, corroborating thereof Homer's statements of a verdant Dulichium. To undertake the exploration of the Zervati – Karavomilo grotto discovered during the course of this work, a scientific team was brought in. It was composed of Dr. Knar, Dr. Schtoibing, and Professor Neubauer accompanied by a group of 25 scientists of various disciplines. The cavern was the result of a geological cave-in. Apart from its blue hue described below, there were certain other finds relative to the fauna and flora of the grotto, the rich vegetation of the steep walls and the vegetation of the coastal areas. From Socratis Mattheou's book the following additional information is extracted:

> *The blue grotto (Azur Tholos) is located at Zervati-Karavomilos, not far from Same; it was discovered by two Austrian scuba divers, Walter Tisch and Franz Raisinger, under the supervision of Professors Maurin and Zoetl. The grotto consists of three lakes, two of them exposed and one inside the grotto itself. During the months of July and August, from 10:30 hours to 13:00 hours, the sun's rays fall directly on the lake situated in front of the grotto, are refracted and through reflection the grotto is lighted assuming a bluish hew, something similar to the well known Blue Grotto of Capri in Italy (Grotta Azzurra).*
>
> *A group of Austrian divers under L. Danes were brought in to conduct underwater exploratory work and necessary measurements, among which the late Taimer from the University of Vienna. Taimer was lost while investigating deep water organisms of the hydrozoa class at a depth of 100 meters around the Alaties area of the Maganon village of Erissos. It was he who took the underwater measurements at the blue grotto at Zervati. A memorial should be dedicated to this brave explorer of the deep, as a tribute for his many contributions to the island of Cephallenia.*

This extensive reference to the observations and discoveries of the German and Austrian scientists was intended to underline the importance of the study undertaken and the scientific interpretation of the

Argostoli whirlpool phenomenon. These same observations, however, were recorded by Homer 3,500 years ago, who reported the fundamental elements of the activity described. Homer uses the word ἐξέ μεσις 'exémesis', while the word used today being ἐκροή 'ekroé' (outflow). He uses the word ἀναρροίβδησις 'anarroébthesis', while today the term is rendered as εἰσροή 'eisroé' (inflow). The differences in Homer's descriptions of the phenomenon, as compared to the situation prevailing at present, concern the shaking of the ground, the inflow of sand along with the water in the eddy, the accompanying noise and the fear it induced. These particulars, however, relate to conditions prevailing in his time. As far as the returning boiling water (Od. 12.237), causing the mist on the summit of the cliffs (Od. 12.238) is concerned, this does not occur today. But this again is a matter of geotectonics. For this to happen, the water should reach levels that are geothermically heated, much as it happens with hot springs. It is also quite possible that Homer refers to sites in the Atlantic Ocean, as is suggested by several foreign researchers (Menz, Pillot, Philip, etc.).

The subject of geothermal energy, of great interest to the geo-physicists, is hardly covered by these few comments. It is, however, interesting to mention certain unofficial reports that touch on the subject. It is noticed, by the crews of the ferry-boats crossing from Brindisi or Ancona, Italy, to Patras in Greece, that as soon as they reach the area between the islets Arcondi and Atokos north of Ithaca, the water temperature rises by 3,0°C. This change is recorded by the engine's cooling system's instruments. A ferry captain, who happens to be a friend, assured the writer of the fact. In jest, he added that the engine crew working on the corresponding shift (they cannot see the surroundings), know immediately that they have reached the area in question. It appears, therefore, that the water sucked in by the eddies, wherever they may be located, returns to the surface of the sea, causing large areas to be warmed up. Something similar, that is, to the action of hot springs.

The remarks and data presented above are not intended to prove that the Argostoli whirlpools are Homer's Charybdis. They do, however, prove that Homer was a keen observer of physical phenomena, and, as such, took notice of geological activity in the Pallis peninsula and the Livadi bay. These phenomena, usually, remain unchanged, and were

used by the poet either to describe actual events or allegorically. Homer's descriptions strengthen the view that the great teacher was born and raised in Cephallenia's Pallis peninsula. Aristotle, in his treatise on poetry (Poetics, 459b13-6), states that «Homer uses all and first with great understanding, and that is concluded because each one of his poems has been constructed in such a way that *The Iliad* is simple and full of passion, while *The Odyssey* is complex, difficult in reading and ethics.» It is believed that if one approaches the paths to which the poet points in *The Odyssey*, one realises that he expresses with accuracy and consistency what he wants to say. Discovering Homeric Ithaca is not an unsolvable mystery, as long as one makes a start. This study of *The Odyssey* is a first step toward this goal. In this respect, certain inexplicable Homeric descriptions regarding mythical monsters such as Scylla, are nothing more than descriptions of physical phenomena over which man has no power. For example, he states through Circe that «She is not mortal, but an immortal evil, dread, and dire, and fierce, and not to be fought with;». Circe then tells Odysseus:

[...] οὐδέ τις εστ' ἀλκή· φυγέειν κάρτιστον ἀπ' αὐτῆς.
ἢν γὰρ δηθύνησα κορυσσόμενος παρὰ πέτρῃ,
δείδω, μή σ' ἐξαῦτις ἐφορμηθεῖσα κίχῃσι
τόσσῃσιν κεφαλῇσι, τόσους δ' ἐκ φῶτας ἕληται.

μ 120-3

[...] there is no defence; the best course is to flee from her.
For if you wait to arm yourself by the cliff,
I fear that she may again dart forth to attack you
with as many heads and seize as many men as before.

Od. 12.120-3

Regarding Scylla, the Kaktos edition scholiast of *The Odyssey* notes:[2] «Scylla, the daughter of Phorcys and Ecate, occupied the strait

2. 'Odyssey', Kaktos edition, sch. ì -8.

around Sicily. She was monstrously big, had twelve feet, six heads of dogs and three rows of teeth in each mouth. Her eyes spewed fire. She was stuck to the rock, part of her body hidden in a cavern sunk in the bottom of the sea, her heads hanging out so that she could from the rock reach the passing ships. It is said that Hercules saw her while driving Geryon's cattle away, knew her to be voracious and so he killed her. Her father forced him by using fire to revive her. The story is mentioned by Dionysius of Halicarnassus.» It is obvious that Scylla represents volcanic activity in the general area of the strait of Messina (Sicily). The remarkable part of the story is that Scylla is the daughter of Phorcys, and that while Hercules killed her, her father Phorcys forced her revival through fire, a clear indication of revival of volcanic activity.

The investigation of the subject requires, of course, geothermal, geophysical and geological expertise. It is, however, felt that ancient people had identified the concentration of earthquake causing energy as being located under the Pallis peninsula, this phenomenon being personified by Phorcys. One of Phorcys' daughters, Thoösa, personified the tempestuous sea. She was married to earth shaker Poseidon, was the mother of the Cyclops Polyphemus and was, thus, involved in causing earthquakes. Scylla of the fiery eyes was also said to be Phorcys' daughter. This simply means that the violence of earthquakes experienced in Pallis, was greater than anywhere else, the volcanic eruptions in Sicily being considered as being the cause of the release of this energy. Seismologists do not adopt this concept today. It is generally accepted that seismic activity moves in an eastward direction, and thus an earthquake taking place in Sicily will eventually move on to Greece. Thus, Phorcys, Scylla, Charybdis, the Planctae Rocks, Thoösa and Cyclops, represent to physical phenomena which, being located in the same geographical area, are interrelated and interacting.

CHAPTER SIXTEEN

TEIRESIAS' RIDDLE AND THE TOMB OF ODYSSEUS

> *[...] αὐτὰρ ἐπὴν μνηστῆρας ἐνὶ μεγάροισι τεοῖσι*
> 120 *κτείνῃς ἠὲ δόλῳ ἢ ἀμφαδὸν ὀξέι χαλκῷ,*
> *ἔρχεσθαι δὴ ἔπειτα λαβὼν ἐυῆρες ἐρετμόν,*
> *εἰς ὅ κε τοὺς ἀφίκηαι οἳ οὐκ ἴσασι θάλασσαν*
> *ἀνέρες, οὐδέ θ' ἅλεσσι μεμιγμένον εἶδαρ ἔδουσιν·*
> *οὐδ' ἄρα τοί γ' ἴσασι νέας φοινικοπαρήους*
> 125 *οὐδ' ἐυήρε' ἐρετμά, τά τε πτερὰ νηυσὶ πέλονται.*
> *σῆμα δέ τοι ἐρέω μάλ' ἀριφραδές, οὐδέ σε λήσει·*
> *ὁππότε κεν δή τοι συμβλήμενος ἄλλος ὁδίτης*
> *φήῃ ἀθηρηλοιγὸν ἔχειν ἀνὰ φαιδίμῳ ὤμῳ,*
> *καὶ τότε δὴ γαίῃ πήξας ἐυῆρες ἐρετμόν,*
> 130 *ῥέξας ἱερὰ καλὰ Ποσειδάωνι ἄνακτι,*
> *ἀρνειὸν ταῦρόν τε συῶν τ' ἐπιβήτορα κάπρον,*
> *οἴκαδ' ἀποστείχειν ἔρδειν θ' ἱερὰς ἑκατόμβας*
> *ἀθανάτοισι θεοῖσι, τοὶ οὐρανὸν εὐρὺν ἔχουσι,*
> *πᾶσι μάλ' ἑξείης. θάνατος δέ τοι ἐξ ἁλὸς αὐτῷ*
> 135 *ἀβληχρὸς μάλα τοῖος ἐλεύσεται, ὅς κε σε πέφνῃ*
> *γήρᾳ ὕπο λιπαρῷ ἀρημένον· ἀμφὶ δὲ λαοὶ*
> *ὄλβιοι ἔσσονται. τὰ δέ τοι νημερτέα εἴρω'.*
>
> λ 119-37

[...] But when you, the suitors in your halls,
120 *you have slain, whether by guile or openly with the sharp sword,*
then go abroad, taking a shapely oar,
until you come to men that know nothing of the sea
and eat their food unmixed with salt,
who in fact know nothing of ships with ruddy cheeks,
125 *or shapely oars, which are a vessel's wings.*
I will tell you a most certain sign, which will not escape you:
when another wayfarer, on meeting you,
shall say that you have a winnowing fan on your stout shoulder,
then fix in the earth your shapely oar

130 *and make handsome offerings to the lord Poseidon –*
 a ram, and a bull, and a boar that mates with sows –
 and depart for your home and offer sacred hecatombs
 to the immortal gods who hold broad heaven,
 to each one in due order. And death shall come to you yourself
 away from the sea,
135 *the gentlest imaginable, that shall lay you low*
 when you are overcome with sleek old age, and your people all
 around you[1]
 shall be dwelling in prosperity. This is the truth that I tell you.
 Od. 11.119-37

These words were spoken by the seer Teiresias when Odysseus met him in Hades (the underworld), and asked him how he should reach Ithaca. The same oracle is repeated almost verbatim by Odysseus to Penelope, when he tells her of his wanderings and of Teiresias' prediction (Od. 23.269-84). Following the slaughter of the suitors, Odysseus purged his house with sulphur. He laid with his wife that same night (Od. 23.354) on the bed he himself had built (Od. 23.189), and with the first light of dawn (Od. 23.370-1) «he girt about his shoulders his beautiful armour» and along with Telemachus and the two herdsmen, Eumaeus and Philoetius, descend from the palace to go to Laertes', his father, well ordered farm (Od. 24.205-6). At this point Laertes recognised his son and so did Dolius, Penelope's servant, who was there along with his children. They, along with Odysseus, Telemachus, Laertes and the cattle herders, subdued the revolt of the Ithacians at its offing (Od. 24.520-28) and, following Pallas Athena's intervention, ceased fighting and a solemn truce between the two sides was made. The events described in Teiresias' omen must, by necessi-

1. « [...] people all round you [&]» ([...] ἀμφὶ δὲ λαοί [...], Od. 11.136) corresponds to «[&] round it lie [&] islands [&]» ([...] ἀμφὶ δὲ νῆσοι [...] Od., 9.22).

ty, have taken place following Odysseus' prevalence over the suitors and relate to acts of expiation from the evil brought about by the bloody slaughter that took place within the walls of the palace. Odysseus was directed by the seer to some place, where he would sacrifice to Poseidon, following which he would return home, and there he would offer a sacred hecatomb (100 oxen) to all the gods. The poet's verses, recounting the omen of Teiresias, contain some allegorical meaning as to the place where Odysseus should go to sacrifice to Poseidon. There are many instances where allegory obscures the meaning of the words used. Such words, for example, as ἀθηρηλοιγός 'athereloegós', (Od. 11.128) in relation to 'eretmón' or oar. The word ἀθηρη-λοιγόν 'athere-loegón', is a compound consisting of ἀθήρ 'athér', the awn of wheat, and λοιγόν 'loegón', meaning ruin, havoc, destruction. It is related to Atheras village, the spring Arethousa and the Atheras promontory, which resembles the awns of wheat. The use, therefore, of the word 'athereloegós', having the same root as the toponym Atheras, cannot but pertain to the essential meaning intended by the poet. It refers to actual conditions and facts that relate harmoniously to each other, as the words:

Athér – Athéras - Arethoúsa – Athereloegós – Atheroloegós

The intention of Homer to link allegorically Atheras and Arethousa with 'athereloegós' is evident. The word was used to indicate indirectly, yet quite clearly, the toponym and the site where the mount on which he was to fix his oar was located. He was directed to a place where the men there did not know, ἴσασι 'essasi' (Od. 11.122), the art of seafaring. It is clear that men who do not know of the sea must be mountain folk. It is also noteworthy that the poet mentions ἀνέρες 'men' (Od. 11.123), and that the wayfarer who would comment on his oar, was to be a man, not a woman, since only men were to be found there, according to the poet (Od. 11.127). These men did not mix their food with salt since, being wayfarers, ate mostly meat roasted on a skewer, sprinkled with white barley meal. At least, this was the meal Eumaeus prepared for Odysseus (Od. 14.74-7), when he hosted him in his hut (Od. 14.45) at the swinesty. This was indeed a site where only

men dwelt, as the poet states, since besides Eumaeus, who took care of the sows (Od. 14.107), four more herders were near by who cared for the boars (Od. 14.24-6). In the same area, at the extreme edge of the land of Ithaca (Od. 14.104), grazed eleven herds of goats watched over by trusty men faithful servants of Odysseus' estate. Eumaeus in fact told Odysseus that he «dwells apart» ἀπότροπος (Od. 14.372) with the swine, and that he did not go to the city unless Penelope called for him. All these references confirm that the shepherds living on the borders of the island, where the swinesty, the spring of Arethousa and the Corax rock were located, were precisely the men who had no knowledge of seafaring, since they could not and did not know how to handle a ship or to cope with the wild sea. They were the same men who did not mix salt with their food, since they mostly ate roasted meat sprinkled with white barley meal. They lived there, in the far-off hills, without women or children, as ὁδίτες 'hodítes', wayfarers on «the long paths» ἀτραπιτοί τε διηνεκέες (Od. 13.195).

Mention of Odysseus' grave occurs only once in *The Odysssey*. This takes place when Eumaeus, told the hero himself about his tomb, while they were both at the site to which the poet alludes when he has Teiresias say that «he shall meet a wayfarer who knows not the art of navigation». This is a matter of importance, since through a similar series of seemingly accidental events, topographical data and other information was provided which led to the identification of the harbour of Phorcys. These facts, therefore, cannot be overlooked. They should be the subjects of thorough analysis, given that they possibly identify the location of this venerable monument, the sacred mound of the royal house of Ithaca. In verses Od, 11.119-34 above, the poet describes how Teiresias, the seer, told Odysseus to go where the mountaineers live (herdsmen), carrying a well-shaped oar. He concluded by telling Odysseus: «[…] then fix in the earth your shapely oar and make handsome offerings to lord Poseidon». The purpose of this remark was to indicate with precision the location of the mound, keeping in mind that it was the custom to fix an oar on the top of such monuments. This is what Elpenor's comrades did following his burial at the time when he was accidentally killed on Circe's island (Od. 10.552-60).

[...] πήξαμεν ἀκροτάτῳ τύμβῳ εὐῆρες ἐρετμόν.

μ 15

[...] and on the very top of the tomb we fixed this shapely oar.

Od. 12.15

This is confirmed by verses (Od. 11.134-7) which refer to Odysseus' death, stating that the tomb which will receive the dead king when he is «overcome with sleek old age» will be right where he fixed his oar. Also, the remark «your people [...] around you» (ἀμφὶ δὲ λαοί, Od. 11.136) corresponds to «around it lie [...] islands» (ἀμφὶ δὲ νῆσοι, Od. 9.22), meaning the people, inhabitants of the surrounding islands, realm of Odysseus.[2] Eumaeus, also mentioned this important monument, the king's grave, to Odysseus, when the latter was at his hut near his swinesty. He stated:

τῷ κέν οἱ τύμβον μὲν ἐποίησαν Παναχαιοί, [...]

ξ 369

Then would the whole host of the Achaeans have made him a tomb, [...]

Od. 14.369

The most obvious site that fits Homer's description is the Fakimia hill, consisting of earth, having all the signs of a regular burial mound or σῆμα, 'séma'. It stands out distinctly in the general area. Eumaeus' sty was located there on top of a small flat-topped hill. The court (Od. 14.5) with the twelve stables could have been there. The hill is wooded all around, has a gentle inclination, but is virtually level. It is a bold spot, which excites the curiosity of both visitors and locals, who believe that, quite possibly, an ancient tomb is to be found within it. The distance between this place and Phorcys harbour is not more than 1500

2. See note 1.

meters, and it offers a vantage point from which the activities in the harbour and beyond can be surveyed. The site lies at the northeastern edge of the peninsula, which in effect, constituted in ancient times the Ithaca *démos*. This is why it was characterised by Eumaeus as «the borders of the island». Odysseus was well aware of these characteristics and knew quite well where Teiresias was sending him. The question, however, arises as to what was the σῆμα 'séma', or sign (Od. 11.126) that Teiresias was going to give him and which Odysseus could not forget?

σῆμα δέ τοι ἐρέω μάλ' ἀριφραδές, οὐδέ σε λήσει· [...]
λ126

And I will tell you a most certain sign, which will not escape you;[...]
Od. 11.126

The same verse, repeated when Odysseus related his adventures to Penelope, is rendered as follows:

σῆμα δέ μοι τόδ' ἔειπεν ἀριφραδές, οὐδέ σε κεύσω·
ψ 273

And he told me this sign a most clear one; nor will I hide it from you.
Od. 23.273

The terms employed in these verses, as is common in Greek, have more than one meaning, depending on what the poet intends to convey. Σῆμα 'séma' apart from sign also stands for grave or mound of earth. The verb ἐρέω 'eréo' means inquire but also search or explore. Μάλα 'mála' means very and ἀριφραδές 'ariphradés', thoughtful but also very clear to the sight (see also glossary). A simplified rendering of verse Od. 11.126, would read as follows: «I will give you a sure sign, which you will not forget.» Using, however, a different interpretation of the terms employed, one would obtain a different meaning of the oracle and discover the intended message hidden under the surface. The verse could be read as follows:

«*Search, explore* (ἐρέω) *for a very, exceedingly* (μάλα) *clear to the sight* (ἀριφραδές) *grave, mound of earth* (σῆμα), *it will not escape your notice* (λήσει).»

If the verb κεύσω 'képhso', meaning to hide or cover, and poetically used «to bury into the grave» (Od. 23.273, above), is taken into account, then, it is noted that this verse as well contains elements concerning the location of the grave.

At this point, another landmark should be noted. It is found in the general vicinity of Atheras, at the Fakimia site, where the hill, on which Eumaeus had built his swinesty, lies. On the southeastern side of the Fakimia hill, a 'hanging' rock is found. Underneath it a depression is formed creating a shallow cave, which can accommodate thirty to fifty animals (goats, sheep or swine). Under this hanging rock, facing toward the Moschonia channel at Trafo, Eumaeus spent the night (Od. 14.532-3), when he hosted Odysseus in his hut[3].

The above is, of course, a simple hypothesis. Odysseus and the members of his family, assuming that he died of old age in Ithaca, as the seer Teiresias predicted, should be located somewhere in the vicinity of the palace on the hill. In fact, the late Sp. Marinatos uncovered a large number of Mycenaean tombs, two to three kilometres West of Crikellos hill, under Kontesenada village, at a site known as 'Ecopeda'. To be sure, there are other ancient sources concerning Odysseus' demise. Thucydides (3.94) writes that he died an old man in Eurytanea, while Eugamus (c. 600-700 B.C.) in his lost epic 'Telegonia', claims that he was accidentally killed with an oar by his son Telogonus born to Circe. We, however, choose to rely on Homer's version. Odysseus, according to ancient tradition, had a large progeny. Sixteen sons and one daughter from his five wives, as follows:

3. The Fakimia hill deserves to be investigated archaeologically, just as the grotto of the Nymphs, at the Atheras harbour. Important finds should be located there. The floor of the Atheras harbour should also have much to reveal.

PENELOPE	PHOAS' DAUGHTER	CIRCE	CALYPSO	CALLIDISE
Telemachus	Leontophonus	Telegonus	Nausithous	Polypoetes
Arcecilaus	Ayson	Agrius	Nausinous	
Ptoliporthus	Romus	Latinus		
	Anteias			
	Cassiphonus			
	Cassiphone (daughter)			

CHAPTER SEVENTEEN

CEPHALLENIA'S TOPONYMS

1. Petanoi

In the verses quoted below, a toponym very well known in Cephallenia comes up: Petanoi.

[...] αἰγίβοτος δ' ἀγαθὴ καὶ βούβοτος· ἔστι μὲν ὕλη παντοίη, ἐν δ' ἀρδμοὶ ἐπηετανοὶ παρέασι.

ν 246-7

[...] It is good land for pasturing goats and cattle; there are trees of every sort, and in it are watering places that never fail.

Od. 13.246-7

The word was obviously corrupted with time, 'epeetanoí' loosing the initial and the second 'e', [(e)p(e)etanoí] became 'petanoí'. The name place was noted initially by the sound of the word in the verse «ἀρδμοὶ ἐπηετανοὶ παρέασι» or «in it there are watering places that never fail» (Od. 13.247). Petanoí today is a very well known tourist resort area on the Pallis peninsula. It was, thus, not surprising to find that the area has many sources with running waters and many wells. Petanoi, is located on the western side of the Pallis peninsula at the Ortholithia bay. Abundant water may be found at Halkes, Kerassi, Tyhia, Eriya, Yiouti and on the coast of Petanoi. The locals say that if one should dig with his hands in the sand of the Petanoi beach, one can draw clear drinking water. Very close-by are the villages of Agia Thekla and Kalata also known for their plentiful water resources.

2. Kakoïlion (Unhappy Ilion)

Toponyms in this area should be taken into careful consideration, since they all contain an element that refers to Homeric Ithaca. The

map of the 'Hydrographic Service of the Navy' indicates that two kilometres northwest of the tower of Telemachus there is a site known as 'Kohilia'. The word means seashells but has no connection to actual conditions prevailing in the area, since no such shells exist there. On another map, the name of the site is noted as 'Kokkýlia', but in this case as well, the name has no connection to a rocky wilderness devoid of vegetation. *Κοκκύλιον* 'Kokkýlion', in post classical Greek, stands for the minute particles found within the protoplasm of the cell. It appears, therefore, that time has not preserved the written form of the term, but came down somewhat altered, preserving its phonetic rendering. It is quite possible that instead of 'Kohília', 'Koghília' or 'Kokkýlia', the correct word is *Κακοΐλια* 'Kakoïlia'. This is a word used repeatedly by Penelope, Laertes, Telemachus, Eumaeus, Mentor and by all those who wept, lamented, clapped their hands in despair. Such a name could only be given to a desolate, rough place, which brought pain and lamentation to mind. Odysseus himself, as well as his men in Ithaca, but also Agamemnon, in their own words, confirm his negative attitude toward the Trojan War. Penelope's deep sorrow is expressed explicitly through the following verses:

οὐ γάρ πω τοιόνδε κατέδραθον, ἐξ' οὗ Ὀδυσσεὺς
ᾤχετ' ἐποψόμενος **Κακοΐλιον** οὐκ ὀνομαστήν.

ψ 18-9

For never yet have I slept so soundly since the day when Odysseus went off to see Ilium the Evil that should never be named.

Od. 23.18-9

τῷ ῥα κακῇ αἴσῃ κοίλης ἐπὶ νηός Ὀδυσσεύς
ᾤχετ' ἐποψόμενος **Κακοΐλιον** οὐκ ὀνομαστήν.

τ 259-60

Therefore it was with an evil fate that Odysseus in the hollow ship went off to see Ilium-the-Evil that should never be named.

Od. 19.259-60

And again,

> ἀλλ' ἦ τοι μὲν ἐγὼν ὑπερώιον εἰσαναβᾶσα
> λέξομαι εἰς εὐνήν, ἥ μοι στονόεσσα τέτυκται,
> αἰ εἰ δάκρυσ' ἐμοῖσι πεφυρμένη, ἐξ' οὗ Ὀδυσσεὺς
> ᾤχετ' ἐπυψόμενος **Κακοΐλιον** οὐκ ὀνομαστήν.

<div align="right">τ 594-7</div>

*But I, you must know, for my part to my upper chamber shall go
instead
and lay myself to my bed, which has become for me a bed of
lamentation,
constantly bedewed with my tears, since the day when Odysseus
went off to see Ilium-the-Evil that should never be named.*

<div align="right">Od. 19.594-7</div>

Perhaps it was here that they waited, looking out toward the open dark sea to see the ship carrying Odysseus return to Ithaca. If this is so, this inhospitable site was drenched with tears and resounded with laments, and was thus named because of the oaths for Ilium-the-Evil, the Κακοΐλιον 'Kakoïlion', which caused godlike Odysseus, the father, the husband, the king, to be lost for twenty years.

3. Assos - Pedasus

Two cities, one in the Troas region and the other in Cephallenia, carry the same name, denoting that some sort of relation existed between them. In Cephallenia, the contemporary village of Assos, is found, built on the coast, near the Myrtos bay. Above it rises the precipitous mountain of Eryssos, or Homeric Aegilips. It is both interesting and noteworthy that this small village was built on this dangerously precipitous site, next to the wide and wild sea. In E. Kosmetatos' book 'Report on Cephallenia's Roads', 1991 edition, an excerpt from a 1825 letter by Charles Napier is quoted, as follows:

«The precipice rises about 600 feet from the foaming sea under it. Clouds are moving beneath our feet at certain points which, I dare say, are no less than 2000 feet above the sea, and are so precipitous that we were forced to open tunnels into the mountain.»

This letter, composed long after Homer's time, but also the testimony of both the inhabitants and visitors, confirm that Assos induces awe and fear to the traveller. It was built on the innermost point of the cove formed by the small isthmus connecting the precipitous Eryssos mountain side and the small Assos headland on which the Venetian Castle that carries the same name is found. It lies across and not far from the Atheras harbour and is one of the most interesting sights on Cephallenia. A similar city, built on a similarly precipitous point, is mentioned by Homer as lying in the Troas region, close to Mt. Ida and the sources of the Scamander river, across from and to the north of the island of Lesbos. This is ancient Pedasus (Il.21.87), but it appears that at a later time it was renamed 'Assos' and was inhabited by a people known as Leleges.

> *[...] Πήδασον αἰπήεσσαν ἔχων ἐπὶ Σατνιόεντι.*
> Φ 87

[...] holding steep Pedasus on the Satnioeis.
> Il. 21.87

and again,

> *[...] ναῖε δὲ Σατνιόεντος ἐυρρείταο παρ' ὄχθας*
> *Πήδασον αἰπεινήν.*
> Z 34-5

[...] who dwelt by the banks of fair flouring Satnioeis in steep Pedasus.
> Il. 6.34-5

The above verses refer to Elatus from Pedasus, whom Agamemnon slew during a crucial battle (Il. 6.1-120) that surged over the plain. During the same battle, Odysseus slew Pidytes of Percote. The descrip-

tion preceding this, concerns the city of Pedasus, native city of Priam's wife, Laothoë, daughter of old man Altes, King of the Leleges (Il. 21.85-8). Hard battles were fought here between Achilles and the children of Priam and Laothoë, in one of which Achilles slew Polydorus, one of them (Il. 21.80-1)[1]. Pitched battles were also fought in the southern plains of the Troas close to Mt. Ida, following which Achilles destroyed the cities of Pedasus and Lyrnessus. Pedasus had close ties with the house of Priam, her men having taken active part in the war activities. It is known that Mysian Assos was built on a strategic location in antiquity, that is was well fortified and that later, in Byzantine times, towers were constructed, from which the neighbouring sea was surveyed. In Ioanna Phoca's and Panos Valavanis' 'Architecture and City Planning in Ancient Greece', Kaktos Edition, 1992, the following are noted:

«*At Assos, the Greek city lying close to Troy, built on a steep hillside, it was necessary to construct a huge retaining wall and to fill the ensuing space with earth in order to create a flat surface on which the city's agora (public square, market place) was built. [...]*
These two large colonnaded buildings are porticoes. The one to the north was two-storied and was used for large assemblies in bad weather, or offered shelter to peddlers. The one across from it was three-storied, one of which housed public baths.»

In the 3rd volume of the 'Great American Encyclopedia'[2], on page 577 the following is noted:

Assos: Ancient Greek city in Mysia, Asia Minor, situated on the northwestern coast of the bay of Adramittium, facing the island of Lesbos. It was built in very ancient times. It was an important city before B.C. 1000 and was possibly the capital city of the Leleges.

1. Achilles, incensed over Patroclus death, slew the other brother, Lycaou, as well, while the latter unarmed was imploring him to spare his life (Il. 21.116-27). Trans. note.
2. Greek Edition. Trans. note.

Thus, we have two cities by the name Assos, one in Cephallenia and the other in Troas. Their characteristics and the morphology of the land are similar. The Cephallenian Assos is characterised by the fortified wall of the Venitian Castle, encircling the hill of the promontory on which it was built. It is connected to the opposite coast of the island by a narrow isthmus, and constitutes a fortified town, from which one can survey the sea across the northwestern coast of the island. It is possible that the Venetian walls were built over Mycenaean fortifications. These two cities, resembling each other as far as their names and their fortifications are concerned, have one other common characteristic. One lies in the land of the King of Ithaca, while the other is the place where fierce battles took place during the Trojan War, Odysseus having participated in them.

4. Kouttavos or Kottavos[3]

The shallow sea at the neck of the Argostoli bay, into which the lavish springs of the land flow, is called Kouttavos. It is a lagoon, it has a circular shape, it is shallow and widespread and resembles a basin full of calm water. There are no waves. The general characteristics of the area do not justify the name, particularly when one considers the importance this area had in antiquity since, a little further in, the city of Nericus was located and, later on, Dulichium. The green landscape, the flat land, the clear fresh waters of the springs and the sea compose an enchanting setting, where men must have lived happily. This is where the dolichos races must have been held, after which, as was previously analysed, the greater area was named Dulichium. Among the games held there, *Κότταβος* 'Cottabus' must have been included. It was a game of throwing heel-taps into a metal basin by revolving a wide-brimmed wine-cup (cylix) containing wine remnants, around the index finger.

3. Kottavos. Phonetic spelling: Cottabus. Trans. note.

τόξον (tókson); κότταβος ... ὃν σκοπὸν ἐς λατάγων τόξα καθιστάμεθα: for shooting of liquor from the cup, Critias 2.2.

The calm bay of today's Kouttavos (Couttabos), forms indeed a basin resembling distinctly the implements of the game played with wine in ancient times. It is obvious that the name derives from the ancient game, which was brought over to Cephallenia from Sicily, across the Ionian Sea. The above reference from Critias (2.1D, 2.2), corroborates the use of the name of the game to describe the bay in question. The above analysis is presented in the hope that it might prove of assistance to individuals in the area who may be aware of pertinent facts, or to researchers who could possibly correlate future archaeological finds to the name, thus confirming the origin.

5. The Bay of Mýrtos, Mýrton and Eretmón

Between the Lithari promontory of Atheras to the West, and the coast of Eryssos to the East, the bay of Myrtos is formed opening to the north. Within the bay and approximately in the middle of the Eryssos coast, a small horn-like headland protrudes into the sea and is known as the Assos promontory. The northwestern point of this promontory bears the most unusual name 'Mouni', which in contemporary Greek usage stands for the female reproductive organ. This strange name was reason enough to undertake the search for its origin which follows, and which provided surprising information regarding the general area. In fact, the data gathered, relates in an interesting way to Homeric descriptions. The relevant lemma regarding the name of Myrtos bay is as follows:

μύρτον (mýrton): neut., myrtle berry; pudenda muliebria. (L. & Sc. Lex.)
: Aristophanes, Lysistrata 1004.
«οὐδέ τό μύρτον σιγῆν⁴ ἐώντι πρίν ἐξ᾿ ἑνός λόγου σπονδάς ποιησόμεθα ποττάν Ἑλλάδα» (They would not let us even touch the 'myrton', before in one voice we make peace in all of Greece).

4. Σιγῆν (sigén): Lacomic for θιγεῖν (thegeín) or touch. Trans. note

: Suidas Lexicographus (A.D. 960).

I. The shape of the female genital.

II. «*Οὖ τό μεταξύ κλειτορίς*» (That in between is the clitoris).

: Rufus Ephesius M.D.(A.D. 100).

I. A name for the human genitalia.

II. «*Τό ἐν μέσω μυῶδες σαρκίον μύρτον*» (The muscular bit of flesh in the middle of myrton).

μύρτος (mýrtos): Hesichius Lex. (B.C. 450).

I. Fem., myrtle, murtis communis; twig or spray of myrtle.

II. The female genital.

κλειτορίς (cleitorís): Rufus Ephesius M.D.(A.D. 100).

I. The small, sensitive, horn shaped, glottis like protrusion of the female genitalia. Medically; bit of flesh protruding from the upper part of the female genital.

II. Found on the upper end of the female genital. Formed by two concave tissues joined by an elastic membrane known as hood.

The purpose of the above detailed descriptions was to give the reader the opportunity to consider the resemblance of the small bit of flesh in question to the small Assos headland. The latter is composed of two concave land depressions, united by a narrow isthmus, like an elastic membrane. Moreover, from a topographical point of view and keeping in mind relative dimensions, the Myrtos bay corresponds fully to the morphology of the female genital. Three facts, therefore, confirm the view that there is a relation between the name of the bay and the female organ. The term *μουνί* 'mouni' which is the name by which the promontory is known in Greek vernacular, the term Myrto which is the name of the bay and which in ancient Greek also stands for the female genital and, finally, the morphological resemblance of the two.

Standing on the road above Assos, at the point where it branches off toward Eryssos and takes a turn downward towards the sea, the landscape confronting the viewer is imposingly awesome and charming at the same time. A rush of feelings overwhelms the traveller as he rests for a moment on the side of the road. Feelings of awe, admiration and

thoughtful engrossment engulf him. He finds himself in a void, there, on the edge of the precipice, between heaven and the deep blue sea. He has the urge to fly high and away into the immensity of Apollo's empire. The interminable alterations of the landscape, the magical hues of illuminated colour, the scents exhumed by the flowers, the immense sea and the azure heavenly vault, personify life itself. They confirm humanity's metaphysical relationship to the past, upon which one strides, looking for the truth. And then, suddenly, the gaze of the traveller is fixed upon the opposite coast, on the Lithari headland of Atheras, which, long and haughty, protrudes into the sea oblivious of the dark deep water of the barren sea. Its menacing presence seems to be aimed at tiny Assos. One's thoughts go way back to the muse that inspired Homer to write about Teiresias' omen. Atheras is where Odysseus was directed to fix his shapely oar, his ἐρετμόν 'eretmón', a term, which also means the male member. The existence of the Lithari promontory and the Assos headland, one across from the other, is not a poetical allegory. It is a fact. The way the Lithari promontory protrudes into the Myrto bay, as seen from Agon, Pylaros, Assos and Eryssos, and regardless of the meaning attached to it, that of an oar or that of a male member, it is there and the use of the term fits the situation quite adequately. From the above, one can safely draw the following logical conclusions. Teiresias directed Odysseus to Atheras, using terms such as ἀϑηρο-λοιγός 'atheroloegós', or winnowing fan, ἐρετμόν 'eretmón' or oar and told him that he will give him a sign that he will not forget, λήσει 'lései' (Od. 11.126). It is exactly because these terms have a double meaning in relation to the morphology of the land that they were used. It was, therefore, sufficient for the poet to use the then current toponyms, so that they would be easily understood by the social environment, which he himself knew and to which he was addressing himself.

CHAPTER EIGHTEEN

CEPHALLENIA, HOMER'S ENCHANTED ITHACA

1. Beautiful Rocky Ithaca

Cephallenia constituted the most important part of Odysseus' realm. It is the largest of the Ionian Islands, covered practically in its entirety by oak forests, which are a necessary condition for the establishment of cattle farming. A multitude of wild flowers, aromatic herbs, plants of various kinds, thick forests and other vegetation enhancing the landscape, grow in abundance on the flat lands and the highlands of the island. The deep, extensive Livadi bay is one of the safest bays of the Mediterranean basin. The land, however, is mountainous and not suitable for raising and using horses. It is not poor but it has no extensive plains. Much wheat grows there and wine, and there is always rain and vigorous dew. It is suitable for raising goats and cattle, and for growing every sort of trees. In it are many watering places that never fail.

Cephallenia's Mt. Aenos is the tallest mountain (1628 meters) of the Ionian Islands and among the largest mountains of Western Greece. It is massive, covering practically the entire island. On it and at an elevation of 1000 meters and up grows the peculiar to Mt. Aenos Cephallenian spruce, the epithet Μαῦρο Βουνό (Black Mountain) deriving from the tree. This great mountain provides unique experiences to the visitor. The sight of the rising and setting sun observed from its heights is breathtaking. Mt. Aenos, by special law, has been declared a national park. On its summit, called today Megas Soros, we are informed by Hesiod, that the sanctuary of Apollo Aenesius was found. Remnants of this and traces of other structures are still visible today. The rocky ground climbs from the enchanting coasts to the top of the forest clad Mt. Aenos, Odysseus' Mt. Neriton, and was the reason why Telemachus, when in Sparta, refused the gift of swift horses offered to him by Menelaus. In Homer's words:

MENELAUS:

ἀλλ' ἄγε νῦν ἐπίμεινον ἐνὶ μεγάροισιν ἐμοῖσιν,
ὄφρα καὶ ἑδεκάτη τε δυωδεκάτη τε γένηται·
καὶ τότε σ' εὖ πέμψω, δώσω δέ τοι ἀγλαὰ δῶρα,
τρεῖς ἵππους καὶ δίφρον ἐύξοον· [...]
 δ 587-90

But come now, tarry in my halls
until the eleventh or the twelfth day is come.
Then will I send you forth with honour and give you splendid gifts,
three horses and a well-polished chariot; [...]
 Od. 4.587-90

TELEMACHUS:

[...]'Ατρεΐδη, μὴ δή με πολὺν χρόνον ἐνθάδ' ἔρυκε.
[...] ἵππους δ' εἰς Ἰθάκην οὐκ ἄξομαι, [...]
ἐν δ' Ἰθάκῃ οὔτε ἂρ δρόμοι εὐρέες οὔτε τι λειμών·
αἰγίβοτος, καὶ μᾶλλον ἐπήρατος ἱπποβότοιο.
οὐ γάρ τις νήσων ἱππήλατος οὐδ' ἐυλείμων,
αἵ θ' ἁλὶ κεκλίαται· Ἰθάκη δέ τε καὶ περὶ πασέων.
 δ 594, 601, 605-8

Son of Atreus, keep me no long time here, [...]
[...] but horses I will not take to Ithaca, [...]
But in Ithaca there are no broad courses nor meadow land at all.
It is a pasture land of goats and more lovely than one that pas-
tures horses.
For not one of the islands is fit for driving horses, or rich in
meadows,
of those that slope abruptly to the sea, and Ithaca least of all.
 Od. 4.594, 601, 605-8

These verses, without exaggeration, give a precise description of
the land, leaving no doubt in the visitor's mind that this rocky land is

indeed the land of the heroes of *The Odyssey*. The land of the Pallis peninsula itself is mostly flat and the most fertile of the whole island. The rolling hills are covered with esparto, thyme and holm oak creating a paradise for the herds of goats grazing there, which along with the wild goats and other mountain fauna give the impression of an enchanted place surrounded by coves, the immense sea and the deep blue sky. The advantages of the land of Ithaca are presented quite lucidly in the description given to Odysseus by Athena, when he first arrived at Phorcys on the Phaeacian ship and did not recognise the place. The dialogue that took place is as follows (Odyssey, rhapsody 13):

ODYSSEUS:

> *[...] τίς γῆ, τίς δῆμος, τίνες ἀνέρες ἐγγεγάασιν;*
> *ἦ πού τις νήσων εὐδείελος, ἦέ τις ἀκτὴ*
> *κεῖθ' ἁλὶ κεκλιμένη ἐριβώλακος ἠπείροιο;»*
> v 233-5

> *[...] What land, what people is this? What men dwell here?*
> *Is it some clear-seen island, or a shore of*
> *the deep-soiled mainland that lies sloping down to the sea?»*
> Od. 13.233-5

ATHENA:

> *ἦ τοι μὲν τρηχεῖα καὶ οὐχ ἱππήλατός ἐστιν,*
> *οὐδὲ λίην λυπρή, ἀτὰρ οὐδ' εὐρεῖα τέτυκται.*
> *ἐν μὲν γάρ οἱ σῖτος ἀθέσφατος, ἐν δέ τε οἶνος*
> *γίγνεται· αἰεὶ δ' ὄμβρος ἔχει τεθαλυῖά τ' ἐέρση·*
> *αἰγίβοτος δ' ἀγαθὴ καὶ βούβοτος· ἔστι μὲν ὕλη*
> *παντοίη, ἐν δ' ἀρδμοὶ ἐπηετανοὶ πάρεασι.*
> *τῷ τοι, ξεῖν', Ἰθάκης γε καὶ ἐς Τροίην ὄνομ' ἵκει,*
> *τήν περ τηλοῦ φασὶν Ἀχαιΐδος ἔμμεναι αἴης.»*
> v 242-9

It is a rugged island, not fit for driving horses,
yet it is not utterly poor, narrow though it is.
In it grows grain beyond measure, and the wine grape
as well, and the rain never fails it, nor the rich dew.
It is a good land for pasturing goats and cattle; there are trees
of every sort, and in it are watering places that never fail.
Therefore, stranger, the name of Ithaca has reached even the land
of Troy,
which, they say, is far from this land of Achaea.»

Od. 13.242-9

An annotation found in the 'Kaktos' edition of *The Odyssey*[1], tran-
scribed below, records the opinion of the well known Homerist Con-
stantine Trypanis[2], regarding the configuration of Homeric Ithaca as
compared to the rocky and precipitous island east of Cephallenia, that
carries the name today.

«Κραναήν Ἰθάκην» (Cranaén Itháken): Hoemric references to
Ithaca present many interpretation difficulties.
Trypanis states that if Homeric Ithaca is today's 'Thiake'[3], then
the poet of The Odyssey is in error concerning its location and
fertility (Od. 13.244, 19.399), and concerning the Asteris islet as
well. He adds that this is what prompted W. Dörpfeld[4] to assume
that the island of Leucas is Homeric Ithaca. Homer's descrip-
tion, without doubt, fits Leucas better, but the change of name
remains inexplicable.»

Had the late C. Trypanis visited Cephallenia, he would have reject-
ed out of hand Dörpfeld's proposition regarding the island of Leucas.

1. 'Kaktos', vol. 86, Rhap. 4 (21), note 2, verse 346.
2. C. Trypanis, 'The Homeric Epea', Athens 1975, p. 70, note 2.
3. Thiake, colloquial name of today's island of Ithaca. Trans. note.
4. W. Dörpfeld, 'Alt – Ithaca', München – Grafelting, 1927.

Generally speaking, the only source of information regarding Homeric Ithaca, is Homer himself. No writer, historian, geographer or traveller before or after Homer gave any precise information regarding its location. There is no possibility, therefore, to cross reference descriptions regarding Homeric Ithaca. The student of the subject, assuming that he accepts the Homeric text, has only one source to consult and try to find the answers he seeks. If, however, the researcher considers that Ithaca and Odysseus' adventures are figments of Homer's imagination, then there is no logical reason why he should accept as fact the tales of others beside those of Homer. Unfortunately, many went to the wrong watering places to quench their thirst, rather than going to the one that never fails, that is Homer himself. So many years went by, while one researcher building upon another's propositions, have compounded the problem, the errors multiplying rather than being corrected as time advanced. The writer's proposition is based on a profound belief in the Homeric word. For this reason the unveiling of Homeric Ithaca is a great discovery from every respect, both because of the correlation of Homer's descriptions to recognisable morphological characteristics of the land of Cephallenia. It is doubtful that the poet ever imagined that humanity some day would search to locate Ithaca. Moreover, in large part, *The Odyssey* describes that unknown world in which Odysseus wandered for twenty years and the supernatural forces he encountered.

2. The Climate of Cephallenia

The dew (fog) was so thick when Odysseus arrived at the harbour of Phorcys, that he was unable to recognise the place.

Περὶ γὰρ θεὸς ἠέρα χεῦε
Παλλὰς Ἀθηναίη, κούρη Διός, ὄφρα μιν αὐτὸν
ἄγνωστον τεύξειεν ἕκαστα τε μυθήσαιτο, [...]
v 189-91

For about him the goddess had shed a mist,
Pallas Athene, daughter of Zeus, that she might make him
unrecognisable, and tell him all things [...]
Od. 13.189-91

Cephallenia is indeed drenched by rain but at the same time it has one of the best climates in the Mediterranean. Cloud coverage is restricted to 3.5 on a scale 1-10, which is somewhat less then that of the Athens area. The number of sunny days is about 167 per year while cloudy days average about 55 per year. Yearly rainfall on the flat and coastal areas reaches approximately 900 mm. per year. These facts are mentioned so that the reader and the visitor may form an accurate impression regarding the island. Homer depicts this analytically and his descriptions are confirmed by present day official studies and statistics. The poet's verses are quite characteristic when he has goddess Athena describe to Odysseus the rain and the dew of the place:

[...] αἰεὶ δ' ὄμβρος ἔχει τεθαλυῖά τ' ἐέρση·
αἰγίβοτος δ' ἀγαθὴ καὶ βούβοτος· ἔστι μὲν ὕλη
παντοίη, ἐν δ' ἀρδμοὶ ἐπηετανοὶ πάρεασι.

ν 245-7

[...] and the rain never fails it, nor the rich dew.
It is good land for pasturing goats and cattle; there are trees
of every sort, and in it are watering places that never fail.

Od. 13.245-7

The abundance of water and moisture in Cephallenia is confirmed by a study conducted by Dr. I. Zoetl[5] and referred to by Socrates Matthaeou[6]. Dr. I. Zoetl, a wellknown Austrian professor, studied the geohydrological conditions prevailing in Cephallenia, and, among other things, he stated the following:

On the basis of many years of observation, the average yearly
rainfall in the area of Argostoli was computed at 860 mm. For a
Mediterranean country this should be considered as remarkable,
particularly since in other areas of Greece it is much less. In the

5. I. Zoetl, 'Geohydrological Basis of the Programme for Cephallenia'.
6. See S. Matthaeou, 'CEPHALLENIA, for a Better Future'.

Cyclades islands, for example, it reaches just 300 mm., while in Cephallenia the yearly rainfall reaches practically that of Graz (Austria), the writer's place of origin. For instance, during the months of October – December 1962 rainfall reached the level of 1026 mm. Moreover, the average temperature during January in Graz is -2.2oC and during July 20oC. The corresponding averages in Argostoli are -1oC in January and 26.3oC in July.

It is noted, once more, that while Homer describes events and conditions poetically, at the same time he provides accurate information. The Austrian professor, as seen above, virtually repeats Homer, regarding the meteorological and climatological conditions prevailing in Cephallenia.

3. Thiaco, the Wine of Ithaca

Wine and current production in Cephallenia was intense until the beginning of the 20th century, at which point it reached its highest level. As old timers will testify, vineyards covered the flat lands and reached even the highest mountain side. Today, Cephallenians see with satisfaction the cultivation of 'Robola' increasing year by year, new vineyards being planted on the highlands of Mt. Aenos, producing this excellent variety which has become well known in both the Greek and the international markets. In Odysseus' time, wine produced in this same land was plentiful. As the poet puts it:

[...] οἶνον δὲ φθινύθουσιν ὑπέρβιον ἐξαφύοντες.

ξ 95

[...] and our wine they waste, drawing it forth wantonly.

Od. 14.95

And further on,

αὐτὰρ ἐπεὶ δείπνησε καὶ ἤραρε θυμὸν ἐδωδῆ,
καὶ οἱ πλησάμενος δῶκε σκύφον, ᾧ περ ἔπινεν,
οἴνου ἐνίπλειον· ὁ δ' ἐδέξατο, χαῖρε δὲ θυμῷ, [...]
ξ 111-3

But when he had eaten his dinner, and satisfied his soul with food,
Then the swineherd filled the bowl from which he was himself
accustomed to drink, and gave it to him
brimful of wine, and he took it, and was glad at heart; [...]
Od. 14.111-3

A characteristic Cephallenian vineyard from which the wine known as 'Thiaco' or 'Vostylidi' is produced should be mentioned. It provides further evidence in support of the identification of the island with Homeric Ithaca. Thiaco is a white grape with a slight pink hue and the wine produced from it is a rozé of excellent taste. This variety thrives only in the area of the Kouvalata village, a little to the south of the Livadi village and spreads all the way to Atheras and the area of the Thenias villages. This, at least, is what the locals maintain who, having inherited the vineyards from their forefathers, cultivate what is left of them. For many centuries Thiaco was the sole source of income for the peasants in the area, being their main product. Tradition, thus, preserved the name of the land, which through the ages came down to the present in the name of this grapevine that insists on growing exclusively in the Pallis peninsula.

4. The Name Ithaca Found All Over Cephallenia

In Cephallenia, and mainly in the Pallis peninsula, the western part of the island, and specifically the Livadi village, Atheras and Thenea areas, certain toponyms, plant names and a female name are found, all derivatives of the name Ithaca. One finds a site called 'Thiacata', a rare variety of olive tree called 'Thiakia', a grapevine called 'Thiaco', a feminine proper name 'Ithaca'. They all testify to the continuity of tradition since the time of Laertes' Ithaca. Such concentration of deriva-

tives of the name Ithaca cannot be found even in the island that goes by that name today. It is certainly not a coincidence. An in depth etymological analysis of nomenclature used in the times of Odysseus may reveal interesting connections which would complete the catalogue of names used in pre-historic Ithaca. The existence, however, of the names mentioned above, in conjunction with toponyms found in *The Odyssey* and other elements that synthesize the picture of Homeric Ithaca, should be an incentive to continue the recording and analysis of every detail of popular traditions and customs of the people of Cephallenia.

CHAPTER NINETEEN

THE ORIGIN OF HOMER

THROUGHOUT the present study, the writer was faced with a recurring problem. Each time a certain fact was confirmed and adequately explained, new questions arose needing examination and analysis. One of the main ones, that came up repeatedly, was that regarding the origin of Homer. The point is, could the poet have described in such detail Ithaca and its environs if he was not intimately familiar with the general area, having been born and raised there? The answer often given is that Homer repeats the same things each time and for every locality he describes. It has trees, caverns, mountains, the sea is nearby. Upon close scrutiny of his verses, this irresponsible view is found to be without merit. He uses different words and terms each time he describes a different place, thus altering the meaning, even though, at times, places and events appear to be similar. The view that Homer was a true son of today's Cephallenia and was in fact born and raised in what is today the village of Livadi, can be supported by many facts and references. These shall be presented in what follows.

1. The Argonautic Expedition

Certain conclusions may be drawn from a brief study of the Argonautic Expedition. According to legend, Jason undertook to travel to Colchis, in the black sea, and fetch the Golden Fleece. His ship was built by Argos, a famous ship builder, one of Phrixus' four sons, as some maintain. He gave the ship his name, Ἀργώ or 'Argó', but it is not known where she was built. Nevertheless, one should remember that shipbuilding was flourishing in Ithaca, as testified by Athena who pointed out that there were many ships in the harbour of the city. It has often been said that the spruce trees of Mt. Neritus (Aenos) supplied the required timber. A host of young men, eager for adventure, respond-

ed to Jason's invitation. Thus, a crew was assembled composed of the scions of gods, semi-gods and heroes. The best known among them were Orpheus, Hercules, Theseus, the Dioscuri Castor and Polydeuses, the sons of Poseidon Euphemus and Periclymenus, the sons of Hermes Echion and Eurytus, the two sons of Aphareus Idas and Lynceus, the winged sons of Boreas Zetes and Calaïs, Telamon and Peleus, sons of Aeacus, Amphiaraus, Argos son of Phrixus and Argos the Argive hero, Apollo's son Asclepius, the seers Idmon and Mopsus, Jason's cousin Acastus, son of Peleus, Tiphys and Alceus, Laertes, Augeas, and others[1]. Also, Atalante, Admetus from Pherae, and Meleager. According the above, both Laertes and Acastus, son of Peleus, took part in the expedition. In Od. 14.336 it is mentioned that Acastus was King of Dulichium while Laertes, Odysseus' father, was the captor of the city of Nericus, on the foot of Mt. Neriton. Assuming that Acastus, the king of Dulichium, is the same person as Acastus the Argonaut, then, both of them hailed from the same region, that is, from the opposite shores of the deep gulf of Cephallenia.

As far as nomenclature is concerned, it is noteworthy that Argos was the builder of Argo, the ship, and that Odysseus' dog was named Argos, perhaps by Laertes, in memory of the ship that brought him safely back to Ithaca. All of the above took place in a region that much later was named Argo-stoli, a toponym in complete harmony with tradition and the historic past. However, the depth of time is so great, that the impression created is that all these parallels are due to mere chance. But it appears that names and toponyms are reproduced through the ages according to each region's land morphology, landscape and tradition, in a mysterious way, which creates continuity through repetition.

2. The Delphic Oracle

«The Roman emperor Publius Aelius Adrianus (Hadrian) (76 A.D. to 138 A.D.) ruled from 117 to 138 A.D. The Athenians

1. Encyclopedia Americana, Greek Edition, vol. 3, p. 261.

erected in his honour and dedicated to him the well known Arc of Hadrian near the temple of Zeus Olympian in Athens.

Hadrian also built the Library in Athens, bearing his name. A splendid structure, situated on the north side and not far from the city's acropolis. According to Pausanias (A. 18.6) there were in it «one hundred and twenty columns of Frygian marble, and the porticoes and walls were built with the same material. And there are living quarters in it on the upper floor, built with gold guilded ceilings and alabaster and in addition there are decorated statues and there are inscriptions, books, ... and here too there are 100 columns built with stones from the quaries of Libya.»

The layout of this building was established following excavations undertaken by the Archaeological Service in 1885, under the supervision of Stefanos Koumanoudis. It was rectangular in shape, 130 meters long from west to east and 82 meters wide, the entrance being situated in the middle of the west side and consisting of a propylon supported by four Corinthian order columns. This side was more luxuriously built that the others.

On each side of the propylon, there were fourteen Corinthian order columns of Frygian marble without flutes, only seven of which remain on the left side of the entrance, towards Ares street.

According to Pausanias, the living quarters and the main library hall were located on the east side of the building. It was 25 meters long and 15 meters wide, with niches in the walls for to storage of books. There were also lecture halls and other buildings within the enclosed library area erected at various periods, among which a four-cornered structure of 400 A.D. which, according to the 1950 excavation director, Mr. I. Travlos, was used as a reading room. According to others, this structure was probably an early Christian era temple. During the excavations, among other things, a bust of Sophocles and the statues of two maidens were found, representing The Iliad and The Odyssey.»[2]

2. Encyclopedia Americana, Greek Edition, Athens 196, Vol. 1, p. 354

The above transcript is presented so as to emphasize the importance Hadrian attached to Greek letters, by building this magnificent library. The presence of the statues of *The Iliad* and *The Odyssey* in the library indicate the emperor's interest in Homer. Hadrian's respect for Homer's work, led him to the Delphic oracle inquiring the god from what city Homer came, and whose son he was.

«ὅπερ δὲ ἀκηκόαμεν ἐπὶ τοῦ θειοτάτου αὐτοκράτορος Ἀνδριανοῦ εἰρημένον ὑπὸ τῆς Πυθίας περὶ Ὁμήρου ἐκθησόμεθα. τοῦ γὰρ βασιλέως πυθομένου, πόθεν Ὅμηρος καὶ τίνος, ἀπεφοίβασε δι' ἐξαμέτρου τόνδε τὸν τρόπον·

Ἄγνωστόν μ' ἔρεαι γενεὴν καὶ πατρίδα γαῖαν ἀμβροσίου σειρῆνος; ἕδος δ' Ἰθακήσιός ἐστιν, Τηλέμαχος δὲ πατὴρ καὶ Νεστορέη Ἐπικάστη μήτηρ, ἥ μιν ἔτικτε βροτῶν πολὺ πάνσοφον ἄνδρα.

οἷς μάλιστα δεῖ πιστεύειν διά τε τὸν πυθόμενον καὶ τὸν ἀποκρινάμενον, ἄλλως τε οὕτως τοῦ ποιητοῦ μεγαλοφυῶς τὸν προπάτορα διὰ τῶν ἐπῶν δεδοξακότος.»

 Ἡσίοδος, Χρονικά

«We will set down, however, what we have heard to have been said by the Pythia concerning Homer in the time of the most sacred Emperor Hadrian. When the monarch inquired from what city Homer came, and whose son he was, the priestess delivered a response in hexameters after this fashion:
'Do you ask me of the obscure race and country of the heavenly siren? Ithaca is his country, Telemachus his father, and Epicasta, Nestor's daughter, the mother that bare him, a man by far the wisest of mortal kind.'
This we must most implicitly believe, the inquirer and the answerer being who they are – especially since the poet has so greatly glorified his grandfather in his works.»
 Hesiod,
 Of the origin of Homer
 and Hesiod, and their Contest

Homer was an Ithacian, his father was Telemachus and his mother Epicasta, daughter of Nestor. This is the answer Hadrian received. Clear-cut, devoid of riddles and evasions, and as such it was transmitted to us.

ἑπτά πόλεις μάρνανται σοφήν διά ρίζαν Ὁμήρου
Σμύρνη, Χίος, Κολοφών, Ἰθάκη, Πύλος, ῎Αργος, Ἀθῆναι.

*Seven cities fight with each other for Odysseus ancestory
Smyrna, Chios, Colophon, Ithaca, Pylos, Argos, Athens.*

3. Cephallenia, Melite (Malta) of the New Testament

In a recently published book 'Apostle Paul in Cephallenia', father D. Metallinos, Dr. of Theological Philosophy at the University of Athens, expounds on the subject of Melite mentioned in the Acts of the New Testament. The book is a critical presentation of Dr. Heinz Wernacke's thesis, in which it is prï posed that the Malta (Melite) of the Acts, visited by the apostle of the Nations, was none other than today's Cephallenia. Father Metallinos notes the following concerning the location of Melite (page 32):

> *«The ancient sea traveller and geographer Scylax places Melite at a distance of approximately 20 stadia or 4 kilometres from Corcyra – Melaena.»[3]*

This bit of information, supplied by Scylax, sets conclusively the issue, confirming all previous propositions. Without doubt, the characterization 'Melaena' refers to the Aenos massive (Homeric Neriton), which extends from 'Megalos Soros' (1628m. high) to Atheras. The

3. 20 Stadia = 184.75m. x 20 = 3,697 meters. See also Apollonius Rhodius, Argonautica IV. 568-72.

crest of the mountain runs along the entire length of the Livadi bay, from Leivatho, to Drapano, Kokkinos Vrachos, Farsa, Thenaea, Zola, Atheras and Pylaros. The distance between the opposite coasts of the Livadi bay is about the same. Specifically, from the Kokkinos Vrachos, which lies at the entrance of the Argostoli bay to Lixouri, it is 3,600m. The distance between Agia Sotira, at the deep end of the bay, to Livadi is also about 3,000m. Melite, therefore, is placed by Scylax across from Melaena-Corcyra (Cephallenia), while the mountain mentioned can be none other than Cephallenia's Megalo Vouno, Black Mountain, Monte Nero, Aenos, or Homeric Neriton. On page 25, father Metallinos proves that the Melite mentioned by Luke (Acts, Ch. 27 and 28) is not Malta as was believed until now, nor the south Dalmatian island of Mijet, but rather it was Cephallenia and more precisely the peninsula of Argostoli (Cranaea). Among other things the author states the following (p. 57, 58).

In antiquity the Argostoli peninsula was called Melite (Acts. 28.1). It could, possibly, be the Melite mentioned in the myth of the Argonautic expedition, which myth mentions in general the toponyms Melite and Corcyra-Melaena. The term Corcyra-Melaena, on the other hand, is characteristic of southern Cephallenia which due to its high mountains and the thick spruce forests covering them was called Melaena (Black) and was known to Pliny. In contemporary literature southern Cephallenia is still called 'Mávro 'ros', that is 'Black Mountain' or 'Monte Nero'. In the Argonautic myth the island is called Corcyra-Melaena due to its thick forests.

The toponyms Corcyra-Melaena and Melite of the Argonaut myth belong to Cephallenia's archipelago, as does the Melite of the Acts.

Father Metallinos continues his analysis of Dr. Warnecke's study remarking (page 33):

According to the author «the place where the two seas met» is the Argostoli promontory, which enters the bay. There exists nothing similar in Malta. This region of southern Cephallenia corresponds fully to the description of the narrative in Acts

27.27-44. Dr. Warnecke quite rightly concludes that the place where the ship carrying Paul moored as she approached Cephallenia was Vardiani. In Acts 27.39-40, it is stated «when it was day they observed at a distance of 4-5 kilometres a bay with a beach onto which they planned to run the ship if possible».

Dr. Warnecke's view is characterized by father Metallinos as ingenious, having caused a sensation in the circles of New Testament scholars and historians in general. The Melite, of the Acts being in fact southern Cephallenia, confirms the proposition that the one mentioned in the tale of the Argonautic Expedition is also the island of Cephallenia. Dr. Warnecke's conclusion that the ship first took in at Vardiani, leads one to worder whether Melite was not in reality the Pallis peninsula. Another point made by father Metallinos (page 23) reveals an interesting connection between the Argonauts and Ithaca.

After three months we sailed in an Alexandrian ship whose figurehead was the Dioscouri, which had wintered at the island.

The Dioscouri, along with Laertes, had taken part in the Argonautic expedition. In Paul's time, 1,300 years later, a ship having the Dioscouri as figurehead, wintered at Melite. This is a clear indication that the ship was moored in the harbour of Ithaca, Odysseus' back yard. The Pallis peninsula is, therefore, the best candidate for the name Melite. Assuming, then, that Melite is Pallis, one can safely conjecture that the city and the villages found on the island in Odysseus' time were located at the same place where they are found today.

4. Milesigenes Homer

«All antiquity accepts Homer's existence. Seven biographies of Homer are extant and many myths, legends and conjectures. Among these the most reliable are those attributed to Herodotus, Plutarch and Proclus. All traditions agree that his original name was 'Milesigenés', Μιλησιγενής or Μιλησιγένης. From this, later

on, the noun 'Méles', Μέλις, was formed which was supposedly his father's name deriving from the river 'Méles', flowing near Smyrna. Whence Smyrna's claim that she was the poet's homeland.»[4]

The name Milesigenes, attributed to Homer, is a most important bit of information, which could possibly lead to the poet's true homeland which, remains unknown to this day. To fully comprehend Homer's spirit, one should examine his references to the nymphs. In Greek mythology, there are two categories of nymphs: those who dwelt in the sea depths, the Nereids, daughters of Nereus (Il. 18.38, 49, 52) and those of fresh water, rivers, lakes and springs, the Naïads, daughters of Zeus «νύμφαι νηιάδες, κοῦραι Διός» (Ï ä., 13.104, 356). The Naiads dwelt in çaverns and Odysseus sacrificed many hecatombs in their honour. Nereus and his brother Phorcys were the sons of Gaea (Earth) and Pontus (Sea). Melite was one of Nereus' daughters (Il. 1.538).

> *[...] πᾶσαι ὅσαι κατὰ βένθος ἁλὸς Νηρηίδες ἦσαν.*
> Σ 38

> *[...] all the daughters of Nereus who were in the depths of the sea.*
> Il. 18.38

Again,

> *[...] ἄλλαι δ' αἳ κατὰ βένθος ἁλὸς Νηρηίδες ἦσαν.*
> Σ 49

> *[...] and other Nereids who were in the depths of the sea.*
> Il. 18.49

Characteristic of the Nereids, according to the above, is that they dwelt in the depths of the sea. Since, therefore, the Pallis peninsula drops to the great depths of 3,500 meters into the Ionian Sea, one could safely conclude that the one place in Cephallenia that could possibly

4. 'The Greeks', Kaktos edition, vol. on *The Iliad* and *The Odyssey*.

be named after a deity representing a physical element is the above region, being located, as it were, on the edge of Abyss.

Assuming that the oracle delivered at Delphi was a confirmation of the prevailing tradition of the time, that is that Homer was in fact Telemachus' son, then quite correctly the original name of Homer was assumed to have been Milesigenes, the name deriving from 'Melite' and not from 'Meles', which was that of his presumed and unknown father. One would expect that since Melite was the name of one of the Nereids, there should also exist a corresponding toponym in Ithaca. Unless, Homer neglecting to mention it in *The Odyssey*, later generations, following tradition, applied it to the general area and thus it came down to Paul's time. It is felt that the above, should be sufficient evidence to support the view that Milesigenes Homer was born and raised in the city of Ithaca, in the ancestral home of his father Telemachus and his grandfather Odysseus. There is no shadow of a doubt that the poet received the inspiration and composed his epic work sitting by his father's tower, on the top of the hill of Hermes. The detailed description of the procession of the dead suitors' ghosts (Od. 24.1-14) and the mention of the chirping crickets, a most characteristic feature of the area, indicate his presence in the area since childhood. The author is led by a deep conviction to put forth this view. When one finds himself in these surroundings, one cannot help but be overtaken by the intense feeling that the poet and his heroes are present.

Homer travelled widely. «Many were the men whose cities he saw and whose minds he learned...» (Od. 1.3). He was, however, able to describe in detail even places he had never known. He had the power of clairvoyance. This is why he was said to be blind. He kept his eyes closed during moments of revelation. Such abilities were attributed to many ancients such as Pythagoras and others. Great divinely inspired forces were at work at Delpi, at Eleusis during the Eleusinian Mysteries and at other sanctuaries. An example of this is given in Plato's Republic, regarding the valiant youth who died (614b) and returned to life twelve days later (621b). The great volume of Homer's creative work and his accomplished personality strengthen the view that he was a great man, who did not restrict his activities to the mundane affairs of every day life.

EPILOGUE

THE STRUCTURE of *The Odyssey* is firmly founded in the ground and the rocks of the land of the Cephallenians. The rocky ground, the headlands, the harbour and coves, the narrow-leaved olive tree, the deep cave, the rolling hills, the fair-flowing fountain, the orgiastic landscape, the flora and fauna, the climate, the wide and deep blue sea, the strong winds that raise the waves, and above all the deep chasm in the sea to the West, bring the observer face to face with reality. Only in this physical environment could Ithaca be discovered. The land morphology, the open spaces, the luminous horizon, the imposing presence of mountain and sea had a catalytic influence in forming the mental attitude that led to the revelation of Homeric Ithaca.

[...] πῶς ἂν ἔπειτ' Ὀδυσῆος ἐγὼ θείοιο λαθοίμην, [...]

α 65

[...] How should I, then, forget godlike Odysseus, [...]

Od. 1.65

It is extraordinary that the poet should characterise Odysseus as a divine person, particularly when this is expressed through Zeus, the father of gods. Aristarchus, at any rate, considers this to be noteworthy. It might not be an exaggeration to say that the reputation of his wisdom and power entered the realm of the supernatural. He was considered to be the epitome of wisdom, the most representative example of the Greek race. His wisdom permeates the pages of *The Odyssey* and *The Iliad*.

τῶν μὲν Ὀδυσσεὺς ἦρχε Διὶ μῆτιν ἀτάλαντος.

B 258-9

These Odysseus led, the peer of Zeus in councel.

Il. 2.636

The writer considers himself fortunate to have been born in Agonas, Cephallenia's beautiful village. Homeric Ithaca lies within sight of the village, spreading as it does on the slopes of Crikellos hill, by the clear blue waters of the Ionian Sea. A long, endless, it seems, promontory protrudes into the deep sea, at the neck of which nests the small leeward

harbour of Atheras, where Odysseus arrived on the Phaeacian ship following twenty years of wandering around the world. Visitors stop to immortalise this incomparable landscape, which keeps hidden the greatest secret of all time. The only remaining thing is for the international scientific community to take notice of this study and to proceed with the verification of the stated correlations, so that a scientific confirmation can follow, and the fact that this is indeed the land of Homeric Ithaca on the Pallis peninsula, may be established. Humanity, along with the Cephallenians, fortunate people of Odysseus, stand facing the great wall of the palace on the hill after thirty centuries of wandering, waiting for the gates to open again and the treasures of Laertes, Odysseus and Telemachus to be uncovered and be seen in the bright sunlight. Scientists from all over the world will have the satisfaction to study by means of historical analysis and excavation, the oldest and most celebrated period of pre-historical times, the precursor of Greek civilization.

It is with understandable satisfaction that the author finds himself in the position of proposing a new approach regarding the identification and location of the complex of islands that constituted Odysseus' realm, of Ithaca itself and of all other characteristic sites mentioned by Homer. The approach is based exclusively on the study of the terms and words used by Homer in *The Odyssey* primarily and in *The Iliad* as needed. It is hoped that this high objective will have the unreserved support of all thinking men, so that the means of accomplishing the task may be found.

«τέκνον ἐμόν, ποῖόν σε ἔπος φύγεν ἕρκος ὀδόντων,
πῶς ἂν ἔπειτ' Ὀδυσῆος ἐγὼ θείοιο λαθοίμην,
ὅς περὶ μὲν νόον ἐστὶ βροτῶν, περὶ δ' ἱρὰ θεοῖσιν
ἀθανάτοισιν ἔδωκε, τοὶ οὐρανὸν εὐρὺν ἔχουσιν;
 α 64-7

«My child, what a word has escaped the barrier of your teeth?
How should I, then, forget godlike Odysseus,
who is beyond all mortals in wisdom, and sacrifice to gods
the immortals has given, who hold broad heaven?
 Od. 1.64-7

Athens 2000
N. G. L.

APPENDICES

APPENDIX I
REFERENCES TO ITHACA

LISTING of references in *The Odyssey*, *The Iliad* and in the Homeric Ode to Pythian Apollo, of the proper name Ithaca.

ITHACA, THE CITY (Livadi, Pallis peninsula) – 37 times.

Odyssey: 1.18, 88, 103, 163, 172, 404; 2.256, 293; 3.81; 4.175, 555, 643; 10.416, 417; 11.30, 162, 361; 12.345; 13.212, 256; 15.157, 534; 16.58, 250, 419, 471; 18.2; 19.462; 22.30, 52; 23.122, 176; 24.104, 254, 259, 269

ITHACA, THE DEMOS (Pallis peninsula) – 32 times.

Odyssey: 1.57, 103, 386, 395, 401; 2.167, 256; 4.601, 605, 608, 666; 10.417; 11.480; 13. 97, 135, 248, 325; 15.36, 482, 510; 16.124, 222, 230, 251; 19.399; 21.18, 109, 252; 24.97, 284, 344
Iliad: 2.632; 3.201

ITHACA, THE ISLAND (Cephallenia) – 19 times.

Odyssey: 1.247; 4.608, 671, 845; 9.21; 10.17, 20, 463; 11.111; 12.138; 15.29; 16.124; 19.132; 20.340; 21.18, 346
Iliad: 2.632

Apollo Pythius: verse. 427

ITHACA IS CHARACTERISED BY HOMER
WITH THE FOLLOWING EPITHETS:

Ἀμφίαλος (Amphíalus): surrounded by the sea; Od. 1.386, 395, 401, 2.293, 21.252

Εὐδείελος (Eudeleíelus): clear-seen; Od. 2.167, 13.212, 325

Κραναής (Cranaés): rocky; Od. 1.247, 15.510, 16.124

Τρηχείης (Tricheíes): irregular, uneven, city of Ithaca; Od. 10.417

Παιπαλόεσσα (Paepalóessa): rugged; Od. 11.480

Εὐκτιμένη (Euctiméne): well ordered, well built; Od. 22.52

APPENDIX II

LISTINGS OF EARTHQUAKES IN CEPHALLENIA
IN THE REGION OUTLINED BY COORDINATES
38o, 10' TO 38o, 40' LATITUDE
20o, 20' TO 20o, 50' LONGITUDE

Official data from the Geodynamic Institute of the Athens Observatory. Eighty-nine (89) earthquakes measuring over 5 points on the Richter scale were recorded over a period of 520 years, from AD 1469 to AD 1988[1]. The region is considered the most seismic area on the European continent.

1.The great earthquake of August 12, 1953, which destroyed Cephallenia and the surrounding islands, registering 7.2 points on the Richter scale is not included in the list because its epicenter was located in the sea, near Vlachata village, and thus outside the above mentioned area.

The author had the unfortunate experience, at the tender age of fourteen, to live through the great earthquake.

Two earthquakes of lower intensity had preceded the main tremor. The first occurred on Sunday, August 9, 1953, at 10:10 hours. The service at Virgin Mary's Church at Agonas was not yet over. The tremor was of short duration and of medium intensity. It caused cracks and pieces of plaster to fall off the walls of the freshly whitewashed houses, having been freshened up in anticipation of the great festival of August 15th. A second earthquake occurred on Tuesday, August 11, 1953, at 05:15 hours. This was more intense than the first one with the result that most houses were on the point of crumbling. Yet the tall, well-built bell tower of the church did not come down.

As by miracle, no roof came crumbling down, so the people, caught in bed, were able to get out of their dilapidated, ready to fall, houses. It was a morning of lament and despair, the court yards and gardens being the only hospitable places to shelter the desperate inhabitants.

Then, came Wednesday, August 12, 1953. At 10:25 hours, thick rising dust covered the sun and everything around became obscure and gloomy. Darkness fell over the land, and a deafening noise as if thundering burst over every house.

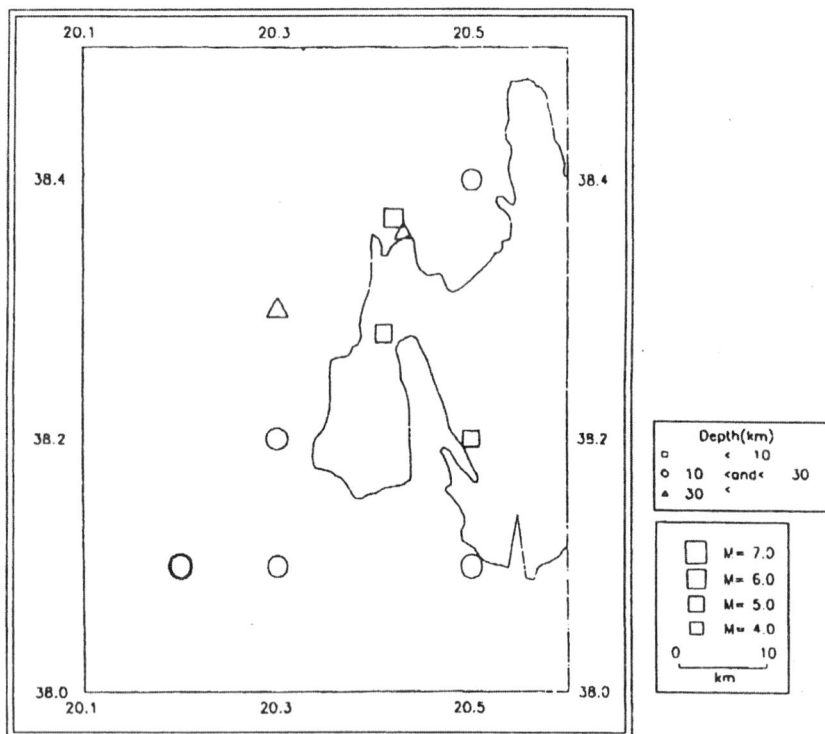

Epicentre Distribution 14 Events
 Scale 1: 400000

Date		Time		L&t (N)	Lon (E)	Depth		M		
1902 NOV	5	23 50	30.0	38.20	20.50	5		5.5	VII	LIXOURI
1905 JUN	3	04 15	30.0	38.20	20.50	5		5.5	VII	LIXOURI
1912 JAN	31	16 22	53.0	38.10	20.50	11	UNS	6.3		
1912 APR	19	00 20	40.0	38.20	20.50	5		5.1	VII	ARGOSTOLI
1932 MAR	9	10 16	55.0	38.20	20.50	5		5.6	VII	LIXOURI
1943 MAY	22	22 05	52.7	38.36	20.43	76		5.2		
1972 SEP	17	14 07	15.0	38.30	20.30	33		6.3	VII	CHAVRIA
1983 JAN	17	12 41	30.0	38.10	20.20	14		7.0	VI	ARGOSTOLI
1983 JAN	19	00 02	13.0	38.10	20.20	13		5.7	V +	AG. THEKLA
1983 MAR	23	23 51	5.0	38.20	20.30	13		6.2	VII	AG. THEKLA
1983 MAR	24	04 17	31.0	38.10	20.30	22		5.5		
1987 FEB	27	23 34	54.1	38.37	20.42	1		6.4		
1986 MAY	18	05 17	42.0	38.40	20.50	21		5.7	VI	KOUVALATI
1992 JAN	23	04 24	16.7	38.28	20.41	3		5.5		

COORDINATES OF THE AREA: 38.10 38.40 20.20 20.50
TIME WINDOW: 1900 1992
DEPTH WINDOW: 0 200
NUMBER OF EVENTS = 14

1469		00 00	.0	38.40	20.50	33	7.6	X CEPHALONIA
1658 AUG.	1	00 00	.0	38.30	20.50	33	7.4	X CEPHALONIA
1759 JUN	14	00 00	.0	38.20	20.50	33	7.0	IX ARGOSTOLI
1767 JUL	11	00 00	.0	38.20	20.30	33	7.7	X LIXOURI
1862 MAR	14	01 45	.0	38.40	20.50	33	7.2	IX ARGOSTOLI
1867 FEB	4	04 19	.0	38.20	20.40	33	7.8	XI LIXOURI
1902 NOV	5	23 50	30.0	38.20	20.50	5	6.0	VII LIXOURI
1905 JUN	3	04 15	30.0	38.20	20.50	5	6.0	VII LIXOURI
1912 APR	15	23 27	7.0	38.20	20.50 ·	5	5.8	VI ARGOSTOLI
1912 APR	18	23 59	16.0	38.20	20.50	5	5.4	V ARGOSTOLI
1912APR	19	00 20	40.0	38.20	20.50	5	6.0	VII ARGOSTOLI
1912 APR	19	00 58	28.0	38.20	20.50	5	5.8	V ARGOSTOLI
1912 APR	21	02 53	47.0	38.20	20.50	5	5.8	V ARGOSTOLI
1912 SEP	28	12 53	47.0	38.20	20.50	5	5.7	V ARGOSTOLI
1919 AUG	3	09 46	20.0	38.20	20.50	5	5.4	VI ARGOSTOLI
1932 MAR	9	10 16	55.0	38.20	20.50	5	6.1	VII LIXOURI
1951 JAN	16	12 36	5.0	38.10	20.30	5	5.4	IV ASPROGERAKAS
1954 JAN	30	03 55	48.0	38.20	20.50	5	5.3	VI KERAMIES
1954 MAR	8	08 17	21.0	38.20	20.40	5	6.0	VI ARGOSTOLI
1960 MAR	6	17 25	59.0	38.30	20.30	5	5.0	IV ARGOSTOLI
1962 APR	18	10 44	41.0	38.10	20.50	5	5.1	IV LIXOURI
1964 PR	17	18 11	40.0	38.20	20.30	17	5.0	
1965 APR	3	14 30	48.0	38.20	20.50	25	5.5	IV + ARGOSTOLI
1967 NOV	5	00 26	14.0	38.10	20.30	33	5.0	
1968 OCT	17	23 56	4.0	38.20	20.20	17	5.0	
1969 JAN	11	10 21	47.0	38.10	20.20	4	5.0	
1969 JUN	12	09 54	40.0	38.20	20.40	5	5.0	
1969 JUN	16	16 06	26.0	38.10	20.30	40	5.4	IV VALSAMATA
1969 JUN	17	05 18	43.0	38.20	20.20	11	5.1	
1970 AUG	22	12 04	49.0	38.10	20.20	33	5.0	
1970 OCT	8	22 14	22.0	38.10	20.30	46	5.1	
1970 OCT	10	13 48	26.0	38.10	20.20	35	5.1	
1972 SEP	17	14 07	15.0	38.30	20.30	33	6.8	VII CHAVRIATA
1972 SEP	17	14 44	10.0	38.40	20.40	40	5.3	
1972 SEP	18	08 20	25.0	38.30	20.20	14	5.2	III+ VALSAMATA
1972 OCT	4	08 48	46.0	38.20	20.30	33	5.3	IV ARGOSTOLI
1972 OCT	16	23 39	37.0	38.20	20.40	34	5.0	
1972 OCT	30	14 32	11.0	38.30	20.30	13	5.9	V NEOCHORI
1972 DEC	9	08 52	21.0	38.20	20.20	19	5.0	IV VALSAMATA
1973 JAN	2	01 50	29.0	38.20	20.20	39	5.0	IV VALSAMATA
1973 FEB	8	03 37	22.0	38.30	20.30	26	5.0	IV+ VALSAMATA
1973 FEB	8	11 57	22.0	38.30	20.40	36	5.0	IV VALSAMATA
1973 FEB	8	16 44	33.0	38.30	20.30	45	5.0	IV VALSAMATA
1974 JAN	24	09 40	17.0	38.20	20.20	56	5.2	
1974 FEB	23	20 55	21.0	38.40	20.40	42	5.0	III+ VALSAMATA
1974 JUN	18	08 26	11.0	38.40	20.40	24	5.4	V+ LIXOURI
1974 DEC	14	21 29	22.0	38.40	20.40	37	5.3	IV VALSAMATA
1975 SEP	17	23 44	19.0	38.20	20.40	15	5.2	
1976 JUL	18	13 30	46.0	38.30	20.30	33	5.1	
1976 NOV	26	13 19	46.0	38.40	20.30	48	5.2	
1979 NOV	8	11 51	27.0	38.10	20.20	26	5.0	IV+ POULATA

1983 JAN 17	12 41	30.0	38.10	20.20	14	7.5	VI ARGOSTOLI
1983 JAN 17	15 53	56.0	28.20	20.40	40	5.7	
1983 JAN 17	16 53	29.0	38.20	20.30	28	5.8	
1983 JAN 18	07 52	43.0	38.20	20.30	24	5.3	
1983 JAN 19	00 02	13.0	38.10	20.20	13	6.2	V+ AG. THEGLA
1983 JAN 19	00 18	21.0	38.10	20.20	29	5.3	
1983 JAN 28	09 12	28.0	38.20	20.20	9	5.1	
1983 JAN 28	17 43	1.0	38.20	20.40	25	5.0	
1983 JAN 31	15 27	2.0	38.20	20.30	39	5.8	
1983 FEB 2	12 43	13.0	38.10	20.30	10	5.1	
1983 FEB 23	06 12	35.0	38.10	20.20	15	5.2	
1983 MAR 4	10 04	14.0	38.20	20.30	12	5.0	
1983 MAR 18	00 45	40.0	38.20	20.20	20	5.1	
1983 MAR 22	05 12	52.0	38.20	20.20	4	5.2	
1983 MAR 23	23 51	5.0	38.20	20.30	13	6.7	VII AG. THEGLA
1983 MAR 24	04 17	31.0	38.10	20.30	22	6.0	
1983 MAR 24	12 50	58.0	38.20	20.20	17	5.6	
1983 MAR 24	14 07	3.0	38.20	20.20	10	5.3	
1983 MAR 24	18 45	3.0	38.10	20.20	8	5.0	
1983 MAR 24	22 03	19.0	38.10	20.20	21	5.1	
1983 MAR 25	18 56	41.0	38.20	20.20	36	5.7	
1983 MAR 25	20 20	46.0	38.20	20.20	28	5.4	
1983 MAR 25	20 43	14.0	38.10	20.30	40	5.3	
1983 MAR 25	21 00	52.0	38.10	20.20	41	5.5	
1983 MAR 26	03 27	19.0	38.20	20.20	20	5.0	
1983 MAR 29	06 26	32.0	38.20	20.20	25	5.2	
1983 MAR 31	07 20	1.0	38.10	20.20	19	5.1	
1983 APR 19	10 23	40.0	38.20	20.20	0	5.1	
1983 MAY 14	23 26	.0	38.40	20.30	17	5.6	
1983 MAY 29	05 09	18.0	38.20	20.30	11	5.2	
1985 JAN 23	16 11	36.0	38.30	20.40	14	5.2	
1985 MAY 20	07 51	16.0	38.30	20.30	17	5.2	
1986 APR 22	20 33	41.0	38.30	20.40	56	5.1	
1988 MAY 18	05 17	42.0	38.40	20.50	21	6.2	VI KOUVALATA
1988 MAY 18	09 09	48.0	38.40	20.40	47	5.1	
1988 MAY 22	03 44	15.0	38.40	20.40	18	5.8	VI KOUVALATA
1988 JUN 2	10 35	25.0	38.30	20.40	10	5.3	V AG. THEKLA
1988 JUN 6	05 57	42.0	38.40	20.50	14	5.4	

COORDINATES OF THE AREA: 38.10 38.40 20.20 20.50
TIME WINDOW: 0 1992
DEPTH WINDOW: 0 400
MAGNITUDE WINDOW: 4.5 9.0
NUMBER OF EVENTS: 89

APPENDIX III

January 1, 1993

To: The Sixth Directorate of Prehistoric and
Classical Archaeology of Patras

Ref. No. 315/25-1-1993

In my continuous effort to relate Homeric descriptions in The Odyssey, to locations and sites mentioned in my study, submitted on Dec. 8th, 1992 (Ref. No. 58622) to the Ministry of Culture and to the office of the Minister of Culture on Nov. 11, 1992 (Ref. No. 6546), and which I hope has been duly communicated to your Department, I am happy to inform you of the following:

Ruins of an ancient temple have been located in the village of Livadi, situated on the coast of the extensive bay of the Pallis peninsula of Cephallenia. The site is found a little below the public road leading to the coast, and to the southeast of the Agios Dionysios church, on the edge of the nearby field and the bottom part of the fence, adjacent to a wooden shed. At this point, a section of a fluted limestone column is found protruding above the ground. On the ground, near by, lie two limestone column capitals or bases. Very close to the above, a pile of stones is seen, probably belonging to the same demolished structure.

These ruins are apparently those of an unknown temple possibly dedicated to Apollo by the ancient city of Ithaca. It is, therefore, imperative that the Archaeological Service should undertake all necessary action to protect these finds. The initiation of archaeological excavations in the area will uncover the treasures of Ithaca, that is the city itself and Odysseus' palace, which lies on Crikellos or Sgouros hill, above the village of Livadi.

The above relics were photographed on Jan. 23, 1993. I herewith place myself at your disposal, being prepared to offer any assistance that might be needed towards the uncovering of this important archaeological discovery.

APPENDIX IV

HELLENIC SPELEOLOGICAL EXPLORATION GROUP (SPELEO)
83A Alexandras Blvd., Athens 114 74 TEL.: 64.38.308

COMPLEMENTARY CAVE EXPLORATION REPORT
ATHERAS MUNICIPALITY AREA, PALLIS PREFECTURE
DISTRICT OF CEPHALLENIA
July 13, 1994
Iakovos Karakostanoglou

I. BACKGROUND - ORGANISATION

The expedition to the district of Cephallenia No 1/25-28 July 1993 of SPELEO (see report of accomplishments by I. Karakostanoglou and I. Eustathios), where speleological exploration was undertaken is considered incomplete due to two main reasons:

a) The limestone deposits of the area are intensively Karstic in nature, while it was not possible for the speleologists of the first mission to visit cavernous openings present, due to unavailability of guides and insufficient time.

b) The researcher Mr. Nicolas Livadas, in his study 'Return to Ithaca – the Island of Cephallenia Home of Odysseus', Cephallenia 1993, locates certain caves in this district which are mentioned in Homer's Odyssey. There is understandable interest by both the Atheras community and the Development Association of the Pallis Prefecture in clarifying this matter. The few caves that were explored during the first expedition of SPELEO in this general area ['Palatakia' site, code A1a or 2,3,4, and 'Vathylaccoma' site, code A1a5, of a depth of 23 m.] did not indicate anything in this respect.

In a telephone communication on January 1994 with the vice-president of the Development Association of the Pallis Prefecture, Mr. Spyros Gouliatos, it was agreed to undertake a brief complementary visit to the area, by a group of speleologists and geo-speleologists, as

soon as the weather permitted it. This visit did in fact take place on the occasion of my sejour in the island (Poros port) during my summer vacation, which proved both inexpensive and helped economise both time and human resourses. These caves were visited by myself and by Miss Parthenia Tsekouras, practising speleologist of SPELEO. Mr. Charalambos Spyratos, president of the Atheras municipality, accompanied Messrs. Gioulatos and Livadas, led us to the points of speleological interest.

II. EXPLORATION RESULTS

1. ATHERAS SETTLEMENT AREA

a. Geographical – Speleological – Speleogenetical Considerations

We first visited cave A1a6 at the 'Handaki of Xeraka' position, approximately 500 m. West of the village's main square, at an elevation of 225 m. The approach is by motor-car from the dirt road leaving the community in a west-northwestern direction (see topographical map of A.G.S., scale 1:50.000, page ATHERAS). It consists of a cavernous fissure basically diaclasigenic cut in a southwestern-northeastern direction. The dimensions of it are 12 m. length x 12 m. width x 1 to 2 m. (see attached map of the cave). We descended rather easily with the help of a rope. The formation of the smaller southwestern chamber was possibly influenced by the southwestern inclination of the stratification of the local thick strata of eocenic - oligocenic limestone (see geological map of I.G.M.E., scale 1:50.000, page ISLAND OF CEPHALLENIA -- North Section). The large precipitations within the chamber are quite possibly connected to the seismic nature of the area. The speleothematic decoration is minimal, and other than the classic sediments of the southwestern rubble, abundant argillites (TERRA ROSA) were present. No bats or other cave dwellers were noticed. On the surface of the southwestern rubble some domestic animal bones were found, as well as some rusty accessories of Italian cartridge detonators (?). It appears that the cave has no corridors capable of admitting human entry, even if the deposits in it were removed. The cave may be considered as an enlarged fissure.

Following this, we visited cave A1a7. It consists of an earth depression (pot hole) in an adjacent field (approximately 200 m. northwest of A1a6) having a diameter of 1 m. and a depth of 0,80 m., which was formed by the collapse of the roof of a subterranean cavity. This is not an unusual phenomenon in this area. At a distance of approximately 1 kilometre as the crow flies, in a southwesterly direction from A1a6 and A1a7, the discovery of a cave was reported to us. It appeared following the collapse of part of its roof during cultivation, creating an opening large enough to endanger the life of pasturing animals. It was estimated that the depth of this cavity was in excess of 15 m. It was covered with branches and other material for safety purposes. It should be noted that A1a8 is located comparatively near A1a1, 2, 3, 4 and which were explored in July 1993.

b. Geological considerations

Following this, an attempt will be made to arrive at a simplified and concise interpretation of the underground Karst of the area, and a correlation of individual phenomena. Both the cave openings recorded on the A.G.S. map, one located north-northeast (A1x1) and the other north (A1x2) of the Atheras community, at an elevation of 320 and 200 m. respectively, will be taken into account.

We note the following:

1) All Karstic cavities (A1x1, A1x2, A1a6, A1a8 and A1a1-5) are located on a more or less straight-line zone, corresponding to the Pleistocene fault which, starting at the coastal precipice of 'Koumbaromazas' in the southwest, continues northwest, and passing near and to the north of Atheras, ends at the 'Kentroma' point. This fault at the 'Handaki tou Xeraka' point, is not visible.

2) The present depth of these cavities appears to increase from the northeast to the southwest. For example, A1x2 depth: rather insignificant, A1a8 depth: over 15 m., A1a5 depth: 23m. In other words it follows the deepening of the water table toward the sea. These characteristics denote direct speleogenetic dependence of the cavities of the fault. The indications regarding the relatively recent formation of this subterranean Karst, and on the basis of the available facts, are briefly the following:

a - The fault to which the cavities appear to relate, dissects the edge of the northwestern breccia conglomerate that appears there and is of a Cambrian age. Therefore, the fault is less than 2 million years old.

b - Present day depth of all explored cavities is small, the width being particularly so.

c - Underground cavities are to found at a short depth from the present day topographical level (e.g. A1a7), or have been recently opened by human intervention (e.g. A1a8).

We, at this point, should clarify that:

a) The enclosed underground cavities have not reached the 5th BOGLI stage of cave development (ageing).

b) The surface disaggregation and erosion of the local limestone formations did not act long enough so as to be able to uncover the enclosed cavities, to open in other words entrances to them. This conclusion is strengthened by the characteristics of the thin top soil (remnant of the surface erosion of the limestone), which is to be found on this rocky area.

Another characteristic of the Karst of the area, besides its recent age, is the ease with which water penetrates in the rock formation, quickly reaching the water table. This is due to the existence of many small vertical conduits, which are due to the serious fracture of the rock formations (fissures, etc.). The intense, even today, seismic nature of the area, explains in part the situation. The presence of these small conduits, could have acted as a factor inhibiting the formation of few but large conduits. Finally, the lithology of the limestone itself should not be overlooked. It could possibly hinder them. The neo-cretaceous limestone present in the Atheras bay, and in the larger part of North Cephallenia, possesses a lithology that favours speleogenesis. The well known caves of the islands are located there.

2. THE ATHERAS BAY AREA

We visited previously mentioned area on Wednesday, July 13. However, our eagerness to help, from a geological and speleological aspect Mr. Livadas' research led us the same day, at noon, to the small

Atheras port, at the Agios Spyridon Chapel. At the beginning of the path leading to the chapel, we located traces of two former cavities (A1961, A1962). They consist of two horizontal U shaped depressions without a roof. They are situated a few meters from each other and face toward the northeastern part of the sea. They are, however, continuously saturated and eroded by the sea.

They were opened in the eocenic - oligocenic limestone formation, similar to that of the Atheras village. In the same bay, some 600 m. to the north, on the western precipitous coast, we located a sea cave (A191), which faces the sea toward the Northeast and the bay's rocky islet. It is opened in the upper cretaceous limestone. This limestone formation is older than the previous one, and it appears that its lithology has favoured its formation.

On the basis of the existing geo-morphological situation, we believe that Mr. Livadas' proposition that the two cavities (A1961 and A1962) correspond to the two northern entrances of the cave of Homeric Odyssey cannot be rejected, but cannot be confirmed either. One could seriously maintain that the unknown southern opening of the alleged enlongated cave:

a) They should not be sought far away from the coast of the bay. I believe the areas close to or in the general vicinity of Atheras village should be excluded. At least this is the conclusion drawn from the brief analysis presented above.

b) One should look for them in places lying in the southwestern side of the bay, along the coast. That is on the limestone holm oak clad hill (height 125 m. w.), commanding, to the west, the small Agios Spyridon valley, and at a distance not more than 100 m. from caves A1961, 2. I estimate, however, that the small openings existing in the past, are most likely blocked today by silt or completely covered by dense vegetation.

GLOSSARY

ἀγρός, ὁ (agrós): field opp. to κῆπος or garden, country opp. to town, cultivated piece of land.

ἀθέσφατος (athésphatos): vast, ἀ. οἶνος, σῖτος, Od. 11.61, 13.244.

Ἀθήρ, ος (Athér, gen. Athéros): Awn, bot., one of the slender bristles constituting the beard of a head of barley, oats, some wheat and other grasses. Webster's Dict.

ἀθηρηλοιγόν (athereloegón): neut., acc.; consumer of chaff, i.e. winnowing fan, or λικμητήριον (licmetérion): winnowing shovel. Also Hsch.. The so-called πτύον (ptýon), or ἀθερολοιγόν (atheroloegón), the consumer of chaff (ἀθέρες); Ἀθέρες (athéres) the awns of some wheat and other cereals.

αἶαν (aéan): accus. for αἶα, fem., land country; Epic form used for γαῖα, Il. 3.245, etc.; also in Trag., chiefly in lyr., A. Pers. 59. II. Original name of Cholchis, S. Fr. 914: also part of Thessaly, ibid 915.

αἰπεινός (aepeinós): high, lofty, of cities on heights, Il. 9.419; of mountain tops; hard to reach.

αἰπήεις (aepéeis): see αἰπεινός above; Il. 21.87

αἶπος (aépos): neut., height, steep, hill.

αἰπός (aepós): high, lofty, of cities; streams falling sheer down, Il. 8.369.

αἰρέω (aeréo), impf. ᾕρεον (éreon), fut. αἱρήσω, aor. 1 ᾕρησα (éresa), Med., fut. αἱρήσομαι, aor. 1 ᾑρησάμην, pf. in med. sense ᾕρημαι (éremae); Pass. Fut. αἱρεθήσομαι (aerethésomae), aor. ᾑρέθην and pf.:

(1) Act., take with the hand, grasp, seize: Od. 8.372, σφαῖραν καλήν μετὰ χερίν ἕλοντο (they took the beautiful ball with their hands).

(2) Take into one's possession, get, obtain, take by force, ἕλποντο δὲ νῆας Ἀχαιῶν αἱρήσειν, Il. 13.41-2 (and they thought that they would take the ships of the Achaeans, ...).

ἀκραής (akraés): blowing strongly, of winds; Od. 2.421.

ἀκτή (acté): fem. headland, foreland, promontory, often with epithets, denoting high, rugged coast, τρηχεῖα, ὑψηλή, Od. 5.425, Il. 2.395.

ἄλεσσι μεμιγμένον (hálessi memigménon): mixed with salt.

ἁλί (halí), dat. of ἅλς (hals): sea (generally of shallow water near shore) Od. 2.261, Il. 20.229.

ἀλλήλησι (allílisi), dat. pl.: to one another, by one another, with another, mutually, reciprocally, very close to each other.

ἀλωή (aloé): Any prepared ground, garden, orchard, vineyard.

ἀμφί (amphí), prep. with gen. and dat.: on both sides.

ἀμφίδυμοι (amphídymoe) plural: two fold, double as of double harbours, double scale.

ἀνά (aná): prep. governing gen., dat., and acc. With accus., the common usage, implying motion upwards: of Place, up, from bottom to top, up along, κίον ἀν' ὑψηλῶν ἐρύσαι, Od. 22.176; ἀνὰ μέλαθρον, up to, ib. 239. **2.** up and down, throughout, ἀνὰ δῶμα, Il. 1.570; ἀνὰ στρατόν, ἄστυ, ὅμιλον, ib. 384, Od. 8.173, etc.

ἄνέρες (anéres): pl., of ἀνήρ, also vocative ἀνέρες, men.

ἄνευθε (áneuthe), adv.: faraway, distant, apart.

ἀνιοῦσαν (anioúsan): fem. for ἀνιών, verb ἄνειμι: sail up, i.e. out to sea.

ἀρδμός (ardmós): place where animals are watered.

ἀριπρεπές (ariprepés), neut.: pre-eminent, majestic, conspicuous from afar. See also Il. 6.477 (Kofiniotis Homeric Lexicon). Also see πρέπειν.

ἀρισφαλές (arisphalés): very slippery or treacherous.

ἀρίφραδές (ariphradés): neut. adj.; clear, manifest; clear to the sight, bright; very thoughtful, wise.

Ἀστερίς (Asterís): the name of the islet as reported by Homer. The official name today is Asteris, but it is also known as Daskalio.

ἀτρυγέτοιο (atrygétoeo): ἀτρύγετος masc., unharvested, barren, freq. in Homer, as epith. of the sea, παρὰ θῖν' ἁλὸς ἀτρυγέτοιο, Il. 1.316, al.; πόντον ἐπ' ἀτρυγέτοιο, Od. 2.370.

αὐλῇ (aulé): Fem., court before the house, courtyard. Later, court or quadrangle, round which the house was built. Generally, court, hall (Ζηνός αὐλῇ); court of a temple; later, country home.

γουνός (gounós): Masc., high ground (Cf. γόνυ or knee). EM: 39.5.

δολιχοδρομέω (dolichodroméo): v. run the δόλιχος, Aeschin. 391.

δολιχοδρόμος, ὁ (dolichodrómos): masc., noun, or, runner of δόλιχος, Pl. Prt. 335e, X. Smp. 2.17.

δόλιχος (dólichos): masc., the long course in racing, app. stadium Inscriptiones Graecae IG22.956, etc.; τὸν δ. ἀμιλλᾶσθαι, Pl. Lg. 833b; θεῖν, X. An. 4.8.27; νικᾶν, Luc. Hist. Couser. 30; δολίχῳ κρατεῖν, Paus. 3.21.1; metaph. κατατείνουσι τοῦ λόγου, Pl. Prt. 329a; δόλιχον τοῖς ἔτεσι ... τρέχειν, Epicr. 3.18; δόλιχον βιότου σταδιεύσας, Epigr. Gr. 311; ᾶ?ῆὺὸ, ib. 231.

ἐθέλω (ethélo): I want.

εἴδωλον (eídolon): neut., phantom, any unsubstantial form, image reflected in a mirror or water, image in the eye, idea, image, likeness, image of a god, idol.

εἷλον (eílon): aor. 2 of verb αἱρέω, Il. 10.561.

εἰν (ein), prep. for ἐν (en): in, Ep. and Lyr.

εἰνοσίφυλλον (einosíphyllon), acc.: with quivering foliage, of wooded mountains. See also Ḗ., 2.632.

ἔμπεδος, -ον (émbedos -on): in the ground, firm-set; neut. ἔμπεδον as adv. (freq. in Hom.), stand fast, firmly, run on and on, run without resting.

ἔνι (éni): for ἔνεστι, verb ἔνειμι, to be in, c. dat. pl. to be among; of place to be present in or therein; to be mentioned in (a treaty); to be possible; to be relevant, pertiment, etc.With dat.: referring to that which covers, surrounds something.

ἐπηετανοί (epeetanoí): pl., abundant, ample, sufficient (Hom. only in Od.); always full.

ἐπηρεφέες (eperephées): fem. pl. of ἐπηρεφής, overhanging, beetling, Od. 10.131, cf. 12.59; pass. covered, sheltered.

ἐρετμόν (eretmón): neut., poet. for oar.

ἐρέω (eréo): ep. verb, ἐρεείνω, ἔρομαι, ἐρωτάω; ask, inquire about a thing. Also search, explore.

ἐρκεῖος (herkeíos): (freq. written ἔρκειος in codd.), or, also ά, or A. Ch., 653; - of or in the ἔρκος of front court, Zeus ?., as the household god, Od. 22.335, Hdt., 6.68, S. Ant., 487, E. Tr., 17, Cratin. Jun., 9, Pl. Euthd., 302d, Arist. Mu., 401a20: abs., Ἑρκεῖος, ὁ, Paus., 4.17.4; also βωμός ἑ. Pi.Pae., 6.114. **2**. Ἑρκεῖοι, οἱ: Lat. Penates, D.H., 1.67, **3**.πύλαι, θύρα ἑ., the gates, door of the court, A.Ch., 561,571,653; πρὸς κίον' ἑρκείου στέ γης S. Aj., 108; ἐψ' ἑρκείῳ πυρᾷ E. Tr., 483; - ίον, τό, fence, enclosure, αὐλῆς Il. 9.476, Od. 18.102; ἐξ' ἑρκίων καὶ ἐξ' οἰκίας ἐκπετόμενος Thphr. Sign., 53; later, dwelling, A. R., 2.1073.ίτης, ου, ὁ, name for a farm slave, Amer. ap. Ath., 6.267c. (written ἑρκῆται in Hsch.).

ἑρκίον (herkíon): ἔρκος (hérkos): court enclosure.

ἑρκίον (herkíon): court yard fence, Il. 9.476, Od. 18.102.

ἔρκος (hérkos): neut., fence, enclosure, round gardens and vineyards, Od. 7.113, Il. 5.90, esp. the courtyard of houses, Od. 21.238 (Pl.), Hdt., 6.134; periphr., ἑ. ὀδόντων the fence of the teeth, Il. 4.350, Od. 10.328; wall for defence, Il. 15.567, Hdt., 7.191; metaph., defence, of a shield, a defence against javelins, Il. 15.646, Il. 5.316; of persons, ἔρκος Ἀχαιῶν, of Ajax, Il. 3.229.

ἕστηκεν (hésteken), v. from ἵστημι: stand, stand still, stay, halt, fix to a place, check, be set-up, be placed, be stationary, bring to a standstill, come to a stop, rest, fixed, stable, upright.

ἔσχατος, -η, -ον (éschatos): of space always in Homer; farthest, extreme.

εὐδείελον (eudeíelon), acc.: clear, distinct; Homeric usually of Ithaca (only in The Odyssey). Also Od. 2.167. See also δέελος, δῆλος: visible, conspicuous.

ἐυῆρες (euéres): neut., adj., well fitted, Hom. (only in Od.) always of the oar, well-poised, easy to handle.

ἐυκτίμενος (eyctímenos): masc. (κτίζω, to build); well wrought, well made, good to dwell in, epith. of cities. ἐυκτίμενον πτολίεθρον, Il. 2.501. Of anything on which man's labour has been bestowed.

εὐρώεντα (euróenta): adj., pl., acc. of εὐρώεις, -εσσα; mouldy, dank; later, dank, slimy, ἰλύς, πηλός (Expld. as: εὐρέα or πλατέα, wide, outstretched).

Ζέφυρος (Zéphyrus): any westerly wind, opp. Εὖρος (Euros), Od. 5.332, 19.206; rainy 5.295, 14.458; ψυχρός (psychrós) cold, Arist. Pr. 494a17.

ζόφον (zóphon), dat. of ζόφος: nether darkness, the gloom of winter, the realm of gloom, the dark quarter, i.e. the West, Od. 3.335, Il. 12.240, Str. 10.2.12.

ἠδὲ (ésan): prop. correlative to ἠμέν, both ... and.

ἠεροειδέι (ieroeidéi): misty, cloudy, dark sea

ἤπειρος (épeiros): fem., terra ferma, land, opp. the sea, Od. 3.90, 10.56, Il. 1.485, Hes. Op. 624, etc.; κατ᾽ ἤπειρον, by land. II. esp. the mainland of western Greece, opp. the neighbouring islands, Od. 14.97; ἠπειρόνδε 18.84: generally mainland, opp. island, Hdt. 1.148, 171.

θέεν (théen): from v. θέω, to run; of ships, ἡ δ᾽ ἔθεεν κατὰ κῦμα, Il. 1.483

θίς, θινός (thís, thína): ὁ Il. 23.693, Od. 12.45, Ar.V696, Phld. (v. infr.); ἡ S. Ant. 591, Ph. I 124, Arist. HA548b6, Call. Fr. 126, D.H. 3.44: - heap, πολύς ὀστεόφιν θίς, Od. 12.45; θῖνες νεκρῶν A. Pers. 818; metaph., θὶς πημάτων, Lyc. 812; esp. of sand-banks, θῖνες ψάμμου Hdt. 3.26; ἄμμου, γῆς, Plu. Fab. 6, Art. 18; τούς ἐν ἄμμῳ θῖνας Phild. Piet. 20; ἐν ταῖς θ. Arist HA548b6, cf. 537a25; θῖνας καὶ ψάμμους Porph. Abst.4.21; of the sandy desserts of Libya, A.R. 4.1384; Νασαμώνων αὔλια καὶ δολιχάς θ. Call. Fr. 126. 2. usu. in Hom. etc., beach, shore, freq. in oblique cases, παρὰ θῖνα ... θαλάσσης Il. 1.34, cf. Od. 6.236, etc.; παρὰ θῖν ἁλός ἀτρυγέτοιο, Il. 1.316, cf. 350, etc.; alone, ἐπὶ θινί, Od. 7.290; παρὰ θῖνα 9.46; later θῖν ἁλός Ar.V1521(parod.); πόντου S. Ph. 1124 (lyr.); θαλάσσας E. Andr. 109 (eleg.); θαλαττία D. H. 3.44. b. sand-bank, bar at the mouth of a river, Plb. 4.41.6: pl., banks of a stream, D. S. 1.30. 3. sand or mud at the bottom of the sea, οἶδμα ... κυλίνδει βυσσόθεν κελαινὰν θῖνα S. Ant. 591: metaph. ὥς μοῦ τὸν θῖνα ταράττεις, i.e. trouble the very bottom of my heart, Ar, V696, v. Sch. 4. shore-weed, θίν᾽ ἐν φυκιόεντι, Il. 23.693, cf. Arist. HA598a5; θινὸς ὄζειν, ib.620a15. II. ἄκρης [πόλιος] θίς, the temple that crowns the Acropolis, dub. in Call. Fr. anon. 332.

ἴκμενος (ékmenos): a fair breeze, only in the phrase ἴκμενος οὖρος, Il. 1.479, Od. 2.420; in this case the wind blowing from the stern.

ἰλύς (ilýs): Mud, slime; of alluvial soil. Dregs, sediment.

ἴσαν (ésan): imperf. Ep. of εἶμι, they went.

ἴσασι (ésase): v., from οἶδα (εἴδω), pl., to know.

ἱστός (histós): from ἵστημι, anything set upright; mast, Od. 15.289, Il. 23.285, etc.

Κακοΐλιον (Kako - Ilion): Fem., unhappy Ilios, Ilium-the-Evil, Od. 12.260.

κατά ἤ κατ' (katá or kal'): with acc., of motion downwards.

κεῖται (keíte), 3rd p. sing.: to be laid, to lie outstretched.

κέλευθα (kéleutha): poet. noun, plural of κέλευθος; rood, path, not common in lit. sense; of the stars, paths, orbits; of the gods, the path of; metaph., the open road of action. II. journey, voyage, by land or water; expedition. III. way of going, walk, gait. IV. Metaph., way of life.

κεύσω (képhso): verb κεύθω, fut.; poet., cover, hide, esp. of the grave. c. dmpl. acc., οὐδέ σε κεύσω [ταῦτα], nor will I keep them secret from thee, Od. 3.187.

κίω (kéo): from the verb κίω, κίεις A. Ch. 680; imper. κίε Od. 7.50: go, in Hom. almost always of persons, Il. 2.565, 24.471, Od. 4.427, etc.; of ships Il. 2.509.

κλυτός (clytós): renowned, glorious.

κλυτότοξος (clytótoxus): one famed for his abilities with bow and arrow.

κοῖλος (koélos): of places, lying in a hollow or forming a hollow, i.e. harbour lying between high cliffs, embayed beach.

Κότταβος (Cóttabus): masc., Ion. and other Att. Κόσσαβος, a Sicilian game (Anacr. 53, Critias 2.1D) of throwing heel-taps into a metal basin, described by Ath., 15.665d 599., Sch.Ar.Pax 342, 1243, Poll. 6.109, Suid. s.v. κοτταβίζειν· found in various senses, 1. the game itself. 2. the prize: κοτταβεῖον. 3. the wine thrown: λάταξ 4. the basin.

Κρίκελλος (Críkellos): hoop of a ring, circulus. See also κρίκος, curtain ring, finger ring, nose ring, armlet, link in a chain, hoop.

λευκὴ δ' ἦν ἀμφὶ γαλήνη (leucé d' en amphí galéne): white was the sea around due to the calm. (Od. 10.84)

λήσει (lései): also λανθάνω (lantháno); verb, fut.; escape notice; without being observed.

λιμένες (liménes): plural, harbours.

λίψ (lips): gen. λιβός (libós). Southeastern wind, Hdt. 2.25; λιβός or λίβα εἰς ἀπηλιώτην from West to East, BGU 1037.15.

μάλ, μάλα (mála): very, exceedingly, prefixed or subjoined to adjectives, verbs and adverbs. Strengthening the word with which it stands.

μάλα (mála), adv.: very, exceedingly.

μέδοντος (médontos): gen. of μέδων, from v. μέδω, protect, rule over, used by Homer only in participial subst. μέδων, -οντος, lord, ruler, Il. 2.79, Od. 7.136: once in sg., of Phorcys, ἁλός ... μέδων, lord of the sea, 1.72.

μέμβλωκε (mémbloke): v. βλώσκω, pf. μέμβλωκε; of time, has passed.

ναιετάω (naeetáo) -άει, -άουσι, frequently found in the participial form ναιετάων, fem. άωσα: of persons, dwell in, inhabit; of places, to be situated, lie.

ναύλοχοι (naúlochoe) plural: of harbours affording a safe anchorage.

νέας (néas): ships.

Νήιον (Néion): Mountain on the island of Homeric Ithaca.

νήιος, -η, -ον (néios): of or for a ship, ship timber, javelin shaft.

Νήρικον (Nérikon): Nericus, the city of Mt. Neriton. The city thus named due to it being situated at the foot of great Mt. Neriton. The last syllable was apparently changed to differentiate the city from the mountain. Thus «Νήρικον Πτολίεθρον»: the city that belongs to or refers to Mt. Neriton. For example (From Demitrakos Lexikon):

– Παρνάσσιος (Parnássius): belonging to or referring to Mt. Parnassus.

– Παρνήθιος (Parnítheus): belonging to or referring to Mt. Parnis.

– Αἰνήσιος, Αἴνιος (Aenisius, Aenius): belonging to or referring to Mt. Aenos. Close to the summit, the sanctuary of Zeus Aenisius or Aenius was built.

– Ἑρκεῖος (Herkeios): belonging to or referring to Zeus Herkeíos. His altar was built by Odysseus' palace great wall (Herkeíon).

– Ἀθῆναι - Ἀθηναϊκόν (Athénae - Athenaïkón) Athens – pertaining to Athens; Πειραιεύς - Πειραϊκόν (Peiraeús - Peiraïkón), Piraeus – pertaining to Piraeus

– Κεφαλληνία - Κεφαλληνιακόν (Kephallenía - Kephalleniakón), Cephallenia – pertaining to Cephallenia.

- *Πήλιον - Πηλιακόν* (Pélion – Peliakón) Pelium – pertaining to Pelium.

- *Νήριτον -Νήρικον* (Nériton - Néricus).

νόσφι (nósphi), adv. of place: aloof, apart, aside, away from, far from, set apart, separate. Behind, (Kofiniotis Hom. Lex.).

νῦν (nýn): now

οἰνοπέδιον (oenopédion): vineyard.

οἶνοψ (oénops): wine-coloured, epithet of the sea, Hom., wine-dark, Od. 5.132, 2.421.

οἷος (oéos): Masc. pron., such as, of what sort, relat. and indirect interrog. Pron., correl. to direct interrog. *ποῖος,* indef. *ποιός,* demonstr. *τοῖος: ὅσσος ἔην οἷός τε* Il. 24.630.

οὐδοῦ (oudoú): gen. of *οὐδός* or *ὀδός,* threshold, especially that of a house.

οὐδοῦ ἐπ᾽ αὐλείου: on the threshold of the court.

οὐ μεγάλη (oú megáli): the poet specifies that the island is not large. This constitutes a fact that should be taken into serious consideration, since a small rocky islet, situated in the middle of the sea does not provide safe anchorage for ships. Furthermore, the sea in this area is tempestuous due to being open and subject to the strong north-westerly winds that literally sweep across it and across the Ithaca channel.

οὖρος, ὁ (oúros): fair wind, Od. 11.7.

πανυπερτάτη (panhypertáti), fem., compound of *πᾶν* (pan), adv. from *ἅπαν* (ápan): quite all, the whole, and *ὑπερτάτη* (hypertáti), superlative of *ὑπέ* ρ (hypér): uppermost, mostly of places.

παρέασι (paréasi): from v. *πάρειμι* (*πάρ-ειμι*); to be by or present or near one, to be present in or at, to have arrived at, to have come from; of things, to be by, i.e. ready or at hand, available.

περικαλλής (perikallés): very beautiful, in Homer mostly of things.

πετρήεσσα (petréessa): rocky, in Homer always an epithet. Therefore a rocky isle.

πίονα νηόν (píona neón) accus. of *πῖος* poet. form of *πίων;* metaph. of soil, rich, Il. 23.832; of persons and places, wealthy, abounding, *οἶκος, νηός* (house, temple), Od. 9.35, Il. 2.549.

πλαγκτός (planktós): masc., poet. adj. wandering, roaming, of ships; πλαγκταί πέτραι, rocks near Scylla and Charybdis, Od. 12.59.

ποιητοῖο (poeetoéo): see ποιητός (poeetós); made, freq. in Homer, especially of houses and arms, always in the sense of εὖ ποιητός; well made. Il. 5.198, Od. 13.306, 1.333, 436. See also v. ποιέω.

πολιῆς ἁλός (poliés halós): white sea. (Od. 2.261, 22.85)

πομπή (pompí): convoy, conveyance, escort

πορθμεῖες (porthmeíes): pl. for πορθμεύς, masc., ferryman, Od. 20.187. Generally, boatman, seaman, especially as one of the crew of a passenger ship. Metaph. conveyor, purveyor.

πορθμεῖον (porthmeíon): neut., place for crossing, passage, ferry.

πορθμεῖον (porthmeíon): neut., place for crossing, passage, ferry. πορθμεύς (porthmeús): masc., ferryman, Od. 20.187. Generally, boatman, seaman, especially as one of the crew of a passenger ship. Metaph. conveyor, purveyor.

πορφύρεον (porphýreon): purple colour, of the sea Arist. Mir. 843a26.

προμαχών (promachón): Masc., substantive; bastion, Proc. Aed., 5.4.

πτολίεθρον (ptoliethron): neut., epic. lengthened from πόλις or πτόλις (pólis or ptólis), Il. 2.133, Od. 1.2.

πύκα (pýka): poet. Adv., close, shut up. Soundly, strongly, with care. (Kofiniotis Lex.).

πυλαωρός (pylaorós): masc., ep. for πυλωρός, gate keeper, Il. 21.530, 24.681; of Odysseus in the Wooden Horse, Tryph. 201, (κύνας) πυλαωρούς, Il. 22.69, but θυραωρούς, Aristarch.; πυλαωρός Πλούτωνος Κέρβερος, AP 7.319. (πύλα-sorwo-(cf. ἐρύω (B)) became πυλα-(θ)ορ(Ζ)ό, πυλαορό-, πυλωρό-: πυλα-(θ)ορ(Ζ)ό-, also became πυλαυρός, πυλευρός (qq. v.) and πυλαουρός (v.l. in Il. 24.681) πυλαυρός (v.l. in 21.530).

ῥεῖθρον (reíthron): that which flows, a river, stream, esp. of rivulets, brooks, bed or channel or a river. Hdt., 1.186, Pi., 15.9.18, A. Pars. 497. Also, bed or channel of a river.

σῆμα (séma): sign, mark, token. Also sign by which a grave is known; a mound; a pile of stones. «[...] ἀθάνατοι δέ σῆμα πολυσκάρμοιο Μυρίνης.» (Il. 2.814).

σῆμα (séma): sign, mark, token; sign by which a grave is known, mound, cairn, barrow.

σχεδόν (schedón), adv.: of place: near, hard by.

τηλεθάων (teletháon) only in pres. and pat.: luxuriant, flourishing, blooming with flowers.

τόξον (tóxon): neut., bow; also metaph. τόξα ἡλίου, the rays of the sun, οὐράνιον τόξον, rainbow. Any part of a curve, a curved support.

φαίδιμος (phaédimos): masc., adj.; shining, radiant, glistening, esp. of man's limps (not used by Homer in fem.).

Φάων (Pháon): from verb φάω (pháo), shine, φάε δὲ χρυσόθρονος Ἠώς, Od. 14.502 (the golden-throned Dawn appeared). Also, γλυκερόν φάος, Od. 16.23 (sweet light of my eyes).

χθαμαλή (chthamalé) fem.: near the ground, on the ground, low. Of Ithaca (dub. sens. In Od. 9.25, Str. 10.2.12 (οὔτε γὰρ χθαμαλὴν δέχονται...), PhIl. 2.619 (χθαμαλὰ δ' ἤδη τά ὄροι πάντα ἐγεγένητο,...), Od. 9.25.

BIBLIOGRAPHY

THE TOTAL number of books and articles on Homer, *The Iliad*, *The Odyssey* and the search for Ithaca should number in the thousands. They are, of course, of unequal value and an attempt at a bibliography should serve no purpose in this instance. In addition, this book is not a comparative study of opinions and views expressed regarding the location of Homeric Ithaca. It is a fresh approach relying exclusively on the Homeric word. As such, the main sources are but one; that of the Homeric text itself.

A. ANCIENT SOURCES

APOLLODORUS, *The Library*, Translated by Sir James G. Fraser, Loeb edition, 1995 printing.

APOLLONIUS RHODIUS, *Argonautica*, Translated by R. C. Seaton, M. A., Loeb edition, 1988 printing.

HESIOD, Translated by H. G. Evelyn – White, Loeb edition, 1998 printing.

HOMER, *The Odyssey*, Translated by A. T. Murray, Revised by George E. Dimock, Loeb second edition, London 1998.

HOMER, *The Odyssey*, Translated by P. Giannakopoulos, Kaktos Editions, vol. 81-86, 1992.

HOMER, *The Iliad*, Translated by A. T. Murray, Revised by William F. Wyatt, Loeb second edition, London 1999.

HOMER, *The Iliad*, Translated by P. Giannakopoulos, Kaktos Editions, vol. 87-92, 1992.

STRABO, *Geography*, Translated by H. L. Jones, Loeb edition, 1989 printing.

B. CONTEMPORARY SOURCES

DÖRFELD, G., *Alt-Ithaca*, Münich 1927.

PLOEGOS, *Nautical Instructions for the Greek Coasts, Western Coasts*, Department of the Navy, Hydrographical Service, third edition, Athens 1971.

METALLINOS, G. D., Dr. Th. Phi., *Apostle Paul in Cephallenia*, Athens 1993.

MATTHAEOS, S., *Cephallenia*, Athens 1978.

KOSMETATOS, E., *Report on Cephallenia's Roads*, Coriallenion Historical and Ethnological Museum, 1991.

PHOCA, I., – VALAVANIS, P., *Architecture and Poleodomy in Ancient Greece*, Kedros Editions, 1992.

TSOPANAKIS, A., *Introduction to Homer*, Thessaloniki, 1998.

KAVADIAS, P., *Ithaque la Grande*, 1908.

PASSAS, I., *The True Pre-history*, Encyclopedia Helios edition, Athens.

EKDOTIKI ATHINON, *History of the Hellenic Nation*, vol. 12, Athens, 1970.

Homer

Zeus

Homer

Cephallenia's map (Homeric Ithaca).

INDEX OF HOMERIC ITHACA'S SITES

WITH REFERENCE TO THE HOMERIC TEXT AND PRESENT DAY TOPONYMS

1. Acastus, King: Argostoli – Crane (Od. 14.336)
2. Aegilips: West of Eryssos promontory (Il. 2.633)
3. Alalcomenae: Megas lakkos, Vardiani (Strabo, 10.2.16)
4. Altar on rock: On road from Atheras to Halkes (Od. 17.210)
5. Apollo, altar: On Skavdolitis (Od. 20.278, 24.1-14)
6. Apollo, grove: Livadi, foot of Skandolitis (Od. 20.278)
7. Apollo, Purifier: Skavdolitis (Od. 24.11)
8. Arethouse spring: Atheras village (Od. 13.408)
9. Asphodel, meadow of (Od. 24.12)
10. Asphodel, meadow of: Livadi, on Pallis peninsula (Od. 24.13)
11. Assos – Pedasus: Assos village
12. Asteris Islet: Asteris, Dascalió (Od. 4.844)
13. Callirous fountain, under rock: Halkes (Od. 17.210)
14. 'Callirous' fountain: Halkes (Od. 17.204, 209)
15. Catagous: Toponym (Od. 17.204)
16. Cephallenians, démos of: Eastern coast of Livadi bay (Od. 20.210, 24.353)
17. Cephallenians, kingdom of: City of Nericus, Crane (Od. 24.377-9)
18. Cephalus, patriarch of Cephallenians (Od. 20.210)
19. Charybdis: Argostoliou whirlpools (Od. 12.104)
20. 'Clytotoxus' coast: Livadi coast (Od. 22.385)
21. Corakopetra: Rock, northeastern limit of Atheras village (Od. 13.408)
22. Corax rock: Atheras village (Od. 13.408)
23. Crikellos: The circular Livadi bay (Od. 22.385)
24. Crocyleia – Eastern side of Mt. Aenos: Agia Eufemia wharf (Il. 2.633)
25. Cultivated fields (Od. 14.344)
26. Curving beach 'Coelos aegialus' (Od. 22.385)
27. Dank ways: Livadi swamp (Od. 24.10)

28. Demeter, invocative inscription: Crane (Od. 14.335, 19.292)
29. Dulichium harbour (Od. 14.336)
30. Dulichium: Argostoli peninsula (Od. 1.246, 9.22, 14.334, 16.247)
31. Eleios village: Toponym
32. 'Eretmon' and 'atheroloegos' (Od. 11.118-37)
33. 'Eretmon': Atheras promontory (Od. 11.118)
34. Eumaeus' court: Atheras, Fakimiá (Od. 14.5-7)
35. Eumaeus' return from the palace (Od. 16.150)
36. Eumaeus' swinesty: Atheras (Od. 15.504, 555)
37. Ferrymen, 'Porthmées': Pallis to Argostoli passage (Od. 187)
38. Gates of the immortals: Caves at Atheras (Od. 13.112)
39. Ghosts' dwellings: Meadow of Skavdolitis (Od. 24.14)
40. Grey (White) sea: Livadi bay (Od. 2.261)
41. Grotto of the nymphs: Cave at Atheras harbour (Od. 13.103-4, 347-8)
42. Handmills: Crikellos hill across from palace (Od. 20.106)
43. Hecatomb, sacred - On Skavdolitis (Od. 20.278)
44. Hermes hill: Crikellos hill (Od. 16.471)
45. Hermes, 'Cleitotoxus' (Od. 17.494)
46. Hermes, 'Cyllenius' (Od. 24.1)
47. Homer, 'Milesigenis'
48. Isthmus: Leucas (Strabo, 10.2.15)
49. Ithaca – Feminine name in Pallis
50. Ithaca, 'Amphíalos': Pallis peninsula (Od. 2.293)
51. Ithaca, 'Eudeilos': Pallis peninsula (Od. 9.21)
52. Ithaca, 'panhypertati': Pallis peninsula (Od. 9.25)
53. Ithaca, boarders of démos: Atheras promontory (Od. 14.103)
54. Ithaca, city of dreams: Livadi village (Od. 24.12)
55. Ithaca, city of: Livadi village on slopes of Hermes hill (Od. 24.468, 23.136, 16.471)
56. Ithaca, Démos of: Pallis peninsula (Od. 9.25)
57. Ithaca, Dulichium – Thesprotia route: Arrival at Livadi harbour (Od. 14.334)
58. Ithaca, harbour (Od. 2.292, 24.102-19)
59. Ithaca, harbour, 'polybenthes': Livadi bay (Od. 16.352)
60. Ithaca, island: Cephallenia (Od. 9.22, 13.95)
61. Ithaca, low lying 'chthamalé': Pallis peninsula (Od. 9.25)

62. Ithaca, people of: Thinea villages, Farsa, Argostoli (Od. 24.354)
63. Ithaca, port, sailing course from Phorcys harbour (Od. 14.503)
64. Ithaca, spacious city: Platies Strates (Od. 24.468)
65. Ithaca, strait with Samos: (Od. 4.671)
66. Ithacus: Founder of Homeric Ithaca (Od. 17.206)
67. 'Kakoïlion' (Od. 23.18)
68. 'Karpalimos' they came down – Path from palace to coast (Od. 2.406)
69. King's Gardens, Βασιλόκηποι: Toponym at Livadi village
70. Kioni – toponym (Od. 16.361)
71. Laertes, estate: Platies Strates (Od. 24.205-7)
72. Laertes, estate: Platies Strates, Livadi (Od. 16.150, 24.205)
73. Laertes, vineyard: Gounos site (Od. 1.193)
74. Leap, the ἅλμα: Skavdolitis precipice
75. Leucas rock: Skavdolitis (Od. 24.11)
76. Leucas, rock: Skavdolitis toponym (Od. 24.11)
77. Livadi – Toponym (Od. 24.12)
78. Mainland shores, ἀκτή ἠπείροιο: ἀκτή = wheat (Od. 24.378)
79. Mainland, Ithaca: Cephallenia across from Pallis (Od. 14.100)
80. Mainland, shore opposite the islands: Acarnania, Leucas (Il. 2.635)
81. Mast of fir – Aenos forest (Od. 15.289)
82. Melite: Pallis peninsula
83. Myrton: Assos promontory
84. Myrtos bay: Northwestern bay
85. Neion, Mt.: Pallis peninsula's low mountain (Od. 1.186)
86. Nericus, city: Crane (Od. 24.377)
87. Neriton, Mt.: Cephallenia's Mt. Aenos (Od. 9.21)
88. Neritus, founder of Nericus (Od. 17.206, 24.375-82)
89. Nymphs, altar: Halkes above fair-flowing fountain (Od. 17.210)
90. Oars of pine – Aenos forest (Od. 12.172)
91. Oceanus, steams: Swamp waters at Valtos (Od. 24.11)
92. Odysseus' grave: Fakimiá hill (Od. 11.129)
93. Palace, eastern gate, pillars: Crikellos Hill (Od. 22.466)
94. Palace, entrance – Crikellos Hill, at Analypsis chapel (Od. 17.30)
95. Palace, Herkeion, great wall: Crikellos hill (Od. 9.476, 18.102)
96. Palace, in the middle of Ithaca démos: Crikellos Hill (Od. 1.103)
97. Palace, north gate: Northern side of palace (Od. 17.261)

98. Palace, northern gate to Royal Estate: Crikellos Hill (Od. 17.255)
99. Palace, Odysseus': Crikellos Hill (Od. 16.471)
100. Palace, propylaea: Crikellos Hill (Od. 1.103, 17.30)
101. Palace, ruins: Crikellos hill (Od. 17.266)
102. Path, rough: Trail from Phorcys harbour at Atheras (Od. 14.1)
103. Peiraeus, dark mainland: Toponym, Agonas village limits (Od. 14.97-100)
104. Petanoi – Area south of Halkes (Od. 13.246)
105. Phaeacian ship turned to stone: Atheronisi within Atheras bay (Od. 13.162-3)
106. Phaeacian ship, return route: Atheras to Corcyra (Od. 13.150)
107. Phorcys harbour: Atheras harbour (Od. 13.96)
108. Phorcys, harbour mist: Atheras harbour (Od. 13.189)
109. Phorcys, harbour olive tree: Atheras harbour (Od. 13.102)
110. Phorcys, nearest shore of Ithaca: Atheras (Od. 15.36)
111. Phorcys, road by olive tree: Wall on the beach at Atheras (Od. 13.123)
112. Phorcys, road to the palace (Od. 17.190)
113. Phorcys, ruler of barren sea: Son of earth-shaker Poseidon (Od. 1.72-4)
114. Phorcys, sheer cliffs: Atheras harbour (Od. 13.196)
115. Planctae Rocks: Lixouri 'Kounopetra' (Od. 12.61)
116. Poseidon, earth-shaker: Earthquakes (Od. 1.74)
117. Reithron harbour: Samoli village (Od. 1.186)
118. Reithron, port: Louros creek at Samoli village (Od. 1.186)
119. Road by the great wall (Od. 23.136)
120. Rock, hollow: On Fakimiá hill (Od. 14.533)
121. Royal Estate: Adjacent to the great wall on Crikellos hill (Od. 1.425)
122. Samos, island: Contemporary island of Ithaca (Od. 4.671, 84-5)
123. Sandy Area: Hypapandi valley, Ammoudares (Od. 14.347)
124. Sandy Beach of harbour: Atheras promontory (Od. 13.119)
125. Sappho, visit to rock Leucas
126. Scheria, land of the Phaeacians: Island of Corcyra (Od. 6.8, 204)
127. Suitors, ghosts followed gibbering: Crickets in the Valtos area (Od. 24.5)
128. Sun, gates of the: Pylaros (Od. 24.12)

129. Swinesty, route to palace, Ocathodos' (Od. 15.505)
130. Taphians: Cephallenian toponym (Od. 1.105, 181, 491; 14.452; 15.427; 16.426)
131. Teiresias' omen (Od. 11.100-37)
132. Telemachus, departure for Pylos: Louros mouth (Od. 2.418-34)
133. Telemachus, gates of tower: Crikellos hill (Od. 1.436)
134. Telemachus, return route past Elis (Od. 15.296-8)
135. Telemachus, tower: Crikellos hill (Od. 1.425)
136. Telemachus' return route: East of Ithaca (Od. 15.33)
137. Telemachus' ship, enters Ithaca's harbour: Livadi harbour (Od. 16.351-2)
138. 'Temenos mega', Odysseus' wide lands on the hill: Crikellos hill (Od. 17.299)
139. Temple, ruins: Livadi village
140. Thiacata: Toponym
141. Thiacia: Olive tree variety
142. Tholos – Storage house on Crikellos hill to the left of the gate (Od. 22.442)
143. Treacherous road, 'arisphalés': Atheras to Halkes (Od. 17.196)
144. Twin Harbours, ἀμφίδυμοι λιμένες: Eryssos, Paliokaravo and Dolicha or Kamini (Od. 4.847)
145. Venus, the morning star: Rises above Agonas village (Od. 13.93)
146. Vineyards: Thiaco wine
147. Wall, great, of the court: Crikellos hill (Od. 16.343)
148. Wall, west side: West of main entrance to the palace court
149. West, the Ζόφος (Od. 9.26)
150. Wind, favourable, 'Ourios': Northwestern wind (Od. 15.292)
151. Wine-dark sea: Sea to the West (Od. 2.421)
152. Zacynthus: Today's island (Od. 4.845)
153. Zeus Herkeios, altar: Crikellos hill, East of palace (Od. 22.334)